Art

Art

Histories, Theories and Exceptions

Adam Geczy

Oxford • New York

English edition
First published in 2008 by

Berg

Editorial offices:
First Floor, Angel Court, 81 St Clements Street, Oxford OX4 1AW, UK
175 Fifth Avenue, New York, NY 10010, USA

Berg is the imprint of Oxford International Publishers Ltd.

Library of Congress Cataloging-in-Publication Data

Geczy, Adam.
 Art : histories, theories, and exceptions / Adam Geczy.
 p. cm.
 Includes bibliographical references and index.
 ISBN-13: 978-1-84520-700-7 (cloth)
 ISBN-10: 1-84520-700-9 (cloth)
 ISBN-13: 978-1-84520-701-4 (pbk.)
 ISBN-10: 1-84520-701-7 (pbk.)
 1. Art. I. Title.

 N7425.G43 2008
 701—dc22

 2008010697

British Library Cataloguing-in-Publication Data

A catalogue record for this book is available from the British Library.

ISBN 978 1 84520 700 7 (Cloth)
 978 1 84520 701 4 (Paper)

Typeset by JS Typesetting Ltd, Porthcawl, Mid Glamorgan
Printed in the United Kingdom by Biddles Ltd, King's Lynn

www.bergpublishers.com

CONTENTS

List of Illustrations vii

Acknowledgements ix

Introduction – Good Art 1

1 Ritual 8

2 Writing 19

3 Imaging 42

4 Gazing 66

5 Media 84

6 Style 101

7 Pleasure 114

8 Money 131

9 Display 145

10 Agency 164

Conclusion – Exceptions 182

Notes 185

Index 203

ILLUSTRATIONS

1.	Joseph Beuys, *Save the Woods*, 1972.	16
2.	Ana Mendieta, *Untitled* (from the *Silhueta* series), 1977.	17
3.	Burial Poles. *The Aboriginal Memorial – The Burial Poles*, 1987–88.	22
4.	Adam Hill, *Average Life Expectancy*, 2006.	23
5.	Code of Hammurabi, *c.* 1750 BCE.	25
6.	Chartres Cathedral, front portal.	26
7.	Ford Madox Brown, *Chaucer at the Court of Edward III*, 1847–51.	28
8.	Paul Delaroche, *Cromwell Before the Coffin of Charles I*, 1849.	29
9.	Peter Kennedy and Mike Parr, *Idea Demonstrations*, 1971–2.	37
10.	Lawrence Weiner, *Nach Alles/After All*, 2000.	38
11, 12.	Brad Buckley, from installation *Every Good Idea Begins as a Heresy*, 2006.	39
13.	Fra Angelico, *The Annunciation*, altarpiece, *c.*1430–2.	46
14.	Georges Braque, *Le Verre d'Absinthe*, 1911.	49
15.	Xia Gui, *Sailboat in Rainstorm*, Southern Song Dynasty, late twelfth to early thirteenth century.	51
16.	Caspar David Friedrich, *Monk by the Sea*, 1809–10.	54
17, 18.	Luis Buñuel and Salvador Dalí, *Un Chien Andalou*, 1929.	61
19.	Hans Holbein the Younger, *The Body of the Dead Christ in the Tomb*, 1521.	63
20.	Hans Holbein the Younger, *Jean de Dinteville and Georges de Selve ('The Ambassadors')*, 1533.	69
21.	Cindy Sherman, *Untitled Film Still #35*, 1979.	71
22.	Mary Cassatt, *The Child's Bath*, 1893.	73
23.	Jean-Léon Gérôme, *The Snake Charmer*, *c.* 1870.	74
24.	Pablo Picasso, *Dance of the Veils*, 1907.	75
25.	Paul Gauguin, *Where Do We Come From? What Are We? Where Are We Going?*, 1897–8.	76
26.	Phillip George, *Affliction of the Protestant*, 2006.	79
27, 28.	Shirin Neshat, *Turbulent*, 1998.	80
29–31.	Vito Acconci, *Following Piece*, 1969.	81
32.	Jan van Eyck, *The Arnolfini Marriage/The Arnolfini Portrait*, 1434.	86
33.	Rhodians Agesander, Athenedorous and Polydorous, *Laocoon and his Sons*, *c.* 200 BCE.	89

34.	Jan Vermeer, *View of Delft*, 1659–60.	91
35.	Albrecht Dürer, *The Martyrdom of St John the Evangelist*, 1496/7.	92
36.	Albrecht Dürer, *Riders of the Apocalypse*.	93
37.	Dennis Del Favero, Jeffrey Shaw, Peter Weibel, *T_Visionarium II*, 2006.	99
38.	Édouard Manet, *Portrait of Baudelaire*, 1869.	101
39.	Édouard Manet, *Portrait of Baudelaire in Profile*, 1865.	101
40, 41.	Two temple sculptures, Khajuraho, tenth to eleventh century.	115
42.	Wheel-lock sporting rifle, Saxony, first quarter of the seventeenth century.	118
43.	Cellini, *Saliera*, Paris 1540–3.	119
44.	Diego Rodriguez de Silva y Velazquez, *The Triumph of Bacchus* (or *The Drunkards*), 1628.	120
45.	Rembrandt van Rijn, *Artemesia*, 1634.	121
46.	Francisco de Goya, *The Flower Girls* (Las Floreras), 1786/7.	122
47.	Otto Dix, *To Beauty*, 1922.	126
48.	Alexander Liberman, *Giacometti*, 1955.	127
49.	William Kentridge, *Preparing the Flute*, 2005.	129
50.	Peeter Gysels, *Still Life near a Fountain*, c. 1685.	133
51.	Wouter van Troostwijk, *Self-Portrait*, 1809.	134
52.	Jeff Koons, *Michael Jackson and Bubbles*, 1988.	144
53.	Impressionist Gallery, Musée D'Orsay, Paris.	145
54.	Hubert Robert, *La Grande Galerie*, c. 1795.	150
55.	Duchamp, *Boîte-en-valise*, Paris 1936 – New York 1941.	153
56.	James McNeill Whistler, *Harmony in Blue and Gold: the Peacock Room*, 1876–7.	154
57.	Maria Fernanda Cardoso, *Cemetery – Vertical Garden*, 1992–9.	157
58.	Carl André, *Roaring Forties*, 1988.	158
59.	Tate Modern, London. Turbine Hall.	162
60.	Louvre Museum, entrance courtyard.	163
61.	Jacques-Louis David, *The Death of Marat*, 1793.	167
62.	Antoine-Jean Gros, *The Battle of Eylau*, 1808.	169
63.	Francisco de Goya, *Third of May, 1808*, 1814.	170
64.	Théodore Géricault, *The Raft of the Medusa*, 1819.	173
65.	Eero Järnefelt, *Wage Slaves*, 1893.	176
66, 67.	Zhu Yu, *Feeding My Own Child to a Dog*, 2002.	179

ACKNOWLEDGEMENTS

To Justine and to Mick who taught me, in different ways, more about appreciation; and to Keith Jarrett, whom I have never met, but to whose music most of this book was written.

Thanks
Thomas Berghuis
Michael Goldberg
John Clark
Jennifer Milam
Conrad Suckling
Eleanor Suckling
Peter Wright and John Spencer

Artists:
Vito Acconci
Brad Buckley
Maria Fernanda Cardoso
Phil George
Adam Hill
iCinema and the artists Dennis Del Favero and Jeffrey Shaw
Peter Kennedy
William Kentridge
Jeff Koons
Ana Mendieta and Galerie Lelong
Shirin Neshat
Mike Parr
The Ramanginning people and Djon Mundine
Cindy Sherman
Lawrence Weiner
Zhu Yu

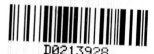
INTRODUCTION — GOOD ART

'To the artist, the working of the critical mind is one of life's mysteries. That is why, we suppose, the artist's complaint that he is misunderstood, especially by the critic, has become a noisy commonplace.' So opens the letter that Mark Rothko and Adolf Gottlieb wrote to Edward Jewel, art editor of *The New York Times* in 1943. Mr Jewel may have paused at this point. For Rothko and Gottlieb seem to be using the convenient screen of myth to shield themselves from criticism, or any verbal gainsaying whatsoever. The use of the word 'mystery' places the artist in the role of mystic, above the critic whose words are mere earthly diatribes that too frequently neglect the deeper, ineffable essence of the work of art. For indeed in a draft of the letter, Rothko stated, 'My own art is simply a new aspect of the eternally archaic myth.'[1] We are offered the artist as seer, and by implication the critic as a hectoring pedant. It is because this binary is so tenacious that I have been prompted to write this book.

Yet my experience has had me peering, if you like, over each side of the fence. As a writer, I have been a defender of the theorist-critic's right to speak, while as an artist I have also clung tightly to guardianship of some indefinable element that evades easy articulation. Meanwhile, my experience as both an artist and an educator is constantly re-revealing, in different ways, that art has a logic, or logics, proper to it. Art has its own sense of order and form, even when it is ostensibly disordered and formless. To some extent, at least, it is possible to say why something works where something else does not. It is at this point where art and theory meet and reveal that art – good art – is itself a theory. Like theory, it can be about itself, it can be about the effectiveness of theory, or it can theorize about outside events and immediate conditions: social, emotional or political. The best artworks announce themselves simply, although their genesis and their means of transmission are anything but simple. The devilish riddle about art is that one needs to know both about art and about life in order to perceive and appreciate that stratum of the priorness of knowledge.

While art may spring from some inner will, this is not the full extent of the matter, otherwise it would be relegated to what the philosopher Hegel termed the animalistic or 'appetitive' states. And for those who contend that art is at root spiritual, all that is spiritual is not necessarily art. Nor does a genuine emotion or deeply felt belief transform directly into a work of art of the same intensity. As David Hume observed, there are two kinds of beauty: beauty in nature and beauty in art;

the first hits us frontally and unequivocally, the other is full of equivocation and requires due consideration.

The consideration that art (some art, good art – it is impossible to put a finer point on it) elicits is afforded through intellectual and emotional experience. It is only as a result of depth of experience that we notice certain works of art before others. Such discrimination is the beginning of appreciation. Art needs to be learned: both its appreciation and its making. As for our friend Rothko, even he knew, though didn't want to admit it, that the Hindu and Buddhist mystics required a long apprenticeship of learning before the world could be seen and felt in all its uncomplicated grace.

Later in their letter, Rothko and Gottlieb remark that 'The appreciation of art is a true marriage of minds.'[2] Appreciation of art is, in other words, not one-sided. While it takes talent for artists to invent new means of communication, it also takes the talents of sensitivity, reflection and perspicacity for the best viewers of artworks to have swift access to what is most at stake. For all this to work, an artist must have an element of the critic about himself, and a critic an element of the artist.

In my late teens, I met an elderly woman who would read Dostoyevski's *Crime and Punishment* every year. Having read the book I couldn't ridicule the obsession, but with so many things to read never entertained the idea for myself. Now, older, I have an even better idea of what drove her to do so. Art acts as a filter, catalyst and gauge of experience. It is not some magic that works upon a passive viewer.

Raw, untutored, 'primitive' talent is always a possibility, but if it does not eventually react to the world in some penetrating way, it is just a pathology. And if we may say that great art cannot be taught, we may say the same of optimal achievement in any discipline. Art is a discipline; it is also a form of knowledge that has its own grammar and syntax. This book, then, is a grammar of art from a perspective of the early twenty-first century. Like any book on grammar, it attempts to explain the grammar but is much less in a position to account for it. Unlike a book on grammar, this grammar is not governed by fixed standards, yet it nevertheless locates the areas of consistency, precedent and consensus that embed themselves into the way that art is viewed today.

Bar none, my favourite defence of the studied, experienced and informed response of art is realized in William Hazlitt's (1778–1830) essay, 'On the Pleasure of Painting' (1820):

> [. . .] all that constitutes true beauty, harmony, refinement, grandeur, is lost upon the common observer. But it is from this point that the delight, the glowing raptures of the true adept commence. An uninformed spectator may like an ordinary drawing better than the ablest connoisseur; but for that reason he cannot like the highest specimens of art so well. The refinements not only of execution but of truth and nature are inaccessible to unpractised eyes. The exquisite gradations in the sky of Claude's are not perceived by such persons, and consequently the harmony cannot be felt. Where there is no conscious

apprehension, there can be no conscious pleasure. Wonder at the first sight of works of art may be the effect of ignorance and novelty; but real admiration and permanent delight in them are the growth of taste and knowledge. 'I would not wish to have your eyes,' said a good-natured man to a critic, who was finding fault with a picture, in which the other saw no blemish. Why so? The idea which prevented him from admiring this inferior production was a higher idea of truth and beauty which was ever present with him, and a continual source of pleasing and lofty contemplations. It may be different in a taste for outward luxuries and the privations of mere sense; but the idea of perfection, which acts as an intellectual foil, is always an addition, a support and a proud consolation![3]

Good appreciation of good art is not immediate. Art is not democratic. While art and democratic values share ethical, positive principles, democracy is discouraged from disrupting the status quo except by degrees, which can be its weakness, while art's powers of disruption are legion. Paradoxically, art at its most obscene and iconoclastic has positive interests at the core: liberating minorities, destabilizing sameness, it can include acts occasionally involving mutilation and sometimes death – which in politics would relegate it to the right wing. Yet so-called democratic taste can be just as reactionary. For it is precisely modern democracy that is manipulated into the service of the most tiresome, belligerent airheadedness: 'I don't know much about art, but I know what I like' and 'I have a right to my opinion.' Beauty, quality and goodness in art may be subjective, but not entirely so. In the words of the great American critic Peter Shjeldahl, 'An experience of beauty entirely specific to one person probably indicates that the person is insane.'[4]

Hence in another essay, Hazlitt, no conservative by any stretch, aptly commented that the right to an opinion in politics is not the same as the right to an opinion in art:

> The diffusion of taste is not the same thing as the improvement of taste; but it is only the former of these objects that is promoted by public institutions and other artificial means. The number of candidates to fame, and of pretenders to criticism, is thus increased beyond all proportion, while the quantity of genius and feeling remains the same; with this difference, that the man of genius is lost in the crowd of competitors, who would never have become such from encouragement and example; and that the opinion of those few persons whom nature intended for judges, is drowned in the noisy suffrages of shallow matters in taste. The principle of universal suffrage, however applicable to matters of government, which concern the common feeling and common interests of society, is by no means applicable to matters of taste, which can only be decided upon by the most refined understandings. The highest efforts of genius, in every walk of art, can never be properly understood by the generality of mankind: There are numberless beauties and truths which lie far beyond their comprehension.[5]

Hazlitt seems a bit severe in his elitism, but we must also look at the facts: Pink Floyd, great as they are, are not greater than Shostakovich because they have sold more recordings, and *Star Wars* is not necessarily a better film than a video by Bruce

Nauman because everyone has heard of the former and only art aficionados the latter. What we take from Hazlitt's statement is that a certain humility is needed when looking at art. Art needs to be learned.

Despite efforts, since the French Revolution, for art to meet the people, there is still a wide gulf between the world of art and the lay public. Some will say that the gulf is invidious, others salutary, still others will say it is just a cold fact. The idea of 'art appreciation' that was widely popular between the 1950s and 1970s was a general set of aesthetic entrées for people who spent most of their lives separate from art to understand art in terms of what set it apart from other things and, simply, what made it special. Art appreciation was cast into the dustbin of discourse by some factions of Postmodernism and subsequent cultural critiques for whom hierarchies are linguistic, social constructs.

This is not to say that I am hostile to Postmodernism or cultural studies. On the contrary, this book is directed at people in line with this interest. But I am not alone in turning my back on Postmodern idiocies derived from taking rhetorical polemics to the letter ('the death of the author', 'the end of the real'). A lot of oxygen has been wasted on taking late twentieth-century French thought at face value, just as art students thought that the best way to be Deleuzian was to act like a schizophrenic, and young philosophers thought that to write like Derrida was a sure-fire route to radical profundity.

It is a convenient crutch of theories in the wake of post-structuralism to disavow hierarchies and to pretend there is a level playing field; extremist political ideologies from Jacobinism to Communism were prone to the same hypocrisies. Anyone serious in examining a culture is inquisitive about the value systems around which power is distributed. And anyone who says that such relegations of power are merely linguistic constructs would then honestly have to turn to his or her newborn child and say that love, too, is just another linguistic product. Nonsense. Without the aspiration to quality, life is boring. Life is also boring when quality is made out to be something resembling components of a car engine, or when quality, the specialness about something, is explained away.

This antagonism against inexplicable elements in art has always been with us, but it is exacerbated to institutionalized proportions with advertising, where the primary logic is to be easily decoded towards a specific aim. It might be said, at the risk of causing offence, that modern-day advertising is to the secular world what religion was to the sacred world. In a world circumscribed by religion, the signs of that faith are everywhere. One of the roles of religious objects and imagery in public places, much of which was only later called art as such, was to announce the omnipresence of a godhead, and to act as a prevailing conscience upon the people. Many other objects not associated with religion were nonetheless connotative of it, such as the cross of the sword in the Christian world; in Japan the Samurai had signs of the sources of his power tattooed on his body. These continuities are in fact implicit in the term 'sacred age' or 'sacred society', for which the secular was always accountable to the sacred, and measured and informed by it. But when we come to the secular

age, the sacred exists as something vastly different: it may be the purview of an elite, it may exist as a religion that no longer reigns supreme, or it may exist as a dream manifested in conventionalized beauty reflected by stardom.

Since as early as the 1930s, with the propaganda machines of Nazism, and the rise of wholesale technological consumption by the 1950s, it has been the media (news media, entertainment and advertising) that define the dominant codes of imagery and their reception. Unlike sacred societies, where the higher abstractions, or master signifiers, are centralized, aspiration is located in the signs of money and mass-marketed beauty. If there can be said to be a higher abstraction, it finds its furtive (because not acknowledged by everyone) embodiment in today's concept of art. This change has a relatively gradual evolution, but it is finally visible by the nineteenth century together with burgeoning notions of nationalism, self-governance, individual freedom, physical mobility and a free-market economy.

The effect that advertising has had on art is not only felt within artworks themselves, but in the ways in which we respond to artworks and what we seek to derive from them. It is, for example, easy to speculate on qualitative distinctions between the cognitive powers of the reader of this book and an educated medieval burgher. Quite simply, the reader of this book knows more. He or she may not know more about friendship or death, but will do so about ecology, biology, geology, geography, anatomy, physics, literature, music, foreign cultures, education, class and social organization. It is not just that most of these disciplines had not been invented in the 1400s, but the average person of today is exposed to literally millions more images, that is, *mediated* perceptions, than in the age when there were no cell phones, photography, television or Internet. This is not some coarse evolutionism; it does not imply that we are any wiser than our hapless medieval counterpart, although it does mean that our heads are full of more 'stuff'. In a way that is particular to mass imaging, we digest images with staggering rapidity and fluency. Our diminished ability for slow, protracted and considered contemplation comes from our heads being so full of mediated visual data as to have a linguistic receptiveness that draws connections between what we are seeing and what we have seen well before we have a chance to reflect upon them. Advertising is predicated upon this conditioning. And the general impatience with the purported difficulty of art is cultivated by the linguistic modality of advertising, which is at root antithetical to the way the majority of artworks expect to be viewed. Whereas art can be said to unfold to perception over time at several levels, meaning it is 'slow' or, to borrow McLuhan's term, 'cool', advertising is tied to specific circumstances and has a particular duty to perform, namely to sell a product and to make money, making it 'fast' or 'hot'. Whereas ambiguity can be desirable for art, it is the enemy of advertising, which, even if it operates according to verbal-visual puns or tricks, is geared to a particular objective.

Imagine a picture in the box below. Imagine a black-and-white photograph of a man's hairless torso, naked except for a pair of briefs. He has enlarged pectorals and six-pack abdominals. What phrase springs to mind?

You could easily be forgiven for coming out with the name of a popular under-wear manufacturer such as Calvin Klein. Try this experiment on someone else, and you may be surprised to meet with a similar response. Even if you didn't come up with 'Calvin Klein', you may have heard of him, or my mention of him may finally call the appropriate image to mind. The point is that we are so linguistically hot-wired to images that we react to them with a subliminal mass of assumptions. As demonstrated above, the mechanisms of advertising have penetrated our minds enough for one to jump to a conclusion on the basis of mere suggestion. The fact that the vast majority of us in the developed world see more images with a planned destiny, such as advertising and news media, than ones with a less definite destiny, such as art, means that, without the right experience, exposure and education, most people expect the same of art as they do of advertising. We have been heavily conditioned to expect art to be easily decoded and therefore legible. A widespread result of this is an increasing distrust of all art as incomprehensible. It is incomprehensible or hard to fathom because a work of art cannot be resolved with a punch line. Lay viewers, when asking to have a work of art explained, are apt to be dissatisfied. Some works of art can be explained more easily than others, but what differentiates art from other objects not deemed art is its engaging ambiguity. What people take for an explanation is really only a set of terms which allow the viewer more immediate access to these ambiguities. When such ambiguities are cast into history, this is another matter altogether, since with every epoch, and with each culture, priorities change, terms of reference change, words change.

I attempt in this book to explore the elements of art that distinguish it from other phenomena: thus what others have said about this (as in my chapter on writing), the uses to which art has been put (as in my chapter on ritual), the physical properties that have informed art's form (as in the chapter on media), the ways in which art is delivered to us (as in the chapter on display), the values we give to art (as in the chapters on ritual and money), the standpoints from which art is seen (as in

the chapter on gazing), or the nature of representation itself (as in the chapter on imaging).

As with every abstract mention of the term 'art', what is implied is 'good art'. It would be foolhardy to attempt to say what good art is, although this book raises the arguments used in evaluating art, locates various dilemmas, and there are several considered value judgements along the way. The chapters follow a rough order – to begin with ritual is sensible enough, and to put the theme of money towards the end is a reflection of the present. Overall, however, the chapters are best seen as a constellation that makes up the vague lineaments of the entity, practice and aspiration that most agree to be art. Each chapter is composed as a selective genealogy that traces the development of its guiding idea. I emphasize 'selective': the study of art is extremely broad because it encompasses both writers and artists (a relationship I will canvass) who themselves have discordant views.

I confess that although there is an attempt to survey a stretch of cultures, tastes and eras, there is a Modernist–Postmodernist (in so far as Postmodernism has an agonistic relationship to Modernism) leaning in this book which probably comes from the tenets that have preoccupied me as a practising artist. My aim is to explore the events, examples and spokespeople who have come to crystallize our present notion of good art. In doing so I not only wish to expose the diverse conditions which allow art to be considered art as such (and by extension, good art), but also, more simply but harder to define, why art is considered special and why it should be considered special as such. For this book is guided not only by the thirst for inquiry, it is also guided by pleasure. As to the word 'exceptions' in the title, I will return to that in the conclusion. Suffice to say that all art that presents a challenge is an exception. Art is defined by the examples that seek to rupture its boundaries and, in so doing, it articulates what these boundaries are, thus in the same movement both defining and undermining what art is. In proportion to the number of images that exist in the world and all that wants to call itself art, good art is exceptionally rare.

I RITUAL

The items that many histories of art incorporate as the most venerable of art's manifestations, from religious idols to cave paintings, were no more 'art' to the cultures from which they sprang than television serials are to ours. Rather, much of what we describe as art belonged to a range of practices that connected people to the forces they believed sustained them, from a spiritual godhead to the animals they relied on for their survival. And the things we isolate as art and stand and look at today are only remnants of a much wider complex of activities – singing, dancing and storytelling. But the reason why it is perhaps acceptable to term these remnants of ancient rites 'art' is that they share a basic condition common to much of the art of today, namely they function as a mode of access to something where other methods are deemed inadequate.

Art began with religion before religion allowed itself to become mired in dogma. Depending on one's point of view, art can either be a window to a higher realm or the catalyst for a spiritual relationship. Thought of in this way, art is either a speculative act of divining with an inconclusive result or, more optimistically, a way of touching the imponderable. In ancient terms, the concept of artistic labour, which artists have cherished since the early twentieth century, was anathema. On the contrary, art was more the child of celebration and play, indissoluble from the festive and solemn rituals of life.

The word 'ritual' dates from the Latin *ritus*, meaning 'religious usage'. A ritual is any activity whose added importance derives from repetition, which, over time, anchors people to others of the past. Yet many of the rituals at the heart of contemporary life, such as mealtimes or Saturday night clubbing, are several orders removed from the essence of ritual – which is to unite the world of the living with the dead. Since ritual is repetitive, it is the temporal that is crucial: the ritual act is the vitalistic nexus between the past and the present. For instance, the rite of passage is an inherited set of rules that solders a person to the mores of a group. Archaic ritual – from prehistoric humanity to the Ancient Greeks – did not distinguish between actions, sounds, images and objects. Many of what we now call artefacts are more exactly ritual items that assisted in the ecstatic, or even sinister process of communing with 'live' spirits. Today, art is frequently discredited as dispensable to life, yet for communities for whom ritual was integrated into all manner of objects and patterns of living, ritual was the very mainstay of life. Even for Western society, where higher ritual (as opposed to mundane rituals such as brushing one's teeth) is optional or

supplemental to living, there are innumerable acts that are richly invigorated with meanings that give us the feeling of continuity in place and time. These customs, rites, sacraments, services, traditions, institutions or procedures occasion a sense of belonging and as such are liable to give us that contentment which security brings. The qualities of ritual reveal the instinctual underpinnings in art: play and excess on one hand, and death and prohibition on the other. What the late nineteenth-century art historian Alois Riegl (1858–1905) described as the will to make art (*Kunstwollen*; also translated as 'will to form') began as a reflective awareness of the will itself. People strive for something beyond themselves with the presentiment that there are things beyond our immediate sensory realm. Both art and ritualistic manifestations convincingly suggest something beyond that which is visible to incurious eyes.

THE NARRATIVE OF THE BIRTH OF ART

The story is the envy of any adventurous adolescent. In 1940, some boys exploring the hills of Lascaux in the Dordogne region of France (north-east of Bordeaux) stumbled upon a warren of caves scattered with artefacts, the walls animated by bold paintings of stags and bison, probably some early version of shrine for the sacred rites of *Homo erectus*. Dated at the early Palaeolithic period of approximately 15000 BCE, the caves were subsequently heralded as one of the greatest finds since the mid-eighteenth century, when countless treasures emerged from the archaeological digs in the hills of Herculaneum. After W. F. Libby's invention of radiocarbon dating in 1949, and when interest in Australian Aboriginal art and culture took wing in the 1980s, the paintings of the caves of Lascaux were considered to be the oldest examples of 'art' in the world. Some still cling to the fact. First or not, they are tenacious symbols of our artistic dawn. People still make the pilgrimage there, but as an ironic testament to our present culture with its uncritical appetite for entertainment and spectacle; what they see is a copy put in place to save the real caves from deterioration by the humid breath of ogling hordes – a replicated subterranean passage nearby the original, duplicated as lovingly as Mad King Ludwig's Neuschwanstein castle in Bavaria has been for the satisfaction of visitors to Disneyland.

Despite now being discredited in some of its facts, the most challenging, evocative and convincing account of the birth of art continues to be *Lascaux, or the Birth of Art* by the French sociologist and one-time Surrealist Georges Bataille.[1] Bataille uses the finding of Lascaux to ask a simple question: Stepping out of the void, what prompted early humans to make art? *Homo sapiens* had long been walking the earth before these paintings; the bipeds well before Palaeolithic man were already proficient at making tools. It was only, as Bataille suggests, when these beings gained awareness of a deeper spiritual experience and, feasibly, a self-consciousness of themselves as *beings* in a *world*, that the reflection and affirmation of an inner life sought its outer form in what we call art. Behind all art, to some degree, is the urge to leave something behind, and in the ritualistic element are premonitions of a life beyond.

It was also a new form of production that was not linked to physical survival. Bataille's thesis is all the more persuasive for his effort to incorporate his own physical experience of the works (when they were still open to the public). The commanding presence of these works, 'prehistory's Sistine Chapel' is for Bataille undeniable and of a piece with any masterpiece of any period of civilization. But unlike our most-cited masterpieces, these works lack all manner of attribution. Their genesis remains obscure. For Bataille, they are decisive markers in the final transition away from appetitive animality to reflective humanity. These beings no longer just preoccupied themselves in the travails of survival, but indulged in the excesses of play, play being an expression of something more to life than the mere processes of self-preservation.

It is also at this point that certain tools cease solely to have a merely prosthetic quality and become imbued with ritual significance. They gain added eminence owing to consciousness of the cycles and processes of life. With this sense that there was something more to life, the incorporation of ritual and play into life's texture, and the embrace of imaginative desire, language flourished. Language and art came into being through an added responsiveness to the beauties and dangers of life. In an argument that in some respects presages Bataille's, the Enlightenment *philosophe*, Jean-Jacques Rousseau, adduced music as the origin of language; rhythm, sound and modulation eventuated into the more regulated structure of language. The beauties of music are reminders that the first languages were 'the daughters of pleasure and not of need'.[2]

Play, as a celebration of life, must also permit its opposite, death; ceremonies of living and dying are two sides of the same coin. But within the ritual game, death, as Bataille points out, is not considered negatively, for it finds itself embedded in the prohibitions that prop up the idea (or ideas) of culture that we cherish today. Thus Bataille's most audacious assertion about humanity and the idea that undergirds most of his writing: 'Without prohibition there is no human life.'[3] All of his major studies, *The Interior Experience* (1943), *Erotism* (1957), *The Accursed Share* (1949) and *The Notion of Expenditure* (1949) revolve around the notion of humanly *excess* that needs either to be hemmed in or expelled. Bataille's ideas share affinities with Freud's concept of repression, the Greek process of *katharsis* as elucidated by Aristotle, and *abreaction* as examined by the mid-twentieth century anthropologist Claude Lévi-Strauss, all of which I will return to in the course of this chapter. For Bataille, the excesses of our nature, which prohibitions protect us from, are shunted (or what Freud called *cathected*: a form of cathartic grafting or projection on to something) into the less damaging realm of art. Art is therefore transgressive inasmuch as it actualizes, metaphorically or not, what we are not allowed to name or do. But the method of actualizing, or revealing, is through repression, by making us aware that such disclosures are either forbidden, dangerous or beyond our ken. Art makes the unpalatable palatable or the unrepresentable representable, from the excesses of

sexuality to the vales of death, excessive because they supersede physical and psychic human boundaries.

What the beings in the cave at Lascaux were enacting had to do with their principal activity, hunting, yet was raised and expanded with all the dalliances of a game. For Bataille, *Homo sapiens*, the 'man who thinks' (the one who supplants *Homo faber*, the 'man who works') is a misnomer – for the greatest contribution of *Homo sapiens* is play; *Homo sapiens* would therefore be better called *Homo ludens*, 'man who plays'. Knowledge of the world is mediated through play, in this case embodied in ritual whose aesthetic form is what we now call art. Art-ritual is the physical expression of something that is additional to their work. It is also what keeps the extremity of their desire – the desire for physical transcendence, to go beyond themselves, which ultimately courts pain and death – in check.

Denis Hollier describes Bataille's birth of painting thesis in terms of a displacement of the productive-reproductive urge, where rather than just *discharging* desire, the developed intelligence of the new human seeks recourse to *symbols* of his desire:

> Deep within the labyrinth of Lascaux, in the most famous of its wall paintings, Bataille saw a minotauromachy: a man lies dead on the ground, and beside him is the animal. *Les Larmes d'Éros* [Tears of Eros] describes the bison as 'a sort of minotaur', and connects the question of the difference between animal and man with the question of painting, to the extent that, for man, painting would be the refusal of reproduction and the assertion of non-specific difference with himself. Minotauromachy – posited as a myth of the birth (death) of man and the birth of painting, breaking with the classical tradition that, since Alberti, had claimed that the assertion of human form expressed in the Narcissus myth was the original pictorial urge.[4]

Bataille stipulates that the rites of life which the early humans of Lascaux celebrated in worshipping the animals that sustained them were matched in equal measure to the end of life. Death, in the earliest ritual according to Bataille, was neither feared nor execrated. Art straddled the extremes of the known, named world of things and the unknown, unnamed world of omens and shadows. In such rituals the living confronted death with the afterlife, as is the case with all forms of death rites, from Aztec sun worship to Aboriginal and American Indian burial ceremonies, and voodoo dance.

The earliest art forms are the rites at the centre of such celebration. 'In isolation,' concludes Bataille, 'making an outline of a figure is not a ceremony, but it is one of its constitutive elements, which consists of a religious or magical *operation*.' The birth of the being who orders life according to laws not solely tied to everyday needs – but with something else, 'magical' – is also the birth of art. This 'human world' that binds 'the signification of man to that of art, [...] delivers us, albeit each time for a short time, from sad necessity, and makes us surrender in some way to that marvellous burst of richness for which each of us are born'.[5]

SYMBOLIC EXPENDITURE

In economic terms, the symbolic exchange represents the variety of objects, services or actions that are not directly necessary for survival. While it is true that human beings need art – otherwise named symbolic expression – or recourse to some abstract power, the need it satisfies differs from biological appetites and is supposedly what endows us with such nebulous qualities as 'mind' and 'soul'.

Religion was Karl Marx's 'opiate of the masses', and art in his economics is counted amongst 'surplus value', that is, what *exceeds* what we need for basic subsistence. It is the product of unquantifiable labour. Bataille, in his rejoinder to Karl Marx, explains that materialism only goes so far because its process of exchange is built on the precept of equity being arbitrariness dressed up as unerring truth. To favour a materialist philosophy is both superficial and limited, since for Bataille the bulk of our lives revolves around assumptions for which the materialist concept of exchange is just a small component. Our conscious, materially productive dimension is in fact dwarfed by the unconscious economies of displaced production, or non-utilitarian productivity. For humans evince a continual and vital need for expenditure, a ritualization of loss that manifests in earlier cultures as rituals of sacrifice. Or we might say that rituals and sacrifices are indissoluble from human production and expression, that they are prerequisites to social formation. Only more recently have they been either displaced and mediated (for most of us death is either an item of information fed to us by the media or trivialized in B-grade films), or encoded in everyday practice (the ritual of dinner is always worth citing, no less than Sunday gallery-going).

Meanwhile the loss effected by the act of sacrifice generates a much greater force, which allows for the sacred to be *produced*. For example, in the crucifixion the Christian finds the source of eternal redemption. And we might then add this to Bataille's formulation: As expressions of death and reproductive power, each sacrifice is an outpouring of energy that in turn opens up a space for other emissions of expression from the individuals who witness the sacrifice, either as an event or in its metaphoric ritualization. Ritual is effective when the original event and its repetition are one. In art the viewer feels as if physically touched by affect and idea. In art, Bataille distinguishes between the 'real' expenditures of music and dance and the 'symbolic' expenditures of painting and sculpture.[6]

ANCIENT GREECE

Ancient Greece privileged theatre over the other arts. Conjoining religion with amusement, it was where everyday lives were able to meet with those of the pagan gods. As the extremes of human experience unfolded before them, the audience experienced the pathos of their humanity with a sharpness that caused an emotive expulsion, a kind of vomiting of the spirit that left them feeling temporarily cleansed. According to Aristotle, this was the social function of tragedy:

> Tragedy is an imitation of an action that is serious, complete, and of a certain
> magnitude; in language embellished with each kind of artistic ornament, the
> several kinds being found in separate parts of the play; in the form of action, not
> of narrative; through pity and fear effecting the proper *katharsis*, or purgation,
> of these emotions.[7]

Our modern equivalent is probably football or rock concerts, held in those vast col-
iseums of the future, where tens of thousands of people partake in a mass expulsion
of energy.

RITUAL AND THE BIRTH OF JAPANESE ART

With the Heian period (794–1184), Japan began to approach a solid idea of its own
identity that distinguished itself from China. The capital transferred to Kyoto; the
era ended with the Kamakura Shogunate at the end of the twelfth century. During
this time, art, crafts and social rituals were tightly bound.

The art of this period is known for its discipline, simplicity and refinement,
qualities that have been hallmarks of traditional Japanese art to this day. The Heian
period marks a flowering of architecture, the decorative arts and literature, the most
famous remnant being the *Tale of Genji* by Murasaki Shikibu. The other great work,
The Pillow Book, is by her contemporary, Sei Shonagon, the lady-in-waiting to the
Empress Sadako. Both works afford valuable insights into the art produced during
the period, as Heian literature is built around the extremely stylized nature of courtly
life. The *Genji*, a set of connected stories about a prince blessed with beauty and
impeccable poise, supplied countless generations with material, most famously the
makers of wood block or *ukiyo-e* prints, such as Hiroshige, Kiyonaga and Utamaro,
who so influenced the French Impressionists. (Kazaburo Yoshimura's (1952) film,
Tale of Genji, provides an accessible entrée into the strict mores of the period.)

The Pillow Book, essentially an assemblage of observational fragments, is a reliable
mirror to the way the Heian elite attempted to give everything aesthetic definition;
the mores of courtly life were thought of as synchronous with the seasonal changes
in nature. A remarkable feature (one may say primness taken to the point of oddity)
of Shonagon's writings is her extraordinary repetition of *okashi* (charming), *medetashi*
(splendid) and *ito* (very). To an ingratiating degree, the book is laced with affirm-
ative formality. The titles of the fragments are enough to convey the degree to which
every aspect of life is loaded with aesthetic baggage: '2. Especially Beautiful is the
First Day'; '18. A Palm-Leaf Carriage Should Move Slowly'; '47. Rare Things'; 'It is
Absurd of People to Get Angry', '170. I Cannot Stand a Woman Who Wears Sleeves
of Unequal Width'. How intolerable. *The Pillow Book* is an invaluable document
that bespeaks the equilibrium which is the duty and the prize of privilege.[8]

Considerations of any of the greater artefacts of this period must always be viewed
in light of the ritual that was woven around all things. In some respects, Japan has
never erred from the ethic that began in the Heian period, for traditional Japanese
values prefer nature refined and transformed over nature rough and unmediated.

ARTIST AS SHAMAN AND MAGICIAN

The theses of the anthropologists Claude Lévi-Strauss and Mircea Eliade were pivotal in the way in which the role of art was articulated, or sought to be articulated, in the 1960s, the period of the protest area in which many artists, musicians and poets sought to rejuvenate the credibility of art, to remove it from the status of a commodity, and to return it to the ecstatic rites which brought it into being.

Eliade's *Shamanism: Archaic Techniques of Ecstasy* (1951), derived from anthropological research in Indonesia and South America, was not directed at art as such. Yet for contemporary readers, the parallels between shamans and artists, both of whom supposedly had access to special codes, was obvious. For Eliade, the shaman exercised 'archaic techniques of ecstasy – at once mysticism, magic and "religion" in the broadest sense'.[9] The note that Eliade's book sounds of shamanic healing – and by extension the symbolic healing of the artist – was particularly resonant in a world still ravaged by the memory of the Second World War and, for America, traumatized then divided by the wars in Korea and Vietnam. The shaman was a figure in the tribe who had access to extreme mental states such as dreams and trances, whilst also being skilfully versed in the traditional codes of his clansmen – spirits, mythology, genealogy, secret language – of which he was both mediator and conduit.[10] The shaman, according to Eliade, was a cipher occupied by a spirit, evidenced in the trance-like state where his spirit leaves his body to undertake a spiritual mission for his group.

For this special channelling function of the shaman, Lévi-Strauss, in his groundbreaking study *Structural Anthropology* (1958), used the psychoanalytic term *abreaction*. The shaman acted on behalf of his audience, expending and expunging inner energies. So cleansed, his group would return for a time to a state of spiritual and psychological (in shaman-driven communities there is no distinguishing the two) equilibrium. The 'sorcerer' occupies himself in acts of 'self-projection' and re-establishes the connection between affect and Symbolism, instinct and language. The 'cure' that the shaman-sorcerer engages in 'interrelates these opposite poles, facilitating the transition from one to the other, and demonstrates, within a total experience, the coherence of the psychic universe, itself a projection of the social universe'. The shaman thus casts himself as an objectification of the aspirations and needs of the group. The value of abreaction is not based on 'real cures' that are medically provable, 'but on the sense of security that the group receives from the myth underlying the cure and from the popular system upon which the group's universe is reconstructed'.[11]

Now let us translate this idea into the realm of art. The artist participates in an act of symbolic exchange between himself or herself and the audience. There must be some commonality of expectation and language for this exchange to work. When the audience welcomes the artist's message, it feels both enriched and disburdened, simultaneously full and light, ready to return, with greater security, to a prosaic world that does not offer the same profound symbolic resonances. It is an excellent

way of understanding the relationship between art and ritual, and artists who wish to restore ritual to the diffuse, secular industrial-technological world, two of whom I will now turn to.

RITUAL (ART) IN A SECULAR WORLD

JOSEPH BEUYS

> Like the sick man, the religious man is projected on to a vital plane that shows him the fundamental data of human existence, that is, solitude, danger, hostility of the surrounding world. [...] The shaman is not only a sick man; he is, above all, a sick man who has been cured.[12]

Eliade's definition of the shaman applies to the artist Joseph Beuys to the letter. Beuys played up to the shaman model in the way he retold his history and his entire make-up: first sick, then cured, he styled himself as artist-healer for post-war Germany – a culture thick with the feeling of guilt and loss.

His story is firmly inscribed in the annals of art historical legend. As a Second World War fighter pilot, Beuys's plane was shot down in the Crimea. Rescued by Tartars, he was nurtured back to health by being wrapped in fat and felt. How much is true about Beuys's self-propagated myth is debatable, but even if he were loose with the truth, it doesn't matter. What matters is the importance he subsequently gave to the substances of fat and felt as curative devices for a shamed and traumatized people. These substances are not only symbolic, they are part of the artist's very pathology, they are part of his body and his meaning as a human, and are therefore implicated in everything he does – or at least this is how we are to read them. All of Beuys's work must to some extent be seen from the angle of performance art, as even the sculptural and installation works are like remnants of a much more expansive ongoing activity. A felt suit on a hanger or a block of fat in a corner – these are not solely meant for aesthetic contemplation, but are like talismans whose meaning is primarily succour: comfort, shelter, relief, purgation.

One of his most inspiring works was a demonstration in the Grafenberger Wald outside Düsseldorf in 1971. Angered by the proposal that the forest would be cleared to make way for tennis courts, Beuys, together with fifty students, swept the forest floor with birch brooms and painted rings and crosses on the trees as if from some venerable Teutonic rite. After unsuccessfully running for the European Parliament in Strasbourg as a Green, in 1982 his contribution to the international art festival, Dokumenta 7, was an environmental project on a Wagnerian scale: *7000 Oaks* was to be an ongoing project of tree-planting in German cities. By the time of his death four years later, they had almost all been planted and his son planted the remaining two thousand to mark his memory.[13]

Beuys is one of the leading members of the international art tendency, Fluxus, still thriving today. Post-Dadaist and avowedly ritualistic, the aims of Fluxus are

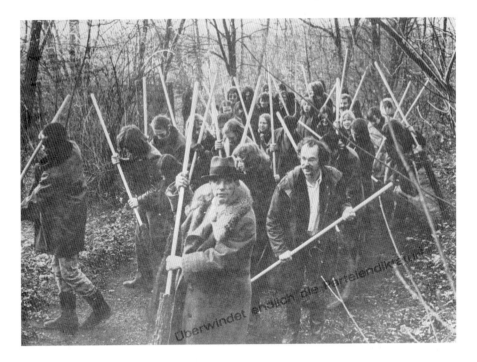

1. Joseph Beuys, *Save the Woods*, 1972. Offset print (black/red), 49 × 50 cm. Collection Art Gallery of New South Wales. © Joseph Beuys and the Art Gallery of NSW.

towards the energetics of exchange and social stimulation, striving always to dodge commercial control and co-option of ideology. Beuys referred to his later work such as *7000 Oaks* as 'social sculpture'. The emphasis is more on what an artist does and on dodging the possibility of the work being treated as a potentially saleable artefact, marketable and thereby corruptible. Interestingly enough, many artists today operate both in modes of experimental, ephemeral, challenging Fluxus-oriented practices and in the more commercial practice based in the gallery or on commissions. Both keep the artist alive, the former spiritually, the latter materially.

THE GUTAI GROUP

Gutai, meaning 'concrete' or 'embodiment', was an initiative of Yoshihara Jiro in 1954, and was in many ways the Japanese equivalent of Fluxus. It had a cultic status, and its members – also Kanayma Akira, Murakami Saburo, Shiraga Kazuo, and Shimamoto Shozo – sought to reinvigorate art with urgency and immediacy as an antidote to the heavy traditions of Japan, still harshly beset by memories of the war. Anticipating the Happenings of a decade later, their work can be thought of as an artistic reaching out to a region free of political and historical burdens. By escaping the lasting work of art, the act in itself could operate as a zone free of conflict or blame. Their performances were typically either instantaneous (as when Murakami

ran through a paper screen in *Laceration* of 1955) or highly elemental (as when Shiraga rolled in mud in *Challenge to Mud*, 1955). Another significant work was Shimamoto's *Throws of Colour* (1956), in which the artist smashed jars of pigment against a canvas laid out on the floor. Gutai disbanded after Yoshihara's death in 1972, a time when artists in other countries were only beginning to explore the non-material and ephemeral as a serious mode of artistic approach, that is, one that went beyond Dadaist disruption. It is still conceivably Japan's most audacious and influential foray into contemporary art.

ANA MENDIETA

In 1972, the 24-year-old Cuban-born artist Ana Mendieta turned her back on painting because she said it lacked sufficient power, meaning the 'magic' that

2. Ana Mendieta, *Untitled* (from the *Silhueta* series), 1977. Colour photograph. © The Estate of Ana Mendieta Collection. Courtesy of Galerie Lelong, New York.

penetrated into people's souls. From that point onwards, she devoted herself to performances and performance acts which she turned into photographs, videos, site-specific installations, drawings, prints and sculptures.

Mendieta's work centres mainly around her own body as a site of sacrifice and crime, the main concern being social taboo. Her works have a compelling balance between rage and serenity. From 1975 until her death ten years later, under the umbrella title *Silhueta* (silhouette), she used her body in multifarious ways to merge, imprint and physically blend within the landscape. Her work makes references to esoteric symbols and ancient ritual, most evidently those about how women are bound to the earth.

The beauty in Mendieta's work resides in how she is made replete, full, super-human almost, an elemental angel; but also emptied out, dehumanized, devoured by the intractability of matter. To transcribe the words of the philosophers Deleuze and Guattari, Mendieta's performances are a constant process of 'becoming-earth'. We the viewers experience the assertion of life as if matter has burst open, and likewise the assertion of death, where the body falls back into the primeval, faceless stuff, a forest of sounds and colours; back to the priorness of language and perception and the restless disorder whence it sprang.

2 WRITING

'Photography' stated Picasso in a conversation with the photographer Brassaï, 'has come to this point so as to liberate painting from all literature, from anecdote, even subject matter.'[1] The 'liberation' of painting from the grip of words and narrative was one of the great aims of art for most of the twentieth century and it is a prejudice that haunts us still. A good part of Modernism sought to winnow out all that was literary or lexical to create art that was visually pure, which, it was assumed, would be more immediate and meaningful. Writing was to be seen as the dialectical other to what could only – stress *only* – be seen as a pictorial phenomenon. Yet it is ironic that the morality that one should not speak too much about art for fear of drowning it in a flood of reasoning came from the period when more was being written about art than ever before.

Since the nineteenth century, artists have relied solidly on critics, and as one sociologist has recently argued, it was the writers of the nineteenth century who played a very tangible role in the development of the idea of an independent art, autonomous and belonging to itself.[2] This is a paradox that reached an apex with the Abstract Expressionists in New York in the 1950s, who flamboyantly strutted work supposedly untainted by written language, and who were nevertheless propped up by a handful of critics writing thousands upon thousands of words for an eager public. At about the same time, Jungian new-age psychologists came out of the woodwork and preached to those who would listen about right- or left-brain characteristics: you were either a visual or written person, that's all there was to it – visual being intuition, written being reasonable (translation: one zany, the other stodgy). The myth is with us today and is a godsend to the commercial market, which sells to an audience intrigued by things it cannot explain.

The old chestnut from the nineteenth century, voiced again most famously by Marcel Duchamp (1887–1968) in the 1960s, of 'stupid as a painter' – I don't express myself well in words, which is why I do so in paint – has never flagged, for to this day an articulate artist is often treated with suspicion; as counterfeit. ('You express yourself so well, isn't your real destiny as a writer?') But the notion of unalloyed visuality can only be defined according to its opposite, hence to the extent that a picture *does not have* the trappings of 'literality'. Once Romantic feeling won over classicist 'telling' – yet as I am about to show, this is not limited to the classic, as art has been in the service of telling for thousands of years – good artists whose work narrates or minutely describes are vulnerable to the criticism of selling out on what

is truest to their art, namely to show rather than tell. In a letter to someone who had bought his work and asked for a bit more explanation, Gustave Moreau confessed that 'I have suffered too much in my life from that unjust and absurd opinion that I am too literary for a painter.'[3]

Although the idea of pure visuality is a fallacy dreamt up by a particular period, it is just as true that works of art can fail if they rely too heavily on explanation, or when they just illustrate a point that would have been stronger if just written. Art cannot subsist independent of the written, any more than the written can survive without the visual. But to try to find a single formula for this relationship is vain: some works of art have a more intimate relationship to the written, others adopt an oppositional stance, while others relate to it a matter of mere consequence. The rule is simply to be guard against dogma.

And it is curious to see art such as traditional Aboriginal art, art that is much more about telling, embraced as abstract and presentational. For it is true to say that the beginnings of art are tangled up in the act of preserving structured meanings, many of which form narratives. Many of the first forms of art, such as Aboriginal and American Indian, were indeed as much forms of writing. Many of the first forms of writing were pictorial; the first languages didn't describe sounds but things, as in allegorical figures in the early art of Mexico and the hieroglyphs of Ancient Egypt.[4]

ABORIGINAL ART

The biggest international market for Aboriginal art – which also happens to be Australia's largest cultural export – is New York. This is no surprise, as it is the city that made the largest claim to non-objective abstraction after many of Europe's best artists fled Paris in 1940–2. Lovers of art in New York have been accustomed to a heaped serving of abstract painting in their visual diet. It is a basic truth that people gravitate to what they know, which explains the great responsiveness of New York to Aboriginal art when it began dribbling into their market in the 1980s. Their appetite for abstraction also explains that the artist who so far asks the highest prices, Rover Thomas, is also appreciated for his bold compositions and flat, simple planes, remotely like a Clyfford Still or Rothko except in earth tones. It is unlikely that the first collectors knew much about Aboriginal art and culture, or the meanings within their art, or may not have cared. But those who bothered to find out may have been surprised to learn that Aboriginal art, while sharing many superficial traits with 1950s American non-objective painting, is in other respects antithetical to it. Aboriginal art is a complex mesh of the visual and written, and in some cases poses more as 'written' than 'visual'. Nelson Rockefeller's quip about Abstract Expressionism, 'What I like about abstract art is that it can mean anything I want it to mean', when applied to Aboriginal art, assumes grotesque ethical proportions about the intrusiveness and presumptiveness of Western capitalism's colonizing eye. Pre-settlement[4] Aboriginal art is not abstract, which is a term only learnt by

contemporary Aboriginal artists in the last few decades, rather it is closer to what we might call a sacred realism.

The Australian Aboriginal ('Aboriginal' means 'originary' or 'primal') peoples are now considered the earth's oldest, dating from between 40,000 and 50,000 years ago. Before their decimation after colonial invasion, they were a culture, or cultures, as varied as medieval Europe, with over 200 language groups. With so many tribes and languages now extinct, traditions are lost forever. Pre-settlement Aboriginal art is/was fundamentally sacred, its entire meaning at the sole behest of a few elders who communicate the content guardedly and gradually. Depending on its level of sacredness, a story could be communicated as a conjunction of dance, song, body painting and sand-tracing, as found in the sacred get-together, the *corroberee*. Such rites told the stories of animals significant to their *moiete*, or totem, relating the people to the spirits to the land. The significance of the land is always the cardinal aspect.

The paintings from the Kimberly Ranges and the Western Desert, for example, act like maps or even imaged distillations of the land, the spirit and the story. A useful way of thinking about the art of these regions is as a map, which depicts a particular movement through a landscape, much as in any story of a person's odyssey from home and over a hill to a watering-hole, an encounter with an animal, hunting and so on. It is often said that the dots that plentifully litter the paintings such as those originating from Papanya and the Western Desert region have grown in intricacy since the 1970s to act as a gauze-like screen to the non-indigenous viewer, protecting the sacred content from exposure to the uninitiated.

In a more recent example of traditional art, a masterpiece of its kind, *The Burial Poles* (1988) were an initiative by a group of artists from northern Arnhem Land (the region around the squarish middle bump of Australia's northern coast) in response to the Bicentennial celebrations. It was like their version of a protest petition, although voiced without belligerence. Fittingly, there are 200 poles, each pole symbolizing a year of white occupation. Nine groups contributed to the work, the location of each group in the installation corresponding with their physical location on the map, and mirrored in the work's configuration (the walkway actually refers to the Glyde river estuary that flows from the Arafura Swamp to the sea). Each pole, or ceremonial coffin, is decorated with designs specific to an ancestral group. They are variously derived from stylized references to the sacred land, or to animals cherished for ritual and survival purposes. In many places, they narrate or connote key encounters of the deceased with their immediate environment. Some poles have a ventilating eyelet which, the story goes, enables the dead spirit to stare out on to the landscape. Most evident in the image of the installation pictured here are the heavily banded poles belonging to the liya-qawumirr-Manyarrngu people, *liya* meaning 'head' and *gawumirr* 'muddy water', as the people live at the head of the river at the point where salt and freshwater meet, causing the tidal flats to go muddy – hence the repeated lines that represent the tidal marks on the tree trunks which monitor the rise and

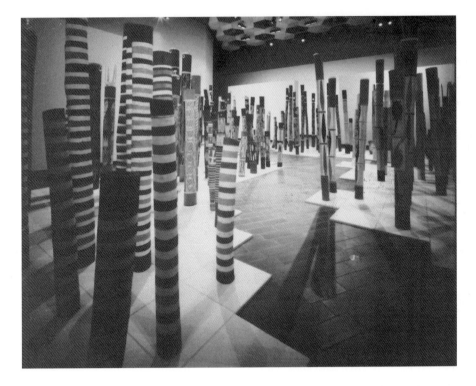

3. Burial Poles. *The Aboriginal Memorial – The Burial Poles*, 1987–88. Wood and natural pigments. National Gallery of Australia, Canberra. Courtesy of Djon Mundine and the Ramingining people of Northern Arnhem Land.

fall of the tide.[6] They are schematic and *diagrammatic* of the land's conditions and effects.

When we turn to contemporary Aboriginal art that has absorbed Western idioms of media and practice, despite its evident differences from the art of their ancestors, there is still a strong degree of lexicality, or readability. Literalness, generally a flaw to the Western eye, is here pardonable to the point of being desirable on the grounds that images perform the same role as words in relating a story or situation.

In Adam Hill's 2006 painting, *Average Life Expectancy*, each element is ripe for decoding. The artist launches a frontal assault on what he sees as the Australian Federal government's derelict handling of Aboriginal affairs. The road sign reads, 'federally defunded black spot', referring to the desert regions within Australia that are the home of indigenous communities. Because they are not in the line of sight of the public or media, Hill is drawing attention to the fact that the lack of sufficient regard for remote Aboriginal groups is a contributing factor in their markedly lower life expectancy. Painted in a style that might be called Aboriginal hip-hop, redolent of graffiti art and urban graphics, in the absence of a 'traditional' upbringing, the artist has drawn together his own set of visual codes. The sun is the Aboriginal dreaming in the distance, the clouds represent the white presence pressing down upon the

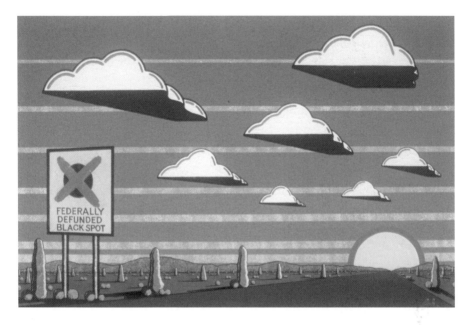

4. Adam Hill, *Average Life Expectancy*, 2006. Synthetic polymer paint on canvas, 100 × 145 cm. Courtesy of the artist.

land, the vertical lumps are like phalluses which suggest the whites' rude intrusion upon the landscape. The scene is void of life. Typical of many urban Aboriginal works, it is decodable and declaims its content with indignant force.

CALLIGRAPHY

The origin of Chinese painting is impossible to separate from the development of their written characters, which by at least 1500 BCE bore resemblance to modern script. The earliest examples are found on bone and then on the bronze urns from the tenth to the ninth century BCE; the words related to the ritual use of the object. By the time of the Han period (third century BCE to third century CE), calligraphy had made the transition from incision to ink on paper, a serviceability that resulted in proliferation and experimentation. It was in this period, when Chinese culture came into its own, that calligraphy was invested with the expectations, refinements and moral imperatives still guarded by its most accomplished contemporary exponents (Chinese art schools also have their own separate calligraphy department).

Calligraphy, as it evolved out of the Han period, became rule-bound with a range of writing classes or types, such as the seal script which was taken from the early bronze inscriptions; or *li* taken from earlier examples in stone, characterized by a resemblance to the Roman serif; or the more rapidly executed florid 'grass' or 'draft' scribes' script. A good calligrapher was known for the way he handled everything: the amount of ink on the brush, the flow of the hand and the receptivity of the paper

in balance, natural spontaneity. Pictorial composition was also a consideration; no single character was allowed to dominate the design.

By the end of the Han period, calligraphic art had reached a point where it exceeded representative painting in sophistication and prestige. A good calligrapher was not only good at execution, but was also expected to be a sensitive critic of the work of others. It was an enduring combination. A millennium later, the renowned artist Zhao Mengfu (1254–1322) was admired as much for his originality and skill as his prowess as a scholar. Much as the values that were passed on to Japan around this time, calligraphy was meant to be at once natural and artificial, and thus an expression of union between the will of the artist and the outside world.

TEXTS IN STONE

The hieroglyph is a written notation that uses pictorial symbols, and we have examples of these from Ancient Egypt that date back further than 3000 BCE, but what I want to concentrate on is a form of writing more germane to ours.

The oldest surviving laws exist in the form of a monumental stone block, known as the Code of Hammurabi (1792 BCE to 1750 BCE). It was ordered by King Hammurabi of Babylon in the last years of his reign and intended as his final testament. On it is written the 'code', edicting the dispensation of justice that became the literary model for schools of scribes for over 1,000 years. As distinct from hieroglyphics, it is written in one of the earliest known lexical scripts. Yet it is presented in a highly visual form and one that is pre-eminently sculptural and monumental.

On the top of the stone, in low relief, is the flame-shouldered sun god, Shamash, accepting the laws from the hands of the king himself. The king is symbolic-ally positioned on a mountain, suggested by the scale pattern beneath his feet. Hammurabi the king is shown in profile, while Shamash's superiority is registered by giving him both front and side views. The Code announces itself visually first as an aesthetic whole that elicits semi-religious awe. Despite the secular level-headedness of its inscriptions, its visual impression is instant and rhetorical. It is the presence of the laws themselves that give this confrontation between a god and a man credence, the law being what binds them together.

The myths excerpted on the friezes of Greek and Roman temples were also related to laws, but more in the manner of allegory. The paintings and floor mosaics in bathhouses and villas were meant to be read like illustrations; they held an idealized mirror up to what physically took place in a particular room. The legible image was imbued with more didactic purpose with the fall of the Roman Empire and the rise of Christianity, accelerated by the unprecedented legalization of the religion (*religio licita*) of Christianity by Emperor Constantine in the Edict of Milan of 313. From then on, the Christian Church was less in need of defending itself against opposition, and could concentrate on codifying and building itself as an institution.[7]

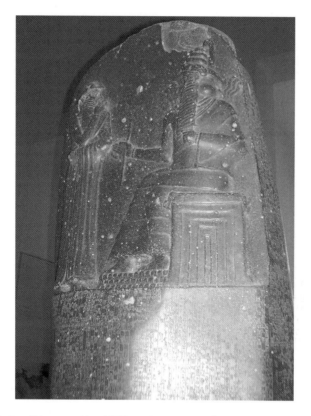

5. Code of Hammurabi, c. 1750 BCE. Stone block. © Musée du Louvre, Paris.

This ushered in a new dogmatism within the Catholic faith that culminated in the pictorial stringency of the Middle Ages, but already in evidence in the great mosaics of the Byzantine Empire, as seen for instance on the walls of the surviving temple of former Constantinople, the Hagia Sophia, in which figures are organized hieratically, thus size, prominence and detail varies in magnitude depending on the importance of the personage. Such organization can already be found in Egyptian bas-reliefs, except that in Byzantine works (partly out of the legacy of Roman painting) the subjects are more humanized.

By the era of the Gothic cathedral, from the twelfth to fifteenth centuries, sacred stories were recounted either in the carvings on the façade or on glowing stained glass within. Images were didactic first and foremost; we do not know the names of the artists who executed the carving in the great cathedrals, as their individual interpretation was secondary to the information presented. Because of this, picture-making was tied almost seamlessly to the monastic fraternity, who controlled education, and whose orientation was predominately religious. Picture-making (from the designs for stained glass to illuminated manuscripts) and sculpture were artisanal, tied strictly to guilds, and could be excruciatingly rule-bound, much as,

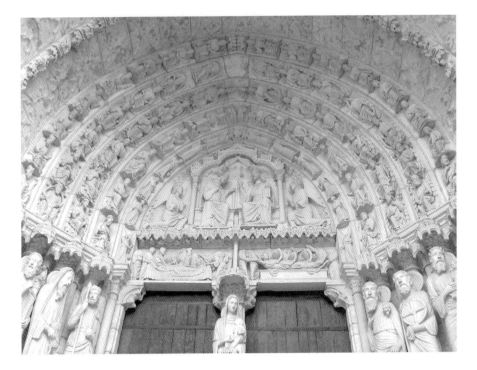

6. Chartres Cathedral, front portal. Photograph courtesy of the author.

we might say, traditional French cooking is to this day. The didactic function of the Gothic cathedral was not just a reflection of the hold of the Church, it was also a surrogate for religious instruction in the absence of widespread literacy.

NARRATIVE IMAGES

The orthodox view of the shift from the Middle Ages to the Renaissance, as reflected in art, is that the Renaissance imbued figures with greater humanity. Giotto di Bondone (1266–1327) is credited with having made the most significant early steps in this evolution from stolidity to poignancy. This change, which occurred at the beginning of the fourteenth century in Italy, was most conducive to the narrative basis of art, as heightened humanity meant increased drama, and with increased drama, empathy – and Giotto was a master of empathy. A bit like the commercial film that establishes some identification with the main protagonist by the audience, the viewer could become involved in scenes in a more vicarious way. By internalizing narrative, the viewer could be made more accountable to its message. Great early examples of this is are in Giotto's early masterpiece (1303–5) *The Life of the Virgin and the Life of Jesus* in the Cappella degli Scrovegni, or Arena Chapel, which miraculously survived the allied bombing of Padua in the Second World War, and Carpaccio's St Ursula cycle (1490–5) at the Accademia in Venice, both known as *istore*, which, like

histoire in French and *Geschichte* in German, are tantalizingly encompassing of both 'history' and 'story'.

Even when art no longer needed to compensate for illiteracy, the demand for narrative never abated. Alberti, in his treatise on painting, compared learning how to paint with learning how to write. It is an interrelationship that reached a peak in the nineteenth century, which also revived the slogan made famous in Horace's *Ars Poetica, ut pictura poesis,* 'As is painting, so is poetry.' Since the seventeenth century the narrative painting, and grand cycles such as the greatest feat of visual flattery ever undertaken in paint, Peter Paul Rubens's gloriously mendacious and, by the end, exhausting *Life of Marie de Medici* (1622–5), were valued above all the other genres – still life, genre (interiors and everyday scenes), landscape, portraiture in ascending order of auspiciousness – for their superiority in conveying a moral message and for the technical demands, based on composition and scale, that were placed on the painter. In theory at least, to master history painting was to master all the other lower genres combined. It was because it was considered to combine so many elements, and to test the artist's skills to the utmost degree, and not least of all because of the time and effort required to look at them, that the narrative paintings of the French Salon were known as *machines*.

The discourse that would lay the ground for this hierarchy is Charles Le Brun's *Conférence* to the Royal Academy, when he commented that Poussin's *Israelites Gathering Manna in the Wilderness* (1638–9) had achieved a particular density in his composition that allowed one to see that he had compressed a 'multitude into a small space'. In other words, the artist was able to grapple with the problem of space for the purpose of giving time's unfolding a visual approximation. Nicolas Poussin's (1594–1665) skill in exploiting the virtues of drawing achieves this concentration of both affect and descriptive content.[9] And thus, somewhere at this point, the bias within the French Academy towards drawing and towards storytelling was instituted in earnest until the entry of Édouard Manet (1832–83) in the 1860s.

Napoleon, as we shall see in more detail in Chapter 10, Agency, was particularly opportunistic in harnessing the forces of the gigantic Salon history painting for his own propagandistic ends. But already in the eighteenth century it had been popular to recount stories of the past in imaginative tableaux reminiscent, in more recent memory, of the Technicolor costume dramas of the 1940s. As with these films, many of which were their own kind of propaganda, they say more about the time in which they were made than to what they refer. Take, for example, the intricate construction by the Pre-Raphaelite Ford Madox Brown (1821–93), *Chaucer at the Court of Edward III* (1847–51), a history/narrative painting about someone, Chaucer, narrating. Like period movies whose characters are clean and robust, with clear skin and white instead of rotting teeth, the painting is ample proof that the idea of the Middle Ages was invented for us in the nineteenth century.

Such paintings need to be seen within the broader reach of history itself as it came to be theorized and reflected upon. In his *Letters on the Study and Use of History* (1735), Henry St John, Viscount Bolingbroke, put forward the need not just to

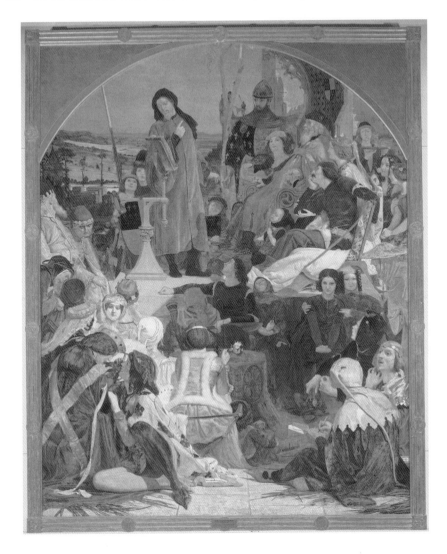

7. Ford Madox Brown, *Chaucer at the Court of Edward III*, 1847–51. Oil on canvas;
372 × 296 cm stretcher, 370.5 × 295.5 × 3.2 cm frame. © Art Gallery of New South Wales.

concentrate on antiquity, but to look to the more recent history of the fifteenth century onwards as a source of guidance and edification. It was such arguments that gained in momentum with the influential contributions of David Hume, William Robertson (1721–93) and Edward Gibbon (1737–94).[9] The paintings that were painted in the eighteenth and nineteenth centuries cannot be seen as imaginative escapades alone. At best they are serious forays into trying to lend a lens to the past, where the painter willingly joined hands with the historian.

While it is good to be reminded of their earnest intent, narrative paintings were also accessible to a widening art-going public thirsty for entertainment. Hence it is fair to say that, by the 1830s in both Britain and France, history painting occupied a

8. Paul Delaroche, *Cromwell Before the Coffin of Charles I*, 1849. Oil on canvas, 226 × 291 cm. © The State Hermitage Museum, St Petersburg.

place equivalent to blockbuster movies today. By far the greatest adept at such manipulations was the Romantic academician Paul (also known as Hyppolite) Delaroche (1797–1856), whose showman's knack for drama is amply demonstrated in the memorable *Cromwell Before the Body of Charles I*. Delaroche's stocky Cromwell is a paragon of machismo. Heavily booted, his sword belted to his side, broodingly taciturn, he stands contemplating the dead king, whose severed neck remains eerily visible. The artist is playing loose with artistic licence, for there are no records to suggest this; indeed Cromwell shunned the body. But we forgive the picture as we do any decent movie that is 'based on a true story'. We are made to feel privy to a private encounter, the witness to the new power's contemplation of the old, the usurper over the king, as the brooding victor is made to reflect the symbolic act of regicide, as he is brought close the wisdom that he too is subject to forces he is powerless to contain.

WRITING ABOUT ART

Writing on art slides between two poles – one being when the writing is secondary to the work, when it serves to explain what the work of art is 'about'; the other when the writing is its own discrete entity, either using the work of art as a point of departure for a philosophical excursus, or for the sake of poetic digression. The latter could be descriptions of paintings or verbal creations that have a distinctive piquancy in their own right: an enclosed, composed quality like a picture. As an aside, it is worth noting that the word *peinture* is used in French for a vivid verbal description, and in French as elsewhere, 'impression' had as solid a currency in the latter half of the nineteenth century amongst writers as it did artists, just as the word 'image' is still used as much by poets as artists.

Art history, as it came to be known in the latter half of the twentieth century (in university departments it now has 'theory', 'visual culture' and the like appended

to the name), began with the assembling of a diverse range of writings that never considered themselves art history as such, since art as a discrete theoretical discipline, as we will see in Chapter 5, Style, only came into being in the period 1760–1830 in Germany. The discipline was cobbled together from writings from antiquity, such as from Plato and Pliny, from the first modern-style comprehensive writer on art, Vasari (1511–74), from subsequent discourses on aesthetics and taste, and art criticism.

Art criticism is an open term, as it simply denotes a critical response to art. Conversational discussion is surely a form of art criticism as are, at the other extreme, specialist academic papers. Art criticism as we understand it today, informed and informative responses by so-called experts, became a widespread practice at the end of the eighteenth century when the early breed of the modern newspaper, pamphleteering (or, in France, *feuilletons*) entered into public life. It was part of the Enlightenment watershed – also serviced by industrialized printing presses and the rise in literacy – that opened up the idea of response and opinion to the everyday person. Everyone was theoretically allowed to have a view and the critic mediated between the artist, the Establishment, or art Academy, and a public hungry for knowledge and amusement. And art criticism has the same function today, although with art blogs on the Internet there are more responses and opinions than can ever be digested. Criticism also serves the primary function within the marketplace of taste; once the dust has settled, art historians and theoreticians will weigh up such responses in their formulations of a particular era.

Anyone who thinks that art criticism is an act of parasitism mistakenly presumes that the work of art is somehow hermetic and independent as opposed to being a coordinate amongst a large number of intellectual, emotional and sensory exchanges. For art criticism is not just a form of reportage, it is a vital forum for celebration and complaint about what has recently been. Art critics at their best are searching commentators on the conditions of society, life and beauty, and take seriously their role as mediators and evaluators of artistic relevance. Some celebrated novelists, such as John Updike, are also seasoned critics, and with Peter Schjeldahl, who is also a poet, art criticism reaches a new level. His eccentricities, his precision and bravura syntax are performances themselves.

It is also a fallacy to think that art criticism just serves the public. A sizeable quantity of it is written in magazines (*Art Monthly, Parkett, Modern Painters, Frieze, Art and America* are among the best known) that are only read by a small fraction of lay people and pitched more towards art professionals. Through such publications curators, collectors and dealers gauge fashions in cities outside their own; not to mention the publications' importance for students of art and the artists themselves, many of whom are also writers, in assessing their times. A share of art glossies are dumbed down to make them more marketable and so meet their costs, and are regularly subservient to their advertisers (regular, big advertising by a gallery is tacit assurance that the magazine will give it occasional coverage), but without them, the globalized art scene would be hamstrung by a feeling of isolation. Many art professionals buy magazines for their advertisements (such as *Artforum,* which

is bursting with them), so they can see who is doing what where. Even the most commercially successful artists crave critical attention. Money aside for once, art periodicals big and small, and with their Internet offshoots, are what keep the art world pumped.

EARLY CRITICISM

Diderot's *Salons* (1759–81) mark the beginning of modern art criticism. These detailed responses were sold as critical guides to the most popular annual art event in Paris. There is little in the contemporary milieu to compare with them. Flamboyant and erratic in tone, they are literary *tours de force*. Diderot (1713–84) mixed description with reverie, diatribe with appraisal, digression with polemic. They may be more than 250 years old, but they make rewarding reading, as one witnesses a good-humoured and wide-ranging mind busy at work. For, of all the *philosophes*, Diderot was the most experimental with genre and form. He finds excuses for discussions of morality and of metaphysics, reminiscences and speculations. His *Essays on Painting* (1765) were widely admired, including by Goethe (1749–1832). In his *Salons*, Diderot makes no profession to the objective eye, which is an ideal that crept into the mid- to late nineteenth century. Instead, his critical manner adopts multiple voices: at turns laudatory, hallucinatory, stern, outraged, sneering, jibing and hectoring. Diderot was not a vacillator but a greedy intelligence whose writings seem poised for anything.

One of Diderot's favourite techniques was the perceptual conceit. He would pretend to walk into paintings and participate in their action, or, in one literary feat, he pretended that he couldn't see Fragonard's presentation piece for the 1765 Salon, *High Priest Coresus Sacrificing Himself to Save Callirhoe* (1765), and instead describes a fantastic dream, in effect suggesting that the sensory rewards of the work exceed its narrative import. His scorn for Boucher is unsparing, while his encomiums to the work of Horace Vernet and Chardin display his ebullient intelligence to the full, beginning the lineage of awe for the latter that leads into the criticism of the poet Théophile Gautier (1811–72) and climaxes with the subtle incorporations of his aesthetic in Proust's *À la recherche du temps perdu* (1907–22).

Following in the free-associative style of Diderot, though with less of his verve and brilliance, the first art critics were seldom specialized within their field in the manner of today's salaried newspaper art critic, and the criteria they used for judgement were far more oriented towards personalized 'taste' (a deeply eighteenth-century concept) than the kinds of standards, orthodoxies and precedents we have today. Some critics had close ties with the craft of painting, such as Délécluze (1781–1863) in France (a student of David's) and Hazlitt in England, who was considered the greatest literary critic of his time since Samuel Johnson.

For the early journalists at the turn of the nineteenth century, it was normal to write on a broad range of subjects. John Ruskin (1819–1900) is surely the greatest English writer on the relationship between visual art and nature, an inheritor of

Wordsworth and Coleridge. Ruskin's *Modern Painters* (in five volumes: 1843–60; epilogue 1888), which began as a defence of Turner, spread into four volumes and encompass his travels and his ruminations on beauty. They are best read as a diary of his sensory evolution as a trained observer of nature, society, cities, and architecture as well as art.

In Germany, Goethe wrote regularly about art, and his first novel, which launched him to overnight fame, *Werther* (1774), is a tragic story about a love-lost painter. At the end of his career, Goethe intended his theory of colour, the *Farbenlehre* (1810), to be his standing contribution to nature and culture. Not only *Werther* and *Wilhelm Meister*, but the pictorially sensuous observations in his *Italienische Reise* (Travels in Italy) (1786–88), cemented Goethe as the most conspicuous influence on the next generation of writers in Germany, particularly the early Romantics of Jena and Berlin who made a point of including the visual arts in the philosophic-poetic speculations. Friedrich Schlegel (1772–1829) regularly included the visual arts in aphoristic fragments to do with aesthetics and politics in the early Romantic magazine the *Athenaeum*, as did his close friend the prodigy Novalis (1772–1801), who held that one should view the world artistically and that the separation of poet and thinker in his time, the rational age, was the sign of a 'sickness and sickly constitution'[10]; Wackenroder and Tieck's *Phantasien über die Kunst für Freunde der Kunst* (Fantasies on Art for Friends of Art) (1799) is a mine of imaginative explorations on art and aesthetic experience, including a rapturous prose-poem on colour. One of the early Romantics' preferred literary strategies was to mix up genres: their writings on visual art were stimulatingly caught up within their views on society, science, fashion, poetry, philosophy and literature.

PAINTING IN PROSE

The *peinture en prose* is a child of the nineteenth century born from a fascination in making something visual in prose (this will be also be examined in Chapter 3, Image). Early examples are Virgil's detailed description of Achilles' shield in the opening of the *Aeneid*. Other examples range from the graphic imagery in Eliot's *The Waste Land* (1922) to William Gibson's vivid description of a futuristic wasted Tokyo in *The Necromancer* (1984).

The great innovators in the nineteenth century were writers who made visuality the focus of their approach, and they would purposely confuse their experience of nature with that of art. Aloysius de Bertrand (1807–41) stands out: *Gaspard de la Nuit* (1842) is the first self-conscious prose poem, each section like a verbally expressed visual enclosure that brings together imagination, memory, dream and hallucination. Even more influential in French literature, its airiness untranslatable, is Gérard de Nerval's *Sylvie* (1853), a story of a tantalizing love interest. The narration comprises of a series of dream-like units, which had as much influence on dramatists and painters as it did on writers. (I should not fail to point out that Proust

was so influenced by this style that his first go at his great novel, the abandoned *Jean Santeuil* (*c.* 1897), is a mosaic of vaguely chronological vignettes.)

THE CRITICAL ADVOCATE

It is one of those symmetries of history that the period of political philosophy of Auguste Comte, Saint-Simon, Proud'hon, Marx and Engels also saw the emergence of the critical advocate who campaigned with what could be single-minded zeal on behalf of an artist. Ruskin and Turner, Diderot and Chardin have already been singled out, their names almost as inseparable as the figure skaters Torvill and Dean, and they have plenty of successors. Baudelaire, the next great French art critic in France after Diderot, took it upon himself to lionize Delacroix with such ardour that it even shocked the artist; the careers of the critic Champfleury (1820–89) and Gustave Courbet (1819–77) intertwined, to the extent that Courbet included the critic (Baudelaire is there too in the corner) in his manifesto painting, *The Painter's Studio* (1855); an ample portion of Zola's (1840–1902) formative career as a journalist was spent in defending Manet; Félix Fénéon (1861–1944) was an ardent supporter of the Pointillists Seurat (1859–91), Signac (1863–1935) and Cross (1856–1910); Guillaume Apollinaire (1880–1918) formed a staunch alliance with the inventors of Cubism; Julius Meier-Graefe (1867–1935) made Van Gogh's painting the bulwark of his concept of modern art.

The bonds between painter and artist were not necessarily one-sided – the stereo-typical assumption being that the artist was primary producer, the critic a secondary producer – and in some cases it was as close as could be to collaborative (although admittedly a nineteenth-century artist would be hard pressed to admit it publicly). Take Monet – the artist known today as all perception and instinct – who would actually reflect deeply on the critical responses by friends on his work, sometimes affecting his next body of work. In the words of his critical biographer, Virginia Spate, 'Monet was a very effective producer of his own history, abetted by his close friends, the critics Octave Mirbeau and Gustave Geoffroy, and other journalists.' It was a narrative that began in 1860 with him as self-made artist and grew in detail with the help of the form he helped to develop from 1880 until his death, the artist interview.[11] So these allegiances are astonishingly varied and with deep mutual effect.

One of the most moving cases of advocacy of an artist was by a writer and artist who was never a practised art critic, of an artist whom he'd never met. Written just before his own death, Antonin Artaud's apologia of Van Gogh, *Van Gogh, Suicidé de la société* (Van Gogh, Suicided by Society) (1947) is part criticism, part poem, part treatise, and unconventional to the point of delirium. As a reflection of the writer-critic's personal condition, the essay is still a milestone of affective art criticism. Artaud, a schizophrenic, believed he had a special empathy with Van Gogh (1853–90), in whom he saw his own persecution at the hands of the art and

medical fraternity. For Artaud there is an unshakeable freedom in Van Gogh's paintings, which are a permanent challenge to conformism. He is such a painter as to be more than a painter, proof (according to Artaud) that the madman is the truthsayer because of his access to the terror within beauty. Artaud rails against psychoanalysis for its imprisonment of irregular passions, finally accusing Dr Gachet, Van Gogh's doctor, of murder. Artaud makes no apology for his verbal neglect of the paintings: 'What's the point?' he cries – no description could match them. Neither can a description match the text: beguiling, enraged, unstructured but somehow memorably (incomparably?) faithful to its subject.[12]

While Artaud was penning his essay on Van Gogh, the astutely clear-headed Clement Greenberg had already established himself as one of the guiding voices of American art criticism. In 1939 he wrote the essay, 'The Avant-Garde and Kitsch' and a year later 'Towards a Newer Laocoon', which was to set the tone of almost everything he wrote until he more or less gave up professional criticism in the 1970s. In the first he set up an a binary relationship between kitsch, art in stagnation, and the cleansing forces of the avant-garde; in the second he speculated strongly on the attributes needed for modern art's development. A distinguishing feature of Greenberg's writing was the sense of a main aim, an ongoing programme, which came into its own in the late 1940s to mid-1950s. He and contemporaries such as Harold Rosenberg and John Canady had set an agenda for the newly dubbed Abstract Expressionists (the name is attributed to Robert Coates writing in *The New Yorker*, Rosenberg's now less lasting term was 'Action Painters') in New York to complete a project that had begun with the Impressionists and reached a crucial turn with Cubism. His reading of Cubism, influenced by the Russian Formalists of the 1920s, is as an innovation in painting that superseded one-point perspective. With Cubism, painting had begun to nudge its limit. All the terms of reference, which came down to the flatness of the picture plane and the physicality of paint, were immoderately articulated. The Abstract Expressionists, or exponents of 'American-Type Painting' (an essay from 1955), were the last in the progression of art's procession towards its destiny of realizing its inner (that is formal) nature. Their art was at once faithful to itself and more rewarding to the viewer, who as a result was given better access to the deeper and transcendental humanistic meanings that art was meant to purvey.

Greenberg became the champion of a handful of artists – such as Baziotes, Kline, Still, Rothko, Newman, Tobey and de Kooning – but none came up to the unbridled zeal with which he approached the art of Jackson Pollock. It is fair to assert that Pollock did not get his household name from talent alone. His fame, which exceeds his contemporaries who were no less great (especially Newman and Rothko), owes much to the star-making of Greenberg's criticism and is a testament to the persuasiveness of newsprint. Subsequent commentators such as Tom Wolfe have gone so far as to suggest that Pollock was not entirely his own creation, but drawn and shaped by the persuasive fancies of Greenberg's tireless pen.[13]

CRITICAL ADVERSARIES

Art critic adversaries are hard to discuss in retrospect only because the artists to whom they give a drubbing rightfully disappear and, often enough, the critic along with them. On the other hand, the idea of the avant-garde was built on the idea of knee-jerk critical disaffection, and the artist misunderstood in his time is still a popular myth. One of the more memorable snubs was given by the novelist and critic Joris-Karl Huysmans (1848–1907), who accused Cézanne of 'sick retinas'. Also noteworthy is that the Fauvist movement got its name from critic Louis Vauxcelles's likening of the painting of Henri Matisse (particularly *The Green Line: Portrait of Mme Matisse*, 1905) and his peers to the work of wild beasts (*fauves*).

The most monumental of all critic–painter conflicts ended in a court battle. In 1878, after seeing Whistler's exhibition at the Grosvenor gallery in London, Ruskin published a chastisement for asking two hundred guineas 'for throwing a pot of paint in the public's face'. Whistler promptly sued for libel. The curt testimony is an invaluable document of two aesthetic positions: pre-modernist pitted against the modern. Whistler was awarded a symbolic victory. Ruskin was fined only a farthing to be paid in damages, but the fiasco marred his reputation and accelerated his mental decline.

WRITINGS BY ARTISTS

Visual artists do write; many more offer their words for transposition into printed interviews. Few are the artists who, given the opportunity, stay mum. One of the more pithy statements about the artist's contempt for words was voiced by that painter of painters, Lucien Freud (b. 1922), when he said that any comments he has made on art have as much relation to a final work as the noise emitted when a tennis ball is struck has to the final shot in a match. But such statements have a tacit agenda as well as an element of truth, since an artist will always harbour the desire for his work to be entirely self-sufficient. Admittedly, artists are remembered as artists for what they achieve over what they say, but that shouldn't trivialize the usefulness of their insights. There is a certain breed of artist for whom writing is a vital supplement to practice. Why else would so many have gone to such effort?

There is a long history of artists setting their ideas down in writing. Vasari, best known today as a writer, was also a prolific painter. And as we saw above, Le Brun spent a bit of time with the pen as well as the brush. Shih-t'ao's (1641–*c*. 1670) *Expressionist Credo*, written in the second half of the seventeenth century in China, is one of the most important essays on Chinese art. In Renaissance Italy, artists turned their hand to as many other things as possible: Michelangelo (1475–1564) was also a recognized poet, Leonardo da Vinci's (1452–1519) theories and lucubrations are now classics and the impetus for a woefully written bestseller and a bogus blockbuster film. The stuff of a film, though oddly not yet attempted, is Cellini's

Autobiography (begun 1558). In addition to being one of the first in the genre, it is a joyous act of self-aggrandizement, a fascinating social document and a salty tale. By contrast, the *Discourses on Art* (1769–90) by English artist and academician Joshua Reynolds (1723–92) are a measured account of the artist's methods of perception and invention and their influence succeeded well into the next century.

By the nineteenth century it was not unusual for artists to defend themselves in writing, either in public or in letters to their friends. Delacroix's *Journal* (*c.* 1822–63) is full of observations about personal character, music, politics, colour, style and talent, and is still in print and enjoyed today. By the end of the century, the added incentive for an artist to write was that it gave intellectual cachet. Maurice Denis and Émile Bernard (1868–1941), members of the Nabis, wrote – Denis's 'Preface to Neotraditionalism' of 1890 is a classic, Bernard's dialogue with Cézanne (1839–1906) is an invaluable document of an artist who normally shunned words. Matisse's *Notes d'un peintre* (Notes of a Painter), *La Grande Revue*, Paris, 25 December, 1908, beginning as a reply to another artist-writer, is another tract of interest to successive generations of artists and critics. Wassily Kandinsky (1866–1944) was an avid writer, and Piet Mondrian (1872–1944) made several forays into theories on art, especially in justifying the style of the group with which he became associated, De Stijl. De Chirico's *Memoires* (1962) is well written and full of anecdotes and personal insights. (It begins with a description like one of his paintings: 'The most distant memory I have of my life is of a large room with a high ceiling'.[14]) Wyndham Lewis (1882–1957), a stunning draftsmen and spearhead of Vorticism, England's response to Futurism, is now more remembered for his writing, which included the Vorticist journal *BLAST* and novels such as *The Apes of God* (1930), *The Hitler Cult* (1939) and his *The Human Age* trilogy (1928–55). Strongly influenced by their European counterparts who ended up in New York in the early 1940s, the American Abstract Expressionists were also searching examiners of art and culture. Ad Reinhardt's writings on Eastern art and mythology are still valued for their wit and imagination, and Robert Motherwell's essays rank among the best on pictorial abstraction.

Then there were the manifestoes which are hard to separate from the artists which they represented: Marinetti's bellicose Futurist manifesto (1909) is a work of art unto itself, worthy of the poet that Marinetti (1876–1944) was aspiring to become; Surrealism, it must be remembered, was launched as a poetic movement in 1924 until Breton recognized the visual arts three years later.

There is currently a whole industry geared to producing writings by and interviews with 'name' artists, led by major art publishers such the MIT Press. Any web-search will reveal the roll call of names that have now been absorbed by the publishing industry. Unless the artist has some ideological reflex against the spoken or written word, most contemporary artists welcome the opportunity to elucidate their main concerns for a reading audience. Catalogues for exhibitions are de rigeur, even to the extent that artists on small budgets will be at pains to produce their own. It is also now a convention of the contemporary art scene to issue artist's statements. These can be written testimonials that take from any of the forms that I have sketched

out above: they can be verbal biographies, descriptions of interests and intent, or manifesto-like diatribes. This minor genre can be a useful point of entry for a better experience, or indeed act as a complement, if not an active component, to the work on show – this point leads to the next section.

CONCEPTUALISM, ART AND LANGUAGE

By the 1960s, the Modernist need for art to diverge from the written word had relaxed. Artists began to explore the ways in which words infiltrated upon the visual field. Jasper Johns, an artist who has always been difficult to categorize, made paintings out of numbers and letters which, like his flag paintings, sought the threshold between the image as linguistic sign and the physical assemblage of paint, line and colour.

Exploring linguistic, or semiotic, threshold was enormously important for this generation of artists. For this reason it is deceptive to separate artists interested in text from artists who use their body, or from those who appear to be straight pictorialists. In a series of film and video experiments in 1971–2, *Idea Demonstrations*, Peter Kennedy and Mike Parr physically enacted a simple action or problem that had previously been written down. Items include:

> 12. Sit up and down as fast as possible in front of a movie camera. Continue until exhausted.
>
> 14. Stare at a strong light without blinking.
>
> 21. Sitting before an audience … bare your shoulder. Let a friend bite into your shoulder … until blood appears.[15]

As well as being landmark works in the development of experimental film and video art, they epitomize the methodology of concept and body art which uses a linguistic framework, usually found in a written directive, to find the limits of words as seen in

9. Peter Kennedy and Mike Parr, *Idea Demonstrations*, 1971–2. Video/film stills.
© Peter Kennedy and Mike Parr. Courtesy of the artists.

their translation into action, whereupon the action and time take over – or do they? The Conceptualist is always interested in the degrees of encroachment of the written idea. From another viewpoint, the relationship between the written schema and the enacted event gives birth to non-equivalence despite being, in theory, the same. This examination of the limit, or liminal point, between language and event, also accounts for the incorporation of pain; bodily limits are paralleled to the impossible and unrepresentable limits of thought and language.

10. Lawrence Weiner, *Nach Alles/After All*, 2000. From wall installation; text applied directly to wall. © Courtesy the artist and the Deutsche Guggenheim, Berlin.

The limits of thought are an ongoing preoccupation of the two seminal Conceptual language artists, Joseph Kosuth and Lawrence Weiner. In Weiner's 2000 installation at the Deutsche Guggenheim in Berlin, *Nach Alles/After All*, he referred to the namesake of the university across the road, Alexander von Humboldt, the naturalist who is one of the fathers of taxonomy and modern science. As is characteristic of Weiner's work, polished, graphic lines and texts were applied directly to the walls of the gallery. They made reference to the exhibition of natural elements in a manner that echoed the ordering of objects according to their shape, size, density and genus, thereby reflecting the systems that underpinned what was seen and how. The words also incorporated elements that complemented and interfered with such ordering, like the display cabinets and vitrines. When equipped with this knowledge, Weiner's installation becomes highly poetic, and creates the space for imagination. The words are conceptual moderators between an exhibition external to the exhibition proper and the mind of the viewer. It is worthwhile to compare this work with one by one of Weiner's contemporaries, the composer Steve Reich (b. 1936). For *Different Trains* (1988), for string quartet, Reich used the speech of his governess, who accompanied him in extensive train travel from the east coast to west coast of America as a child, and testimonies of Holocaust survivors about their journey to concentration camp. Speech transforms into a melodic pattern, which the strings

then imitate. Language is thus embedded into the work's process and effect. Reich uses the preformed material of words on which to build an elaborate conceptual and emotive structure that attempts to do justice to the incommunicable memories that lie behind the stories.

Another way of thinking of this process is that the artist uses language as a ready-made, no different from using a prefabricated object and assigning to it a more abstracted purpose in a sculpture or an installation.

In Figures 11 and 12, a shot and detail of an installation by Brad Buckley, text, colour (the room was painted blood red) and graphic image are combined to make a highly synthetic theatre, a schema of lines and signs much like language itself. Here

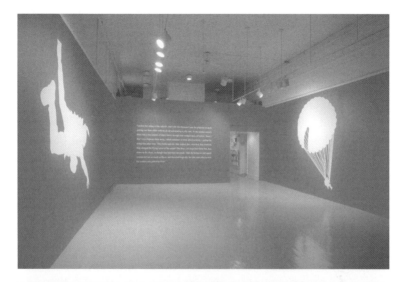

> I pulled the string of the whistle, and I did this because I saw the pilgrims on deck getting out their rifles with an air of anticipating a jolly lark. At the sudden screech there was a movement of abject terror through that wedged mass of bodies. 'Don't! don't you frighten them away,' cried someone on deck disconsolately. I pulled the string time after time. They broke and ran, they leaped, they crouched, they swerved, they dodged the flying terror of the sound. The three red chaps had fallen flat, face down on the shore, as though they had been shot dead. Only the barbarous and superb woman did not so much as flinch and stretched tragically her bare arms after us over the sombre and glittering river.

11, 12. Brad Buckley, from installation *Every Good Idea Begins as a Heresy*, 2006. Paint on wall and digitally altered 30-minute soundtrack. Anna Leonowens Gallery, Nova Scotia College of Art and Design University, Halifax, Canada. © Brad Buckley. Courtesy of the artist.

the artist uses an excerpt from Conrad's *Heart of Darkness* to mount a critique on the 2003 American invasion of Iraq. Buckley uses an older, famous text to interrogate historical recurrence of imperialism and hatred, from the Belgian Congo to America and Vietnam, pinpointing the hypocrisy of strong states that intrude on weaker ones with the presumptive intention to improve, only to cause lasting devastation.

Dispensing with images and references to images altogether, US artist Jenny Holzer uses aphorisms to explore the emblematic nature of words and the way they impregnate themselves into consciousness in the manner of ideology or belief. Near all of her slogans derive from a personal lexicon of statements, what she calls her 'truisms', which began in 1979 and are the Postmodern equivalent of Flaubert's *Dictionary of Received Ideas*, in which preposterous class prejudices are presented as moral laws. They range from lapidary cliché such as 'A little knowledge goes a long way', to statements that curiously merge irony with wisdom: 'Your oldest fears are the worst ones'. Holzer has beamed her gnomic phrases on buildings or illuminated them with commercial street neon as well as exhibiting within a museum setting. Beaming was used by the Nazis and neon is indispensable to night-time street advertising – both are mass-media tools of audience manipulation which Holzer both embraces and subverts. In 1982, Holzer's slogans 'Abuse of Power comes as no surprise' and 'Money creates taste' appeared on a Spectacolour board in Times Square. At their most effective, Holzer's statements cause a double take: they fit squarely within their commercial milieu but somehow miss a register. You may be unsure on whose behalf it speaks. Is the joke on you? Then, in that reflection you may also be led to ponder on how seldom we reflect on the innumerable other state-ments we absorb as fact. We may go so far as to say that Holzer's work begins as physical text and ends as mental image. Before I turn to the multiple conceptions of the image, I will conclude with the Internet, the most diverse and widespread proliferation of writing humans have ever seen, and where the visual image and the written are in near perfect symbiosis.

INTERACTIVE AND NET ART

With a good deal of digital art in which the viewer-interactor engages directly with an interface, the word-image relation of early forms of art comes full circle. The Modernist ideal of the work of art formally independent of other genres and pract-ices, mute and presentational, is but a brief dream. With digital art, words are central to its production and to the processes of its presentation. In the case of Internet art, they cannot be dispensed with, as they are the means by which the user tracks into the site of interest. The web is a living demonstration of Hypertext, an idea conceived of by Vannevar Bush in 1945, wherein units of text are spatially linked to one another, are free to compose and reintegrate, and which follow constantly variable flows of meaning and connection.

For access to Net Art (or 'net.art') a potential viewer/user must employ words, and words are the normative tool for directing the user throughout the site. In

audiovisual forms such as film and video, word and image frequently combine. In video as well as within web interfaces, there is often sound, which more often than not features the spoken word and which may be reproduced in the gallery catalogue or on another page of the site. What we now take for granted with the moving image is that it literally speaks, within itself, or, if the speaker is directed at the camera, to an imaginary spectator, the viewer. It is not uncommon for artists working in these media to work from scripts that are rigorously worked through before realization on tape or hard drive.

It has recently been asserted that Net Art has suffered something of a demise – as rapid and sudden as its birth – because of the strengthening organization of the Internet around commerce (everyday banking and investment), information retrieval and entertainment. Blogging and YouTube have entered into most homes in the developed world, but their political merit is more incidental than coherent. Artists find themselves strangely subsumed by a medium and its users who seem less and less interested in subversion and more dedicated to information and fiscal consolidation. According to Julian Stallybrass, design tools such as Flash high-light the specular allure of the medium, thus softening its critical potential, while individual practitioners have not lasted long within the field because of the feeling of being drowned out by corporate might.[16] There is no cause to despair, however, owing to the relative youth of the Internet and the irrepressible desire of artists to find gaps within the surface to keep edgy practices alive.

But when we look at writing's relation to digital art as a whole, we might say that the status of much digital technology as a transmission system as opposed to a medium (e.g. paint) does not make the art-writing debate redundant, rather it exposes their interdependence. The best analogy may be gender. Man and woman are markedly different when in their extremes; these differences sometimes overlap, yet they both share similar desires, expectations and ethical concerns.

3 IMAGING

An image is a picture of something. Paintings and photographs are images, and there are images in poetry and in dreams. There is also a less historicized dimension to image, since it is also cognitive, experiential and sensory, a giving-to-form that occurs between the mind and the objective world. An image can be a form given to an idea, or an identity that earlier cultures thought of as an evocation, like a ghost. Imaging as a result of artistic gesture through the mediation of anything like a brush or a digital interface appears to have emptied out the occult aspect of imaging, yet a closer look at theories of the image uncovers an underlying consensus that the image is tantalizingly, alluringly, present-absent; a shadow or disembodiment whose power lies in its insubstantiality, conveyed to us magically over space and time.

THE FIRST IMAGES

Images begin as impalpable creations of consciousness, sensory constellations that can involve sounds and smells as well as pictures. Without some mind-image there is no manufactured image, but to say which precedes the other is altogether moot. While other forms of intelligence such as advanced mammals are known to have rudimentary capacities of recognition, they do not have a self-conscious ego that has the power not only to distinguish between personal mental activity and external life, but also to visualize the world in an internal way. Part of what we call knowledge is the ability to identify the activity of intellection and cognition as something caused by us before it is shared with the world by way of speech, gestures or pictorial representation. This reflexive relationship, in which I know I am doing something, and generate mental approximations in order to transact ideas with others, is the beginning of the linguistic relation to the world. Analogous to an infant's development, the conscious image-relation is upon the realization that one is different from and not continuous with the world.

Once we actively know that we have ideas, we then advance to become aware of a third quality, imagination (*imaginari* – literally to picture to oneself), something unaccountably independent of the world that can be interpreted, created and desired. Religious worship is the ultimate stage in the imaging process since it re-anchors the imaginary back into the frame of the physical world. It suggests that the power to create images in the mind must correspond to other possibilities of creation by a

higher being. The degree to which humans have a right to produce images beyond those in their minds is among the oldest sources of religious conflict.

The stages of image and language acquisition are generally echoed in the human facility to shape mental and physical images. In the absence of conclusive evidence, it is however safe to assume that the earliest *Homo sapiens* did not have recourse to the image until they essayed representation and basic decoration. As I discussed in Chapter 1, Ritual, the human assumption of external, material pictorial images began as expressions of wonder at being in the world. They were as a result of either one or a combination of factors involving ecstatic rites, in which the ways of life were elevated to dangerous-beautiful feverishness, or a means of telling stories about the role of people's ancestors in creation. In this first stage – which is not necessarily inferior or 'primitive' with regard to our present way of imaging – the image of the shaman-artist is still thought of as continuous with the energy of what is being represented, be it a bison, a snake or a hill. It is feasible to assert that the 30,000-year-old ivory figurine of a bird in flight found at Hohle Fels Cave in Germany's Ach Valley, or the cave paintings in Kimberly Ranges in north-west Australia, or those in Lascaux, were viewed as imbued with essential qualities, to be treated and seen as just another facet of the thing. This perception is no different from the sacred belief, still practised in numerous religions, that the image of a person (as an eidetic, mental construction or as sacred effigy) is invested with special power.

But the image, as something recognized as such, only comes into the equation as an item of intellectual speculation once some formal, metaphoric separation occurs between the image and to what it refers. This separation, based on a reasoned set of qualitative differences, comes after the age of what classicist Jean-Pierre Vernant has called the 'mythic imagination' of early humanity.[1] For cultures where the image was but an extension of what is seen, hunted, eaten or worshipped, representation was not an issue. Indeed, a greater part of Western art to this day has been a search to reclaim the immediacy and purported innocence of this acutely *presentational* aspect of the image, in which there is an absence of the logical or perceptual separation between the thing known (the signified) and the thing seen (the signifier). This is common Western nostalgia in art and religion: it hankers after a world that no longer poses the question of what an image is, and where objects are experienced immediately and unto themselves (Minimalism or performance art are prime examples of such efforts).

Our present era witnesses an imponderable migration of images, broadcasted over the media on television and over the Internet, and more still from person to person on mobile phones. But the big paradox is that this dizzying magnitude has caused a diminution of vision. So stuffed are we with images that we have reached a level of torpid, abject insensitivity. The way we have become inured to tragedies such as the war in Iraq, or the tsunami of late 2004, is testimony to this. Where once images were phantoms treated with tentative veneration, we are more like horror-film addicts for whom phantoms are never frightening enough.[2]

ANCIENT GREECE

The Ancient Greeks were the first to theorize on the notion of something created, whether in the mind, a theatrical gesture, or in a physical object, that either imitated the things in the world, or that supplemented them.

Writing in Rome in the first century, Quintilian (35 CE to 95 CE) commented that what they called *visions*, the Greeks called *phantasiai*, denoting something seen with aid of the imagination.[3] Plato (428/27 BCE to 348/7 BCE), in the fourth century BCE, defined the image (*eidôlon*) as a secondary object, hence one in imitation of a prior, superior version. Since for Plato what we see is removed from ideal things, everything we grasp with our senses is an image. The makers of images, *eidôlon poiêtes*, were accorded his suspicion because they trafficked in appearances of things that were already appearances: shadows of shadows, echoes of echoes, obscure and inconsequential. No wonder they had no rightful place within Plato's ideal state. There was no substantive term of 'artist' in Ancient Greece; here the word *poiêtes* refers to any maker of images, from painters and sculptors to poets, playwrights and actors; and although musicians are on his hit-list, Plato did have a soft spot for them. The dominant art form in Ancient Greece was drama, the medium that communicated pagan myths and shared people's anxieties. Mimesis, imitation or replication, was the fundament for Plato of all art, and 'poets' were nothing but slaves to the things they represented.

Plato's thought has found itself in innumerable debased and simplified forms, the most recent being the scourge of economic rationalism that treats art as over-indulgent fakery which is the insidious enemy of virtuous, profit-making labour rooted in so-called real life, unfettered to the evil deceptions of art. That aside, we can safely say that aesthetic philosophy after Plato is a campaign to show either that reality and the image are bound or, more radically, that it is the image that has overriding power over reality. In a feverishly mediated world, this argument is more than tenable.

According to Plato, the image has three incarnations. These are enumerated in increasing order of the feeling of both presence and absence that they convey: the first is presented in dreams (*onar*); the second is the vision at the behest of a god (*phasma*); the last is the phantom of the dead (*psuchê*). The principal difference between the images as seen and felt by us as compared to the Greeks is that, while we generally understand the image to be a representation that bubbles up within the thinking, feeling subject, the Greeks considered images to be apparitions entering the world of the living from their otherworldly dwelling place. Hence the discrepancy, as Vernant calls it, between apparition and appearance. In terms of Ancient Greece, the image is not psychological because it has its own life; it does not belong wholly to mortals – they are its conduit, not its creator.[4]

The life that the Greeks believed images to have is revisited over the epochs in the kind of veneration given by families to portraits of their dead, in paintings and photographs; and now, with far greater preponderance, with the presence of

celebrities within the domestic sphere thanks to television. The lifelike presence of celebrity demigods on television recalls the same presence-absence dynamic of Greek images; the everyday person feels both desperately remote from celebrities while at the same time cherishing a false sense of ownership over them in some miniscule fashion, since the people whom they idolize are central to the way they organize their hopes and their own self-image. The deification of Princess Diana was, and still is, decisive in this regard: she was a figurehead whose image, thanks to the unflagging idolatry of the media, became owned and protected by a staggering number of people in Britain and beyond.

THE TWO FORMAL PHASES OF THE STRUCTURED IMAGE: ONE-POINT PERSPECTIVE, CUBISM

Before the inception, or invention, of one-point perspective, two-dimensional imagery of Western art was to varying degrees decorative and hieratic. As we saw in the previous chapter, hieratic imagery is didactic and expressive of generic hierarchies. In so-called primitive art, distinctions are made between body parts and animals according to their dynamic relationship to the action. (Such distinctions, which Alois Riegl called 'haptic', will be discussed again in Chapter 6, Style.) When I use the term 'decorative' here, it refers to the ways in which painting echoes the decorative functions of low-relief sculpture on architecture. This can be seen in numerous manifestations, as in Egyptian bas-reliefs, Ancient Greek vase painting, in the murals from the early Aegean civilizations, and in the surviving wall paintings of Rome, notably in Pompeii. If there are spatial figure-ground relationships, they are normally rudimentary. This is also the case with medieval art: the imagery is pressed against the frontal plane.

The revolution of the organization of pictorial space synonymous with the Italian Renaissance can be seen as reflecting a need for pictures to do more than describe and decorate, and to reflect the deeper instincts of the new humanism, thus imbue figures with an inner life. This is what Leon Battista Alberti (1404–72), in his famous treatise on painting (first appearing in Latin, *De pictura*, in 1435, and translated into Italian a year later) meant by *istoria*. Alberti's introductory remarks on this theme have uncanny undertones of the Greek manner of conceiving images: 'Painting contains a divine force which not only makes absent men present [...], but moreover makes the dead seem almost alive.' But it is not only this presence that is the aim. Painted images must, according to Alberti, have affective power. The emotivity that he reads in Cicero and Horace is to be translated into the visual image: 'The *istoria* must move the soul of the beholder when each man painted there clearly shows the movement of his own soul'.[5]

Since the figures within the frame were supposed to body forth with greater expressive profundity, they had to be shown as agents within their milieu, as occupying

some causal relationship with identity and existence. As Hubert Damisch explains in his impressive study on perspective, the question of perspective was entered into once the subject had placed him/herself as an occurring and thinking subject with a certain point of view as distinct from the generic, universal view of religious icons. The origin of perspective presumes the role of a thinking, participating viewer.[6]

This is the contradiction that is at the heart of sacred images of the Renaissance. They are as much in the name of someone on earth as they are in the name of God. Take, for instance, one of the annunciations produced during the period when Alberti's tract was being written. Fra Angelico (*c*.1395–1455) produced several paintings of the Annunciation, but the one formerly of S. Domenico in Florence and now in the Prado exemplifies many of Alberti's stylistic aims. There is a clear sense of the consecutive placing of the figures according to their position in allegorical time: the Fall and the expulsion of Adam and Eve, and subsequent redemption through the Annunciation of Christ's coming. To return to Alberti's argument: the order and arrangement of these events, the fact that they don't simply occur as pasted on a single plane, allows for empathetic engagement. They are understood with greater poignancy. In contrast to medieval and Gothic art, which speaks to us more

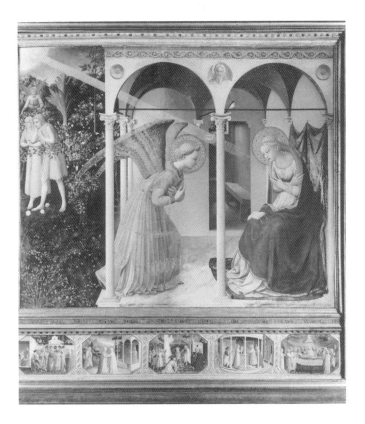

13. Fra Angelico, *The Annunciation*, altarpiece, *c.*1430–2. Tempera on panel, 194 × 194 cm. © Museo del Prado, Madrid.

schematically, Renaissance *istoria*, as Alberti would have it, appeal to our sympathy and hence to our humanism.

The most enduring part of Alberti's *On Painting* is the section that deals with the arrangement of objects on a two-dimensional plane so that they give the illusion of three. Yet Alberti's treatise was not by any stretch the first of its kind. Already, in the year 1000, the Middle Eastern philosopher-mathematician Alhazen (Ibn al-Haytham, 965–1040) had explained in his *Perspectiva* how light projects itself into the eye conically. Although not specifically concerned with picture-making, such discoveries were quickly adopted. It was Brunelleschi (1377–1446) who made the main development in the discovery of pictorial perspective by showing how, when a an object with a discernible linear structure such as a building is reflected in a mirror, its tapering outline recedes into the horizon. Donatello (1386–1466) too exhibited the use of perspective through the use of tapering grids in his paintings, in the form of floor tiles. It was Alberti's outstanding contribution to extend Brunelleschi's findings by arguing that the eye was the midpoint between two pyramids, their two tips, or vertexes, meeting at the iris. Some forty years later, Piero della Francesca (1420?–92), in *De Perspectiva Pingendi* (1474), overcame what he saw as the weakness of Alberti's thesis, which limited its recessions to the ground or frontal plane by showing how solids could be figured in any part of the pictorial recession. Finally, Leonardo da Vinci (1452–1519) criticized the mathematical methods as unconvincing, and sought a distinction between what is now known as classical perspective and natural perspective.

Leonardo's natural perspective allowed that the human eye is seldom at an ideal point of looking; it will look at things from more than one point. Even when the body is still, the eye blinks and makes numerous imperceptible spasmodic movements. One of Leonardo's main challenges to traditional perspective came in the form of what he called 'aerial perspective', 'because by the atmosphere we are able to distinguish the variations in distance of different buildings, which appear placed in a single line'.[7] It is an observation that anticipates Cézanne's intense reconfigurations on space in his paintings of Mont Saint-Victoire, which attempt the impossible – fusing the fluctuations of human perceptions with those of the physical atmosphere.

The acknowledgement that the image is a concentration – a kind of intelligible compromise – of countless multiple perspectives reaches its climax in Cubism. Cubism is the cornerstone of the powerful Modernist conceit of reading art as an incremental stylistic progression; painting begins as flat by dint of its nature, progresses to illusionistic space and then returns to two dimensions by transcending the inadequacy of perspective and through conscious deference to the picture's formal truth of two dimensions.

Yet this theory misses the point somewhat, as Cubism cannot claim to be a predictable stage of representation that responded to the developments of its time in the way that pictorial perspective can. Put another way, we cannot say that it was inevitable, like Impressionism perhaps after photography, or the Baroque after

Mannerism. Rather, its invention was something of a mystery. Whereas pictorial perspective had its precedent in geometric deduction, Cubism's precedents are only to be found after the fact. It did respond to the need for a more solid pictorial form following the spatial dissolution of Impressionism, but that does not suffice as an explanation. Cézanne's interpretation of space as a series of subtly interlocking, imbricating planes was certainly a breakthrough, as was the 'discovery' of African sculpture, whose reductions of the face to starkly abstracted planes was congenial to artists seeking alternatives to the naturalist or idealized human form.

Braque (1882–1963) and Picasso (1881–1973) came up with Cubism after Picasso showed his friend the terrifying and ground-breaking *Les Demoiselles d'Avignon* in 1907. It is inaccurate, however, to call this the first Cubist painting as Picasso never considered it complete. Since 1906, Picasso had already been experimenting with chunky nudes with mask-like faces and vaguely prismatic surfaces reminiscent of Cézanne's jagged-lined, roughly hewn bathers (*Two Nudes*, now in MoMA, is a signal example). The forms of the bodies still do not have the crisp, planar look that made later figures look like they had come from a robot factory, nor do they have the radically abstract disaggregation that reduces everything into shards and splinters. Notwithstanding, *Demoiselles* is an artistic milestone of image-making like that of Michelangelo's Medici Tomb or of Giotto's Arena Chapel. It made artists and non-artists alike see things with new eyes. In the words of Picasso's biographer, John Richardson, the painting 'was a principal detonator of the modern movement, [...] for Picasso it would also be a rite of passage: what he called an "exorcism"'.[8]

Vauxcelles, in 1908, had used the word 'cubes' to describe Braque's painting, but it was, as mentioned in the last chapter, Guillaume Apollinaire, poet, friend-cohort and impresario for the group, who was the first to understand the full importance of Cubism and to commit this conviction to print. In his article, 'The Cubists', printed in *L'Intransigeant*, on 10 October 1911, Apollinaire stipulated that Cubism was 'not the art of painting everything in the form of cubes', but a school that lays claim to the highest aims of the art of its day. In a more informative article written four months later, Apollinaire defends Cubism as a 'pure painting' and 'an entirely new plastic art' belonging to 'mathematicians [...] who have not yet abandoned nature'. Picasso himself 'studies an object the way a surgeon dissects a horse'.[9]

The dissection metaphor was not glib, but specifically chosen, since one of the more amenable clichés about Cubism is that it lays out its subject on the picture plane like a concertina, allowing more than one side to be seen at once. But such analogies do not leave sufficient space for the highly intuitive side of Cubism. Cubism advocated itself as realism, arguing that it could (supposedly) penetrate to the inner order of space to broach the fourth dimension, time. Philosophers such as Henri Bergson (1859–1941) and mathematicians such as Maurice Princet (1871–1971) are periodically invoked in discussions about the Cubist cause, but their influence should not be taken too far. Cubism was a fortuitous discovery of some enormously talented artists at a time of social struggle and frenetic stylistic change in all the arts.

14. Georges Braque, *Le Verre d'Absinthe*, 1911. Oil on canvas, 37 × 28.7 cm. Art Gallery of New South Wales. © Georges Braque, 1911/ADAGP. Licensed by VISCOPY, Sydney 2007.

Its subsequent adherents, such as Juan Gris (1887–1927), (whose paintings are fine enough to be considered alongside those of Cubism's co-founders), Albert Gleizes (1881–1953), André Lhote (1885–1962), Ferdinand Léger (1881–1955), Jean Metzinger (1883–1956), Kasimir Malevich (1878–1935), and Jacques Lipschitz (1891–1973), took their business as Cubists very seriously, so much so that Charles-Édouard Jeanneret (1887–1965, before he called himself Le Corbusier) and Amédée Ozenfant (1886–1966) published their Purist manifesto in 1920 in their review *L'Esprit Nouveau* (The New Spirit). Here they promulgated a *rappel à l'ordre*, (return to order), a call for Cubism to return to the discipline of the 'heroic phase' of analytical Cubism (*c.* 1910–12), for to them Cubism had become lax and prodigal. They believed that even Picasso himself had betrayed the cause by lapsing into decorativity. The Purists' reproach, that Cubism had been unable to realize its destiny, suggests ambitions for the style that reached towards social and perceptual reinvigoration. They and other artists with the same penchant for pictorial discipline revived the golden section, or golden ratio, to the extent that a group, the Section d'Or, was named after it. Dating from before the Renaissance, the formula dictated

that the ideal pictorial structure consists of a relationship where the sum of two qualities is to the larger quantity as the larger is to the smaller.[10] These devices, including Cubism, were for them a gauge, a lens, a conduit to better awareness, the key to the eternal structure of things, and thus their inner being.

The Czech-German poet, Rainer Maria Rilke (1875–1926) remarked that Cubism was not the invention of a new stylistic veil to be cast over the subject, but the opposite, which exposed the inner structure of the image, the 'subcutaneous net beneath the image's skin'. Cubism stood for a tool for a better understanding of the laws of painting, the relationship of simple things to the whole.[11] To go even further, for many artists in the first decades of the twentieth century, such as Ferdinand Léger, Cubism was an imaging process that could change people's perceptions and would alter the world positively in tune with the (they still believed then) utopian promise of technology.

THE SUGGESTED IMAGE: CHINESE LANDSCAPE PAINTING

While mathematics played a role in Renaissance perspective and in Cubism, albeit in differing ways, there is nothing mathematical about Chinese perspective; the space is invented and intuited. Chinese landscape is an ancient tradition, but it reached a climax during the Tang Dynasty (618–906), whereupon it came to embody the principles of Chinese art. For artists of this period and still for those who carry on the tradition, landscape painting was the meeting point between the outer world of nature and the artist's inner spirit.

Chinese landscape painting uses what is known as shifting perspective.[12] We may think of Cézanne in this regard, who learned a great deal from such painting, but in Chinese painting there is an element of description that Cézanne strove to avoid. Chinese landscape painting's multiple viewpoints typically give the viewer a floating feeling of simultaneously being within, before and above the landscape.

The most successful of such renditions, as in Figure 15, a painting of a sailboat in a rainstorm from the Southern Song Dynasty (1189–94), are airy encounters that allow for, in effect, multiple visual-mental journeys within its skewed ravines and pastures. A common device for resolving points at which contradictory passages met was to insert areas that connote mist or cloud.

The most persistent ideas about Chinese painting are expressed by one of its best English-speaking interpreters, James Cahill, thus:

> Chinese painting is concerned with revealing universal aspects of nature, not transient phenomena; it aims at representing inner essence, not outer forms; it is fundamentally an art of line and distinct brushstrokes; it is much given, especially in its later phases, to copying or imitating the past; it places little premium on originality [...][13]

15. Xia Gui, *Sailboat in Rainstorm*, Southern Song Dynasty, late twelfth to early thirteenth century. Ink and color on silk, 23.9 × 25.1 cm. Special Chinese and Japanese Fund. © 2007 Museum of Fine Arts, Boston.

But to give a sense of the analytical nature of the Chinese credo of style, one need only turn to the seminal text written by the artist Shih-t'ao in the late seventeenth century. For instance, article twelve on 'Woods and Vegetation' has all the elements of the intriguing mixture of rigidity of rule and freedom of execution. The last line explains how the most effective images visually emulate a Buddhist prayer:

> The ancients painted trees in groups of threes or fives, or even nine or ten trees together. They were so arranged that they faced in different directions with light and shadow at different heights, giving a sense of life-likeness. When I paint old pines and cypresses, ash and locust, and there are four or five of them, I make them look like sportsmen rising to dance in different bending, crouching and stretching positions. They seem to move freely. Sometimes the lines are hard and sometimes soft, both the brush and wrist being moved. Mostly the movement of lines is like that used for painting rock surfaces. [...] there are changes of light and heavy spots, and the result is a spaciousness fraught with life. This method may also be applied to large mountains, but not to other subjects. The goal is to create vibrant energy with haphazardness. This is so, not to be explained.[14]

THE ROMANTIC IMAGE

What the Romantic sensibility shares with Chinese painting is not only a moody, prayer-like quality, but also that the image mediates between the outside world and the individual. That's where the parallels end.

With Romanticism, the objectivity of the image is overturned and the phantom-like contours of the image from early Greece returns with self-conscious intensity. External 'Nature' existed only as the raw material for the artist to model and shape, to modify and distort, to escape into and to perfect. This perfection was subjective, and if it was called universal it was either through the notion of seeing the general in the particular, or just because Romantic poets and philosophers had that charismatic habit of thinking themselves absolutely right. Their veneration of the world was aestheticized and what would later, with Surrealism, be called free-associative. The Romantic artist and critic plays over the surface of the object or scene such that his or her (it was an era that saw a flowering of female talents) response forms a flamboyant carapace that fuses with the object itself. Another way of thinking about this relationship was summed up by Friedrich Schlegel when he stated that Romantic art must 'hover at the midpoint between represented and the representer [...] on the wings of poetic reflection'.[15] Romanticism was deeply indebted to Immanuel Kant (1724–1804), who attempted to account for the limitations of perception. In a way that Kant did not quite approve of, the Romantics took subjective expression to be a strength and not a limitation. A fuller summary of Kant's ideas will follow in the next chapter.

What the Romantic saw was always altered, self-consciously an embellishment, while all the more worthy because felt, filtered and experienced, rather than allowed to dry out in the thankless task of objective truth. Arthur Schopenhauer (1778–1860), loosely extrapolating the philosophy of Kant, said that the force ever present beneath the formal boundaries of our perception is the will, formless and the thing that steers us to action or inaction. Thus what we see is guided and coloured by our will. And as Friedrich Nietzsche (1844–1900), Schopenhauer's most distinguished devotee before Freud, repeatedly advised, what we see and believe in our world to be reality should not be subordinated to philosophical diatribe. The only problem with this notion, however, is that reality, the image we have of the world, ends up becoming chronically plural, since it depends on the individual's unique point of view.

Despite the lopsidedness of the Romantic approach (the Danish philosopher Kierkegaard grumbled that Romanticism could not come up with an overarching vision, only isolated feelings), it continues to be the most popular because of the licence it gives to untrammelled expression and response; the image need not be measured up to a preordained standard or external ideal. The respondent, the maker of the image as either artist or perceiver, is before else a free agent, or at least is given that confidence.

The role of metaphor is crucial to understanding the Romantic image, as is the notion of the palimpsest, writing on something erased. Since my image of a thing

bears the stamp of my unique subjectivity, then it follows that everything is seen through the veil of my own incommunicable imaginative powers. 'What is truth?' Nietzsche asked early in his career. 'It is a moving hoard of metaphors, metonyms, anthropomorphisms; in short a sum of human relations.'[16] The image was seen as comprised of an endlessly proliferating chain of associations whose validity lay in the further associations they set in motion. Romanticism was a communicative logic of cross-galvanization: the originality of my image seeks to spark an equally original image in you. No wonder so many Romantic artists drove themselves, and each other, round the twist.

Since the location of the image was within the individual, it therefore also meant that it was located within time. The Romantic image witnesses the increased usage of the word 'impression' by artists, critics, poets and even composers, well before its widespread use in the 1860s with French Impressionism – where perception and the image partake of an unrepeatable moment, the trace of something ungraspable. Hence the melancholy that permeates Romanticism, rooted in the imminence of death. The Romantic image is particular, it is transient, and all the more compelling because of this. The German word for 'impression', *Eindruck*, coveys the sense of inscription, an imprint made by the sensorium, of something immediate, lived and undeniable.

Oscar Wilde (1854–1900), a radical synthesizer of the late Romantic vision, echoing Nietzsche, declared that 'The primary aim of the critic is to see the object as in itself it really is not.' It is one of Wilde's joyous convolutions. The critic – the trained, voracious and audacious observer – is also a maker of new images, no less an artist except one who makes art based on the former artist's form: 'To the critic, the work of art is simply a suggestion for a new work of his own, that need not bear any obvious resemblance to the thing it criticizes.'[17] Wilde is voicing the philosophy of the aestheticist movement of art for art's sake, or *l'art pour l'art*, that persisted from the 1880s until the outbreak of the First World War. These Decadents, as they were proud to be called, abjured the empirical world for that of their own artifice. Since the cognitive construction was the real one, then the world was made up; if the world was made up, those with the most superior images of the world were the artists because of the acute refinement of their sensibilities, which made them the best at unleashing the forces of the imagination. It was an approach that left ample space for artistic change, though it was not an effective approach for models such as democracy, whose measurable standard is consensus.

Because it developed out of the aesthetic liberties offered by early Romanticism, the extreme subjective licence hallmarking the aestheticist movement is already discernible in the poet-dramatist Heinrich von Kleist's (1777–1811) famous response to Caspar David Friedrich's *Monk by the Sea* (1809–10). The piece is a model of brooding Romantic criticism, exemplifying the way that the respondent's images take over from that of the artist, epitomizing the Romantic primacy of the inner world over the outer. With his back to the viewer, the monk stares into a nondescript beyond; since there is nothing much of note to see, the viewer has no

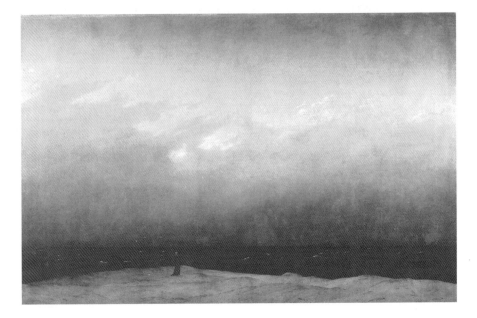

16. Caspar David Friedrich, *Monk by the Sea*, 1809–10. Oil on canvas. © Nationalgalerie, Berlin, Preussischer Kulturbesitz.

choice but to follow through with an imaginative response; the viewer's own images take over from those withheld by the pictorial image before us.

> It is splendid to look out on the water's edge with endless loneliness, under a gloomy sky, at the limitless sea. All this belongs to life, where we have perhaps once gone and whence we must return, where we want to overreach and where we cannot; where everything belonging to life is missing while yet the voice of life can still be discerned in the rush of the waves, in the blowing of the wind, in the drift of the clouds, in the lonely cry of the birds. This belongs to the claim made by the heart and then one's break, caused by my own expression, from nature. But this isn't possible to do before an image [*vor dem Bilde*], and what I myself should find in the image was what I first found between myself and the image, namely a claim [*Anspruch*] that my heart made upon the image, and the loss [*Abbruch*] that the image wrought upon me; and thus 'twas I who was the Monk, the image was the dune, but what I might so yearningly have looked out upon – the sea – altogether absent. Nothing could be sadder or more discomforting than this kind of position in the world: the sole spark of life in the vast empire of death, the lonely centre in the lonely circle. With its two or three mysterious things, the image stands before us like the Apocalypse, as if it were dreaming Young's *Night Thoughts*, and in its uniformity and horizonlessness, with nothing but the creamy white of its foreground, it is such, when looking at it, that one feels as if one's eyelids have been cut off. Indeed the painter has indubitably paved a new path in the field of his art; and I am convinced that with his spirit I could represent a quarter-mile of Prussian sand, with a barberry shrub

on which a lonely crow is ruffling its feathers, and that this image could have a truly Ossian or Kosegarten-like effect. Indeed, were one to depict this landscape using its very own chalk and water, then I believe that it would be enough to make the foxes howl: doubtless the greatest potency of what one could bring the apogee of landscape painting of this kind. And yes – my own impressions over this wonderful panting are too crazed; and so rather than venturing to describe it all have set out [*zu belehren*] the appearance that passes in the alternations of day and night.[18]

The most-quoted phrase from this article is 'as if one's eyelids were cut off', in which Kleist characterizes a contemplation of such intensity that it permits of no retreat. *Bild* means both 'picture' and 'image', which makes for some stimulating confusions, but as Kleist admits at the end, he has not attempted anything more than his own 'crazed' gloss. But the way Kleist describes it, the Romantic image is interminably tragic: by being able to lay claim to the world with our own images of it, we also, at the same time, signal our alienation from that world, because such images are our own separate, isolated inventions, tied to – yet always distant from – the world to which they refer. We are distant witnesses to the internal unfolding of the image within the monk, and, in our wonder, are made interminably conscious of our failure to share in his experience. It is the lot of the Romantic to be brought to the lonely conclusion that the only sure things are the unspeakable, unverifiable constructs of our own mind.

PURE IMAGES

Another remarkable quality of Kleist's text is that it is richly synaesthetic. Synaesthesia is the sense impression that is provoked through stimulating another faculty, such as the evocation of colour in music, or sounds in a picture. Visual evocation through the verbal image is a given within poetry, which was why Plato and Hegel gave it a special rank against the other arts; Plato saw poetry as belonging to the domain of music, and Hegel to the world of ideas, but such translations and attributions – the derivation of the image of one medium from the image of another – become a good deal more elaborate with the Romanticisms of the early nineteenth century when Schelling (1774–1854) and, most thoroughly, Schopenhauer raised music from among the lowest ranking of the arts to the highest. The musical image, in the words of Samuel Beckett, is cherished by the Romantics and Modernists for being 'perfectly intelligible and perfectly inexplicable', and since inexplicable to the Modernist way of thinking, then all the more pure.[19] Famous examples of synaesthesia are in Théophile Gautier's poem, *Symphony in White Major* (1872); the French Symbolists' enraptured reaction to the music (or what less sympathetic ears would call its inexorable 'dum-ti-dum' rhythm) in Poe's poem *The Raven* (1845); in Whistler's (1834–1903) titling of paintings such as *Symphony in White No. 1: The White Girl* (1862), *Variations in Pink and Silver: Chelsea* (1871), *Arrangement in Grey and Black No. 2: Portrait of Thomas Carlyle* (1873) and *Nocturne in Blue and Gold:*

Old Battersea Bridge (c. 1872–5); or in Debussy's piano pieces such as *L'Apparition*, or the 'Images' whose titles seem lifted from Impressionist paintings: *Jardin dans la pluie* (Garden in the Rain), *Cloches à travers les feuilles* (Bells Through the Trees) and *Reflets dans l'eau* (Reflections in the Water). With these titles as keys, the listener is brought to affix visual images to aural images. Kandinsky, in his famous tract *Concerning the Spiritual in Art* (1914), makes the defence for the way in which music has special access to supra-sensory abstraction:

> A painter, who finds no satisfaction in mere representation, however artistic, in his longing to express his inner life, cannot but envy the ease with which music, the most non-material of the arts today, achieves this end. He naturally seeks to apply the methods of music to his own art. And from this results that modern desire for rhythm in painting, for mathematical, abstract construction, for repeated notes of colour, for setting colour in motion.[20]

Note Kandinsky's valorization of 'non-materiality'. At its extreme, dematerialization is the purest kind of image, but it is also remotest from what can be articulated or grasped by the conscious mind. It was, after all, in the best interests of Modernist artists to frustrate the efforts of the critic or aesthetician with images which suggested something protean and mobile over something that could be linked or indeed verified, namely a 'real' signified in the outside world as exemplified in the rhetorical simulation of truth of, say, Albertian perspective.

Artists such as Kupka (1871–1957), Kandinsky and Mondrian were all heavily influenced by Theosophy, the mystical pseudo-science that espoused that thoughts had equivalents in colours and sounds. This desire to reconcile materiality with illusion was already present in the optical experiments of the Post-Impressionists and the Pointillists. Seurat, for instance, composed his paintings of tiny dots of colour usually chosen from primaries (red, yellow and blue) and secondaries (purple, green and orange). Owing to the optical field of focus of the naked eye, the more they were seen at a distance, the more these particles would fuse to make a colour plane. The surface of the painting would flicker and fluctuate according to the viewer's distance from the picture. As much as Pointillism exploits the physicality of colour in relation to our optical capabilities, it is also a major development in what we today call interactive art.

When we turn to the beginning of the twentieth century, much more ambitious claims are made for the optical experience and the abstract-spiritual functions that colour, line, and their considered combination, can perform. So in the painting of Kandinsky, lines and colours were approximated to psychic energies and mental states; with Kupka, bodies are endowed with shimmering auras. In Mondrian's *Pier and Ocean* (1915), the ocean is reduced to cross-like forms, embodying the intersecting forces of the universe. Infinite and multivalent change has been reduced to an intuited but somehow precise formula based on variable and interlocking cruciforms. Its elliptical composition makes us think that are staring into the smallest opening of what is infinitely large. It as if we are initiated into the secret of the atom, the vectors within matter.

At its most severe, the reductionism for which Mondrian is best known is an abstruse mechanism of translation of matter and movement into a static essence that suggests a disappearance of the image into a feeling, or an imageless idea. As Beckett remarks with regard to the musical figure, or image, 'The essential quality of music is distorted by the listener who, being an impure subject, insists on giving a figure to that which is ideal and invisible, on incarnating the Idea in what he conceives to be an appropriate paradigm'.[21]

There was much discussion of pure poetry, *la poésie pure*, in the late nineteenth century as there was of a pure painting up until the middle of the twentieth. It was believed that art could find its transcendental axis, independent of nature – hence Mondrian's much cited 'horror of green'. The aim of making art in which an image was liberated from its answerability to the image was no more evident in the visual arts than in Mondrian and his circle, and subsequently in the New York School. Mondrian, who at the end of his life spoke of destroying painting, aimed at a kind of 'imagelessness' in which all material traces of the outer world were cleansed. In the artist's own words, 'The rectangular planes (formed by the plurality of straight lines in rectangular opposition, which are necessary in order to determine colour) are dissolved by their homogeneity, and rhythm alone emerges, leaving the planes as "nothing"'.[22]

This 'nothing' was an absence only in so far as it was an absence of undesirable elements foreign to the articulation of a higher, purer art. It is non-mimetic and serves to articulate the inner necessity of a nobler truth. The work of art, according to Mondrian and to Kandinsky, not only communicates a utopian message of an impeccable consciousness, it *is* that purity, the icon of innumerable forces; simplified, made aesthetically intelligible, and assembled into a harmonic whole.[23]

These aims continue to be pursued as a matter of faith and conviction. With Abstract Expressionism, the painted image acts as a gateway into the numinous. When we come to the work of Rothko, we see a similar uncompromising stress on an absolute spiritual-aesthetic experience divorced from reference to the outside world, but as opposed to Mondrian's impassable matrix, in Rothko's mature works the viewer is allowed to sink into a pulsating visual mantra. The figurative image is absent. The ghost is at last set free.

VISIONARY IMAGES; DREAM IMAGES

The word 'surreal' is invariably linked to the movement in art and poetry that sprang up in Paris between 1924 and 1927, although as we saw in the first chapter, art and dreams have always been closely linked. It is next to axiomatic that images and urges from dreams, be they spiritual or sexual, play a strong though unaccountable role in artistic invention. In his writings on the Salon of 1859, Baudelaire (1821–67) extolled the imagination as the queen of the faculties and condemned artists who enslaved themselves to nature instead of apprenticing themselves to their dreams. For Baudelaire, 'A good picture, faithful and worthy of dreams that gave it birth,

must be created like a world.'[24] Another great poet, Rimbaud (1854–91), preached that: 'The Poet makes himself a *seer* by a long, gigantic and rational *derangement of all the senses.*'[25] It was a line that would become a Surrealist mantra, and because spoken by a child genius, and by implication untutored with access to the immediate image, all the more worthy of reverence.

We know that the Ancient Greeks saw all their activities as a complement to the gods' activities; and subsequently we cannot discount the importance of visions for figures such as the medieval mystic Hildegard of Bingen (1098–1179), who was convinced that she had access to God's secrets. The same conviction was passed on to the great English artist of the eighteenth century, William Blake (1757–1827). His friends Henri Fuseli (1741–1825) and Samuel Palmer (1805–81) believed themselves to have keys to visionary doors as well. Goya's *Caprichos*, which purposely muddy the line between dream and waking life, are pre-Surrealist no less, and a French artist of the turn of the last century, Odilon Redon (1840–1916), gives all but proof that Surrealism is a name for an undying impulse of the artist to make the furtive, magical, impulsive and haunting image of the mind flesh within art.

One of the most winning aspects of Blake's visionary art is the knowledge of the sincerity of his belief. Even if we are unforgivingly sceptical, we want to believe him. With Blake we are reintroduced to an immodest pantheon of saints, demons and angels in compositions that lay no claim to naturalism. The most telling anecdote about Blake's visions is recounted by the young painter George Richmond, who asked the older painter about his own lack of inspiration, whereupon the sage turned to his wife and said, 'It is just so with us, is it not, for weeks together, when the visitors forsake us? What do we do then Kate?' 'We kneel down and pray, Mr Blake.' And later, when Richmond was eighteen, he visited Blake on his deathbed. When he died, Richmond closed Blake's eyes expressly 'to keep the vision in'.[26]

Redon's religious world was more eclectic, and the stuff of drug-inspired ravishment, or at least for the concupiscent, preening, inbred aristocrat Jean de Floressas des Esseintes, the despotically indulgent anti-hero of Huysmans's *Against Nature*, which became the bible of the Decadent movement of the *fin de siècle*. Huysmans's citation of Redon did wonders for his celebrity. The principal passage is worth extensive quotation and perhaps does a better job than any subsequent commentator:

> Those were pictures bearing the signature: Odilon Redon. They held, between their gold-edged frames of unpolished pear wood, undreamed-of images: a Merovingian-type head, resting upon a cup; a bearded man, reminiscent both of a Buddhist priest and a public orator, touching an enormous cannon ball with his finger; a dreadful spider with a human face lodged in the centre of his body. Then there were charcoal sketches, which delved even deeper into the terrors of fever-ridden dreams. Here, on an enormous die, a melancholy eyelid winked; over there stretched dry and arid landscapes, calcinated plains, heaving and quaking ground, where volcanoes erupted into rebellious clouds, under foul and murky skies; sometimes the subjects seemed to have been taken from the nightmarish dreams of science, and hark back to prehistoric times; monstrous

flora bloomed on the rocks; everywhere, in among the erratic blocks and glacial mud, were figures whose simian appearance – heavy jawbone, protruding brows, receding forehead, and flattened skull top – recalled the ancestral head, the head of the first Quaternary Period, the head of man when he was still fructivorous and without speech, the contemporary of the mammoth, of the rhinoceros with septate nostrils, and of the giant bear. These drawings defied classification; unheeding, for the most part, of the limitations of painting, they ushered in a very special type of the fantastic, one born of sickness and delirium.[27]

PSYCHOANALYSIS

In the *Traumdeutung*, or *Interpretation of Dreams* (1901), the text that made his reputation, Sigmund Freud (1856–1939) immediately lays down a challenge to the idea that the image is a form of haunting. He argues that the images that we see in dreams come from none other than ourselves, translated, reordered and perverted from our original waking perception. During the period that Freud calls 'pre-scientific', the mythological consciousness felt no need to interpret dreams since they were considered omens or visitations and only vaguely graspable. Yet Freud argued that dreams are significant monitors of our psychic state and have a syntax and logic that can be interpreted to the profit of our everyday lives.

Freud's now famous and highly influential argument is that the dream expresses unresolved anxieties. These can be unresolved desires, typically sexual, or phobias such as the fear of heights, or worries about money. What we see upon the screen of our sleeping mind is the result of what Freud calls 'dream work', which is the way in which the 'latent dream thought' makes use of the material of recent events to express itself as the 'manifest dream' or 'dream content'. The manifest dream is a collision of elements that the unconscious has chosen according to a personal affective association with an event in recent memory: within the dream the carping schoolteacher returns as a symbol of authority; a mountain that one couldn't climb becomes a symbol of failure.

The symbolic changes that these images undergo are caused by sublimation. While most critics see the displacing operation of sublimation as Freud's principal contribution, what divides them is the way in which Freud grounds the motives of sublimation in sex, whence the eye-rolling cliché of Freud's association with the libido. In Freud's words, sublimation...

> enables excessively strong excitations arising from particular sources of sex-uality to find an outlet and use in other fields, so that a not inconsiderable increase in psychical efficiency results from a disposition which in itself is perilous. Here we have one of the origins of artistic activity; and, according to the completeness or incompleteness of the sublimation, a characterological analysis of a highly gifted individual, and in particular of one with an artistic disposition, may reveal a mixture, in every proportion, of efficiency, perversion and neurosis.[28]

In short, for Freud, the artistic act has, as its primary determination, sexual drives which it translates into images. The image imagined or realized is both a truthful *expression* of an inner urge while at the same time being an inaccurate *description* of it. With this theory Freud gave a psychic justification for the way in which art can be truthful although it is a falsification. We are also asked to resign ourselves to the notion that an image is something transformed, modified – take it at face value at your peril.

The main problem with Freud's theory is that he is unclear as to the precise standpoint from which to make the most accurate interpretation. And too often, Freud views the work of art as a symptom of psychic drives. Does a fair grasp of the artist's biography, and the drives that tormented him (we are still in the realms of the sexualized male subject here), suffice to deduce the work of art? This has been so for artists as tempestuous as Van Gogh and Cézanne, who also happened to have left behind plenty of written evidence of their tribulations. Freud's symptomatology favours a certain kind of art, and a certain kind of desire. The desire, as feminists and women artists rightly aver, is far too one-sided.[29]

In his preference for a certain form of art, Freud, an avid adorer of the Italian Renaissance, omits art produced for anything other than personal ends, for example strictly coded forms such as Muslim or medieval illuminations. Freud's argument sets in motion a teleology in which art becomes more of itself as the artist is freed from all duties other than meeting the call of sublimating his sexual fears and appetites.

Acknowledging its indebtedness to Freud, Surrealism sought to harness the dream image for revolutionary effect. Surrealist artists used numerous strategies to emulate the (again overridingly male) dream experience epitomized by the line taken from the Isidore Ducasse (1846–70), aka Lautréamont, who described the beauty of a young boy as being like 'the chance meeting of a sewing machine and an umbrella on a dissecting table'. Radical juxtaposition was not their only forte. Works with a healthy power of suggestion are often more effective that those that attempt to illustrate dreams, as in Man Ray's work that pays homage to Surrealism's dark priest: *The Enigma of Isidore Ducasse* (1920; remade 1972), which is a nondescript lump wrapped in a blanket and tied with twine – the image remains hidden.

One of the lasting testaments to the movement actually occurs in film, in Salvador Dalí (1904–89) and Luis Buñuel's (1900–83) *Un Chien Andalou* (An Anadalusian Dog) (1929). The Mexican poet Octavio Paz observed that Buñuel's film was a 'marriage of the film image and the poetic image, creating a new reality, inevitably … scandalous and subversive'.[30] Again circumscribed by male desire at the expense of the female – there is a scene of a man's furious breast-grinding of a prone woman that is as eerie as it is ridiculous, much like some dreams can be – as a corpus it is unforgettable, and as a rendition of a dream, possibly unmatched. The scene of ants flowing from out of the palm of the protagonist's hand and the most famous, the scalpel cutting the pupil, are referred to again and again as images which touch an unsurpassable threshold. Here the origin of the image – desire – and the limits of the image – fear – meet.

17, 18. Luis Buñuel and Salvador Dalí, *Un Chien Andalou*, 1929.

In Surrealism, there is no distinguishing beauty and ugliness in a conventional sense. Buñuel's achievement calls to mind Breton's statement in the First Surrealist Manifesto (1924): 'Let us not mince words: the marvellous is always beautiful, anything marvellous is beautiful, in fact, only the marvellous is beautiful.'[31]

POST-STRUCTURALISM AND THE IMAGE

When we come to the period from the late 1970s to the end of the twentieth century, we see a campaign within French theory to bypass binary logic, to rethink the limits of representation and to question the Western obsession with absolutes. One way of approaching post-structuralism and Deconstruction has been in terms of their critique of the Platonic theory of representation. For instance, in the commodity market, the initial impulse is to prefer to have an original over a copy, be it an authentic brand name or a painting. But as the post-structuralists have pointed out – including Baudrillard (1929–2007), Derrida (1930–2004), Lyotard (1924–98), Deleuze (1925–95), Guattari (1930–92), Kristeva (b. 1941) – it is only via the copy that we come to value the original, and we only know about the origin according to the things that come after it. If we are to speak about the image in art in these terms, then it is fair to say that our interest in the origin of the image has only come from the many stimulating ways it has been rendered within artistic form; it is only by virtue of its obscurity that we want to decipher it.

This may sound like a rehashing of the German early Romantics of the early eighteenth century, which may be true to some extent, but the thinkers who fit loosely under this banner were enormously resourceful and influential in challenging conventional ways of thinking and writing about the nature of artistic imaging, especially in attempting to dispel the way that the West (Platonic) privileges the supposedly authentic or 'real' object over its representation (to Plato a humble copy) and in seeking the limits of representation and the unrepresentable, I will gloss four examples.

DELEUZE AND BACON

Deleuze had already made a name for himself in his philosophy of expression in his studies of Hume, Nietzsche and Spinoza when he embarked on *Francis Bacon, Logic of Sensation* (1981). It is a treatise, in the form of an appreciation of one artist, on the visual representation of sensation, conceived here as the gamut of human sensory powers. Deleuze's thesis is in the spirit of the French tradition of phenomenology, particularly to be found in Merleau-Ponty (1908–61), who stressed that all facets of sensory awareness are brought to bear in our acquisition of knowledge, and that our sensory organs are also the organs by which we organize and make sense of the world; the senses are not just a conduit to the brain, rather the brain and the senses are one. Indeed, Deleuze devotes considerable space to such ideas, including to Cézanne – on whom Merleau-Ponty wrote a seminal essay that appeared in 1948. Venturing a step further, Deleuze sees an inner violence in Bacon's painting that takes the lived body of phenomenology to its deathly limit.[32] These are big claims that Deleuze makes for Bacon and for which he has more recently been criticized. True as it may be that there is an expressionist nostalgia that drips from the text, Deleuze is eloquent in the way in which figure and form (in this case Bacon's) are a kind of crystal or embodiment of an ineffable force that would otherwise remain unarticulated. Bacon, argues Deleuze, does not abandon the figural because he finds that expressive force in non-objective abstraction is dissipated rather than concentrated.[33] But the main challenge for Bacon is to transcend the illustrative and narrative element of the figural and to expose the sensations that constitute the figure, hence the relations that give form to form. For Deleuze, Bacon's bodies are in the 'hysterical' becoming-process of returning to the state of brute matter. In Bacon's paintings we view the

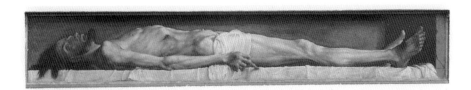

19. Hans Holbein the Younger, *The Body of the Dead Christ in the Tomb*, 1521. Oil on wood, 30.5 × 200 cm. © Kunstmuseum, Basle.

human body in an unending encounter with outside vectors of force, which shape it through admission or resistance; in his works we 'feel' physical pressure and we 'hear' the screams. These expressions/responses approximate an essence because they return to the inner silence of the body whence they sprang. One can be forgiven for thinking that Deleuze's book on Bacon, for all its philosophical apparatus, is as mystical as his work ever got.

KRISTEVA AND HOLBEIN

Kristeva's early work in the 1960s and 1970s was in the area of semiotics and linguistic theory. By far her most penetrating foray into the visual arts is in her 1987 essay on Holbein's *The Body of the Dead Christ in the Tomb* (1521), an impassioned meditation on the representation of death. In itself, Holbein's painting is astonishing in the way it presents Christ as a naked, unadorned corpse; startled dead flesh laid out on a slab. The elongated canvas suggests a glimpse inside a tomb. It is the unceremonial nature of the image, bordering on callous, that preoccupies us, what Kristeva calls a 'dereliction' on the part either of the artist or of God Himself, for Christ is left alone and shorn of all auratic honours with which we commonly associate him. Denuded in the extreme, the artist presents death in all its horrid, material banality. For Kristeva, this work is a point of fascination into the attitude of the artist, the melancholia that comes from severance with another: Christ from God, man from Christ; the severance of one person from another in death. The ultimate severance comes upon the recognition that death is the idea of non-existence that exists only in the mind of the living. Holbein's pared-down picture, his 'Minimalism', is an effort not to escape the truth, which, anyway, he can only partially comprehend. For Kristeva the painting asks the most pertinent question of representation: 'Is it possible to paint when the bonds that tie us to body and meaning are severed? [...] Holbein answers in the affirmative.'[34] The painting is a metaphor of severance, at that hiatus, or caesura, between what we are and what we eventually will become, which is dead.

LYOTARD AND NEWMAN

Lyotard is the most accessible of all the post-structuralist thinkers on representation, inasmuch as he deals directly with the unrepresentable in terms of the sublime. He devoted a sizeable part of his later philosophical career to the study of Kant whose *Third Critique*, on the sublime and the beautiful, provides the foundation of modern Western aesthetics. For Kant, human beings are limited by the formal constraints of space and time on their knowledge, but the sublime (literally 'above the lintel', hence what is beyond us) registers an encounter with what is external to the limits of our knowledge, if only that we sense that limit and not the beyond. In his essay on Newman (1905–70), Lyotard is preoccupied with this encounter, which he calls the 'event'. Newman's paintings (Newman himself was also obsessed with

the sublime) are so simple that 'the feeling of the instant is instantaneous'. But this is not Minimalism, as Lyotard senses something impersonal in Newman, or rather, pre-personal, the idea of beginning: 'This beginning is an antinomy. [...] It does not belong to this world because it begets it, it falls from a pre-history or a history.'[35] Newman's sublime rests in 'reducing the event-bound time', and through the matter of canvas, paint, colour and proportion we experience with 'wonderful surprise, the wonder that there should be something rather than nothing. Chaos threatens, but the flash of [...] the zip, [...] divides shadows, breaks down the light into colours like a prism, and arranges them across the surface like a universe'. Lyotard's beautiful essay ends with the lines, 'The work rises up in an instant, but the flash of the instant strikes like a minimal command: *Be*.'[36]

PHOTOGRAPHY, DIGITAL IMAGING AND THE INTERNET

Ironically, with mechanical forms of imaging we are brought back full circle to the ancients. For with the infinite duplicability of the image, we are surrounded by thousands upon millions, trillions, of simulacrums: fragments, traces, echoes of the living. Indeed most people in the developed world have contact with simulated presences – the telephone voice, the photograph, the image on a screen – which exceed in number and even importance those in 'real' life. As Susan Sontag opens in her classic book on photography, 'The most grandiose result of the photographic enterprise is to give us the sense that we can hold the whole world in our heads – as an anthology of images.'[37] It is a Faustian megalomania that soon turned to anxiety, like nausea from overeating.

With the world-wide web, the ability to store the information about the world has all but come to be realized. So Jean Baudrillard's polemics of the 1970s – that thanks to mass-imaging and mass production we are all displaced beings lost in a maelstrom of copies and copies of copies – are close to redundant. Or at least, the anxiety has gone. In this the digital age we have more contact with most forms of communication imaginable. Guy Debord made the celebrated remark that 'The spectacle is *capital* accumulated until it is an image',[38] which is only tenable if one accepts that capitalism is all-pervasive like oxygen. The digital image is wholly mutable while unaccountably weightless and ever shifting. In its make-up it bears no relation to its analogue counterpart, which bore the imprint of its host as cast by the amplitudes of light. With digitization, images perform as connectors between people and technological functions. We are continually within some form of technological loop, which also means that interactivity within art is not as novel as some technophiles would have us believe. I agree with Ron Burnett's criticism that the term 'interactivity' has become misunderstood and overblown, since it presumes that less mobile acts such as listening are passive. Burnett proposes the term 'reverie' for the way we immerse ourselves in the technological image-worlds, since it does

not privilege vision, and accounts for the wider range of sensory experience, and engages with the facet of inner imagining and mental digestion, without which seeing is just an empty process.[39]

We are still debating the effect of the digital image as cast over the Internet, but it seems to me that because of it we oscillate between states of multiple and closed being. The heady profusion of images and their accessibility (even in countries that exercise censorship – there are loopholes everywhere), make us subjects of supreme possible choice and supreme possible conscience. If you look hard enough you can still find clips of Pam and Tommy fornicating just as you can also see American GIs in Iraq loading planes full of body bags.

The major change brought about by new media is that the viewer becomes a user. The image is both inside and outside. In the words of Lev Manovich:

> New media change our concept of what an image is – because they turn a viewer into an active user. As a result, an illusionistic image is no longer something a subject simply looks at, comparing it with memories of represented reality to judge its reality effect. The new media image is something the user actively *goes into*, zooming or clicking on individual parts with the assumption that they contain hyperlinks...[40]

Despite the changes wrought by digitization and the Internet, we have nevertheless, uncannily, not escaped the ghostliness of the image, which inhabits us both from within and without. Although about photography, Jacques Derrida's comments, self-consciously echoing the ghost of Roland Barthes and his book on photography, are as relevant as ever:

> Of all the arts, photography seems to me the only one that does not suspend its explicit dependence on a visible referent. In the final analysis, however perverse or ingenious the montage might be, it is unable to produce or domesticate its referent. It must presume it to be given, a captive of what is captured by the apparatus. [...] it's all about the return of the departed [...] The spectral is the essence of photography.[41]

When we think back to the Ancient Greeks, and we think of the myriad abuses of the myriad images around us, we know to make the choice between a good or bad haunting. The being that we call ourselves is itself a protean mosaic of images.

4 GAZING

The previous chapter was largely concerned with the process of imaging from within a frame, either by the thinking subject or within representation. This chapter deals with looking at images already formed. This may seem a foolhardy distinction because of countless overlaps, beginning with the fact that image-formation begins as a translation of light upon the retina. Yet there is a perceptible difference between the more internal process of imaging-imagining, and the more external act of gazing which, by virtue of its externality is active and, at its extremes, aggressive. This externality also means that the everyday gazer at art is just as forgetful of what he or she brings to the object, from the richness of education and experience on the one hand to prejudices and ideological quibbles on the other. A brief look at the various key philosophical positions concerning the gaze show that we seldom, if at all, just look. For our own part we bring to the image as many precepts as there are within the artwork itself. It is only by interrogating this binary approach of imaging versus gazing that we can begin to ask where the art object is located. For what is seen is shaped by the viewer's expectations, which are bound up with an intricate combination of social mores; add to that subjective expectations and the vicissitudes of feeling. In the end the only answer is this: once the work of art ceases to excite responses and no longer elicits our gaze, once it loses its intrigue and the secret is uncovered, then as an object of contemplation it is exists only as something dried out, inertly expended like a filled-in crossword or a mastered computer game. The greatest works of art continually pose alternatives to our habits of image formation, or challenge the way we look at the world, or both.

A prime quality of looking at something that we know to be a work of art is that we know there is something more to what we are seeing. When we see something, it is recognition; knowing. When something is not formally recognized, then it will be understood in terms of similar qualities already seen. There is no such thing as an innocent eye, nor is sight ever perfect. When art is successful it compensates for the inadequacies of our sight, perception and knowledge by rendering something visible in a way that is superior to mechanisms available to us in everyday life. Art has the capacity to displace what in everyday life is a limitation, and to make things be seen as if shorn of their habituated trappings. Its presentational clarity typically poses itself as a mystery. So we are back where we started: we have to look beyond what is before us.

The theories of looking with regard to art and society oscillate between these two poles of either accounting for the inadequacy of representation, or arguing that art at its finest exemplifies the deeper sight of looking, vision, which strips away the world's artifice and gives us a deeper perception of the world that reveals itself to us gradually, like a lesson.

PRISONERS OF THE CAVE

As introduced in the last chapter, Plato's allegory of the cave makes us prisoners of the inadequacy of our gaze. The famous passage is in Book VII of *The Republic*:

> Behold! Human beings living in an underground den; here they have been from their childhood, and have their legs and necks chained so they cannot move, and can only see before them, being prevented by the chains from turning round their heads. Above and behind them a fire is blazing at a distance [...] and you will see, if you look, a low wall built along the way, like the screen which marionette players have in front of them, over which they show the puppets.[1]

Condemned to see only shadows of the truth, Plato instructs us to distrust everything we see, a distrust that defines Western vision, which by nature distinguishes between different activities of seeing, based on the degrees by which something calls for interpretation. Linguistic and phenomenological philosophies of the twentieth century have contested the validity of this distinction, since identifying something is by nature interpretative, though perhaps not profoundly so, and what we don't identify or name we barely see, and it falls from our consciousness and memory.

THE KANTIAN SUBJECT

While Kant retained the distinction between what he called 'things-in-themselves' (*noumenon*) and 'things-as-appearance' (*phenomenon*), he accounted for the incompleteness of our knowledge by arguing that we are limited to seeing the world through the formal boundaries of space and time. How we see and what we choose to see are relative to these two parameters. Although we may be limited in our apprehension of the world, we are nevertheless possessed of free will, and the sublime, the experience of which exceeds our understanding, is abstract proof of this. Thus the Kantian subject is no longer an object of understanding from elsewhere (i.e. God), but his or her own object of understanding, a free agent, capable of making independent decisions.

This independence opens a Pandora's box that contains the tribulations of modernity itself: political, social and artistic. In the Romantics' extrapolation of Kant (note again that they were not in line with Kant's own intentions), the subject has a point of view that is indefinably his/hers, as opposed to what the philosopher Foucault (1926–84) referred to as the classical subject whose point of view was only an inferior facsimile of a unitary truth. The Kantian subject is coterminous with the

democratic subject who, by the mid- to late eighteenth century, has the luxury of entitlement to an opinion and can self-consciously adopt an individual view of the world, or *Weltanschauung*. And as I have suggested already, the new rights of the Enlightenment may have had salutary consequences for politics but the democracy of the gaze engendered not one right way of seeing, but many. The concept of external law gave over to internal consensus.

This dilemma was already located by Kant, who stressed the limitations of the thinking being. As Slovaj Zizek comments about Kant:

> Man's finitude is not the simple finitude of an inner-worldly entity lost in the overwhelming totality of the universe. The knowing subject is a substanceless point of pure self-relating (the 'I Think') which is *not* 'part of the world' but is, on the contrary, correlative to 'world' as such and therefore *ontologically constitutive*: 'world', 'reality' as we know them, can appear only within the horizon of the subject's finitude.[2]

When we relate this back to the gaze, we deal with a certain lack which is both constitutive and the object of the gaze, which is the discovery of Lacan (1901–81) via the thought of Sartre (1905–80).

THE GAZE AND THE OTHER

Kant's philosophy may be relevant to the shift in the agency of the individual subject in relation to what he or she sees and knows, but Sartre was the first philosopher to explore the gaze per se as a function of the way we position ourselves in the world. What separates the gaze from just a look is that the gaze is active as opposed to passive and is performed with intent. In this dualism, there is the subject and the Other (capitalized in the English because, unlike the French *autrui*, we do not have a special word for it). Our understanding of ourselves, the self-reflection that defines us as subjects, is reflected in others. However, we become aware of the Other's presence when we are subjected to the gaze, thereby noticing that someone external to us has the power to discriminate, similar to our own. The operable word here is power: in moments when we are startled, the presence of the gaze is the most pronounced. Sartre gives the example of how, if we hear a branch crack behind us, it makes us jump: the feeling of vulnerability begins with being the recipient, not the agent, of the gaze. One of the most remarkable aspects of Sartre's observation is that the gaze is not necessarily beholden to sight. Some of the most suspenseful movies are built on this very principle, as are cultural critiques by minorities, as I will show in a moment.

In one of his famous examples, Sartre relates the shame we feel when caught spying through a keyhole, which results in the gaze's abrupt reversal. Only then, as on object of the gaze, does one become aware of the subjectivity that one had as holder of the gaze: 'The person is present in consciousness *inasmuch as he/she is the object of the Other.*' The shame that this realization engenders is…

shame of *oneself*, being the *recognition* that I am well and am well and truly the object that the other gazes at and judges. I am only shamed by the loss of my freedom through becoming a *given* object. [...] And this 'me' that I am is only within the world where the Other has alienated me, [...] [emphasis Sartre's][3]

Sartre has taken the first step by stating that we are made conscious of ourselves as subjects by another subject who makes us the object of the gaze, whereupon Jacques Lacan replies that the only acceptable positioning of the gaze is therefore on the side of the Other. He agrees with Sartre's insight that the gaze is not limited to sight, but he emphasizes that the look and the gaze are a split inherent in a drive that is manifested within 'the scopic field', an overarching zone of vision that is enlisted by desire or, in Lacan's case, lack, the cause of desire. The gaze is a look underscored by need. Without lack, there can be no gaze. But Lacan goes even further: without lack there can be no consciousness, as the gaze is the 'underside' of consciousness. Lack of what? The phallus, but conceived of by Lacan in non-literal, mystical terms: not limited to the penis, the phallus is what defines the split between the sexes. For men it is what they have but is incomplete; for women it is what they do not have and what they want. Both desire it, but women want it more. I will return to this touchy point. In his discourse on the gaze, Lacan sticks to the term '*objet petit a*', 'a' being the key term in the algorithm of the gaze, where 'a' is the essence of the gaze. It is what the gaze seeks – although we know now that seeking defines it – and what eternally eludes it.

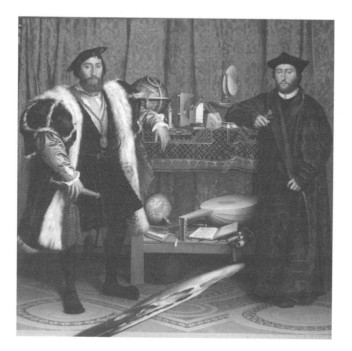

20. Hans Holbein the Younger, *Jean de Dinteville and Georges de Selve ('The Ambassadors')*, 1533. Oil on oak, 207 × 209.5 cm. © National Gallery of London.

In a wonderful ruse, Lacan calls upon Hans Holbein's *The Ambassadors* (1533), to illustrate the gaze itself as a process of eluding. He draws attention to the partly imperceptible thin diagonal form cutting across the foreground, a skull distorted by anamorphosis, a technique popular in Holbein's time. Lacan makes the audacious suggestion that 'Holbein makes visible for us here something that is simply the subject that is annihilated – annihilated in the form that is, strictly speaking, the imagined embodiment of the *minus-phi* $[(-\phi)]$ of castration'. If we are to see the phallus, to be in its presence, it can only be at the expense of its own extinction and the annulment of the gaze itself, hence the death of the one who sees; the stretched skull is the symbol or better, proxy, for a black hole. It is through this confrontation with 'the anamorphic ghost' that the gaze is then able to imagine itself 'in its pulsate, dazzling and spread out function'. The painting locates precisely what Lacan says: any picture is 'a trap for the gaze'. Since pictures are not people, we can gaze at them, stare at them no less, without fear of reprisal, embarrassment – shame. In discerning a picture we are not just looking at features of representation and description, rather our love of illusion is what both empties out the gaze, sucks it up, but as much momentarily satisfies it, makes it replete.[4]

FEMINIST REVISIONS: THE MALE GAZE

The two major rebuttals to Lacan's influential theses came with his former student, Luce Irigaray (b. 1930) and the film theorist, Laura Mulvey (b. 1941). Irigaray is one of the great feminist minds. She mounted an assault on Lacan's centredness of the phallus and posed the alternative of the gap or cut, but also problematized binarization itself, which is the cornerstone of Western logic and power, since binarization seldom admits of parity. In dominant discourse, woman is the other that defines man. But for Irgaray, woman does not inhabit this binary; she is not an alternative to man but a wholly different configuration, possessed of a different kind of body and operating along different emotional and intellectual lines. The phallus may be elusive, says Irigaray, but the feminine eludes the phallus. What we universally define as thought is properly called male, or phallocentric, thought, whose persuasiveness comes at the expense of excluding the feminine. Irigaray's project is to reclaim a space for the feminine through highlighting alternative values and avenues of thought.

At roughly the same time as Irigaray, Laura Mulvey coined the term 'the male gaze' in her 1973 essay 'Visual Pleasure and Narrative Cinema' to define the condition of the way in which women were viewed by post-war Hollywood cinema. She points to a 'sexual imbalance, [wherein] pleasure in looking has been split between active/male and passive/female'. This dichotomy controls the narrative structure, reducing women to the status of vulnerability as always being the receptors of the gaze. Taking up the Lacanian assertion that the gaze is threatened by the very thing it seeks – since to found something only affirms what the gaze lacks – Mulvey states that the male gaze is subdivided into two seemingly incompatible stereotypes, for

21. Cindy Sherman, *Untitled Film Still #35*, 1979. Black and white photograph, 101.6 × 76.2 cm. © Courtesy of the artist and Metro Pictures Gallery, New York.

which the feminist shorthand is madonna/whore. The first is 'fetishistic scopophilia' (scopophilia – 'love of looking'), in which women are beauteous items for visual delectation; the second, 'voyeurism', is the obverse, a sadism that ends in submission and defeat of its object/victim. More insidious still, as Mulvey argues, narrative film forces women viewers into ownership of the male gaze as well, since they see on behalf of the male protagonist who is supported by the ostensibly universal, but actually male eye of the camera.[5]

The artist who epitomizes the subjection of the female by the male gaze is Cindy Sherman, particularly in the work that launched her career, *Untitled Film Stills* (1977–80) which look like they have been extracted from classic film noir. Although staged, with the artist as the centrepiece in different roles and costumes, one cannot help but be disarmed by their air of authenticity. The one constant is the manner in which the nameless woman is steeped in vulnerability and sexual availability, in expectation of the male presence of which she is a mere symptom. With her mime of defencelessness and subordination, Sherman manoeuvres her viewers squarely into the shoes of the male gaze.

HISTORICAL PRECURSORS

In light of Mulvey's essay, it is possible to say that the salient historical precursor to the male gaze is found in Baudelaire's *flâneur*. *Flâner* is to amble or stroll, but as a result of his essay 'The Painter of Modern Life' (1863), Baudelaire (1821–67) all but takes theoretical ownership of the word. The *flâneur* is the eternal observer of the modern city, the detached, possibly bohemian (and therefore nobly indifferent to both the lower and middle classes) consumer of the spectacle of the delightful, ever-changing, dangerous, teeming city. The Surrealist writer Louis Aragon (1897–1982) would later reprise the idea in his novel-cum-prose poem *Paris Peasant* (1926), in

which the writer-narrator seeks out an array of encounters with city paraphernalia, odd people and motley scenes, singling out jarring juxtapositions that average city-dwellers take for granted. But as feminists have shown, the Baudelairean *flâneur* is in confident possession of the male gaze, not to mention the male body. In nineteenth-century cities, women were not as free to wander the streets. Their susceptibility to the gaze was a regular indication of their limited freedoms in comparison to men.

The Paris in Baudelaire's thrall was the Paris that evolved as a result of the vast redevelopment at the hands of Napoleon III's minister of public works, Baron Hausmann, who tore up the tangle of rank old streets that were narrow enough to be the potential shelter for barricading revolutionaries. In their place, he installed the large, sweeping boulevards for which Paris is now known. With this the concept of public space was born, and with it a new visibility.[6] Such spaces opened up new zones of sociability where, en masse, people were able to indulge their joy of seeing, which is still one of the charms of the great cafés of Europe. 'The artist, the true artist', as Baudelaire proclaimed in his *Salon de 1845*, 'will be the one who can extract what is epic from modern life'. The expanded parameters and status of roving, free (male) seeing is a chief characteristic of modernity and was integral to the birth of Impressionism, where, if one looks closely, it delineates between private and public space, the interior and the panorama. The cliché that Impressionists were obsessed by light elides the issue of their responsiveness to all kinds of spectacle, high and low. The emphasis on visibility reflected in the painterly technique of Manet and the Impressionists is inseparable from the complex form of social visibility that developed out of the shifting social organization which resulted from increased urbanization (the mass migration from country to city that occurred around 1870) and the birth of the modern metropolis.[7]

Impressionism was also the first movement in art that publicly encouraged the success of women, namely Mary Cassatt (1844–1926) and Berthe Morisot (1841–95). In an approach analogous but more historically extensive than Mulvey's, Griselda Pollock compares their works with the great male artists of the time, such as Manet (1832–83), Pissarro (1830–1903), Degas (1834–1917), Monet (1840–1926) and Caillebotte (1848–94), and observes a difference in the subject matter, the deportment of the figures and the spaces they occupy, prompting the question as to whether there really is a female vision. Both Cassatt (who never bore children) and Morisot (who did) concentrate a large part of their output on women, girls and children, particularly the mother–child relationship. Pollock convincingly shows how the strictures enforced on the middle-class female are mirrored in pictorial spaces which are in many respects enclosed, whether through tight compositions, the deportment of the female figures themselves, or through privileging the domestic interior. Concluding an analysis of a work by Cassatt, Pollock states the artist 'manipulated space and compositional structure to endow what women did in the home with respect and seriousness, while at the same time being able to make us recognize the limitations resulting from the confinement of bourgeois women in the domestic sphere alone'.[8]

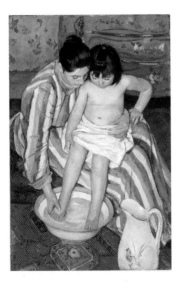

22. Mary Cassatt, *The Child's Bath*, 1893. Oil on canvas, 100.3 × 66 cm. Robert A. Waller Fund, 1910.2. Photography © Art Institute of Chicago.

By contrast, in paintings by men there is a greater oscillation between inside and outside space, with emphasis on the latter. As Pollock notes, the everyday gendering of space – women inside, men outside – affected pictorial representation. It is an open question, however, as to whether this gendering of vision is essential or conditioned.[9]

THE COLONIAL SUBJECT, ORIENTALISM AND THE IMPERIAL GAZE

When it came to those whom the active Enlightenment subject trained his gaze on, women were still treated as objects, as were non-Western peoples, who were the objects of knowledge. Evidently the modern European subject believed himself to be the only viable one, and until others were converted to his way of thinking, they could not be treated as subjects. 'Primitive' cultures – African, North American, South American, Indonesian, Pacific Islander, Australasian, in short the rest of the world – took their name because they were considered by the Western eye to be in a state of arrested development.

The appropriation of the East – a vast generalization in itself, covering everything from Turkey to Siam (Thailand) and Madagascar – began in earnest with the imperial wars between Holland, Portugal, Spain, England and France at the end of the sixteenth century. In art it is evident in the Moorish influence, which came much earlier, and is everywhere in the architecture of Venice and in paintings such as those of Jacopo Bellini (*c*. 1396–*c*. 1470). In France in the seventeenth century, many vestiary silks, wall coverings and tapestries bore the mark of a new titillative style, '*chinoiserie*', which was about as generic and unspecific as a packet of dried 'Asian' flavoured noodles. Well might the designation of Asian have entered into today's

popular speech, but its crassness as a generalization – still worse France continues to employ the anachronism 'Orient' – lies in the fact that it can be extended to over eighty per cent of the world's population.

Edward Said, who coined the term 'Orientalism', explains that it is an idea that asserts Europe's self-assured dominance:

> In a quite constant way, Orientalism depends for its strategy on this flexible *positional* superiority, which puts the Westerner in a whole series of possible relationships with the Orient without ever losing him the relative upper hand.[10]

It is a double standard that is played out to this very day with Western tourism. We have the means to explore countries that are both constricted by and dependent on our own, where the people have meagre means for survival, let alone the ability to travel.

It was by the nineteenth century that this dominance became entrenched, by which time 'Oriental' was a style that had permeated from the arts into fashion and interior decoration. The academician Jean-Léon Gérôme (1824–1904) made a career of turning out crisply painted canvases of Middle Eastern and North African scenes – snake charmers, harems, slave traders – the men swarthy, brutish and usually indolent, the women underclothed, nubile and frequently pallid, the boys lithe, sexualized ephebes. In short, the Oriental 'other' is made into a fetishized stereotype that reflects the Western male's desires rather than observes considerations of cultural respect.

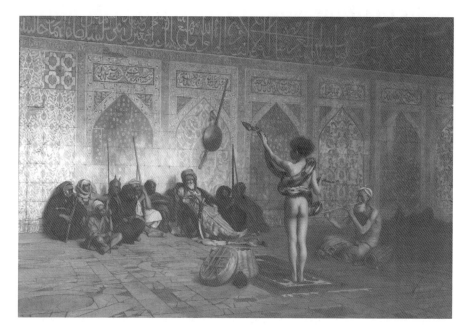

23. Jean-Léon Gérôme, *The Snake Charmer, c.* 1870. Oil on canvas, 83.8 × 122.1 cm. © Sterling and Francine Clark Art Institute.

Nonetheless, the exotic other had a definitive role to play for the European avant-garde, and even in extraordinary cases such as Paul Gauguin (1848–1903) or the German Expressionist Erich Heckel (1883–1970), both of whom had direct contact with the peoples who influenced their art, the upper hand is still there. For the 'primitive urge', as it is expressed within painting of the late nineteenth and early twentieth centuries, rests upon a contradiction. The 'primitive' other is elevated to an eminence that sets him/her/it above the European. By virtue of being 'primitive', such peoples were/are viewed as having a vigour that the European thinks he has lost. By making use of the 'primitive', the European is given a special boost to truth. So the superiority of the 'primitive' is a chimera, determined solely according to the use to which the Westerner can put him. Moreover, the appropriation of the 'primitive' is selective, without much concern for the ritual meaning and uses of the motifs; the keynote is that the 'primitive' is manipulated to make a new Western style whose art is *superior* to the art or artefacts that it borrowed (stole).

In recent decades, feminist scholars have rightly pointed out that the contradiction was/is the same for men's use of the female form: woman may be idolized, but this idolization is not positive as it drains her of life; she is symbolic, inert and objectified for the purpose of fulfilling particular uses and desires specific to men. The objectification of the 'primitive' and of woman converges in paintings by Picasso, particularly in those during the time of his co-discovery of Cubism around 1907.

24. Pablo Picasso, *Dance of the Veils*, 1907. Oil on canvas, 150 × 100 cm. © The State Hermitage Museum, St Petersburg.

Here women are made the receptacle of all of the artist's harshest, darkest passions. Nameless and characterless, they are a grade up from beasts; forces of nature given shape, ugly and angular.

Circumstances of the presumptuous imperial gaze may have shifted to a more self-critical conscience within the Academy, but they have not for tourism or advertising, which are ready to exploit anything with exotic appeal. (Note the woolly definition of 'exotic'; and is something appealing for being exotic or is something exotic appealing?) A problem with the fraught legacy of colonialism is that resetting the mark cannot be achieved ideologically or without due reflection. In other words,

the Orientalist critique cannot be mounted to discredit writers and artists wholesale. When we delve deeper into Gauguin's experience, for example, and read his letters, and look longer at his later testimonial paintings, we sense palpable disappointment at the plight of the Tahitians at Western hands, an honest joy taken in their ritual, and a gratefulness to them for teaching him ways of relating to the world differently. He was too sensitive not to know that his own presence was a symptom of the scourge of Europeanization (which brought smallpox and venereal disease) that was ravaging the indigenous populations, and which consumed him as well. His final masterpiece, *Where Do We Come From? What Are We? Where Are We Going?* (1897–8) is a spiritual allegory composed in the spirit of peace and trans-cultural sympathy.

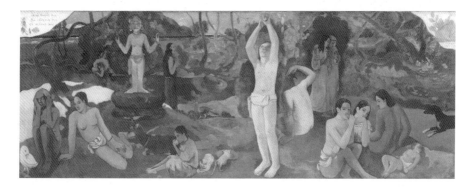

25. Paul Gauguin, *Where Do We Come From? What Are We? Where Are We Going?*, 1897–8. Image: 139.1 × 374.6 cm; framed: 171.5 × 406.4 × 8.9 cm. Oil on canvas. Tompkins Collection – Arthur Gordon Tompkins Fund. © Museum of Fine Arts, Boston.

THE GAZE, KNOWLEDGE AND POWER

In 1961 Michel Foucault published the first of a series of influential books about how dominance, power and control has been organized within Western society and thought since the seventeenth century. *Madness and Civilisation*, recognized as an intellectual milestone when it came out, dealt with the new phenomenon of incarceration of abnormals that occurred in the 'age of reason' after the Middle Ages. Foucault's reasoning seems almost self-evident: for the idea of reason to hold sway, it required qualifying contrast with an opposite – unreason. But unreason could only be defined in terms of what reason cannot define. Madness was the social typology to fit into reason's too hard basket, conflating social misfits and mental illness. Foucault followed similar trajectories in his subsequent 'archaeologies', as he called them, of the clinic and of prisons. The birth of the clinic at the beginning of the nineteenth century was coterminous with the system of diagnosis in which doctors came to enjoy special privileges based on their ability to discriminate, to see the signs that erred from good health. In *Discipline and Punish*, Foucault focused on the prison reform of Jeremy Bentham, the inventor of the panopticon, an architectural device of surveillance that exposed prisoners to an omnipresent gaze.

After the student riots in May 1968, Foucault's questions about the substance of power and who wields it gained in momentum. 'Who owns the gaze?' Answer: the owner of power and knowledge. Yet power and knowledge can never be said to have their permanent source in one quality or thing. This means that whilst it is important to locate the gaze in order to determine the locus of power, the holder of the gaze is neither reducible to that power, nor is he or she ever in complete possession of it. Power and the gaze, for Foucault, is a configuration like a kaleidoscope: any discernible pattern is one among many; the pattern changes, along with the effect. 'The question of power remains a total enigma,' says Foucault. Power is 'not in the hands of those who govern', and governance itself is a 'fluid' notion. 'It is often difficult to say who holds power in a precise sense, but it is easy to see who lacks power'.[11]

Foucault's insight that power is fundamentally irreducible finds its equivalent in art in his examination of Velazquez's *Las Meninas* (1656) that opens *Les Mots et les choses* (1966, translated as *The Order of Things*). He draws our attention to the reflections of King Philip IV and his spouse in the mirror at the rear of the room. Their blurred image serves Foucault's thesis perfectly: the ruler's presence is only a reflection, and so, being a painting, a representation within a representation, stands outside of the picture, a mere shadow. Meanwhile it is the artist – working on a painting we cannot see or perhaps the painting we are now seeing, and who gazes directly at us – who has the greatest presence, signifying a possession of the gaze made possible through artistic invention. The sources of power in this picture find themselves continually displaced: for Velazquez the artist, because it is mediated through representing self-presentation (becoming both subject and object), and for the king and queen, through a double mediation which drives home the truth that the king's power is bestowed by his subjects. The power of each is interdependent and finite; like the king, the artist's power depends on the viewer's recognition.[12]

The idea that power is everywhere and nowhere has a potentially destabilizing effect on foundational philosophies such as Marxism and positivism, and consequently excited bitter antagonism, pre-eminently in the German Hegelian Jürgen Habermas, for whom power's indeterminacy in Foucault's thought only defers efforts to discourage solutions to power's abuses.[13]

THE POST-COLONIAL AND POST-FEMINIST GAZE

Once Foucault's critique of the centralization of power in the modern age is applied to the Western male Orientalist, it raises a gamut of apposite yet thorny questions. Who has ownership of the gaze and what are its entitlements? If an indigenous society happens to approve of an outsider's vision of it, artistic or otherwise, does their chorus of opinion make it right? Can a woman have the male gaze? If you resemble the peoples of one culture and grow up in another (Indians in England, Turks in Germany, Chinese in Australia, Koreans in the US), does this give you a

special advance on your access to the culture whence your family came? To what extent does identifying with a culture have to do with genetic material?

In the absence of sure answers, these questions and others crave reassessment on a periodic basis. In stable countries, identity is the catch-cry for artists and curators who fear the scourges of globalization. Whereas the Orientalist gaze of a superior 'us' seeing an inferior 'them', there is now as much the case of a 'me' seeing 'my own' for the delectation of a curious 'them'. While many artists who identify with minorities make worthwhile statements of what it means to feel oppressed and subjected, just as many use parts of their background because it has become fashionable to do so and lubricates their possibilities to get into exhibitions; for there is never a shortage of exhibitions that sentimentalize identity.

As events since the Cold War have shown, the imperial impulse has not abated, especially evident in the tergiversations of American foreign policy. Yet America and Western Europe's ability to dominate other nations is sporadic and its inadequacies expose their local agendas and patchy cultural understandings. Nations under the weight of gratitude to international aid – for damage that imperialism has wrought in the first place – such as many in Africa, can still be said to have what Homi Bhaba has called 'the threatened return of the look',[14] a gaze that, while subjected, is still forcefully active as reproach. Karina Eileras develops this notion with reference to the images by Marc Garanger, a photographer for the French army in 1960 to 1962, at the time of the Algerian revolution. In the photographs of women who submitted to being photographed, Eileras notices a healthy pattern of tacit resistance in covert markers such as pursed lips, uneven deportment, skewed looks – all signs of displaced submission. Attentive analyses like hers are helpful in exposing the lack of neutrality of the image, and the way that the gaze can intercepted and deflected in a way that does not combat the West's way of gazing (which, so the theory goes, would only duplicate its negative power-play), but rather in a manner that comes at it from the back door.[15]

But speaking on behalf of the Western white male, can there be said to be a post-Orientalist gaze? *Affliction of the Protestant* (2005), by Phillip George, indicates that the question can be answered in the affirmative.

George has captured three black hawk helicopters hovering over a mosque under construction, thereby deftly repositioning his own cultural baggage as a Western observer through the visual decoy of observing the considerably more dominant eye of the United States observing the East. This is amplified by the work's colour, the eerie emerald monochrome of night vision, a metaphor for the covert intrusiveness of military surveillance. The title considers the Western ignorance towards Muslims as more illness than attitude.

This and the next work reveal the lengths that artists go to combat the tortured legacy of the Orientalist gaze. The two stills in Figures 27 and 28 are from the two-channel video installation, *Turbulent* (1998), by the US-Iranian artist Shirin Neshat (b. 1957). It is a poetic yet disturbing work that singularly recasts the stereotypical position of the mute Muslim woman.

26. Phillip George, *Affliction of the Protestant*, 2006. C-type print (night green), 90 × 120 cm. © The artist; courtesy of the artist.

The work opens with a moving song from a man in a white shirt; facing him on the opposite screen is the back of a woman clad entirely in black. When he finishes, the woman turns and begins her own song, a plaintive, wordless lament. During each song, words roll over the images (for the man in Latin and English, for the woman, Arabic and Persian), enforcing the dichotomy. The man, who is in the company of a male audience, sings in an illuminated room, whereas the woman, alone, sings in darkness. Neshat drew inspiration for this work from a blind girl performing in the street in Istanbul, which made her reflect on Iran's disregard for female expression, since under the Khommeni regime, women were expressly forbidden to perform. For all its profound references, when physically experienced, *Turbulent* lives up to its title; when the man finishes his song, a quizzical expression appears on his face as he 'watches' the woman takes her turn on the opposite screen. The wordless hymn is like a dolorous chant welling up from out of a crack in a hard surface, be it the barrier of Western expectations or the wall of male laws. Even with her eyes closed, we as viewers nevertheless feel the weight of her gaze, as some form of corrective to delinquent Western assumptions about what Middle Eastern women are, or should be.

27, 28. Shirin Neshat, *Turbulent*, 1998. Film/video stills. © The artist; courtesy of the artist and Gladstone Gallery, New York.

THE PROSTHETIC GAZE

With the invention of photography came a whole new kind of observer, as well as an eruption of conjecture about pictorial truth and evidence. 'Evidential' is a stock term in photography, designating a category rather than an essential quality; critics of photography rightly observe that its truth is qualitative: *photographic* truth. The French word for the photographic negative, *cliché*, is a convenient place to start when thinking of the uses to which the photographic apparatus (analogue and digital both) is commonly put. Surely we too have at one point set out to make a good photograph – seeing in terms of an anticipated outcome – rather than just plainly seeing. The apparatus determines to varying degrees what and how things are seen – this will be explored more in the next chapter.

As we have seen already, it is hard if not impossible to locate the gaze when it is refracted through a mediating lens whose power to augment is at the expense of less perceptible constraints and limitations. Take the touristic gaze: the camera renders the gaze passive; the gaze is annulled for the sake of the static reproduction; the event *in situ* exists for the sake of the dour replica. But when we think of two films about photographic vision, Hitchcock's *Rear Window* (1954) or Antonioni's *Blow Up* (1966), the prosthetic gaze of the camera is the defining element in what is to be seen and understood. We cannot forget the movie camera itself either: thus these

movies are as much about their own inner mediation, and the mercurial relativity of truth and deception, since we are always using a manipulating device – material or linguistic, or both – to make something visible.

In a pioneering work of performance and video art, *Following Piece* (1969), Vito Acconci had himself filmed randomly following people in the streets of New York.

At first we are carried along by the ebb and flow of the video's continuous movement, determined by the trajectory of the people whom the artist is following.

29–31. Vito Acconci, *Following Piece*, 1969. Video stills. © The artist; courtesy of the artist.

We initially assume that it is Acconci who is the owner of the gaze, but it quickly dawns on us that his gaze is solely at the behest of whom he follows. Since he has no other motive but to follow them, it is they who possess the gaze; the artist's surveillance trick sustains itself only upon the act of pursuit. We too are complicit in this arbitrary magnetic game, since we are the only ones who gaze upon both pursuer and pursued. But – to end the loop – the artist has intended this to happen, so by default he has the last laugh, binding us up in his work's logic. Everyone is the object of another's gaze; none escapes it.

These shifts and gaps are what precipitated Derrida to write *Droit de regards* ('right of inspection', or 'right to gaze'), written to accompany the photographs by Marie-Françoise Plissart. Plissart's suite of images half-narrates a story involving lesbians, a child in *commedia dell'arte* make-up and finally an interloping male. I say 'half-narrates', because what preoccupies Derrida are the lacunae, the mid-spaces that force the viewer's assumptions. The kinds of transactions that occur within the images convolute the self-consciousness of the gaze. In other words, we do not know in what capacity we look – as man or woman – and whether we are entitled to look at all or at what. Derrida goes so far as to claim that the photographs are neither referential nor evidential but rather embody a wish; they are symbols or phantoms of what we want to see but is not 'really' there. Resuming from Lacan, Sartre and Merleau-Ponty, Derrida's ambling excursus, also with its implicit subtexts of stock photographic theory and French poetics, is more memorable than the photographs themselves. He locates a critical area in which the gaze is fractured and multi-layered.[16]

When we get to cyberspace, this split of the gaze is constant and intricate. There is a chain of mediations whose source is difficult, if not impossible, to locate. With spyware and surveillance, intrusion takes on a new and sinister face. The gaze can become small and local and, in the next breath, macrocosmic and global as with Google Earth, which is a commercial offshoot of Digital Earth.

The Digital Earth project, as it has come to be named, was an initiative of Al Gore, begun in 1998 via NASA, and was envisioned to bring together disparate communities – a 'grass roots effort' as Gore described it – to be the next great innovation of the web. It was part of the deregulation of digital technologies in the 1990s designed to stimulate a range of economic and social activities. But consonant again with technology that vaunts itself too strongly as progressive (utopian?), its present uses are markedly different from initially intended. As would perhaps be expected, the outcome is decidedly cynical. Digital Earth technology serves the corporate entities that made the technology possible from the start, for the viewer will always be part of the network, absorbed within it like a worker bee within a hive. As Lisa Parks remarks in her article on this subject, the promise of recentralization obscures a media infrastructure which is itself decentralized. Whereas the models that Digital Earth propagates are linear and smooth, the spaces it traverses are not. It proposes to reduce a domain that encompasses the social, global, inner, outer, local and national, corporate and individual, to a common denominator. As Parks asserts, Digital Earth

conceals the struggles taking place within the world and 'instead naturalizes these spaces as the rightful property of the spectator/navigator'.[17] The viewer assumes false ownership of the world with the help of interfaces such as Work Bench, which enable anyone to zoom in and twirl the world at will. In short, the viewer is lulled into a false sense of agency with the power to lord it over the hemisphere like a pagan god, when in reality he or she is dupe to the medium, where the distinctions between real and virtual are obscured forever.

These prostheses of the gaze end up becoming imperceptibly incorporated within the gaze. We cannot imagine an alternative, believing ourselves bereft, incapacitated or non-functional without them. This fluid interconnection between vision and what allows that vision to be palpably realized is among the issues in the next chapter on media.

5 MEDIA

'Medium' comes from the Latin word for 'what lies between', hence phrases such as 'medium-sized' and 'happy medium'. When we turn to art, the implication is that the medium exists between what the artist does and what the viewer sees; between the idea and its realization. But closer scrutiny reveals the equation to be too narrow.

Changes in media are a bit like changes in warfare. Each change results in a new organization, a new process, a new set of expectations, a new set of rules for both deliverer and recipient, artist and spectator. Some shifts are too gradual to be noticed, others come crashing down, like digitization, which arrived before most people had time to adjust. Changes in artistic media affect style, approach, content – and the kinds of people who become artists. Is drawing important today? Of course; but not as exclusively as it was less than a century ago. What constitutes skill today bears no resemblance to what constituted skill in the Renaissance. Now artists have fewer limitations in their choice of media and it is common for them to shift across media to suit the expression of a particular idea.

As we saw in the first chapters, the earliest forms of art were tied to ritual law. The media that were used – rush fibres, stones, wood, ground pigments – all carried complex meanings related to their immediate source and their mythic associations. Out of ritual continuity and because of the simple fact that there wasn't much to choose from, the issue of the medium as such never entered the picture.

The Iron Age and then the Bronze Age (note again the parallel with warfare) and the warlord communities of early civilization introduced new possibilities for resilient forms, as seen in the urnware of China and the sculptures of Ancient Greece. But the main media throughout the world, from the South Pacific Islands to Scandinavia, remained stone and paint. The first paints were bound with water, or, if ritually oriented, by bodily fluids – urine, saliva, mucus, blood or semen – or combined into gummy, oily substances (distemper) such as were used in the Ancient Egyptian wall paintings in Dendera. Until the introduction of oil and finally resinous commercial paints, the most reliable binders for paint were proteinaceous substances such as milk and animal glues. The most resilient, egg yolk, made the compound known as tempera, which is still occasionally used (most memorably in recent memory by the American photo-realist Andrew Wyeth (b. 1917).

That the Latin word for paint is *pigmentum*, or that the German word for paint, *Farbe*, also means colour, suggests that the original emphasis lay not in the consistency of paint, as is generally the case today, but in what went into it. Pigments

were originally drawn from the earth and were thus limited to black (from coal), white (ash or gypsum rock) and earth tones, or ochres (soil, stone, pulverized bark etc.). With widening skills and cultural needs, more colours became available, sometimes at sizeable cost. The vibrant blues of the Egyptians were a ground semi-precious stone, lapis lazuli. The Roman obsession with 'imperial' purple was surely due in part to the fact it took some 4,000 molluscs to make 1 lb of dye, which, one cannot help thinking, was about as many heads as one had to trample on to become emperor (or a general, since before Diocletian claimed exclusive right to it, purple could be worn by military leaders after a grand victory). The same excess went into the cochineal red of the Aztecs, which required around a million insects for 1 lb of powder. Indian yellow came from concentrated cows' urine. Whites became more available and vibrant with the manufacture of white lead, which Vitruvius (80–70 BCE to *c.* 25 CE) described in the second century CE. (This perilous pigment was also the source of much illness in artists, who absorbed it through their skin.) The wrangling over pigments, which predated the seventeenth century spice wars by millennia, occupies a study unto itself, and explains a great deal about the absence of some colours and the dominance of others in certain cultures at certain times.

The most brilliant and largest examples of early painting are frescos, the word denoting the freshness of the plaster to which the paint is applied. As opposed to painting on dry plaster (*secco*), requiring distemper or tempera, the paint for a fresco is just pigment and water. The pigments sinks into the plaster and forms a thick, hard membrane which, as we see from the burial tombs of Ancient Egypt and the decorative wall scenes of Pompeii and Herculaneum, is far more resilient than either wood or canvas. Because of its quick drying time, the paint has to be applied rapidly, and big mistakes couldn't be undone without starting afresh. This made demands on the artist, who had to be versed in proportion and design, and had to be content with simplified designs. The greatest of all frescos is of course Michelangelo's ceiling and *Last Judgement* in the Sistine Chapel in the Vatican. But memorable frescos from eighth-century Islam also survive at the *Qasr Amra*, the desert palace of the Umayyads in Jordan.

Oil-based paints were around for a long time, but only began to be used in earnest in the fifteenth century. Olive oil was used by the Ancient Greeks to bind pigments, but the drying time was interminably long. Using an arcane concoction of piled glass, calcinated bones and mineral pigment, the Flemish painter Jan van Eyck (1390–1441) manufactured the first modern-type oil paint. His principal contribution was to use siccative oil such as linseed oil, which took significantly less time to dry. Van Eyck's other innovation was to use the oil paint in successive translucent layers or 'glazes', which trapped light and added luminosity to the surface.

Soon after, Antonello da Messina (1430–79) improved on Van Eyck's invention with the addition of white oxide. Subsequent modifications were made by the likes of Leonardo, the Venetians Giorgione (1477–1510), Titian (*c.* 1488/90–1576) and Tintoretto (1518–94), and later Rubens (1577–1640). It is curious to notice that

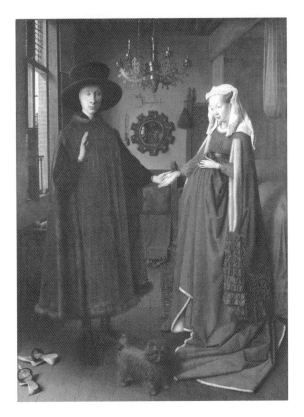

32. Jan van Eyck, *The Arnolfini Marriage/ The Arnolfini Portrait*, 1434. Oil on oak, 82.2 × 60 cm. © National Gallery of London.

the great innovators in the medium of oil paint were also masters of simulating texture: silks, velvet, skin. Their paintings have a volume, sumptuousness and sensuousness that melds, joyfully, with the descriptive function of the painting. Titian's exhortation to his students to add layer upon layer of glazes to their (and his) canvases is legendary, and it is what makes his fabrics shimmer so vividly. The Venetians are known to have painted 'cold on warm': that is, based on a monochrome underpainting in reddish browns; whereas Poussin (1594–1665) and his followers preferred 'warm on cold', the ground being grey (*grisaille*) or blue. Either technique exploited oil paint's capacity to 'bleed'.

In his classic *Ways of Seeing*, John Berger makes the potent argument that the popularity of oil paint spread in response to the accumulation of material riches.[1] Like no other medium before it, oil paint could do justice to the furs, precious metals and stones worn by the rich and the ornaments, sculptures, carpets and wall-hangings that graced their homes. For many artists this was a forte. In the portraits of Thomas Lawrence (1796–1830) for example, the nineteenth-century equivalent of Annie Liebovitz, the sitters are no less than caressed and illuminated by their wealth. Their lack of contrivance stems from an age of people who believed

in their destiny to rule and to own, a notion nigh on contemptible to a Marxist like Berger.

The colours that artists used were also indicative of wealth. Lavish patrons were not shy of bankrolling artists to enable them to use the rarest and most expensive pigments, such as ultramarine blue, in a portrait or other commission. The flaunting of one's access to such colours was bound to be noticed, like buying high-end brands today. On the other hand, when straitened, artists were bound to make the best use of their duress: the earth tones dominant in Caravaggio's paintings are attributed to his penury.

By 1880, oil paint had become commercially available in tins and tubes and in a wider variety of affordable colours. With William Reeves's invention in 1766 (or reinvention because water-based paints had been used in the Renaissance and much earlier in China and Japan) of watercolour paints that fitted smartly into a small paintbox, it became popular for artists and amateurs alike to make sketches during their rambles over manorial grounds or at intervals during their Grand Tour. The greatest of these artists was Turner. By the mid-nineteenth century, artists from Constable (1776–1837) to the Barbizon school had already begun to make painting in the open air – *en plein air* – an integral part of their practice. The ease with which paint could be obtained and transported greatly enabled non-studio painting, and, by the beginning of the twentieth century, was de rigeur for any Sunday painter. It is thanks to paint available in tubes that we get Van Gogh's striated impasto, which had a direct influence on the Fauvist Maurice Vlaminck (1876–1958) and the German Expressionists, all of whom were fond of applying paint straight from the tube.

By the 1930s, artists had begun to experiment with the commercial paints made from resins. Ripolin, a flat-drying house paint, was used extensively by Picasso, including for *Guernica* (1937). A decade or so later, house paint was an accepted alternative to oil paint. The latter's irregular lustre, let alone expense, was unattractive for large-scale paintings and murals. Pollock's drip works are all from cans, and the evenness of Newman's colour fields owe their finish to commercial blends. Yet the hypnotic depth of a Rothko and a Reinhardt (1913–67) comes from having exploited the translucent properties of oil glazes to an obsessive degree. Experimentation has its casualties, however. Leonardo's *Last Supper* (1494–8) has all but disintegrated, an unfortunate effect of the incompatible application of tempera on plaster. And commercial paints are generally alkali, and so have a short life span. At this very moment a number of collectors face the melancholy sight of treasured Pollocks, painted on masonite with house paint, disintegrating before their eyes.

When Pollock (1912–56) painted on unstretched canvas on the floor, it signalled a watershed for picture-making, destabilizing media divisions since it was effectively painting, drawing and performance art all at once. Being a medium that remakes itself while also reflecting continually on past traditions, painting has always been able to accommodate such changes. Easel painting, as we know it, was popularized by Venetian painters of the sixteenth century such as Giovanni Bellini (1430–1516) and Giorgione. Canvas on wooden stretchers was more transportable than wooden

panels, or, dare we say, walls. Smaller than a mural and lighter than an altarpiece, easel paintings were particularly attractive to merchants and noblemen who regularly shuttled their belongings from estate to estate. With the growth of urban centres and the diminution of living space, canvas was also practical for artists, as it could be removed from its support, rolled up and the stretcher reused. The white ground of the so-called virgin canvas is actually an innovation from the Impressionist period, when artists dispensed with a tonal palette (based on grades of tertiary colours) in preference for a chromatic palette (based on primaries and secondaries), and for whom the white was sympathetic to vibrant contrasts of colour. (Look again at the unpainted white grounds of Cézanne or a pointillist such as Seurat or Cross.) Traditional academic-style painting entails a ground that is beige or *bistre*, or in some cases pale blue.

Contemporary painters still use traditional oils with (if they can afford them) real pigments on cotton duck or linen, but they also have a multitude of synthetic materials at their disposal: low-odour solvents to replace turpentine (which kills the brain's synapses); paints of synthetic compounds that handle like oil paint but wash out in water; canvases from nylon or polyester which are countless times more resilient to time than their cotton counterparts.

MEDIA, EXPRESSION AND CONTENT

The divisions between the arts – painting, sculpture, poetry and so on – exist not just for the sake of semantic convenience but classifying different orders and means of expression. The essay *Laocoon, or on the Limits of Painting and Poetry* (1766) by the poet-dramatist Gotthold Ephraim Lessing (1729–81) stands as the first concerted effort to deduce the discrete capabilities of artistic media by reasoning their formal boundaries. *Laocoon* here refers to the Hellenic sculpture depicting Laocoon and his sons battling the snakes sent by the gods in punishment, reputedly the most copied sculpture of antiquity in Lessing's day. He set out criteria proper to each of the arts, especially painting, which he observed is primarily spatial, and poetry, which is temporal. In *Laocoon*, states Lessing, we experience someone uttering a cry for life, yet to compensate for the silence the artist must devise a series of visual subterfuges that make the viewer jump to some imaginative conclusions. Lessing borrowed from Shaftesbury's *Characteristics* (1711), which mentions the need to choose the most apposite instant for representation.

Thus Lessing stated that different works of art announce themselves in different ways and express themselves in a manner relative to their physical properties and how these are perceived. Until then the arts had all been lumped into a single category of Fine Arts (or *schöne Künste*, literally 'beautiful arts'), and Lessing's discourse marks the subdivision of art appropriate to the properties of their media, namely the pictorial and plastic arts, and by extension, the beginning of formalism that culminated in, as we saw in Chapter 2, Greenberg's advocacy of American painting. Shortly after Lessing's treatise appeared, the poet and philosopher Johann Gottfried Herder

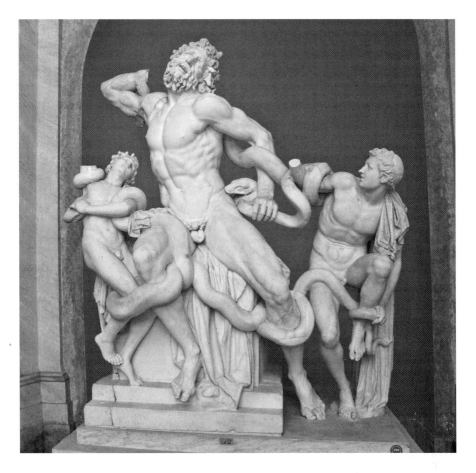

33. Rhodians Agesander, Athenedorous and Polydorous, *Laocoon and his Sons, c.* 200 BCE. Marble, h. 184 cm. Found in the Baths of Trajan, 1506. © Musei Vaticani, Vatican City.

(1744–1803) warned that to examine art on formal grounds is impoverishing, and when taken to an extreme has 'ludicrous consequences'.[2]

With formal demarcations more or less as a given, G. W. F. Hegel (1770–1831) placed the arts within the contours of history in such a way as to argue for an artistic evolution based on the formal capabilities of each art form. The purpose of art was to disclose a much profounder concept, the spirit. Sculpture, he held, reached its apotheosis in Ancient Greece, which achieved a comfortable balance between outer form and inner idea, whilst painting and music most excelled, or found their authentic 'identity', in the umbrella phase he called the 'romantic' (roughly from early Renaissance to his day, the early 1800s). Colour and spatial illusionism in painting, and melody, instrumental texture and rhythm in music, serve as the expressive conduit of the spirit which now seems to disburden itself from the form that houses it. For Hegel, there is a historical explanation for the dominance of media at certain intervals in history, based on a spiritual-intellectual evolution of the

deeper force that guides art and which, ultimately, exceeds it. I will return to Hegel's aesthetics in the following chapter; for now it is necessary to turn to an area that did not concern him much: technology and optical devices.

ART, OPTICS AND DEVICES

Art in the West began to accept the assistance of optical devices as soon as it became interested in the possibilities of empirical observation over imaginative representation. Concentrated observation and ordering of the outside world entailed the jettisoning of the hieratic order of representation – which, say, made gods and kings bigger and the commoners smaller – in favour of structures such as one-point perspective based on mathematical and pseudo-scientific values of ordering the world. Both strategies were concerned with their own version of truth: the first based on the inner nature of the constructed entity, the second on the appearance of the external entity. Riegl asserted that there was a historical progression in art's orientation from the haptic, or bodily or tactile, to the optic. Antiquity put a premium on the object present to touch, as if making the imaginative real, whereas, according to Riegl, after the Renaissance (he focuses on Dutch painting in this instance), the image was more about perception and the intellectual-aesthetic suggestion of something present.

Thinkers, from Euclid and Aristotle to Bacon and Kepler, had already noted that when light passes from a small aperture into a dark chamber it casts an inverted image on the opposite wall. However, it was only by the late sixteenth century that a device was used which specially served this purpose – the camera obscura, the incipient form of the analogue camera. It and a battery of other visual devices such as telescopes, eyeglasses, microscopes, spyglasses and magic lanterns were used for art as well as science and general interest. The ordering of the picture plane since the Renaissance and the contraptions for assisting sight were not independent of one another, since they were the instruments for descrying nature with detail and accuracy.

In his book on observation and optics, Jonathan Crary accounts for the relatively late invention of the camera obscura in the concordance of scientific observation and the development of the individualized modern subject. He explains how the use of a new medium is interchangeable with a new way of seeing that assumes, in turn, a new model of personal awareness in which the optical device is the bridge between the self and the world.

> Beginning in the late 1500s the figure of the camera obscura begins to assume a pre-eminent importance in delimiting and defining the relations between observer and world. Within several decades the camera obscura is no longer one of many instruments or visual options but instead the compulsory site from which vision can be conceived and represented. Above all it indicates the appearance of a new model of subjectivity, the hegemony of a new subject-effect. First of all the camera obscura performs an operation of individuation; that is, it necessarily defines an observer as isolated, enclosed, and autonomous

within its dark confines. It impels a kind of *askesis*, or withdrawal from the world, in order to regulate and purify one's relation to the manifold contents of the now 'exterior' world. Thus the camera obscura is inseparable from a certain metaphysic of interiority: it is a figure for both the observer who is nominally a free sovereign individual and a privatized subject confined in a quasi-domestic space, cut off from a public exterior world. (Jacques Lacan has noted that Bishop Berkeley and others wrote about visual representations as if they were private property.) At the same time, another related and equally decisive function of the camera was to sunder the act of seeing from the physical body of the observer, to decorporalize vision.[3]

Crary echoes Riegl's thesis that vision has moved from embodiment to disembodiment. I will return to this at the end with digital art, which forces a new transition again, which Riegl was in no position to predict.

Although used in Italy, the camera obscura was used most widely by artists belonging to the materialist societies of Holland and Flanders. The enticingly serene interior spaces of Vermeer (1632–75) owe themselves to the camera obscura, as do the somewhat insipid flawlessness of the marine landscapes of eighteenth-century Venice by Canaletto (1697–1768). The works by artists who used the camera obscura are conventionally on the small side, since the canvas was initially laid flat to accommodate the projection that provided the initial design.

In an uncharacteristically larger work, Vermeer's *View of Delft* (1659–60), what is so hypnotic is not only the composition, but the artist's flawless rendering of

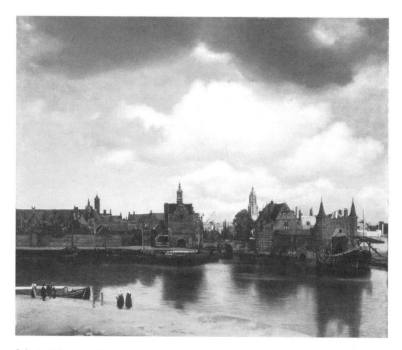

34. Jan Vermeer, *View of Delft*, 1659–60. Oil on canvas, 98.5 × 117.5 cm. © Royal Picture Gallery Mauritshuis, The Hague.

surface and atmosphere. As if carved out from time, the image makes us feel that we can touch the untouchable. Its lens-like quality and its confident, restrained paint-handling present a world firmer and somehow more real than that which we normally see before us.

REPRODUCIBILITY

Woodblock printing began in China in the ninth century, after which it spread to the Islamic world. From the thirteenth century onwards in Europe, it was used almost exclusively for textile patterns. Due to the scarcity of paper, pictures came significantly later, at the end of the fourteenth century. The first paper mills were established in Italy in the late 1200s and a century later in Germany, where printing flourished. Movable type was invented by Gutenberg in 1447 (actually, as with so many things technological including reading glasses, China invented it much earlier, in this case by Bi Sheng between 1041 and 1048) which, as we know, changed the flow of information and culminated, among other things, in the Protestant Reformation led by Martin Luther in 1517. Outside of the printed word, the pictures produced by wood blocks were playing cards and crude religious images. The first most significant suite of woodblock works appeared in Nuremberg in 1493. The *Weltkronik* (Story of the World) was published by Albrecht Dürer's uncle, Anton Koberger; the text by Hartman Schedel illustrated by Michael Wolgemut.

It was the intricacy and sophistication of the works of Albrecht Dürer (1471–1528) that ushered in printmaking as a major art form. It is also noteworthy that when Dürer published his celebrated designs of the *Apocalypse* (1499), the *Great Passion* (1511) and *Life of the Virgin* (1511), he accompanied them with a facing text. And in a sense, this illustrative dimension has never left printmaking. Another lasting aspect is that it has never quite escaped its relation to the artisanal, something that certain artists themselves passionately enjoy – immersing themselves in technical processes – and which collectors deeply appreciate. For printmaking is often a group – even collaborative – activity. Dürer was a notoriously testing taskmaster

35. Albrecht Dürer, *The Martyrdom of St John the Evangelist*, 1496/7. From the series 'The Apocalypse'. Woodcut on paper, 39.5 × 28.4 cm. © Kunstmuseum, Basle.

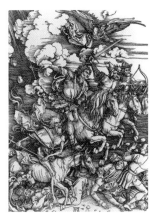

36. Albrecht Dürer, *Riders of the Apocalypse*. From the series 'The Apocalypse'. Woodcut on paper, 39.5 × 28.4 cm. © Kunstmuseum Basle.

of his woodcarvers. Since printmaking has so many separate specialist techniques – including woodblock, linocut, intaglio, screenprinting (serigraphy), monotyping and lithography – it is the last surviving artistic practice that accords the guild-like appellation of 'master printer'. Today, artists not versed in printmaking enlist experts to make reproducible, or print-like versions of works in media in which they are known to excel.

Like the dissemination of the book, the dissemination of prints meant that more people could have works of art for less money. Together with increased literacy in the printed word, the exchange of images increased visual literacy and, with that, widened opinion and debate. The critical awareness announced the beginnings of the shift away from religious unilateralism to secular pluralism.

By the sixteenth century, which saw the consolidation of the etching, or intaglio processes, printmaking was adopted as a serious arm of the artist's practice, as we see with Rembrandt (1606–69); a tradition continued by Blake in the eighteenth century, and Whistler, Bresdin (1822–85) and Redon in the nineteenth century. Toulouse-Lautrec (1864–1901) innovated lithography, introducing both Japanese designs and painterly techniques.

Printmaking in the eighteenth century served the dual purpose of being responsible for disseminating pornography and of popularizing paintings shown in the Salon. As is the case with photographic reproductions today, the first experience of a work of art could begin with the reproduction. Curiously, the sympathy with which the original work lent it self to reproduction was and is a factor in its popularity. Once photography took over, artists still continued to make prints, either as a way of making works more affordable (the op art artist Victor Vasarely (1906–97) made an express point of doing this, producing small prints of larger paintings) or by using photographic technology within printmaking (photolithography), and in the famous case of Warhol, when he worked on canvas, opting for slight de-registrations and inconsistencies in the screenprinting process to meld the tactile uniqueness of painting with the sturdy precision of the mass-reproducible print.

Like the near-simultaneous invention of calculus by Leibniz and Newton in the 1670s, photography too enjoyed something of a parallel birth. The first known photograph arrived in 1826, a heliograph of over eight hours' exposure of the view from the window of Joseph Niépce. A little later, in 1833, the English scientist William Fox Talbot (1800–77) began experimenting with photography while using a later variant of the camera obscura, the camera lucida. The next year, using silver nitrates on paper, he began working on a process he named 'photogentic drawing'. Meanwhile Niépce had teamed up with Louis Daguerre (1787–1851), who had also become interested in fixing the images seized by the camera lucida. Six years after Niépce's death in 1833, and to understandable excitement, Daguerre published the finding of the daguerreotype, a significant improvement on Niépce's find. The *Gazette de France* stated that the invention 'upsets all scientific theories on light and optics, and it will revolutionize the art of drawing'.[4] Spurred on by Daguerre's announcement, Talbot made his hitherto secret findings public and announced his 'calotype' (which literally meant 'beautiful picture') to the Royal Academy in 1840. In the same year, Voigtländer constructed the Petval lens, which reduced the time for exposure by ninety per cent. Glass negatives persisted until 1884, when flexible film was introduced; in 1888 came the Kodak camera, making photography comparatively cheap and easy.

By the 1850s, photographs and photographers were everywhere. Photography had effectively put two whole demographics – the painters of portrait miniatures and all but the most exceptional engravers – out of business. Understandably, photography caused widespread consternation amongst painters who excelled in skill over ingenuity, and Delaroche was prompted to make the exasperated exclamation, 'From today, painting is dead.' In one way it was, but the watershed of photography proved painting to be the most adaptable of all media. It has died several deaths (its death was proclaimed most recently in the 1980s), but it has a feline resilience. As Meyer Schapiro notes, photography caused painting to emphasize its material, textural, abstract elements with which mechanically reproducible media were at a loss to compete.[5] The absolutely fundamental role that photography plays in our everyday lives causes one to forget that photography was first discussed in the light of painting and drawing. Daguerre's first pictures were still lifes and in 1844 Talbot published a treatise on his discovery, entitled *The Pencil of Nature*, which defined the medium almost exclusively in terms of painting. Numerous painters of repute responded positively to the invention: at advanced stages in their career, both Delacroix (1798–1863) and Ingres (1780–1867) made use of photographs, as did the Impressionists (their first exhibition in 1874 was housed in the studio of the renowned photographer Félix Nadar), whose snapshot portraits, sweeping panoramas and abrupt framing are all indebted in some way to photography.

This did not stop a raft of antagonism towards photography; Baudelaire, who frothed at the mouth when confronted with photography's encroachment upon art, opined that it was uninventive, unsurprising, and unimaginative and that it gave talentless painters a new wind. But it was Baudelaire's most admiring

twentieth-century critic, Walter Benjamin (1892–1940), who wrote the provocative and easily most influential essay on photography and film in 1934, *Das Kunstwerk im Zeitalter seiner technischen Reproduzierbarkeit* (Art in the Age of Mechanical Reproducibility). Here Benjamin mourns the demise of the aura surrounding the unique work of art as a result of photographic reproduction. Robbing the artwork of aura, Benjamin feared, threatened to have the negative effect of depriving it of what made it special, its genuine presentness, allowing it to join the dream world of commodities, displacing the object from its station within its physical place and from its historical moment. He acknowledged, however, that the positive repercussion of this upheaval was to demystify the art object, divest it of its cultish status and open it to greater scrutiny.

At the end of the essay, Benjamin welcomes the introduction of film, by then over three decades old, as a form that could deliver messages in a less ambiguous form than art. Benjamin was a liberal Marxist and his agenda for art was perceptual and spiritual freedom. Film could portray things in a way that the everyday man could digest and possibly conduct him to a more enlightened state. Benjamin was particularly responsive to the new visual language that film introduced. The camera opened up a form of perception, the sharpness of which was unprecedented, arresting the flow of perception and breaking it down into its own mechanics. Benjamin speaks about experiencing the 'optical unconscious' at work. Technical reproduction returns to perception what other more dulling effects of technology have removed. For Benjamin, technological production speeded up life, leading people into a perpetual state of distraction. Film provided a salutary antidote: the newly disassembled and reassembled nature of filmic montage allowed the viewer to see experience as slowed down, and 'according to a new law'.

Unfortunately, as Benjamin was seeing as he wrote the essay, film's ability to alter and freshen mental states was being proven in an adverse way by the Nazi propaganda machine's aestheticization of politics, manipulating its audiences to ulterior purpose. Benjamin foresaw the relation between media and politics that, with television, has become the norm.[6]

Benjamin's contemporary, Martin Heidegger (1889–1976), was also concerned about the manipulation of technology to the detriment of the human spirit. Both thinkers fell foul of historical events. Benjamin, believing himself to be in the clutches of the Nazis, killed himself. Heidegger, for a time, joined them, something he regretted and never lived down, tainting some of the most searching philosophy of the last century.

ART, TECHNOLOGY, MEDIA AND THE WORLD

In Heidegger's much quoted essay, 'The Origin of the Work of Art', he observes that the Ancient Greeks used the same word for both craft and art: *techne*. Artists and craftspeople were *technites*. But he advises us not to be too misled by this ambiguity, for *techne* signifies rather 'a mode of knowing'. '*Techne* never signifies the action of

making' but instead a process of 'bringing forth' something 'concealed' within the object. The kind of 'doing' of a *technite* is an act of creation that brings truth out from its concealment. Thereby, according to Heidegger, the artist creates an 'opening' through which this truth is made possible. This change, mediation, is crucial for Heidegger, who suggests that what is revealed is fundamentally through the endowment of form, the giving of form to matter, which has the capacity to open up a 'rift' in the world, revealing the world to be disposed to a deeper form of revealing and appearing which is Being itself. Art's task is to preserve truth by revealing it. 'Art is history in the essential sense that it grounds history'; and 'The history of the nature of Western art corresponds to the change of the nature of truth.'[7]

Heidegger reminds us that it doesn't matter how good the tools are, it is what is done with them that matters. The artwork employs a medium and the artwork is itself also a medium for the aesthetic experience. In his essay on technology, Heidegger argues that the two definitions of technology that 'technology is a means to an end' and 'technology is a human activity' belong to one another. Heidegger's attitude to technology is tempered by the suspicion that its facilitating function should not be lost on us and that we should not become beholden to it by being in its thrall.

All technology, for Heidegger, is a matter of causation. The causation for the Greeks was crucially to do with a 'bringing forth' of something. We might remember Vernant's explanation of the Greek image discussed in Chapter 3, wherein to imagine something or to create an image was to call forth a latent shadow of something always present elsewhere. Likewise, Heidegger suggests that to create something is give matter a form that is somehow latent within it, as if releasing an inner spirit 'slumbering' within the material. While such an idea may seem obscure to us, Heidegger emphasizes the gentleness within the mediation of the Ancient Greeks in contrast to modern technology whose practices and above all consequences are violent. Since *techne* is to do with knowing, *episteme*, technology is the process of that knowledge's 'revealing'. Technology is the manifestation and the means to achieving man's destiny. Heidegger was also, however, anxious about technology used for its own sake, which obscures this destiny.[8] As Julian Young insists, whether or not the 'Greeks' in Heidegger's terms exist or not, they are at any rate a foil to what he sees as the negative coercions of modern technology.[9] As with many thinkers of his time, he was suspicious of the violence of modern technology and the mindlessness with which people were caught up within it. This permeation of technology into the very systems of our actions and functioning of our thought was later taken up by McLuhan, and with somewhat less foreboding.

Marshall McLuhan (1911–80) threw new light on Heidegger's reflections by identifying why we find ourselves as passive recipients of technology on the one hand, and on the other, active manipulators of it. In a book published in 1967 – almost exactly two centuries after Lessing's *Laocoon* – *The Medium is the Massage: An Inventory of Effects*, McLuhan advocated that media are picked up by different combinations of our sensorium. Media should not be thought of as outside or extra but as continuous, as extensions of our processes of reception. McLuhan's argument

can also be used to explain the gradual way in which we adjust to new media, such as video art, for example. When it became a widespread medium for artists in the late 1990s, it was still not received that well by the lay public. A decade later, everyone with a decent computer has access to basic video-editing software. Video is now within the ambit of amateurs, as were automatic cameras in the 1880s. Correspondingly, more people are responsive to video art because they have become comfortable with the system of video for interpreting and archiving their world.

In an earlier book, *Understanding Media* (1964), McLuhan proposed that our world is composed of technological stimuli that are either 'hot' or 'cool', metaphors borrowed from jazz lingo, which distinguished between the big and brassy (hot) and waftingly laconic (cool). 'High definition', being 'filled with data', is hot; whereas low definition is cool. Film is hot; television is cool. Hot media are low in participation and cool are high: telephones, for instance, are cool, as are books. McLuhan allowed that 'no medium has its meaning or existence alone' but rather is 'in constant interplay with other media'.[10] Media undergo constant change through pressure from their users. The pressure is exerted either from mastery or boredom, or it can be from an innovation of another medium external to it. (The Sony Walkman created a headphone culture that eventuated in iPods, which have eclipsed the Walkman; in reply Sony and Nokia have marketed multimedia cell phones.)

A wordsmith of pithy phrases, McLuhan remarked that we lived in the 'Gutenberg Galaxy' – our world has been transformed as consequentially as the invention of the printing press, but on an exponential scale. With Columbus and Magellan, the earth 'exploded' into new reaches; with technology, it 'imploded'. McLuhan had in mind the access provided via the telephone and television, but he could not have predicted the massive implosion wrought by the Internet: from dating to buying, possibilities are limitless. In art, it means that audiences are large and diverse; artists participate in new media festivals and exhibitions to which they can send their work via broadband.

NEW MEDIA

McLuhan's theses were prophetic for the digital revolution that began in the 1980s. It is true enough to say that computers were invented early in the twentieth century, but when we talk about the digital age, we mean when the technology entered into the public, domestic domain and into everyday parlance. What we experience is not just hot and cold media but a rich folding of the two: media within media within media: films have been reduced to cool media in the shape of QuickTime files, television stills are made large and hot; writing comes together with film; fonts move with LiveType, and all this is available to anyone with a bit of money and a bit of patience.

But first a few caveats about the term 'new media' itself. If we return to Lessing and Hegel, we will remember that they demarcated the various media according to their internally formal and affective properties: sculpture is physically present, painting

is spatial and uses colour, music is aural. So new media has/have (the conjugation is also ambiguous, alas) to be understood as everything that exists outside of the traditional 'fine arts' as they were defined by eighteenth-century aesthetics and by categories set up by French and British academies. Do we inhabit what Rosalind Krauss has termed the 'post-medium' condition?[11]

If only it were so simple. We are more dependent on media than ever, and the speed of changes asks that we assess standing definitions of media with healthy scepticism. Photography, when used as an art form, is not new media, but if it is computer-manipulated it may be; shown in a non-physical form, on the computer screen or as a projection, then more probably so. (We must also not forget the phenomenon of the big colour photographs pioneered by Andreas Gursky (b. 1955), Thomas Ruff (b. 1958) and Thomas Struth (b. 1954), which were only made possible by the availability of huge photographic processors in the late 1980s.) Until the late 1990s, video art, which only began in the 1970s, was classified as new media. In some quarters is it is still referred to as such, in others it is now lumped in with the traditional fine arts. 'Straight' video – one basic projection – is classified less as new media, while multi-channel video (more than one television screen or projection) is getting there; if there is an overt sense of digital mediation, then probably definitely.

All in all, there are a handful of constants that appear to be consensual. The first is that new media involves computers in some way. The second is that it is hybrid, be it the most familiar hybrid medium, film, which combines sound, movement and image, or a combination of numerous components in one work. Third, new media is anomalous to both Lessing's and McLuhan's definitions. It is capable of involving all of the senses barring smell, and, because new media can exist in several incarnations – a sequence on a television, a series of projections in a chamber, on a URL or on a cell phone – the classifications of hot and cool lose their currency. (And if television was to McLuhan's mind cool, what do we make of large-screen, high-definition TV? And so on...) Hence new media are either a conglomeration of media or an elision of the definitions as devised by Lessing and Hegel. Even before the close association of new media and digital technologies, artists in the late 1960s were working outside the frame of a single strategy. Picasso had mastered all the traditional arts, while Bruce Nauman (b. 1941), who works across media, was until recently commonly referred to as an early or proto-new media artist. Not defined by approach, tactic or medium, Nauman was one of the first to take seriously the idea of installation as a way of manipulating the viewer's sensory realm. Nauman's work is the antithesis of the pious notion of 'truth to materials' espoused by artists such as Henry Moore (1898–1986) and Barbara Hepworth (1903–75), who claimed that they let the medium (wood, plaster, clay) guide their decisions. With such work one is in effect seeing into the medium of the work. In Nauman's case, the sanctity of the medium is disrupted by the way he leads you outside its physical limits.

Fourth, but not finally, new media frequently has an immersive effect: the viewer becomes physically conscious of experiencing the work rather than seeing it. If the

work is interactive (responding to the viewer/visitor's movements or navigated by voice or a mouse), the viewer transforms into a 'user'. With new media, the only material element is the technology (projectors and speakers) and the interfaces (computers, terminals), which render the work seeable and 'usable'. One is also made conscious of oneself as the material witness (having to be alone is a large weakness of some new media, which only admit of one user).

In becoming a user, one moves through sequence or sequences, thus splintering the gaze. Seldom do two people see exactly the same thing. What is seen is virtual, indefinite, hypothetical. As the Finnish new media curator and theorist Erkki Huhtamo explains,

> The gaze exists as a series of proposed subject positions for the user implanted into the structure of the work; while these may be 'preferred', they by no means exhaust the ways in which the work can be read.[12]

Further, as Mark Hansen explains, new media transform the gaze back into the movements of the body. Both are in process and flux.[13] Take, for instance, the collaboration between the new media artists Jeffrey Shaw, Dennis Del Favero and Peter Weibel, *T_Visionarium II*, where the viewer navigates between an intricate mosaic of moving images. The viewer/user is made to combine the images as he or she pleases. It is decadently Futurist, but also a hyperbolic approximation of dream states: images interceding, colliding, sense disrupted and shunted in a diverse and infinite relay or reorientations. On an earlier work by Shaw, Hansen comments,

> Shaw deploys the panorama interface in its traditional form – as a photographic image – precisely in order to defeat its illusionist aim. By giving the viewer control

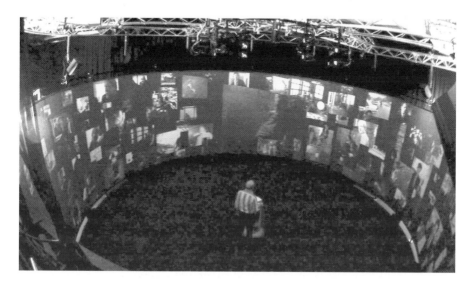

37. Dennis Del Favero, Jeffrey Shaw, Peter Weibel, *T_Visionarium II*, 2006. Digital and mixed media. © Courtesy i-Cinema Centre for Interactive Cinema Research, University of New South Wales, and the artists.

over the projection, the frame, and the space it depicts, and by foregrounding the reversibility of the screen (which allows the panorama to be seen from outside), Shaw opens the photographic space of illusion to various forms of manipulation – all involving bodily movement – that serve to counteract its illusionistic effects. Photography [...] becomes the pretext for a movement that is simultaneously *within* the viewer's body and the virtual space and that is – on both counts – *supplementary* to the static photographic image.[14]

In works such as these, content and style are the same. This chapter has covered the evolution of media and the way they have affected what has been produced. To be sure, media have a significant role to play in the style of the work produced. The evolution and concept of style is the subject of the following chapter.

6 STYLE

Édouard Manet did the etchings of his friend Baudelaire that are reproduced in Figures 38 and 39. They could easily be by two different artists. One is conventionally Realist, the features recognizable, not setting out to make any overt visual challenges to the viewer. The other, with next to no identifying features, is executed with a few sparse lines, ethereal enough to seem to want to lift off the page. One captures an identity firmly (it was based on a photograph by Caspar Nadar), while the other, based on the criteria of the first, is nondescript. Instead, it captures a particular air (also to be found in his depiction of Baudelaire in *Concert in the Tuileries*, 1862.) It is an impression. Manet's other great supporter, Émile Zola, famously declared that style was 'nature viewed through a temperament'. Yet which one is the more

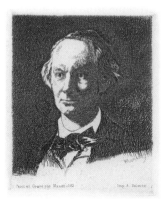

38. Édouard Manet, *Portrait of Baudelaire*, 1869. Etching on paper. Courtesy of the author.

39. Édouard Manet, *Portrait of Baudelaire in Profile*, 1865. Etching on paper. Courtesy of the author.

'Manet'? Moreover, these works are etchings and we may ask ourselves how the etching process, which is sharp and linear, compares to Manet's paintings, notable for their full and fluid handling of paint.

It is a lasting cliché of Modernism that an artist begins with detailed, conventional representation and gradually evolves into his (with Modernism it is almost always 'his') signature style that with age gradually becomes more simplified and abstract, as if the artist is converging with his true identity. The list is long enough: Cézanne, Degas, Rodin, Matisse, Miró, Arp, Mondrian, and numerous others in the canon, all to a greater or lesser extent conform neatly to this paradigm. But in Figures 38 and 39, the more traditional portrait (1869) was executed after the simpler and more abstract one (1865).

Manet was, throughout his career, a tireless visual *pasticheur*, working in or through the style of others. He drew from a wide range of influences – including Velazquez, Ribera, Goya, Giorgione, Raphael, Titian, the brothers Le Nain, Chardin and Fragonard – some of whom are unmistakably evident in his painting as a kind of visual dialect with which he is choosing to inflect his message at a particular time. In the case of the later etching, produced after the poet's death in 1867, Manet made an allusion to the banner in Dürer's famous etching *Melencolia* (1514), in the memorial banderole at the bottom of the image. Knowing of this allusion steers the viewer in yet another direction. With the posthumous nature of this etching we can now hazard an explanation for its difference from the first. Working from a photograph added something to the testimonial character of the picture, done in the absence of the sitter, its sombreness fitting to its role as visual epitaph. The first is more touched with the fleetingness of life, when the abstraction could be measured against the reality; the second has the emblematic permanence of a restitutional image, when the semblance of reality compensates for the absence of life. Ironically, the picture that appears more real is in fact the more imaginary.

Each of these styles tells us something about the artist and the sitter. But the relationship is tantalizingly variable from artist to artist, work to work. Their appearances were perhaps deceptive at first but benefited from being given a circumstance and a motivation. An explanation of why a work is the way it is generally gives us better access to how to experience a work of art, although the intensity of that experience is as much a matter of our own knowledge and responsiveness as it is a matter of the qualities within the work. But it remains to be asked, to what extent is style the bearer of the so-called truth of a work of art? Is style something that can be separated from the form like the shell of a nut, or is it a quality of the essential quality of a thing?

One thing is certain: the discourse of style is tightly bound to the discourse of art history itself, and it is the theory of style that formed the joists used to support art history until it experienced its 'crisis' in the 1980s, that is, at precisely the time when the visual arts in West no longer enjoyed a discernible set of styles. Before this point, and somewhere before non-objective abstraction became widespread as a result of Abstract Expressionism in the USA in the 1950s, Kenneth Clark observed

that one could trace the history of Western art since the Renaissance through the male representation of the female nude, from the Venus of Botticelli and then Titian to Rubens, Canova, Goya, then Manet's Olympia through to Picasso.[1] This is so true that it was also one of the biggest grievances of feminist artists in the 1970s and art historians in the 1980s, who were rightfully indignant at the way the male artists were dismissive of female experience while using the female body as a shop dummy on which they could hang all their passions and anxieties. Is style owned? Is there a universal style? What is stylistic truth? Art history begins once the concept of style is introduced as a serious theoretical issue. What we now call art theory, as opposed to art history, is a reflection on the methods which art history has called upon to legitimize itself.

STYLE, HISTORY, RISE AND DECLINE

There is no convenient beginning to art history in the way that the novel can be said to have been born at the hands of female French courtiers in the seventeenth century. Yet we might turn to the architect Marcus Vitruvius Pollio, whose classification of Roman capitals – the shape and decorative detailing at the top of columns – is still in stock art historical currency, and is a foundation stone for the inferences to be drawn between style and historical period. *De architectura*, or *The Ten Books of Architecture*, is the only extant document of its kind of the period. Here Vitruvius outlines three principles of architectural style: *firmitas* (the strong), *utilitas* (the useful) and *venustats* (the beautiful). Architecture, said Vitruvius, was inseparable from the movements and proportions of the human body. When a work of architecture foregoes this fundamental relationship, it unfastens its relation to its basic principles and loses its purchase upon the beautiful. The three Greek orders – Doric, Ionic and Corinthian – were not to be understood relationally, that is, in terms of their difference from one another and with regard to the innovations in engineering that allowed for the development from thick to slender columns, rather, they were also to be understood stylistically, as reflecting a particular mentality. The Doric is thick and austere, while the Corinthian is feminine, decorated and thin. The Ionic was the harmonic unity between the two and represented a more refined, restrained expression of the beautiful. It is from this stylistic topology that we now have the accepted subdivisions of Ancient Greece: Archaic, the rise of the culture, Classical, apogee, and subsequently Hellenic, decadence and decline.

The tenacity of this model of stylistic development cannot be overstated. As I have already touched on in the discussion of the two etchings by Manet, we are used to looking at an artist's development through the same developmental lens, and also culture. This diagnostic model of the pattern of people and societies culminated in Arnold Toynbee's magnum opus, *A Study of History* (1934–61) – a survey of world civilizations that sought to account for their rise and fall. Toynbee's history was a far more serious version of the more dubious approaches by the classicist Otto Seeck (1850–1921) in his *Decline of Antiquity*, which influenced the nihilistic diatribe by

Oswald Spengler (1880–1936), *The Decline of the West* (1917), both of which viewed decline in terms of social Darwinism, later to be taken up by the Nazis in their chilling effort to eradicate the avant-garde on the grounds that it was 'degenerate art'.

The Nazis' systematic efforts to expunge the most experimental art of their time was spearheaded by the blue-collar tastes of Adolf Hitler who, at the rally to celebrate the Day of German Art in July 1937, promised to wage an 'unrelenting war of purification [...] against the last elements that have displaced our art'. The official art reflected the Nordic aspirations of the Reich and consisted almost exclusively of Aryan peasant families, highly posed nudes and battle scenes.[2] They were all represented in a stylized classicism that made the figures appear soulless, pretentious, and numbingly effete – ironically, inhuman. (It is also curious to see the close similarity in official styles of other totalitarian regimes, from Fascist Italy to Stalinist Russia to Maoist China – the same stilted poses, the healthy faces, the same literalized obsequiousness. They purport the good and promise pleasure and happiness, but the motives that bring synthetic official styles into being are a whole lot more sinister.) The exhibit received a lukewarm response and was swiftly dubbed the 'Palazzo Kitschi' while the exhibition Degenerate Art, housed in less auspicious circumstances, was frequented to the point of chronic congestion, with crowds in excess of 2 million. This historical episode is an invaluable example of the struggle of styles and ascendancy of an 'organic' or natural style over an artificial one. At least in this case it suggests that style is an extension of a social condition. Disingenuous and mawkish, the official Nazi style also drew from this belief but turned it on its head. By depicting an Aryan, heroic people, they asserted the prior existence of what they were attempting to build through force so that these images are today best viewed as exemplifying that force and the manipulation of truth. Styles have been encouraged and imposed, as they were by the religious institutions of antiquity to the Middle Ages and beyond, but their greater effectiveness is based on a consensus of beliefs, whose evolution is gradual rather than abrupt. To accept a style is also to accept that it has a creditable relation to the one who made the work and its historical circumstance. Of course there are exceptions, but they are seldom if ever wrought by violence.

The stylistic standard of antiquity that marks the Renaissance essentially remade antiquity through the adoption, adaptation and rejuvenation of its forms. The classical or Greco-Roman style diminished upon the decline of the Roman Empire from the fourth to fifth century. What we refer to as the Byzantine and medieval styles differ from the classical inasmuch as they are instrumental in communicating an ideal that is external to the form, whereas in classical and Renaissance art the ideal is by degrees internal to that form; form became more an end in itself.

Vitruvius' treatises were revived in 1414 by the Florentine humanist Poggio Bracciolini, and while Vitruvius' presence can be detected in the writings of Alberti, his writings did not become freely available until 1486, after which they became

available in English, French and German in the opening decade of the next century. Working from this foundation, what the growing list of writers shared was an inquiry into what made an artist and his style better, in order to delineate a set of structural imperatives that would be future assurance of good art. As with the burgeoning scienticism in the Renaissance, art in its own way was treated as its own special machine. The incentive to these treatises was to speculate on the components of this machine, to lay down the base for the most appropriate, as opposed to wayward, style in order to facilitate more consistently good art in the future. With the adoption of Greco-Roman models of form, and with strict rules of indenture of students to artist-masters, the Renaissance had, as we know, begun to achieve this.

While the classical inheritance continued to be strong, the next major theoretical watershed came in 1764 with the first book to have the words 'history' and 'art' in the same title, Johann Joachim Winckelmann's *Geschichte der Kunst des Altertums* (History of Ancient Art), in which style and art is placed within moral, social and anthropological contours. Inspired by the uncovering of Herculaneum and Pompeii in the mid-eighteenth century, Winckelmann (1717–68) set about trying to account for what he saw as the level of consistent excellence in the art of Ancient Greece, why things were not the same in his era, and why such art should and had been emulated. Following his first book in 1755 and two small treatises on the discoveries of Herculaneum, Winckelmann's ground-breaking study shifted the emphasis away from praise of Rome, then associated with the pinnacle of styles, towards Greece. Greek art, for Winckelmann, projected an unsurpassed freedom, which, he held, remained unmatched. Winckelmann was also influential in the subsequent view that the art of the Baroque and Rococo was a corruption of ideals forged in Ancient Greece; fluency and grandeur reduced to a series of gratuitous devices incongruous with the work of art's internal meaning. Winckelmann's crucial contribution was to suggest that the liberty that the Greek subject felt was reflected in the serenity of the object (*Heiterkeit* – serenity – is a word that German aesthetics would cherish for another hundred or so years). In short, he surmised that the moral health of a nation was ramified in the excellence of its art. He viewed style as an index of its age, looking at art from an overarching sense of time and development as opposed to isolated categories of taste and quality. He was responsible for the term more commonly used in architecture and design, Greek revival, advising that it is through imitation of the Greeks that society could regain the personal sovereignty and the social truth that had since gone askew. Reiterating the tripartite evolution of progenitorship (experimentation, early stages – incipience), zenith, and decline, '*The History of Ancient Art*', Winckelmann wrote in his preface, 'is intended to show the origin, progress, change, and downfall of art, together with the different styles of nations, periods, and artists'.[3] He singled out certain Greek works as epitomizing his theories, and his deductions were sometimes unconvincing, for in his time most of the antiquities were as yet undated.

For an idea of the kind of watershed carved out by Winckelmann, we might look at one of his notable predecessors, Roger de Piles (1635–1709) who, in a peculiar

book published a year before his death, *La balance des peintres* (The Balance of Painters), posited standards of measure according to four criteria of drawing, colour, composition and expression, scoring artists out of twenty, the highest mortal score being eighteen. For composition only, Rembrandt and Guercino rated highest, Palma Vecchio achieving only five; Raphael top-scored for drawing while Michelangelo came second; for colour Titian and Giorgione did best while Michelangelo wooden-spooned with four; Raphael came top in expression while Rubens and Domenichino came second. Quaint as all this may sound to us today, de Piles's taxonomies are useful as a gauge of contemporary taste. By contrast, Winckelmann dispensed with finicky itemizing and pushed the merits of an overall conception of beauty, which sacrificed the details of individuality that were bound to be idiosyncratic, not universal.

Among the challengers to Winckelmann was Herder, who rightly argued that the standard of value that he offered was far from universal. It was specious, for instance, to judge Egyptian art by Greek standards, since their art had different uses and was dominated by different myths. Herder was indeed one of the principal spokes-men for ideas – to germinate more openly in the early decades of the next century – about the cultural specificity of form: each place and age has its own forms as it has the motives that drive them. Herder states that language is not just an arrange-ment of signs that refer to one thing or another, it is the vehicle itself of conscious-ness. Words are not to be understood in terms of reference, they are manifestations of the very activity of human consciousness. The way we grasp things is through *Besonnenheit*, or 'reflection', which comes into being through a medium, such as language; and it is a people's language that is the expression of their essence. When applied to the history of art, Herder's observations were to have profound consequ-ences, since by extension they identified art also as a language. As a medium of thought, art varied in accordance with the way its makers communicated their beliefs, desires and taboos. Art and language had a reciprocal relation to the culture from which they sprang. Style could thereby be understood in organic cultural terms, as referring to the truth of people in place and time.

Herder's ideas were to branch out into two irreconcilable directions. The first was to defend local styles against the imposition of dominant criteria, such as those of, say, ancient art. According to Herder, a language or work of art ought to be evalu-ated according to criteria proper to the very intellectual and spiritual workings that called it into being in the first place. With this we see the germ of cultural pluralism, which enjoys powerful sway amongst post-colonial theorists who are duly sceptical of judgements imported from outside that vitiate the work of art, the language, the law, or whatever they set out to judge. But the unfortunate extreme of this view, and this is the other side of the story, is a cultural atomism that says that any judge-ment from the outside is bound to be wrong. And to preach the virtues of local truth is to descend into a conservatism that results in a paranoia that excludes its foes, often with recourse to violence to defend its purity. As we have already seen, National Socialism, which took joy in perverting a lot of German thought for its

own ends (Hölderlin, Nietzsche and many others), was guilty of this. But beyond all that, the ethical and social defence of specificity is a vexed question in this age of globalization, of cultural confluence, where cultures are diversely convoluted. Styles considered purer than another are there for reference only, not as weapons.

To return to Herder, the questions to be asked were that if we place limits on styles and languages, why is it that we can still have enjoyable access to them, why do we think we sympathize with them, and, if they are divorced from the way we look at the world (*Weltanschauung*), how do we bring ourselves to interpret them? The theologian Friedrich Schleiermacher (1768–1834), associated with the circle of early German Romanticism, is credited with having opened up the 'hermeneutic circle' from specialist pursuits such as philology. Interpretative practice, hermeneutics, could be used by a member of one culture to grasp the experience of another. Schleiermacher argued that we can try a kind of process of divination, an empathy to the extent that we subordinate our interests for those whom we seek to understand. While this could only ever be achieved in part, Schleiermacher helped to develop a psychology that brought things unfamiliar to us closer to hand.

HEGEL'S AESTHETICS

Hegel's lectures on aesthetics in the1820s were an exhaustive elaboration on what had already been laid out in *The Phenomenology of the Spirit* (1807) and the *Encyclopaedia of the Philosophical Sciences* (1811–16; rev. 1831) and are the cornerstone of the discipline of art history. Borrowing substantially from Winckelmann, Hegel expanded the theory of style into the wider gamut of art to attempt to theorize a systematic progression concordant with the enlightenment of man.

What allowed Hegel to do this was a developed philosophy of history. Hegel sets history together with the progressive agency of the human spirit. Whereas there had been histories long before Hegel, they lacked a synthesizing structure made possible by a *telos* or objective end point. Hegel regarded the isolated story as an incident in a succession of others whose sole purpose was the point at which history is no longer necessary and when spirit becomes absolute and self-aware. Unfortunately, Hegel was unable to say when this revelation took place or how we knew it was there, but his supreme importance still lies in his detailed efforts to give history coherence through positing a reciprocity of time and thought.

To Hegel, the arts were important for being the first way in which the spirit becomes manifest, like a carapace from which it would, in time, burst. To this end he divided art into three evolutionary phases: 'symbolic', 'classic' and 'romantic'. Taking his cue this time from Lessing, who espoused the expressive particularities of the different art forms, Hegel argued that each phase was a form corresponding to the encroachment, or emergence, of the spirit. The symbolic was the least developed state, evincing itself in heavy, sombre works of architecture. Hegel cites the pyramids of Ancient Egypt, where only general aspects of the spirit were expressed. In the 'classic' phase, epitomized in Greek sculpture, we find the most eloquent balance

of form and spirit; the beauty of the human body seems comfortably at one with the ideal it conveys. Finally, as we saw in the previous chapter, the 'romantic' was expressed through painting and music. Hegel sensed a struggle internal to the art of his era that he believed was deducible only to the desire of the spirit to escape its material shell, whereupon art ends so that it may find its next juncture in religion before it winds up in philosophy.

Hegel's thesis has many, mostly self-evident, shortcomings, yet it is still discussed today because it gives art prevailing purpose by combining it tightly with history, style, culture and, not least, religion. Until at least the middle of the twentieth century, art historians and critics would continue to draw on Hegel's evolutionism, unconsciously or in the conception of their own polemics, such as we saw with Clement Greenberg, who asserted American abstraction as the resolution of an effort that began somewhere around the Renaissance. School art textbooks are rife with pocketbook Hegelianism: the timeline view of art history, a history of art from style to style, from 'ism' to 'ism', is merely a broad application of Hegel's *Aesthetics*. It is also through Hegel and his 'end of art' thesis that we can begin to understand Postmodernism, whose rhetoric is full of 'ends' equating to the rejection of a unitary purpose or understanding of the reflective organization of time, namely history. Curiously enough, once the historical unities that Hegel noted began to fall apart, styles become less coherent. Once history loses its mooring from consensus, styles diversify with mesmerizing rapidity.

GOTTFRIED SEMPER AND HIS INFLUENCE

When émigré Dresden architect Gottfried Semper (1803–79) visited the Crystal Palace in London housing the Great Exhibition in 1851, he made a prescient observation about the way designers and architects were using ornament. While Victorian Britain flexed its imperial muscles, Semper observed that industrialization, in its undaunted manipulation of ornament in such products in wrought iron, wood or wallpaper, had increased art's range and availability, although at the cost of its cultural relevance and aesthetic intensity. Mass-produced items, for having to please a general public, made potentially everything a receptacle of ornament, which was used in an understandably generic and arbitrary way. But this upheaval, Semper argued, was more beneficial than destructive, for it caused 'the *disintegration of traditional types* by their ornamental treatment'.[4]

British contemporaries saw artists and designers choosing between conventional and naturalistic ornament, whereas Semper saw the disruption of art's historical basis – 'Art especially is being fatally hit.'[5] If this was a crisis in art, a style problem, for Semper it was ultimately salutary. It laid bare the fact that style's function lay in 'giving emphasis and artistic significance to the basic idea', the absence of style in an object being a shortcoming that reveals the artist's 'disregard of the underlying theme'.[6] Semper introduced the view that nothing can be entirely style-less, and

that the self-consciousness of style felt in its knowing manipulation is the normative process for artistic production in the West. As Harry Malgrave has argued, Semper's theory of style can be broken into three parts. The first is the work of art's underlying idea and intention, the second is the materials and techniques employed in the work's production, the third is external variables, whether national, personal or temporal. None of these 'coefficients', as Semper called them, are dominant or determinate; they are what exert pressure to one degree or another on the idea 'like a musical theme' guiding the production.[7] Take a portrait: the idea is the representation of a person through status and personality. Then the artist can choose whether this is rendered as a photograph, a digital animation or a terracotta bust. Finally, the way this is carried out is coloured by contemporary expectations, the languages to which the artist may want to conform, or reform.

Semper's theories of style, embodied in his most famous text, *Der Stil* (1860), came to be read by several generations of thinkers influential in the theory of style, including Heinrich Wölfflin (1864–1945), the architect Adolf Loos (1870–1933), and Alois Riegl whose first two books, *Altorientalische Teppiche* (Ancient Oriental Carpets; 1891) and *Stilfragen* (Questions of Style; 1893) both acknowledged their debt to Semper.

In his most celebrated book, *Principles of Art History* (1915), Wölfflin expanded on Semper's theories to say that style was something in its own right rather than an abstract entity. His main interest was the Renaissance and the Baroque era, which contrasted in terms of the development of the linear to the painterly; the former favoured line, the latter colour. Compositionally, the closed (techtonic) nature of Renaissance painting was compared to the openness (or a-techtonic) of the Baroque. These were tendencies which, to Wölfflin, were fundamental to the style and the meaning it conveyed. Taken at its most forceful, Wölfflin stipulated that the only way to read a work of art is through its style. At its weakest, it could only be applied to a limited range of painting: Mannerism, which falls between the Renaissance and the Baroque, is not seriously dealt with, and his system all but falls apart with modern abstraction in which the linear and painterly converge.

Wölfflin's method lost its popularity with the rise of iconography, which as its main proponent Erwin Panofsky (1892–1968) states, 'is that branch of the history of art which concerns itself with the subject matter or meaning of works of art, as opposed to their form'.[8] In his *Studies in Iconology* (1939) Panofsky distinguished between three tiers of subject matter: the primary or natural subject matter, say a madonna and child, which to a naive non-Christian can be taken as just a mother and child; the second, or conventional subject matter, identifies this as Mary and Jesus; third, meaning and content, the manner in which the artist has represented the madonna and child and what had driven him to do so, be they personal or social pressures. Panofsky's method continues to be dominant in the Academy and even more amongst curators who use it for explicating works for exhibition catalogues. As with his predecessor, the theory begins to founder when faced with non-objective abstraction and technical media, from photography onward.

In his seminal study, *Stilfragen*, Riegl aimed to extract the discourse of style from the realm of material and technique towards an inner, spiritual impulse, for which he coined the term, *Kunstwollen* ('will to form'). In what is perhaps a mystical humanism, Riegl averred that there were much deeper inner issues that drive humans and the forms they make bespeak the need for each epoch to make its particular imprint. Taken as a collective, each style is a call by its time to be understood in its own way. Riegl's intelligent arguments are somewhat lost in the present, whose worst habit is to make omnipresent claim to cultural context without accounting for anything like a collective will that desires to distinguish itself from the past. Riegl admitted that material factors had to be considered, but it is a lot more stimulating to see the myriad ways the same family of materials is manipulated.

As Meyer Schapiro (1904–96) remarks in his essay on style, Riegl advanced the theory of style by doing away with the triad of rise, high point and decline, showing how periods in decline are better thought of as periods in transition, such as in late Roman art. Moreover, Riegl did away with the Hegelian evolutionary schema and saw each phase as having its own problems of form and expression. 'The history of art is, for Riegl, an endless necessary movement from representation based on vision of the object and its parts as proximate, tangible, discrete, and self-sufficient, to the representation of the whole perceptual field as a directly given [...].'[9] What Schapiro is referring to is Riegl's assertion that art advanced in history from the haptic, or bodily, to the optic, something easy enough to sustain at the turn of the century with photography and the invention of the cinematograph. But with the invention of interactive gaming and immersive installation, the haptic and optic have conjoined.

From the point of view that art is an effect or modality of a spiritual will, Riegl's influence was most heavily felt in the ideas of Wilhelm Worringer (1881–1965), whose *Abstraktion und Einfühlung* (Abstraction and Empathy; 1907) became one of the primary theoretical supports of Expressionism of the period before the First World War. Produced from a dissertation under the tutelage of Wölfflin, Worringer posited a new direction from that of the European and classical leaning of art history. He held that at its core, all art is subjective and intuitive. Impressed by Henri Bergson's conception of *élan vitale* (vital energy) educed in the *Creative Evolution* (1907), Worringer became a spokesperson of his time for artists and writers who believed in a deep and communal wellspring of energy that fuelled the creative urge. With so-called primitive art, so held Worringer, we have evidence of these inner energies whose omnipresence was only emphasized by the artists, alienated by industrial society, who were seeking solace in it. Worringer filled a breach in studies of artistic style, enabling 'primitive' art to be considered a style in its own right, and abstraction to be a serious subject for study.

But when taken to an extreme, abstraction can always point to a vacuum as much as to plenitude. Embracing these extremes in the efforts of finding a universal style was one of the grand projects of twentieth-century Modernist art, architecture and design. Where so many of his contemporaries at the end of the nineteenth century

treated style, objectively stated within ornament, as unavoidable if not necessary, the Viennese architect, Adolf Loos, in his broadside against the Viennese Secession, 'Ornament and Crime' (1908), advocated against any ornament whatsoever. Loos effectively ushered in the most lapidary statement of style since the French Revolution's embrace of masculine classicism and its denigration of the 'aristocratic' fripperies of the *ancien régime*. Affected by Semper's discovery that industrialization had dislocated ornamental styles from their point of origin, and hence their social truth, Loos equated ornament with lax bourgeois philistinism. The only viable option was to purge the object, in Loos's case the work of architecture, from the defilements of ornamentation altogether. Loos was responsible for the first buildings that at their most severe resembled toy-like geometric blocks (although the Looshaus in Vienna thankfully does not go that far). Later echoed in the slogan of the architect-designer Ludwig Mies van der Rohe (1886–1969), 'Less is more', Loos was also was instrumental in the dictum 'Form follows function' proclaimed by his disciple, Le Corbusier, who remained faithfully hostile to architectural niceties. He went so far as to liken ornament to disease, unwanted excrescences, nodules and pustules that mar the clear surface of the flesh.

UNIVERSAL STYLE

Loos's extremism was endemic of the change welcomed by Modernist design for a style freed from eccentricity or association. By removing all ornament altogether in designing objects for living, it was thought possible to come up with something resembling a style-less object that was linked neither to a people nor a time, which would imply that it could be used by any person at any time. This dream, which began in the Bauhaus (1919–33), is to some extent fulfilled today. We now have a post-industrial 'international' style, pared down and sleek, to be found in tenements and villas alike. At the same time we accept that a style-less object is a myth. For, by default, the style that aims at non-style is itself a style, embodying the beliefs of the age, in this case to be austerely universal. To modify Riegl's dictum, its will is to be without form.

In the same era as the Bauhaus were two movements in art whose ambition it was to be a definitive climax in the procession of style: Purism and De Stijl, which touched all the plastic arts, and which in Dutch literally means 'the style'. With the same penchant for geometry, the earlier (provocatively named) movement, Suprematism, spearheaded by Kasimir Malevich (1878–1935) in pre-Revolutionary Russia, sought in the most simple forms – a cross, a quadrilateral – the extent of all energies and all things. There is one thing all these 'ur' or 'supra' styles had in common – a reduction of form to the basic components of primary colours and hard, intersecting lines which in their severity threatened to eventuate the eradication of form altogether.

POSTMODERNISM AND THE CRISIS OF STYLE

At the close of his essay on style, Schapiro writes:

> A theory of style adequate to psychology and historical problems has still to be created. It waits for a deeper knowledge of the principles of form construction and expression and a unified theory of the processes of social life in which the practical means of life as well as emotional behaviour are comprised.[10]

Now when this is applied to Postmodernism, it is next to redundant. Postmodernism rejects 'a unified theory of the processes of social life' because it acknowledges, if not embraces, a lack of uniformity. Historical problems with Postmodernism have to do with its lack of coherence in comparison with the Hegelian model. We now inhabit a time which has differing conceptions of what that coherence may be, micro-histories, and histories that are as yet unwritten, or whose fit within the doxology of art history is inadequate. The crisis, if it is (was?) a crisis, of Postmodernism in art was that no style is dominant. Postmodernism represents a lack of faith in what Lyotard calls the 'master narratives' of Modernism; styles could be had for any degree or purpose – Semper's observations were prophetic. If one can take or leave styles without shedding a tear, then they have perforce lost their integrity. With only an ironic relation to style, Postmodernism must then be a movement in decline.

Craig Owens (1950–90), among a gamut of theorists since the late 1970s, prefers a different approach, arguing precisely that Postmodernism requires a reformed way of interrogating its object which is relative, not objective; suggestive rather than prescriptive. In the essay for which he is best remembered, 'The Allegorical Impulse: Toward a Theory of Postmodernism', Owens claims that Postmodern works of art are hallmarked by the way they layer meanings derived from previous visual languages to arrive at a new meaning that supplements or eclipses the old one. What he calls to mind are the artists of his generation in New York whose main practice is to reproduce other works of art: Troy Brauntuch, Sherry Levine and Robert Longo. When artists appropriate images, the style is, to use the Duchampian term, readymade. Since allegory relies on overlaying several meanings – at the most basic the surface and what lies beneath – it is constantly decentralized and is open to multiple viewpoints. Owens defends this role of allegory, arguing that allegory's supplanting of the previous model is its 'theoretic significance'. Allegorical displacement is indeed the 'coherent impulse' of Postmodernism – the central feature of Postmodernism is its drive towards decentralization.[11]

So style must be seen in entirely different terms. The style of Postmodern art lies more in the *approach* to its content rather than embedded *within* the content. This relationship assumes an ironic relation to its subject matter. But irony in the best Postmodernist sense need not be cynical but rather a plural consciousness that knows it is both part of a relationship as well as outside of it. This stance has since been enormously useful to feminist artists, most of whom warn that women are

forced to use a language shaped and dominated by men, yet insist that they inhabit another world whose parameters 'male' language cannot describe.

If I return to the conundrums faced at the beginning of this chapter, and draw on some of the material I have canvassed, we can conclude that there is more than one way of accounting for changes in Manet's style. Which is the true Baudelaire and which is the true Manet? Is the second allegorical? Is the first a caricature or does it use the style of caricature? It is good that works of art make us ask these questions.

We must not forget that styles are made by artists, as individuals or groups. It is uncommonly rare for an artist to set out to make a style when making a work of art. The styles we consider to be the most resonant are usually honest emanations of real impulses: intellectual, emotional, ethical, religious, social. We can never discount the role of individual will, even in the anonymous and devout artist who believes he performs a function for a supernumerary. We only need to turn to the delightful jokes and terrors left behind by the thousands of nameless sculptors of Gothic cathedrals. Minor exceptions to a rule, which to a later generation might be seen as seminal, help to create the slippages that keep generalizations about style from being fixed. Why did Manet alter his style so dramatically between the two portraits? In Zola's words, Manet's vision was altogether true and sincere: 'This daring man who is ridiculed has a well-disciplined technique, and if his works have an individual appearance, they owe that only to the entirely personal manner in which he sees and translates objects'.[12] Manet himself may have had no better explanation than it felt right at the time – he willed it so. It made him feel good to do so. An account of pleasure in art, described, experienced and disavowed, is what follows.

7 PLEASURE

Located in the middle of India in Rajasthan, below Agra to the north-west and Varanasi to the east, lies Khajuraho, once home to the Chandela dynasty, one of the most prominent dynasties between the tenth and thirteenth centuries which, between 950 and 1050, erected no fewer than eighty-five temples, about a quarter of which survive. It was the scene of the kind of cultural flowering comparable to Knossos in Crete between 1600 BCE and 1400 BCE, or Florence in the Renaissance, which, in its density and extent, remains mysteriously unaccountable. Khajuraho is a place concealing several deep spiritual strata: there had earlier been Buddhist settlements there and shrines of the different sects of Shaiva, Vaishnava and Jain, attesting to the Chandelas' religious tolerance.

As abruptly as it began, Khajuraho toppled in 1203, and by 1309 the Delhi Sultan Alauddin Khilji had all but eradicated any Chandelian trace. For the next five hundred years, Khajuraho lay derelict beneath the languid arms of the surrounding jungle, which had formerly acted as a deterrent to foreign invaders. Like some Eldorado, it was rediscovered in 1832 when a British engineer, T. S. Burt, stumbled across the ruins, although it took more than a century for their true significance to be recognized.

The temples are festooned with intricate masonry, the most lasting impression being the explicit erotic carvings that festoon many of their surfaces, a writhing, serpentine mass of strong, confident forms, many of whom are engaged in ravishing, carnal pleasure. Gothic cathedrals may have their share of incidental irreverence, but there is nothing in Western architecture or sculpture to match the ribaldry and sensuality of these carvings. The two shown in Figures 40 and 41 are coy in comparison to the explicit nature of many other carvings, but they are characteristic of the swaying sexual arousal of the bodies, and their wanton surrender to one another. In one scene a woman with full thighs and breasts rotund enough to make any cosmetic surgeon's pupils dilate decorates her eyes; diminutive figures stand in attendance, while in the neighbouring recesses writhe panther-like forms, flanked by smaller beings, crouching and twisted. In the other image, Shiva fondles a woman's breast whose body is bent to fit snugly into the arc of his. In this imaginary world of plenty, each encounter is topped and bottomed with foliage and decoration. Just looking at these buildings leaves a feeling of surfeited physical indulgence.

There are three popular explanations for the erotica lacing these temples. The first has to do with the myths behind the genesis of the place. A daughter of a Brahmin

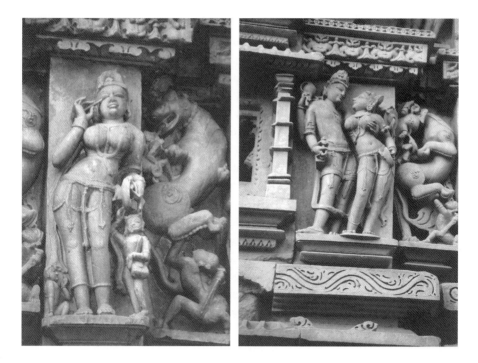

40, 41. Two temple sculptures, Khajuraho, 950–1050. Stone, main figures c. 60 cm tall. Photograph © and courtesy of Eleanor Suckling.

priest was seduced by the moon god while bathing one evening; she bore a son, Chandravarman, but, because her demigod status incited vilification, sought refuge in the forest. After her son had become the first ruler of the Chandelas, he received a visitation from his dead mother, who charged him with building shrines devoted to the human passions, with the intention of revealing the vanity and transience of human desire. The other justification is that the sculptures were made to instruct the boys bound to the law of brahmachariya about human passions in order for them to graduate to the role of 'householder'. The last is that the Chandelas were devout practitioners of Tantrism, a belief that promises attainment of the infinite through disciplined and exhaustive satisfaction of earthly desire.

One reason why there is nothing in the Western tradition to compare with this is not just because the West didn't invent anything like Tantrism, it has to do with the Neo-Platonist values dominant since the fall of the Roman Empire to the Italian Renaissance. Taking its cue from Plato of course, the Neo-Platonist view points to a world as the appearance of things. The great Neo-Platonist Plotinus (204–70), although influenced by Aristotle in several branches of his thought, did not condone the pleasures of the body, which were to be subordinated to the gratification of the spirit. In the section on happiness in *The Enneads*, Plotinus warns against distractions from the development of the intellect. He rejects the doctrine of hedonism espoused by Socrates' contemporary Aristippus, and equally the ideas of Epicurus, who advised

that we must always attend to satisfying our senses since they are components of our being. To Plotinus, happiness is related to the Good, which on this mortal earth is but the image of the higher Good; sensations are nothing without 'Reason and Authentic Intellection', without which a 'perfect life' cannot be realized. The body is full of sensory fluctuations, whereas to Plotinus, the mind's aim is for constancy. 'There is nothing but to cut away the body or the body's sensitive life and so secure that self-contained unity essential to happiness.'[2]

Let me now brings some of these coordinates together. What we are presented with on the subject of pleasure is either to surrender to the fruits of bodily desire, or to sublimate the sensuous world. To take this latter course too literally is to suspect sensual material as wicked and distracting, as we find with fundamentalist religions. It is also for this reason that some religions have and do treat art with suspicion. Pleasure is always somewhere in the work of art. This may not at first be due exclusively to beauty, or rather the beauty that the viewer finds is in the idea, the sentiment, or the objective of the art object. What drives people to art is the pleasure taken in being challenged, pleasure in being stimulated, and the extreme, pleasure from how the work of art satisfies the instinct for displeasure.

Pleasure is what we receive from a work whilst beauty is a quality of it. Beauty can be a sensuous, physical phenomenon, or it can be an idea. Art has always had a troubled relationship with the decorative, the quality of beauty that announces itself out of hand. For a work of art may look commonplace or ugly at first, until it works upon the sensibilities and the understanding, which finally accept it as beautiful.

The particular stimulation we draw from many works of art is not only that they give us pleasure, but they also engage us in the way in which that pleasure is to be achieved. In his Introduction to *A Historical Grammar of the Visual Arts*, Riegl remarks that, 'Visual Art is thus a cultural phenomenon like any other, and ultimately its evolution depends upon the same factor that governs all human cultural evolution: the world-view (*Weltanschauung*) as an expression of the human need for happiness'.[2] Happiness is the extension of pleasure, yet the pleasure from the work of art is not the same as pleasure in a good wine or a pretty frock, rather it poses tantalizing questions about how pleasure might be achieved and maintained. If the pleasure we get from art were reducible to gratifying one or more of our senses, we would not be concerned with it the way we are; it would join the ranks of eating or copulating. When we see art that represents pleasure, we perceive the suspension of that state and a promise that we can maybe achieve it. When we are glad to experience a stimulated displeasure in a work of art, we might experience a relief in experiencing a pleasure not betokened by society's mores, or the work tries to rupture the status quo to open up an alternative for a better state of affairs.

There are three main topics that I will explore below. Firstly, a handful of works that exemplify a state of profane pleasure. Secondly, the dislodgement in Modernism of beauty from its service to religion, which results in making the work of art an active agent in experimentation and critique; and thirdly the perversion of pleasure

in art when pleasure is conflated with entertainment. In Modernism, pleasure and especially beauty are treated with particular philosophic interest, as something belonging to human awareness as distinct from belonging to a deity. Once humans took active responsibility for their own thought, the meaning and apprehension of beauty was cast in a different light, as were the uses of pleasure. And if art no longer serves a higher power, what function does it serve? The answer is inconclusive except to accept that the pleasures are in the making, the seeing and the thinking. With exceptions no doubt, in the main art represents a higher form of living, either in what it conjures or in what it aims to dispel, or what it brings to those who give it the time.

In comparison to the splendid art of the Aegean or of Khajuraho, which was still about ritual pleasures, art occasioned by pleasure alone comes into force by the middle of the sixteenth century. At this time the foremost text on pleasure and happiness was Book Ten of Aristotle's *Nichomachean Ethics*:

> The view may be held that all men seek pleasure because all desire life. Life is a form of activity, and when a man engages in an activity it is always in connection with those objects and by means of those faculties which he likes best. Thus the musician exercises his sense of hearing on musical sounds, the student uses his brains upon the problems of science, and so on. The pleasure which supervenes upon these activities perfects them and so perfects life, which all men desire to have. It is understandable then that we seek pleasure, for it perfects life for each of us, and life is a desirable thing. But the question whether we desire life for the sake of pleasure or pleasure for the sake of life is one which must be dismissed for the moment. At least we may say that they appear to be bound together too intimately to admit of separation. There is no pleasure without some activity, and every activity is crowned by pleasure.[3]

One of the curious things about this period between the High Renaissance and the flowering of the Baroque is that it is associated with a fair amount of discord, which is reflected in the tensions and compositional imbalances in works that gave their name to Mannerism. The year 1527 had a singular effect on Italy and the rest of Europe, in that Rome was brutally sacked by the troops of Charles V who ravaged the city and imprisoned Pope Clement VII. The bitter effect of the pope's fall was to cast his probity into doubt, an unimpeachability that popes such as Julius II (1443–1513) and Leo X (1475–1521) had struggled so hard since the end of the fourteenth century to resolder. The rape of Rome is a convenient marker for the end the Renaissance and the beginning of new period of uncertainty, the age of doubt (Michel de Montaigne was born in 1533 and René Descartes was born in 1596, four years after Montaigne's death), and blighted by two centuries of conflict between Catholics and Protestants.

Mannerism is said to be symptomatic of the feeling of insecurity and loss, as seen in the loss of the harmonies found in the works of artists such as Raphael

and Perugino. Michelangelo's last phase, signalled in his *Last Judgement* (1536–41), commissioned by Pope Clement VII shortly before his death in 1534, is one of the first masterpieces of the Mannerist period, and a manifesto work that combines faith with doubt, for the beneficence of God is depicted entirely through terror. All the calm of religious equilibrium is sacrificed in favour of bodies that are contorted and gyrating in the throes of their retribution.

Despite the dilemmas of faith, or perhaps because of them, the mid-sixteenth century witnessed an outpouring of a huge variety of works that celebrated the marvellous, the indirect consolation, as Romanticism was later to prove, of an increasingly confusing and enlarging universe. With the adoption of gunfire in warfare and duelling, weaponry became a constant resource for artists' revenue. It was the smaller works – objets d'art from statuettes to table settings to pistols to sword pommels – that were the bread and butter of artists of the period, who took advantage of the growing availability of gold, gems and ivory thanks to increasing naval trade. Secular culture, as we know in our overly consumerist culture, is one that seeks satisfaction in the material world and in the feats of its own ingenuity. I would advise anyone with an interest in art but a dislike of war to suspend the aversion and to visit an exhibit of historic weaponry from the sixteenth and seventeenth century, where there are some of the most astonishing examples of intricate decoration to be found anywhere. Take the sporting rifle from Saxony (Figure 42) of the early 1600s, adorned with images related to hunting in a filigree of brass with fruitwood, horn and mother-of-pearl inlay. Such objects were prized among the gentry, who were fond of using them for ceremonial purposes, such as for gifts to honoured guests before the hunt.

By the end of the Renaissance, sculptors had to be skilled metalworkers as well as carvers and clay modellers. We need only scan the achievements of Flemish-born

42. Wheel-lock sporting rifle, Saxony, first quarter of the seventeenth century. Steel, brass, fruitwood with horn and mother-of-pearl inlays, and gilt. 133.7 × 18.4 × 8.3 cm; weight 5.1 kg. St Louis Art Museum.

43. Cellini, *Saliera*, Paris 1540–3. Gold, enamel, ebony;
h: 26 cm, w: 33.5 cm. © Kunsthistorisches Museum Vienna.

Florentine Giovanni Bologna, known as Giambologna, who is credited with being the first artist since antiquity to have made his career from secular as opposed to sacred works. His work, together with that of Cellini, signals a conclusive change, already staged in Renaissance works that incorporated classical mythology, towards a sumptuousness whose limits are never too great. A memorable example of this is Cellini's *Saliera* (1540–3) or salt cellar, which was commissioned by François I. His only known work in gold, the table setting's allegory is not concerned with culinary delights as might be expected, but the whole world; the sea is depicted as a man and the earth, predictably, a woman; at the base are the four winds, the times of day and general human activity. Think of this gorgeous relic next time you salt your potatoes.

Then there are the pleasures of love, and the pleasures of sharing the fruits of the earth. There are two works from roughly the same time in the early seventeenth century that celebrate these things, Velazquez's *Feast of Bacchus* (1628), and Rembrandt's *Artemisia* (1634). Painted under the spell of Rubens, Velazquez elaborates on the high realism of his earlier Seville *bodegones* or still life works, for an image that combines pageantry with the common man savouring common things. The picture comes with a number of interpretations, one being that the semi-nude figure to the left is a 'false Bacchus'; another is that it depicts a scene where Bacchus pays a visit to mortals to present them with the gift of wine. Whether or not Velazquez handles his subject with the same assurance as his later works is open to debate, but what is undeniable is that this image celebrates the efforts of mere humans to partake in worldly experiences that, all too briefly, give them a taste of higher things. It is also about bountiful charity: giving abundance to the poor; Bacchus the spreader of

44. Diego Rodriguez de Silva y Velazquez, *The Triumph of Bacchus* (or *The Drunkards*), 1628. Oil on canvas, 165 × 225 cm. © Museo del Prado.

miracles discovered in the mixed blessing of inebriation. With Velazquez one always needs to look closely at his paint-handling, masterfully controlled, whilst always responsive to its physical lusciousness. From the startlingly clear glint of the glass at Bacchus' feet to the heavy folds of the brown blanket on the right, this is a work of an artist whose discipline never eclipses the joy in what he does.

Rembrandt's *Artemesia* (1634) comes from the artist's earlier period, when he was more materially prosperous and when his paintings betray an optimism that would be replaced by introspection and melancholy in later life. Here Artemesia, Queen of Pérgmo, receives the cup containing the ashes of her loved husband, Mausolus. It is a painting exuding the fullest love with the least mawkishness and greatest frankness. Executed in the same year as his marriage to Saskia van Uylenborch, there is no doubting the artist's sincerity, for whom the glowing gold figure of Artemisia seems to exude light.

Much like Rembrandt, Goya was exuberant in youth and sombre in old age. His work *The Flower Girls* (1786/87) was painted for the royal dining room in the El Pardo Palace and is characteristic of the artist's positivity, which reigned until the death of Carlos III. The subject is the wine harvest and it is a work that stands out for its absence of any negativity while avoiding triviality. It has a lightness that comes from relaxed comfort and happiness. This genre of work was also popular in France, though candied with greater hedonism and provocative sensuality. In the late

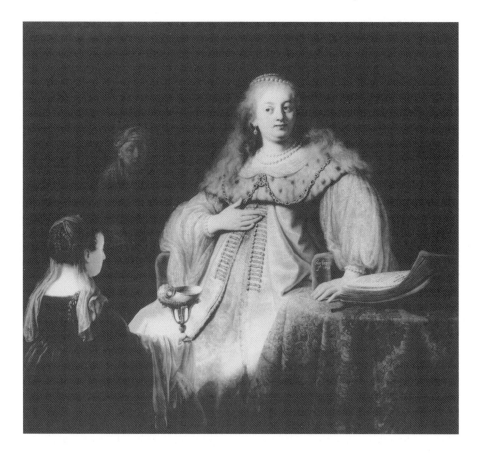

45. Rembrandt van Rijn, *Artemesia*, 1634. Oil on canvas, 142 × 153 cm. © Museo del Prado.

eighteenth century, writers such as the Goncourt Brothers looked back nostalgically on the eighteenth century as an age of lost joy. When we look at Goya's later paintings such as his gathering of crones in *Witches' Sabbath* (1821/23), a work drained of any happiness or redemption, and his brooding etchings, there is a distinct fall from grace. It is as if the artist nurses a deep unhealed wound.

By the late eighteenth century, however, there was growing identification with the role of pain and terror within beauty.

AESTHETICS

In everyday parlance 'aesthetic' means pleasing to the senses, or something with artistic orientation, denoting a special quality of life and a plea for refinement. Aesthetics began to be discussed seriously in the middle of the eighteenth century: in 1746 the Abbé Charles Batteux proposed that the arts should be grouped together for the investigation of fine art and Alexander Baumgarten introduced the term 'aesthetics' in his *Reflections on Poetry* (1735). Nonetheless, his *Aesthetica* (1750) was

46. Francisco de Goya, *The Flower Girls* (Las Floreras), 1786/7.
Oil on canvas, 277 × 192 cm. © Museo del Prado.

concerned principally with the world of the senses as distinct from the apprehensions of the mind. Thought since Plato had always distinguished between mind and body; both Plato and Aristotle were interested in whether art was adequate to convey knowledge and truth. But the systematic debate that springs up in the eighteenth century is as if, in the words of Terry Eagleton, philosophy 'suddenly wakes up to the fact that there is a dense, swarming territory beyond its own mental enclave which threatens to fall utterly outside its sway'. For the first time, philosophers in the eighteenth century began to take seriously phenomena such as smelling a rose or looking at a sunset, and the aesthetic effect that these experiences beget. To Eagleton, the questions of late eighteenth century coalesced into something like: 'Must the life of the body be given up on, as the sheer unthinkable other of thought, or are its mysterious ways somehow mappable by intellection in what would then prove a wholly novel science, the science of sensibility itself?'[4]

Although not concerned with art or beauty per se, Baumgarten's treatise did offer alternative philosophical viewpoints that would take the experience of beauty and pleasure seriously, albeit that Baumgarten placed his aesthetics as the *ratio inferior* to logic. The aesthetic was the manner in which the mind made sense of diffuse sensory

material to produce a response, an affect. An affect that is pleasing can often be 'confused' with the good.[5]

Leaving aside the desultory nature of Hume's aesthetics and the fact that he appears to take only poetry seriously as a pleasure-giving art, his reflections on beauty (to be found well before the 1757 'On the Standard of Taste' in *A Treatise on Human Nature*, 1739–40) crystallized the work of his direct predecessors, especially the work of Francis Hutcheson (1694–1746) and Joseph Addison (1672–1719), in particular the latter's essays of 1709–15. Hume (1711–76) accepts that the experience of beauty is not just something felt, it is processed through the imagination. The positive emotions that beauty evokes are the first steps towards moral judgement. Chiming with Hutcheson, Hume accepts that value judgements are subjective rather than reasonable. They are therefore irreducible and unaccountable and their conclusions are relative, although they are deducible to a family of values. (Wittgenstein would later take up these ideas in a far more worked fashion.)

Kant's *Critique of Judgement*, or *Third Critique* (1790) – following the *Critiques of Pure Reason* (1781) and *Practical Reason* (1788) – is widely regarded as the cornerstone of modern aesthetics and resumes Hume's ideas, especially with regard to the moral ramifications of the contemplation of the beautiful and the primacy given to the constructs and limitations of human perception. But Kant's treatise is altogether more rigorous, and is still actively discussed today.

Kant put forward that the contemplation of beauty was 'purposiveness (or functionality) without a purpose' – *Zweckmässigkeit ohne Zweck*. This was to say that the contemplator had a sense of direction that, crucially, was not linked to a concept. The claims of taste are subjective and based on feeling even if they make us feel we are being convinced of something far more consequential. Our response to beauty is without the ability to explain it in terms of a causal chain or through dismantling the object and recomposing it bit by bit. According to Kant, we base judgements of taste on the degree to which an object brings us pleasure or aversion. Beauty can be free or dependent. Our taste acts upon the former, and while the latter is linked to some kind of purpose, which usually involves the issue of perfection, it is linked to set of intellectual justifications. Then there is the sublime (which comes from the Latin *sublimis* meaning 'above the lintel': what is over our heads), which shares the conceptlessness of beauty yet cannot be linked to an object. The sublime is the beyond of our sense perception, a phenomenon beyond our reach: the vastness of a landscape for instance. The experience of nature is a case of the 'dynamic sublime' wherein we sense something unfathomable that extends beyond the data of what we directly perceive.

There have been many discourses on the sublime, most notably by Longinus (first century CE), and Addison and Burke (1729–97), but Kant's is the most sustained account and was hugely influential on recent thinkers such as Adorno and Lyotard. Despite Kant being invoked as an orthodoxy within discussions of art and aesthetics, his *Third Critique* was not concerned with art per se. Kant was not that interested in art or pleasure but in self-knowledge and human freedom.

George Santayana (1863–1952), more worldly in his grasp of pleasure and the beautiful, defined beauty as 'pleasure objectified'. The word 'sense' in *The Sense of Beauty* (1896) is purposely ambiguous, suggesting that we have a sense of beauty that is like our other five senses but more latent but no less present. Santayana's philosophical precursor is Schopenhauer (another disciple of Kant's) who held that when we perceive beauty it is the closest state we have to actualizing our will, which is what defines and sustains all our actions. Our will seeks satisfaction through pleasure; in beauty is the promise of pleasure which offers temporary (ultimately unsatisfactory) release from the nagging will. Echoing Schopenhauer, Santayana also separates the world of representation from that of feelings. When we experience beauty, we are touched by something deeper than the plain and superficial image of the thing and are directed to an image of more pleasurable states of being. Elsewhere, in *Realms of Being*, Santayana refers to beauty as what inspires 'a special emotion, half wonder, half love [...] The beautiful is the great liberator of other essences'.[6] With beauty we are liberated from the lethargy of habit, and from restraint, to pleasure created through allowing our inner being to feel at harmony with the outer world.

I refer the reader back to the introduction and to Hazlitt's call for respect for a cultivated eye in appreciating art. We find something similar in Santayana who says that 'the world is so much more beautiful to a poet or an artist than to an ordinary man. Each object, as his aesthetic sense is developed, is perhaps less beautiful to the uncritical eye'.[7] Like a blind person who must cultivate the other senses to compensate for the one lost, or the sharpshooter whose eyesight only gets more acute with the continued practice of taking aim, the poet and artist, for Santayana, have trained their 'sense of beauty' to afford them a deeper sensory understanding of things and a more rounded responsiveness to the world.

While on this idea, it is worth ending this section with two exhilarating passages from Hazlitt's 'On the Pleasure of Painting':

> Those winter days, with the gleams of sunshine coming through the chapel-windows, and cheered by the notes of the robin-redbreast in our garden (that 'ever in the haunch of winter sings') – as my afternoon's work drew to a close – were among the happiest of my life. When I gave the effect I intended to any part of the picture for which I had prepared my colours, when I imitated the roughness of the skin by a lucky stroke of the pencil, when I hit the clear pearly tone of a vein, when I gave the ruddy complexion of health, the blood circulating under the broad shadows of one side of the face, I thought my fortune made; or rather it was already more than made, in my fancying that I might one day say like Correggio, '*I am also a painter!*'
>
> What is the state of mind of the artist while he is at work? He is then in the act of realizing the highest idea he can form of beauty and grandeur: he conceives, he embodies that which he understands and loves best: that is, he is in full and perfect possession of that which is to him the source of the highest happiness and intellectual excitement which he can enjoy.[8]

THE ENDS OF BEAUTY AND PLEASURE

Of all the lasting comments about art and pleasure in the twentieth century, Matisse's statement that 'Art must be like a comfortable armchair' is the most emblematic. It is such a straight statement as to be enigmatic, and it is also ostensibly incongruous with the instrumental aims of the avant-garde. Since the late eighteenth century, and artists such as Goya, the Romantics had wallowed in the possibilities of ugliness, danger and absurdity. The Gothic (initially a pejorative with connotations of crudity) revival, which embraced anything from novels to architecture, is part of this general urge. In an extended preface to his history play *Cromwell* (1827), France's Romantic lion, Victor Hugo (1802–85) wrote his treatise on the grotesque as an alternative to straight beauty. With the potential to make the ugly beautiful, the grotesque, to the Romantic mind, was truer to the human condition because it visibly contained suffering.

Confidence in beauty and pleasure began to erode at the end of the nineteenth century as a result of seismic social upheavals such as the depredations brought about from the mass migrations of country people into cities unequipped for them, the social alienation of industrialization, and a succession of brutal wars beginning with the Crimean War (1854–6), the wars of German unification culminating in the Franco-Prussian War (1870–71), and the British imperial wars such as the Boer Wars (1880–81 and 1899–1901). By the First World War, the idea of beauty in art was all but exhausted. While it may be true that aestheticism played a significant role in Symbolism at the turn of the nineteenth century and in Surrealism, the kinds of pleasures that the respective ethos of these movements portrayed were firmly rooted in the Romantic premonition of death, decay and putrefaction. With Symbolism there is typically a femme fatale, a 'belle dame sans merci' to tarnish the allure, or a skeleton in the closet, as we find in Wilde's allegorical tale of worldly beauty and self-destruction, *The Portrait of Dorian Grey* (1891); with Surrealism the beauty exists as the remnant of some perversion, the virginal surface awaits its imminent defilement.

By the beginning of the twentieth century, certain artistic circles sniffed suspiciously at beauty that presumed innocence. For beauty and pleasure were seen as infected by socially oblivious bourgeois hedonism. And after the war, with mass grief, shame and disgruntlement, beauty was all but a corrupted, debased idea, associated with imperial decadence. A ravaged world that could still smell death required new forms of consolation. Straight representation of pleasure was anodyne and irresponsible.

The painting, *To Beauty* (1922) by Otto Dix (1891–1969) is as good an example of an era's wallowing in its fall from innocence as one will find. The preposition 'to' in the title is the fist suggestion of the work's dour irony. The picture is not about beauty, nor beautiful, but about the way that beauty has fallen prey to the pursuit of shallow pleasures. There is nothing beautiful about this painting in a conventional sense. Standing in the midst of a teeming brothel, the artist stares out at us with a

47. Otto Dix, *To Beauty*, 1922. Oil on canvas, 140 × 122 cm. Heydt-Museum, Wuppertal. © Bild-Kunst; Licensed by VISCOPY, Sydney, 2007.

mixture of cynical resignation, suspicion and complicity. A crazed black drummer leers menacingly on the right while a pale-faced vampire of a man on the left is about to slink off with a prostitute. The shabby girders of the ceiling amplify the kitschy faux-classical capitals. As a testament to moral squalor, it is a merciless testament to a fall from grace, the soullessness of pleasure, and is steeped in foreboding. Paintings like these by Dix and his contemporaries – under the banner of the Die Neue Sachlichkeit (loosely translated as 'the new objectivity'), which included Grosz (1893–1959), Beckmann (1884–1950), Hubbuch (1891–1979), Schad (1894–1982) and Schrimpf (1889–1938) – remorselessly portray the faithless decadence of the emptied German soul of Weimar Germany. Their caustic realism casts a sad eye over a world that has given up on lasting happiness.

To mark the Second World War's negative effect on world consciousness, Theodor Adorno made the lapidary statement: 'To write poetry after Auschwitz is barbaric.'[9] Published in 1967, it has been a catch-cry for several generations of artists and intellectuals for whom the Jewish Holocaust's unthinkable horror obliterated the philosophical notion that humans are essentially good and that a better world is

possible. For humans to be capable of such systematic evil implies a loss of mastery; the control with which the Holocaust was undertaken calls the order of civilization into grave account. Poetry, for Adorno, is all art that gives us pleasure through a beauty it upholds as an aspiration. Now both aspiration and the truth in that beauty are lost. Adorno's statement suggests that art must commit itself to eternal displacement.

Adorno's definition of the post-war condition of distrust of conventional beauty finds a moving example in the existential terror that the radical dramatist Jean Genet (1910–86) responded to in the work of Alberto Giacometti (1901–66), in a series of responses assembled under the rubric, *The Studio of Alberto Giacometti* (1958–63) (which Picasso pronounced the best essay on art he had ever read). Plain in language, honest in tenor: as a piece of writing it is an exploration of personal affect. When confronted with Giacometti's sculptures, Genet feels the presence of something divine. He is also confronted with the origin of beauty, the wound within us:

> There is no other source of beauty than the wound – singular, different for each person, hidden or visible, that every man keeps within, that he reserves and to where he withdraws when he wants to leave the world behind for a temporary but deep solitude. It is therefore far from the kind of art known as miserabilism [a Surrealist version of the grotesque]. It seems to me that the art of Giacometti wants to reveal this secret wound within every being if not of everything for the sake of their illumination.[10]

48. Alexander Liberman, *Giacometti*, 1955. Chromogenic print, 31 × 49.2 cm. Research Library, The Getty Research Institute. Letter sent, favourable reply given, then no further correspondence.

ART AND ENTERTAINMENT

If one of the reasons for the distrust of beauty and pleasure after the Second World War is the unremitting legacy of atrocity (and since then its repetition from Bosnia to Rwanda), the other is its cheapening through mass marketing, kitsch and globalization. Written before the idea of globalization entered common currency, Adorno and Horkheimer's essay, 'The Culture Industry: Enlightenment as Mass Deception' first published in 1944 (revised 1947), is nevertheless as relevant as ever.

To Adorno and Horkheimer, the culture industry of popular music, cinema, television and advertising lulls its receivers into a state of torpor, of false pleasure, deluding them into believing that they are in full possession of their free will. This counterfeit bliss involves a welter of vulgarizing compromises – in today's parlance, dumbing down: 'a movement from a Beethoven Symphony is crudely "adapted" for a film soundtrack in the same way as a Tolstoy novel is garbled in a film script'.[11] Mass media gives its audience everything and more; the arts are willingly bowdlerized and conglomerated, expurgated or refashioned. In commercial film, people expect a hackneyed plot and a certain ending and are disappointed when they do not get it. The same goes for the structured temporal and formulaic limitations of commercial music. In a statement that presages Baudrillard, they exclaim that 'Real life is becoming indistinguishable from movies.'[12] The public are encouraged neither to imagine nor to reason for themselves. The manner in which mass media shields its audience from the plain realities of being human robs humans of the power to create for themselves a happiness external to what has already been defined for them by the mass-marketed juggernaut of the culture industry.

The effect of this muzak life on art? Adorno and Horkheimer yearned for the possibility for art to sing over the cacophony. One of the ways for art to counter the industry that constantly undermines it is to adopt for itself a critical stance that all but eschews the kind of beauty that makes the gormless public hallucinate. If not, art becomes as shallow as anything else. Art is forced into entertainment at certain intervals since it must give its audiences a modicum of what they know, or else it never has a chance to enter into public discourse. But whereas art is supposed to be a creditable form of knowledge, 'the culture industry perpetually cheats its customers of what it perpetually promises',[13] since the real promise within the commodified image is not that we will be led to a better way of thinking, but that we will continue to be entertained. It is barbarism hiding in the sheep's clothing of civilization.

More recently, Jonathan Vickery, among numerous other critics and artists, has commented that much art is indistinguishable from the entertainment to which it is meant to be a significant foil. Vickery argues that society has largely lost its ability to discriminate between knowledge and information,[14] knowledge implying a method, information being just unqualified material, like data downloaded on to a computer desktop. An example is the recent phenomenon of 'YBA' – Young British Artists – that emerged in the late 1990s; this actually meant the collection of the advertising magnate Charles Saatchi. Touted as the next great wave in art, it was

indistinguishable from an elaborate marketing stunt, but it was unstoppable, and Saatchi's collection travelled to many of the blue-chip contemporary art exhibition centres throughout the world. Young artists were agog at its sensationalism, the most notorious being Damien Hirst's (b. 1965) *The Physical Impossibility of Death in the Mind of Someone* (1991), a fourteen-foot tiger shark in a case of formaldehyde that was no different from an exhibit in a natural history museum. There are many other

49. William Kentridge, *Preparing the Flute*, 2005. Model theatre installation with two 35-mm animated films transferred to DVD. 241.6 × 114 × 154 cm. Courtesy of Marian Goodman Gallery, New York and Paris.

examples of artists who exhort surprise from their audience or are happy to make jokes, long after the transgressive jokiness of Dada and Pop Art. In his chapter 'Art and Amusement' in *The Principles of Art*, R. G. Collingwood draws attention to the fact that amusement is bound to date. In Collingwood we find an answer to why artist-entertainers are so widely approved, not just because their goal is to elicit quick pleasure but also because: 'So long as art is identified with amusement, criticism is impossible.'[15]

But all this not to imply that art is doomed. The fusion of several of the arts into one, which Adorno and Horkheimer warned about, is well and truly the norm with video art and multimedia installations. That something like video art is an accepted and developed art form has partly been due to the success with which artists can continue to address concerns that existed well prior to the medium itself, and the way in which it has come to be used as a formidable critical weapon against the other more decorative and manipulative audiovisual forms, notably certain commercial films and selectively partisan newscasting.

Figure 49 is not video art but it does involve animation and it is about entertainment. But it is here for the purpose of ending this chapter on a positive note. William Kentridge's sets interpreting Mozart's *Magic Flute* are a revelation for the way they infuse the artist's signature style with a form of mechanical phantasmagoria dating from the late Renaissance: mobile sets, flickering backdrops, stylized silhouettes, orchestrated tableaux. Kentridge's (b. 1955) work is also inspired by the earliest narrative films, in particular the brilliantly constructed scenes of the eccentric pioneer Georges Méliès (1861–1938). This work, which is as much a working set design as a work of art in its own right, is an exception to the cheap sort of art entertainment that relies on a few jokes and tricks, because the work returns to a certain history of illusion and fantasy in opera and theatre, and, like Mozart's opera itself, makes adults reflect on the fantasy lands they inhabited as children. All good art is entertaining inasmuch as we are entertained by what is stimulating and challenging. Instead of the disingenuous trick, Kentridge's work delights through a modesty that is always fascinated with the way things work, down to their simplest phenomenal components, whether that be the movement of an rhino's hoof or a girl raising her arm, which can also often be the preoccupation of childhood wonder.

8 MONEY

Art's relationship with money begins with patronage. When under the shadow of religious ritual, art is financed by the religious body it obediently serves, the artists often remaining anonymous, as in the Middle Ages, when artists were artisans whose duty was to describe the stories and virtues of the Christian faith. Artistic innovation was not an issue, since the artist-artisan's duty was to discharge objectives within set prescriptions. They were paid for their creations as a carpenter would be for a table or a tailor a coat. The late Middle Ages saw the advent of trade routes on land and sea, which resulted in a greater influx of goods. People became more demanding and discriminating, suppliers more competitive. For those in secondary production, in the arts as elsewhere, increased competition accompanied the desire to garner attention through novelty, invention or efficiency. And thus in the Renaissance the flowering of the notion of genius: the artist attracts patrons for his ability to distinguish himself, which reflects directly back on the distinction of the patron. Patronage is therefore not just a matter of spending riches, it is what secures these riches and justifies them. The central paradox of patronage is that it engenders a culture of prosperity that reverses the perception of the patron's fortunes: art comes to be seen not as a result, but a cause of the patron's success, like securing a birthright after the birth, a favourite ruse of usurpers and bastard princes.

Just as the relationship between artist and patron was so often built on a healthy contempt, the relationship between art and money is agonistic, fraught by inequities, morality and guilt. How can an object like a painting made of cloth, wood, oil and pigment be worth more than a housing estate? The answer lies in the mystery – which is its religious legacy – that art enjoys, of being above or outside the world. Abstract in value and speaking the unspeakable, some works of art do this better than others, but the unfortunate pitfall is that artistic merit may become conflated with the price laid on its ineffable power, confusing monetary with spiritual, or symbolic value. This displaces the function of art to become just a cog or rivet in the colossal international monetary machine. While art's first encounters with patronage were to represent wealth, its ensuing purpose was to transcend it, making art all the more desirable, and ironically, monetarily valuable. The persona of the artist was, and is, also an essential tool in marketing the mystique that attracts curiosity and desire.

Patronage featured in ancient Rome, which drew the distinction between the dispensing of political favour, or what Renaissance Italy called *clientelismo*, and support

of the arts, *mecenatismo*, coined after the great literary patron and friend of Augustus Octavian, Gaius Maecenas (70 BCE to 8 BCE). Patronage was also a feature in early feudal Japan, where wealth was conspicuously imbalanced. Nobles were expected to engage in tasks, to wear clothes, dine on plate and to inhabit places commensurate with their perceived status. But the system we have today originated with the bankers and princes (as with the Medici and Sforza dynasties) of Renaissance Italy, who surrounded themselves not only with artists, but with astrologers, alchemists, scholars and philosophers, as well as the breed that will always dog patronage, the fraud. This came at a period, around the mid- to late 1300s, when princes were beginning to take on such people as part of an inner circle, or *familiaris*, separate from the family, military or civic domain. The pursuit of abstract knowledge reserved for an elite few was part of Neo-Platonist ambitions of rulers conscious of the fact that power lay not solely in tyranny but in ideas. A new social value had begun to take shape. Courtly prosperity was measured not just on grain and gold but on cultural richness: the people it could attract and the quality of the art produced for which rulers were apt to pay handsomely.

Patronage was always a tricky business. As Ingrid Rowland, in her study of the Renaissance suggests, in many cases the line between *mecenatismo* and *clientelismo* was muddied, as with for example Raphael (1483–1520) or Sebastian di Piombo (*c.* 1485–1527), who had administrative sinecures in gratitude for their artistic services, while Machiavelli and Guicciardini, who held political appointments, also nursed literary ambitions.[1] Families with scions in both the clergy and ruling nobility, which was not unusual, found themselves having to manoeuvre between their various interests, normally negotiated so they could be covertly met rather than foregone.

Once artists had forged a separate relationship for themselves and a class distinct from artisanship, and once they were deemed guardians of taste, experience and feeling, the issue of patronage could often be moot. By the end of the eighteenth century, works of art were seen to be superior to tribulations about money. But artists need to live, however inflated their self-importance. For this, an ersatz form of payment, the honorarium, was invented. Artists could thus be paid without feeling like salaried workers or usurers. It is still a term that is often used today – as in Germany (*Honorar*) – in place of the flat contemporary phrase, 'artist's fee'.

From the sixteenth century onwards, painting was conspicuously about, and descriptive of, wealth. The development of Dutch and Spanish painting in the seventeenth century was thanks to their naval supremacy and the high rate of foreign trade. Holland became so prosperous that it suffered from what one historian has called 'an embarrassment of riches'. As a middle-class mercantile culture, the most popular paintings in Holland at the time were people enjoying everyday pursuits (the genre known as genre painting), portraits, and still lifes describing the plenty around them. The still life had numerous functions, pre-eminently as the expression of *vanitas*, the vanity of earthly things which, when taken optimistically, meant relishing the profusion of objects in a transient world. It was also a convenient way

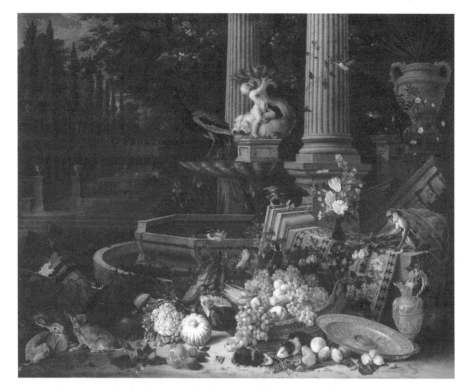

50. Peeter Gysels, *Still Life near a Fountain*, c. 1685. 38 × 47 cm. © Rijksmuseum, Amsterdam.

of flaunting possessions, especially when curios, flowers and musical instruments and the occasional parrot were concerned. In a work by the Flemish artist Peeter Gysels (1621–90), shown in Figure 50, the artist combines landscape with still life to depict a world that is divinely benevolent. It is representative of work in this era for the way it combines taught empirical observation with a fanciful design. Still life accounted for what was closest to hand in a culture overflowing with everyday things, an emporium mundi or consumers' paradise, and a culture whose lowly worker, an astounded Diderot remarked on his visit there, was better fed than many average gentlemen in other lands.

But maybe because of its materialism, many thinkers of the early nineteenth century – Hegel and Hazlitt come to mind – thought Dutch art bland in comparison to the great feats of the Venetians and the magnificence of the court of Louis XIV. The painting, sculpture and architecture of the Baroque period, which has to take account not only of France but what was then the Habsburg Empire, which stretched from northern Italy to eastern Europe, produced the most splendidly unapologetic statements of prosperity and opulence – even when the kings and princes were parlously in the red. (As indeed Louis XIV was in the second half of his reign after spending on a dizzyingly lavish scale and successive defeats at the hands of the Duke of Marlborough.) And as we see in the massive tomb sculptures of this time throughout Europe, patrons were as lavish in death as they were in life.

MARKETING THE ARTIST

The Napoleonic years taught that people could rise in society on the basis of talent as well as birth, which was after all the secret to the success of his marshals, many of whom were born commoners. For the Romantic youth of the early nineteenth century, an individual's worth was directed towards inner experience. When we inspect self-portraits from this era, they have more than their fair share of stern brows, close-set lips, tousled hair and florid cravats spilling out from tight coats. The age of the *poète maudit*, or embattled artist, lasted until the beginning of the next century. He was the paragon of the isolated artist, left to his own devices, inhabiting his own imaginative, subjective universe. The revolutionary era was also an era of self-conscious genius.

And it was particularly those less gifted artists who monopolized on educated society's willingness to be duped by the flamboyant spectacle of the artistic, bohemian persona. This curiosity became a convenient myth for artists for whom commercial livelihoods were far less secure, owing to the more desultory and scaled-down nature of bourgeois patronage and also to the fact that there were a lot more

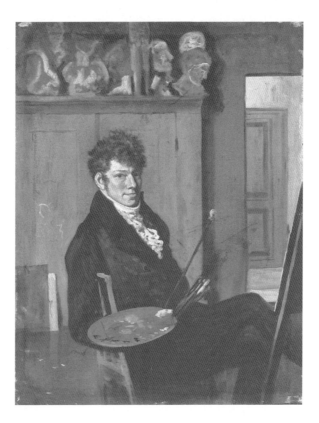

51. Wouter van Troostwijk, *Self-Portrait*, 1809. Oil on cardboard mounted on panel, 51.3 × 40 cm. © Rijksmuseum, Amsterdam.

artists circling around the honey pot. Rather than being integrated into society when art was integrated with ritual, in a fiscally rationalized society, artists were purveyors of what could not be accurately valued, much less adequately understood. Inevitably, artists without the right social or academic connections found themselves branded outsiders, and they marketed themselves as such: radically independent, deep and tempestuous souls, they were invited to dinner parties as a foil to the proceedings (and they may have needed the feed); they styled themselves as reckless, insouciant dandies; they were snubbed and envied as great lovers; they lived out the pleasures of the flesh and experienced both its punishments and rewards. Innumerable works of art have been sold on the personal allure of the author above any real merit.

Like all myths, it has its share of truth. Art is valued because it takes risks in excess of any prosaic, unrewarding job. The social phenomenon of the artist-bohemian has now become an accepted dimension of artistic practice, acceptable from the way that artists have literally sculpted their persona so that it cannot be disassociated from what they produce. Artists from the last century who come to mind are Salvador Dalí with his cane and Dr Seuss moustache; Yves Klein (1928–62), who patented his own blue (International Klein Blue), self-consciously cast gold leaf into the Seine as a ceremony of his disregard for art commodities, or doctored photographs with himself leaping from a window; and the perennial pièce de résistance, Andy Warhol (1928–87), the ultimate perform-ance artist, who played at playing the artist. He would notoriously turn up to cocktail parties and leave once someone had photographed him. His studio, known as The Factory, was less a place of industry than an ad hoc party venue for models, musicians, junkies, weirdos, and artists both failed and made. He also made and sponsored films and founded the magazine *Interview*. Warhol's overall output is one of great ingenuity and subtlety. He was overwhelmingly struck by the idea of death, and behind his apparently imperturbable showmanship, there lurks an impenetrable personal demon that touches us as the dual nature of the satisfaction and hollowness of commercial culture.

Arguably his greatest work of art was his own celebrity. He made himself into a readymade: I point to myself; I am the work of art. Just as important as the works themselves is the fact that Andy Warhol did them – he was the ultimate signatory, the artist as brand name. Warhol was the pioneer of art's entry into the sphere of mass-market production and entertainment. He still stands out from his successors because of an inscrutably laconic temperament, which lent an air of ironic indifference to everything he did.

THE ART MARKET

The art dealer and the collector is a conspicuously modern phenomenon, born of free trade and speculation. Until around the middle of the nineteenth century, the commonest way for artists to forge a career was through the public forum (or circus) of the Salon. Optimal, for any artist, was to get his or her work purchased by the

state, or at least a collector. Young artists would be on the lookout for prospective commissions, portraits being the most common, though religious commissions were still coveted despite the loosening grip of the Church. Until the 1870s in France and a little later in other centres, the Academy, which was attached to government, exercised a crippling dominance on the artistic system, conferring legitimacy on all things artistic: it decided who could enter, decided on the curriculum, dictated priorities, organized all the major exhibitions – to which it gave ostentatious priority to the artists it trained – at which it divvied out the prizes and advised on purchases.

With this in mind, it is understandable that the new breed of independent artist, starting with Courbet (1819–77) and Millet (1814–75), were so antagonistic to the Establishment; and obversely it is easy to see why dominant academicians such as Gérôme and Bouguereau (1825–1905) tirelessly, anxiously, obstructed the success of the vanguard any way they could. A decisive blow was dealt to the Academy in Vienna in 1897, when a group of artists led by Gustav Klimt (1862–1918) announced their 'Secession', justifying their break on three counts: to keep abreast of the most progressive art of the day, to make exhibitions of a more self-sufficiently aesthetic type, and to defend modern art at every level of society, which actually meant educating the conservatives of the Habsburg regime. The Viennese Secessionists helped to widen the notion of exhibition practices and worked closely with architects and designers, developing sophisticated spaces for display, latter-day temples of art that delighted and barraged the senses. Interestingly enough, however, these formats had already been tried out in the previous decade or two in commercial galleries, albeit on a smaller scale. By the beginning of the twentieth century the Secessionists had built the foundation for the new Establishment, an entrepreneurial mentality in the artist that admitted commercial concerns as a way of furthering private experiments. Liaising between Academy and public, a shrewd artist would reap the benefits of both.

Dissent between radicals and the Establishment had already taken root since 1830, and by the end of the century, rebuffs from academicians held a cachet, certifying rebellious status, from which they and shrewd speculators stood to profit. As Pierre Bourdieu claims in *The Rules of Art*, this division between traditional-academic and radical-vanguard was an essential component in the growth of the marketplace. The mainstream quickly consumes works of art (he is also talking about novels), which get forgotten in the long term, but gives the basic infrastructural support to gallerists of publishing houses to support the minority of radicals whose reputations will outlive their commercially viable peers. The cycle of radical to established, he argues, is not internal to workings of style, it is external and an effect of perceptions driven by fashion and commercial interest. And curiously enough, it is only with the expansion of the market that classifications such as 'nude' or 'landscape' become comprehensive and more intricate: 'peasant scene', 'beach scene'. The same goes for the ways in which artists are grouped according to their media and subject matter.[2] If we accept Bourdieu's thesis, we must conclude that a significant vector of the

modern experience of the work of art is the market that drives, disseminates and ratifies it.

In 1852 the French state established an auction house, the Hôtel Drouot, to take advantage of a heated art market. It was a combination of commercial speculation and historical know-how not dissimilar from the Christie's and Sotheby's of today. As Robert Jensen makes clear in his study of the art market of this time, there were hundreds of dealers in Paris by the 1850s, but few participated in the coterie of experts used by the Hôtel Drouot. Established in 1848, just before Drouot, two firms, the Galerie Petit and the Galerie Durand-Ruel, took part in the driving power of the centralized scheme by guaranteeing authenticity of objects, making market forecasts, predicting hazards, and calling upon historians and critics to confirm an artist's importance.[3] Durand-Ruel became what Jensen calls the first major 'ideological dealer', meaning one who dealt with artists in a more than arbitrary way, but worked according to groupings of artists which reflected a particular investment in taste, in their case the best investments of all, the Realists and the Impressionists.

This aesthetic organization has carried through to the present. Galleries have aesthetic biases or generational foci that they target at prospective buyers and institutions. The biggest galleries are organized like the auction houses (to which in the 1800s they were once more closely affiliated), in so far as they employ a small cohort of administrators and experts who ensure that the artists within their stable are written about, known about by other experts, represented in major collections, in short, made part of a system that secures their marketability. Such efforts are important when dealing with an abstract value such as art, but they are dubious when mediocre artists are bolstered to ridiculous heights. Since the art market is like the stock market – an expression of confidence in abstract *quanta* – when many interests are at stake, it takes time for the value to correct itself, and sometimes it doesn't; the prices for mediocre artworks can remain unindicatively high. Art and money have a lot in common. Both are unstable; both pretend to a truth that neither can verify; both rely on consensus, conviction, desire and memory.

As auction results have shown, Impressionism and post-Impressionism are the surest bet on the commercial market, indeed anything in the bracket from about 1860 until 1910, perhaps the most sensuous phases of Modernism. It is also curious to note that many of the paintings that have commanded the top prices are of people, lending truth to the journalist's adage that if you are going to make a picture interesting, ensure that it has a person in it. At the time of the printing of this book, the top three most expensive works of art, all paintings, are: first, Gustav Klimt's portrait of Adele Bloch-Bauer (1907), moodily, haughtily peeping out from a trussed-up and flattened neo-Byzantine surface in a cavalcade of gold leaf, sold to Robert Lauder in June 2006 for $135 million, for his Neue Galerie in New York (does that make the purchase tax-deductible?). A radiant orgy of gold, the work drips wealth, so perhaps it met its destiny. The second on the list is Vincent van Gogh's portrait of Dr Gachet (1890), sold to the Japanese businessman Ryoei Saito in May 1990 for

US$82.5 million; third, also to Saito, the smaller version of Renoir's work about the young urban party, the *Moulin de la Galette* (1876) for US$78 million. Sums like these defy words.

COMMODITIES, AUCTIONEERING: BAUDRILLARD

For Baudrillard's lively and polemical discourse on the art market it is necessary to go back to Bataille, and the issue of ritual, sacrifice and exchange. For Baudrillard, the art commodity is the object par excellence of Western society's hankering for bygone objects. Art objects purchased for astronomical sums have only peripheral bearing on the circumstances which gave rise to them (their historical 'truth'), but rather are endowed with a special meaning that sanctifies their symbolic nature as eminently precious and obscure. In other words, there is absolutely nothing we can say about Klimt's portrait of Adele Bloch-Bauer that may justify the sum paid for it except maybe that other works by the same artist have had a healthy market history. The work was bought on taste and personal inclination. Its status as a fetish is double: the buyer fetishizes the work and, as a result of the sale, the work epitomizes the commodity fetish.

In this crazy process, the historical boundaries that circumscribe the object become more and more tenuous; its interest as 'most valuable object' takes over. For Baudrillard, this kind of slippage is integral to art's role within a society that has lost the continuities of symbolic exchange which bind it to mythic origins. The myths underlying being are displaced by the myth that emanates from funnelling immense amounts of capital into things; once the signifiers of blood, birth and title unravel, the symbolic energies invested in them leap into objects: bibelots, jewels, furniture, artefacts and art. With undertones of McLuhan's 'hot' and 'cool', Baudrillard examines the difference between the bygone object and the modern functional object as 'heavy' on one hand and 'light' on the other. Our techno-culture has secured the passage from what he calls 'a *metallurgic* to *semiurgic*' society, from the theatre of ritual to a floating system of indefinite values whose meaning derives from their relation to one another.[4]

The art auction, 'this crucible of the interchange of values', is the unrivalled site of symbolic exchange. Baudrillard bypasses Marx's thesis in the *Critique of Political Economy*, which states that symbolic exchange, money, is buoyed by use value: in the art auction 'economic exchange value' is exchanged for a 'pure sign', namely the work of art. This engenders an endless relay and flux that cannot be atomized to an activity or an equivalent object except those that have been subject to the same kind of exchange. Art auctions are where aristocrat-plutocrats play out their games of dominance, albeit amongst themselves. Baudrillard notes the ritual in the auction event and the personal character of the exchange (recorded in the precious

artwork's mandatory provenance: what belonged to whom for how long and where it was sold). Moreover, there is no interplay between supply and demand. Value is decided upon according to the whim of the auctioneer and the extent to which the ability to exercise that whim is flaunted. If there is any parity in the process, muses Baudrillard, it is in the individual buyer and the work he or she buys:

> In fact, what we call the 'psychology' of the art lover is also in its entirety a reduction from the system of exchange. The singularity that he asserts – that fetishist passion for the object lived as an elective affinity – is established on his recognition as a peer, by virtue of a competitive act, in a community of the privileged. He is the equal to the canvas itself, whose unique value resides in the relation of parity, or statutory privilege, which, as a sign, it maintains with the other terms of the limited corpus of paintings. Hence the 'elitist' affinity between the amateur and the canvas that psychologically connotes the very sort of value, of exchange and of aristocratic social relation that is instituted by the auction.[5]

And what of the museum as an institution which assembles artworks for the communal good rather than for individual gain? It 'acts as a *guarantee* for aristocratic exchange' on a material level, operating as a kind of 'gold bank', and at an 'organic' level, ensuring that art is valuable, and that its value plays a part in society, and in deciding which works are worth seeing over those that are not. I will return to this in the next chapter, where I will also discuss questionable entitlement and plundered objects.

For not all museums themselves are benign. Many, such as the Getty, whose trust is $8 billion, were initiated not only out of the love of art but because of tax breaks it could achieve by operating as a public museum and trust. It has recently come to light that the Getty was involved in a series of scandals involving Grecian urns acquired under illegal circumstances through the now discredited Italian dealer, Giacomo Medici. Although it never dealt with Medici directly, it is now known that the Getty acquired fragments of the same urn at different times, which they then assembled. To make matters worse, in 1996 the prominent philanthropic couple Barbara and Lawrence Fleischman loaned $400,000 to the antiquities curator, Marion True, but declined to disclose the transaction as a possible conflict of interests because of the mammoth $20 million purchase (already underway) by the Getty of their antiquities collection, which went hand in glove with an equally lucrative donation (the latter being tax-deductible). These shenanigans were revealed when it came to light that the donated corpus of antiquities contained a stolen item, an ancient Roman statue. Barbara Fleischman, who was also on the board of the Getty, resigned shortly afterwards. As can be expected, a severe dent was put into Getty's status as a tax-exempt institution.[6]

Such transactions are effected by advice, advice offered by complex specialist make-up of curators, historians, dealers and collectors; a role that until recently was embodied in one suave, sagacious and shifty type, the connoisseur.

COLLECTING AND CONNOISSEURSHIP

Early in Marcel Proust's magnum opus, *Remembrance of Things Past*, the young narrator makes the acquaintance of the novel's great aesthete, Charles Swann, son of a rich stockbroker, who spends his time in leisure consorting with the titled elite, offering society women advice on painting purchases and home decoration, while amusing himself with finding resemblances between Renaissance painting and prominent figures.

> Had it been absolutely essential to apply to Swann a social co-efficient peculiar to himself, as distinct from all the other sons of other stockbrokers in his father's position, his co-efficient would have been rather lower than theirs, because, being very simple in his habits, and having always had a craze for 'antiques' and pictures, he now lived and amassed his collections in an old house which my grandmother longed to visit [...] 'Are you really a connoisseur, now?' she would ask him; 'I ask for your own sake, as you are likely to have fakes palmed off on you by the dealers'.[7]

There is much more to this than subjective observation and social satire, for what Proust has painted is a portrait of the quintessential gentleman collector at the end of the nineteenth century, and the curiosity and scepticism he aroused. I could as easily have quoted a dozen other passages from other authors, especially Henry James, many of whose major novels are based on the pressures occasioned by the infiltration of the new wealth of America into Europe.

The robust art market of the latter half of the nineteenth century gave birth to the connoisseur (from the pre-modern French, *conoistre*, 'to know'), a gentleman of taste whose knowledge came not only from professorial wisdom but from continuing experience and lay advice. The connoisseur was conventionally someone of knowledge with the unquantifiable gifts of discernment and good taste, and such beings, like Swann (who had real prototypes in the aesthete Charles Haas and the founder of the *Gazette des Beaux-Arts*, Charles Éphrussi), were sought out by people wishing to make the right decisions, for the purpose of keeping up with the Joneses and for making profitable investments. Such commerce was in the best interests of the connoisseur who did not just hanker after recognition, but always the opportunity to view rare and beautiful objects. Connoisseurs could seldom resist becoming collectors and their passion would frequently lead them into becoming art dealers.

The great antecedent of the connoisseur is Diderot, whose most reliable source of income in middle life came from Catherine the Great (1729–96), who entrusted him with major purchases of art treasures from France and the Netherlands to grace what she planned to be her Francophile, newly enlightened empire. Many of the great works in the Hermitage are thanks to Diderot's amiable prejudices.

Already, by the end of the nineteenth century, the focus began to move from Paris to other great European cities like Vienna, London and Berlin, and to New York, which is now the hub of the commercial art world. I say 'commercial' because even if

the best work is not done there, it is where artists, dealers and collectors gather with the confidence of the best buying and selling successes and, by virtue of being in New York, with the best prestige. It is commonplace for major dealers in commercial centres in Europe (Cologne, Munich and Zurich) to have offices there, as it is seen as the international nexus of artistic affairs. It is much like what Rome was in the eighteenth century. The idea of a commercial artistic centre only came about with the invention of tourism. Rome was the last stop on the Grand Tour popularized by the British in this time, and was a place where artists gravitated to find commissions and where the affluent sought the right artist for what they had in mind. As Goethe remarked in 1787 in his *Journeys in Italy*, 'Big money is now being paid for Etruscan vases [...] There is no traveller who doesn't want to own some.'

But there was a difference between the gentleman collector and the modern speculator-dealer who monopolized on the turn of Europe's fortunes, when old patrimonies started to dry up, which forced their progeny to look across the Atlantic in order to mop up mounting debts. The king bar none of connoisseur-dealers was the son of a Jewish-Dutch immigrant to Hull in England, Joseph Duveen (1869–1939), who later became Baron Duveen of Millbank. His most famous saying, 'Europe has a great deal of art, and America has a great deal of money', was exploited mercilessly and he, more than anyone, exploited the decline of the old families and rise of the American financial empires.

Duveen's clients comprised the *Who's Who* of collectors and collections: Frick, Hearst, Huntington, Morgan, Kress, Mellon and Rockefeller. Point to a handful of masterworks in one of the American collections and the chances are that Duveen had a hand in at least a couple of them. In the process Duveen amassed enormous wealth, and built the Duveen gallery in the British Museum in his own honour to house the Elgin Marbles (for whose disastrous cleaning he was also responsible).

In 1912, Duveen entered into a private pact with the other magus of connoisseurs, Bernard Berenson (1865–1959), who in his heyday was treated as the last word in the field of attribution. The erudite Berenson and mercurial Duveen were responsible for reviving interest in the Renaissance – which then also raised their prices. Their relationship ended in acrimony just before Duveen's death in 1937, over the attribution of the *Adoration of the Shepherds* (intended for the Kress collection) which Duveen rightly attributed to Giorgione, but which Berenson hailed as a Titian. While their story is the stuff of legend and their influence one of envy, respect for them has paled, as many of their attributions have been proved to be false, some indeed are of fakes. It has given us cause to presume that this was due to cynicism as much as casual error.

The equation that both motivated and haunted connoisseurs and collectors at the turn of the century was this: culture equals class. The great magnates of the USA used art not just as a vehicle for buying class, but also as a means of expiating their sins, of cleansing their unimaginable wealth while still allowing them to be able to keep it.

There are many fascinating tales to be told, and I can only offer a glimpse. In the case of Mellon, who for most of his life had no time for art, collecting only began in his sixties. During the Depression, he bought half of the best paintings in the Hermitage, which Stalin let go for a song. Having long been victimized by F. D. Roosevelt, Mellon took revenge through beneficence, donating his collection to the National Gallery in Washington. Then there was Alfred Barnes, who made his fortune from the antiseptic drug, Argyrol, who, with the help of the dealer Paul Guillaume and luminaries such as Gertrude Stein and her brother Leo, bought up some of the finest works of early Modernism, the centrepiece being Matisse's *Joy of Life* (1905). His foundation had over 2,500 objects to its name. The paintings alone are estimated to be worth over $2 billion. To rarefy the collection all the more, it is not permitted for works from the Barnes collection to be lent out, making any visit like an act of pilgrimage.

Another interesting case is that of the names behind the Clark Institute in Williamstown, Massachusetts, two brothers of wildly different temperaments and tastes, Stephen and Sterling. Inheritors of the Singer sewing machine firm, Stephen was sedate and bourgeois, Sterling an extrovert with cosmopolitan leanings. Yet it is Stephen's collection, with its share of pioneer Modernists such as Cézanne, that holds the greater interest, Sterling having a penchant for the softly brushed idylls of Sargent and Renoir. Taken apart, the collections are studies in personal preference; taken together, they cast a wide and clear lens on the artistic developments of four decades.

But when one casts one's eyes over the gamut of any of the great collectors, one sees the victory of idiosyncrasy over objectivity. Exercising a powerful subjective will appears to be a lot more interesting that trying to please everyone. Private collections – whether in the Cognacq-Jay or Nissim de Camondo in Paris, the Beyeler in Basle, or the Wallace in London – bear the imprint of their originator, and as Walter Benjamin remarked in his famous essay on the collector, they reveal as much about the collector as what is collected. As such, they retain the stamp of the fallible individual. Collections are not motivated by the generalizing impulse to which, rightly or wrongly, many public collections are accountable. As imprinted with an individual sensibility, the private collection has many surprises and curious, incidental works that enrich the significant ones. For each work has been chosen according to imperatives that have nothing to do with public accountability. While such collections remain on display without supplementation or interference, experiencing them is frequently, in my opinion, a less depersonalizing and more rewarding experience. One has the sense of having uncovered and shared something rather than of being the witness to an aesthetic event that subsists in all its grandeur whether you are there to see it or not. Ironically, it would seem, the private collection, although born from elitism, the least democratic impulse, succeeds in highlighting the humanist function of the objects in its store, and of the particular (as opposed to general) impulse that gathered them together. As John Updike remarked in a review of an exhibition devoted to the Clark collections, 'Collectors invest in the future, assembling a perpetuation of their best, most discriminating selves.'[8]

No national budget or latter-day billionaire can realistically compete with the collections that the American magnates of the turn of the century assembled, especially since museums will do anything to avoid de-acquisition. An alternative for the contemporary collector is to buy from the present, and hope that in time the works will experience a similarly favourable fate.

ART ABOUT MONEY

In one of those curiosities in the annals of historical beginnings and ends, Pop Art originated in England, not America (just like Romanticism originated in Germany, not France) – reputedly attributed to a collage work of Eduardo Paolozzi (1924–2005) in which the word 'pop' issues from a gun, Peter Blake (b. 1932) (designer of the classic album cover for *Sergeant Pepper* by the Beatles), and the critic Lawrence Alloway (1926–90) (who is credited with coining the term).[9] Pop Art was in many ways a logical phenomenon. America's economy had been artificially heated by the war effort, which led to the boom decades of the 1950s and 1960s. Many artists of the generation that followed the Abstract Expressionists were tired of earnest navel-gazing, preferring to turn their eye to the teaming outside world of commodity fetishism that was drowning out the solitary voices of men caught up in their own internalized tragedies. Urban nature, as the Pop artists saw it, did not consist in trees, pastures and peasant girls, but in the objects geared for consumer desire, a world bright in colour and dim on subtlety. Many of the Pop artists came from commercial backgrounds: Lichtenstein (1923–97) graphic design, Warhol advertising and Rosenquist (b. 1933) billboard painting. Pop is an art that has no compunction about poetizing the arbitrary, stereotypical signs that spill unremittingly from the capitalist funnel. It was also astonishing to see artists renouncing the transcendent quality of art, so single-mindedly pursued by Abstract Expressionism, to embrace the vulgar commodity.

Pop Art enjoyed a revival in the boom years of the mid-1980s, in which artists, especially American, took special licence in the notion that art holds a mirror to its times. Their indulgence was to make art that was shamelessly overblown about the shamelessly overblown. Jeff Koons's *Michael Jackson and Bubbles* (1988), reputedly the biggest porcelain in the world, has become something of a symbol of the high-flung art of the 1980s.

Works such as these beg serious questions about the social function of the artist and the nature of artistic commentary. Artists such as Koons (b. 1955; who also financed his first major series from money earned from playing the stock market) argue that kitsch is the most accessible and pervasive factor in our lives, and to deny it is to make art that denies the truth. (At the same time as this, most conspicuously following the 1987 market crash, other artists adopted a newfangled *Arte Povera*-cum-Dada now known as grunge art, which aspires to all that is formless, dilapidated and crude, a sign of déclassé urban hardship.)

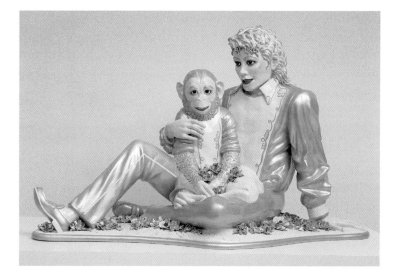

52. Jeff Koons, *Michael Jackson and Bubbles*, 1988. Ceramic, 1067 × 1791 × 826 mm. © Courtesy of the artist and the Astrup Fearnley Museum of Modern Art, Oslo.

The critical claims of the disproportionately commodified art object are caught within a cyclic argument, which I will attempt to conclude with here. One of the reasons why art treasures command such astronomical prices is for the very reason that they are believed to have meanings that are unique or at least hugely rare. But we must question art that is about the commodity which assumes the status of commodity about which it is a commentary – such art has it both ways, setting itself both above the discourse, commenting upon it, and within that discourse, profiting from it. When art engages in meanings that are about those which it proudly sets itself above, and especially money, it is dealing with something whose virtue is its limiting, simplifying power, and is therefore trafficking in fool's gold. The world still subjugates the majority of women. Does this pardon sexist art that justifies itself with the call that the world is sexist? Or racist, classist art that supposedly truthfully reflects a racist world? How shallow.

But to make affairs more complicated, it might still be tenable to suggest that Koons is a great artist – add to this that his prices are among the highest for any living artist, and that three years after it was made, the *Michael Jackson and Bubbles* sold for US$5,616,750 – because he most precisely, graphically and memorably captures after Warhol the socio-aesthetic phenomenon of stardom and the massive accumulation of capital. It is his work that comes to mind upon any mention of artworks about money that make money. The circle is complete.

To combat what to many is a critically self-defeating practice that is simply about the inequities in the system, artists continue to resort to non-material practices that question the market and the museums that represent it. This is one of the ideas in the chapter that follows, on museums and on modes of display that try to destabilize them.

9 DISPLAY

53. Impressionist Gallery, Musée D'Orsay, Paris. Photograph by the author.

'I don't like museums much' wrote a disenchanted Paul Valéry (1871–1945), in 1923. Now that museums are a way of life and new ones are being designed and built every year, it is a complaint that may sound overly shrill, but it is still resonant today. After his opening strike, he states,

> There is much that is admirable about them, but nothing delightful. Ideas of order, conservation and public utility, exact and clear as they may be, have little to do with delight. [...] Upon my first step toward the things of beauty, a hand takes my cane, a notice tells me not to smoke.
>
> Already numbed by authority and feeling constricted, I make my way into a room full of sculpture where reigns but cold confusion. [...] I am within a tumult of frozen creatures, each of which requires but is not afforded, inexistence of the other.

For Valéry, museums are modern vales of death. Rather than offering a satisfying aesthetic experience, the artworks, wrenched from their roots, lovelessly satisfy a purpose foreign to the circumstances of their creation. Edification has won out over contemplation, instruction over pleasure; the museum 'makes scholars of us'. With shades of George Eliot's haggard Casaubon, whose erudition was just a loveless compensation for his inadequacy with the world –

> In matters of art, erudition is a kind of defeat: it clarifies to the detriment of delicacy, renders the inessential profound. It substitutes sensations for hypotheses, the spirit of wonder for prodigious memory, annexing a limitless library into the museum. Venus is transformed into a document.[1]

Valéry's thoughts lend themselves to anyone who has been jostled by someone walking backwards with an audio guide affixed to the ear, or whose private contemplation had been shattered by a voice on the intercom telling visitors of a lecture about to take place in the museum auditorium. Or who has been witness to viewers stooping to read the didactic panels, pausing all too briefly at the paintings to corroborate what they have read? It is an example of what Paul Virilio has called the degradation of vision: the outside world of advertising has anaesthetized us to experiences which require contemplation for their own sake, since everything in a world run by the media is sensationalized out of proportion and requires moral or monetary validation.[2]

It is now a truism to say that the context in which a work of art is seen is critical to its import. There are many, like Valéry, for whom museums sap works of art of their authentic context. For them, the art in museums is always a dish served cold. The counterclaim is that museums are havens for visitors who wish to free themselves temporarily from the travails of the world outside. It is a delusion, however, to think that museums are free of ideologies and agendas; on the contrary, they are rife with them. And while detractors may have real grounds for resentment, there is no escaping museums in the foreseeable future.

The grandly designed museums that have been built in the last two decades, and the others that continue to be planned, are part of a phenomenon reminiscent of the seventeenth century, of magnificent, resource-sapping architectural feats that shout the glories of high culture. The Jewish History Museum in Berlin, the Guggenheim in Bilbao, the Los Angeles Art Museum, the Milwaukee Art Museum in Wisconsin, the Musée Guimet and the Musée du Quai Branly in Paris are just some of what are alternately monstrosities or wonders, which quite often overshadow in brilliance the objects they hold. Not only is sight obscured by architectural sublimity, we are lost for words.

THE FIRST MUSEUMS

Ironically enough, conversation, social intercourse, and visual wonder were one of the sources for the first manifestation of the museum, the *Wunderkammer*, the

wonder closet or cabinet of curiosities, also known as the *studiolo* or *Kunstkabinett*. Originating in the 1500s, when sea travel flushed Europe with a profuse variety of objects, these proto-museums were not devoted to art as such. Far from it: they were a diverse conglomerate of cultural and biological rarities, with anything from the foetus of a rare species of animal to a narwhal horn, exquisite musical instrument, or artefact from a distant 'primitive' tribe. Oddities of idiosyncratic interest rubbed shoulders with articles of real value, such as antiquaries and jewels. Paintings and statues were there too, augmenting the anecdotal rapport of the objects, such as offering the picture of a place whence something came. Such collections were valued for their diversity. While it is true that collections of art and artefacts had always existed in the collections of kings and grandees since the Roman Empire and before, these are to be seen as part of the symbolic formation of dynastical wealth and power. If they were to be viewed by others, it was by a select few, indeed the pharaohs took their treasures with them to their tomb.

It is also true that paintings and sculptures were collected by all levels of gentleman amateur during the same time of the *Wunderkammer*, but what I wish to highlight is the anthropological and pseudoscientific ambitions that went into such pursuits. The *Wunderkammer* was a collection of objects assembled not solely for the sake of displaying wealth but also for intellectual curiosity, a notion that carries over into today's art museums, whose acquisitions are supposed to be justified not on quality and monetary value alone, but on interest and how they complement other items in the collection. Like many state art museums, the *Wunderkammer* aspired to something like a physical encyclopedia, albeit a lot more erratic and idiosyncratic: each object has some metonymic relation to a time, place or idea. The concept of historical contiguity would not be instituted until the mid-eighteenth century.

A famous example of one such curious plethora in England at the very end of the sixteenth century was in Whitehall. A recent commentator on William Shakespeare vividly recreates it:

> Shakespeare would have appreciated the extent to which Whitehall was ultimately about competing, contesting histories. Allusions to the Virgin Mary kept company with portraits of Reformation worthies. Fantasies of distant worlds – like the Ethiop astride a rhinoceros – fought for attention with state-of-the-art maps and globes for extending the reach of English trade and colonization. Sundials shared space with the latest in Continental clock technology. The riches contained in the palace were distantly related to those found in that sixteenth-century phenomenon called the *Wunderkammer*, or wonder cabinet. Ancestor of the modern museum, the wonder cabinet was usually a room set aside to display exotic objects. The finest of these in London probably belonged to Walter Cope, merchant-adventurer and a member of the Elizabethan Society of Antiquaries. During his London visit in 1599 Thomas Platter visited Cope's wonder cabinet 'stuffed with queer foreign objects in every corner': an African charm made of teeth, the bauble and bell of Henry VIII's fool, an Indian stone and axe and canoe, a chain made of monkey teeth, a madonna constructed of Indian feathers,

a unicorn's tail, and shoes from around the globe. In another, unnamed house of curios on London Bridge, Platter even saw 'a large live camel'.[3]

The proud assembler of the *Wunderkammer* was typically a gentlemen merchant, intellectual and scientist, being of a time when all three could coexist in one person, and when science and art were not yet as categorically divided. It was also a period when 'taste' (and then subsequently the role of connoisseurship) was only beginning to be identified as a method of discrimination. The more curious the cabinet of curiosities, the more likely its owner would be to attract visitors, locally and abroad, who would come to exchange ideas and to make their own verbal contributions about things they had seen on their travels or in rival collections. As Stephen Bann remarks, pilgrimage played a significant role in the early museums, such that visiting a shrine and collection of note became tellingly confounded. The particular air or presence of the collection/shrine went a long way in its overall appeal.[4]

Historically speaking, *Wunderkammern* appear in the age at the cusp of the Renaissance and the Baroque, between the era when the nobleman as artistic patron had relatively strong control over his social circle, and the eighteenth- and nineteenth-century Salon, whose prestige was commonly measured according to the calibre of person it could attract. This incipient museum was as essential to early scientific inquiry as it was to the most unscientific forays into the imagination. There is a contemporary equivalent. Taking their cue from the Surrealist celebration of incongruity, many installation artists working with mixed media bring together a variety of objects, using their love of juxtaposition to expose prejudice, prise out new perspectives, or to express their astonishment at the vastness of the world.

THE FIRST EXHIBITIONS

Although we associate the commercial exhibition with the open market, and the public museum with the spirit of democracy, the first step towards this kind of public display germane to the modern museum began with an autocracy. Cardinal Mazarin (1602–61), Louis XIV's chief minister at the time of 1648, founded the *Académie de Peinture et de Sculpture*, which served as the benchmark for the others that followed: sciences (1666), architecture (1671) and music (1672). In 1673 the recently founded art Academy held its first exhibition, the purpose of which was not just to impart knowledge, but centralization, to be maintained by something resembling objective standards, upheld strenuously by the first of the redoubtable Academy's masters, Charles Le Brun. By making the artists compete for honours in the annual Salon, by appealing to what Napoleon would later refer to as every man's love of 'shining baubles', the state was more assured of attracting able young artists who could then be assigned public commissions. Ancient Rome had always fostered the spirit of competition to exert its control over the bureaucracy and the military, but never in the arts. Given that in the arts egos are worn on the sleeve, peer group pressure works wonders and is the mainstay of art's most enduring vulgarization, the

competition. It is worth remembering that the Venice Biennale hands out medals, and until the end of the nineteenth century, the Paris Salon was the single biggest event in art and had the same topicality as any Dokumenta in Kassel or Whitney Biennial in New York.

From 1725 the Salon was held in the Louvre, and in 1737, it came into its own when it opened to the public. The rights of the ownership to taste thereby expanding, the work of art became the locus of public discussion and dissent. On the heels of the French, the British Royal Academy was set up in 1768 thanks to the dauntless urging of Joshua Reynolds. In contrast to the French Salon, one had to pay to enter the Royal Academy Exhibition, which was and is not state financed. But there were other motivations. Unlike the capacious Louvre, space in Somerset House, the home of the Royal Academy from 1771–1836, was restricted and an entry fee vetted the hoi polloi. A throng of powdered and spotty toffs perspiring against one another was enough.

In 1769 the Royal Academy ushered in a set of rules to which artists had to comply if they were to be considered for exhibition (e.g. 'No Picture to be received without a Frame').[5] Similar criteria governing originality, media, size and subject matter and the like are still enforced by competitions today. The need for such logistical rules was indicative of an institution whose purpose it was, through exhibition and an organized competition, to make concrete sense of a wide range of outside activity. Competitions tout themselves as a gauge of current talents and trends, and institutional rules are supposed to ensure accuracy of measure. The diversity of art in the present climate means that standards are diverse and mixed. Claims to objectivity are rhetorical at best. Let it be said that competitions are conservative by definition and many are marred by discrete agendas and bogus annual themes.

By the nineteenth century, the Salon was an annual state-sponsored event, the exhibition fully juried and opened with full pomp by a national dignitary, usually the king. By the middle of the century, a schism had opened between Academy-sanctioned and more public-oriented Realist artists, such as Courbet and the Barbizon school. In 1863 the Salon rejected an inordinate number of paintings, inciting uproar, which Napoleon III tried to mollify by establishing a satellite exhibition, the Salon des Refusés. In 1874 came the first Impressionist exhibition. From then on the ubiquity of the Salon gradually began to pale, hearing its death knell when the state withdrew funding in 1881. Then in 1903, Renoir (1841–1919) and Rodin (1840–1917), by then pillars of the French Establishment, founded the Salon d'Automne, named after the season during which the exhibition was held.

THE FIRST PUBLIC ART MUSEUMS

The Louvre needs to be singled out not just because it is the biggest art museum in the world, but because of its role in the evolution of the major public gallery. The first such venue in France was the Luxembourg Gallery, which opened in 1750 and displayed the royal collection, but even then display was limited (Wednesdays and

Saturdays for three hours) and it closed in 1779. Although the state was planning a larger gallery, and the Grand Hall had been open for temporary exhibits, the Louvre only opened to the public in earnest in the summer of 1793, when the Revolution was at its bloody height. It was proclaimed that the collection was no longer that of the state, but of the people. The Revolution had 'liberated' the palace and returned the works of art – which also included a handsome booty of plundered works from private houses – to their 'rightful' owners.[6] Common property is a standard of state nominalism today, but when we consider that at the end of the eighteenth century most of Europe was still largely feudal, for treasures to be in the hands of the common person, at least in name, was a staggering idea.

The repercussions of this cannot be underestimated. Not only did everyday people have the opportunity for an autodidactic cultural education, but artists were able to be exposed to the masters of the Renaissance and their recent past. A chief method of learning was copying; paintings and engravings of this time of the inside of the Louvre will invariably show more than one person busy at an easel. This daily practice is easily evident in this painting of the Louvre's Grand Hall by Hubert Robert, who was also one of the museum's first curators of painting. It was this freedom that later led Delacroix to declare in his journal that the best teacher was the Louvre.

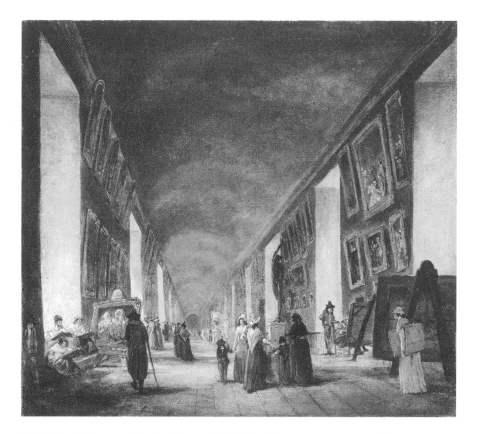

54. Hubert Robert, *La Grande Galerie, c.* 1795. 37 × 41 cm. Louvre Museum, Paris.

The next phase in the history of the Louvre came in 1799 with Napoleon's invasion of Egypt. The man leading the cultural side of Napoleon's incursion, Vivant Denon (1747–1825), later became the museum's director. As Napoleon's European campaigns wore on, Denon, faced with an ever-expanding stockpile of loot, found himself in the position of having to categorize and order. The modern curator was born.

Another important figure was Alexandre Lenoir (1761–1839), who was the main force behind the other great initiative of the Revolution, the Museum of French Monuments, officiated in 1795. Spurred by the Revolutionary need to re-write the past, the collection consisted of sculpture and architectural masonry since the Middle Ages. Since Lenoir's collection was not as diverse as that of the Louvre, whose ordering was according to cultural type and to genre, he resorted to chronology. These efforts mark the beginnings of the sequence that art history, as a nascent doctrine, inherited. Seen in such terms, what is seldom emphasized is that art history's beginnings are not solely theoretical, they begin with early museology; making sense of the objects themselves in relation to one another.

Lenoir's collection was also plunder, but this time from within France itself, supposedly to safeguard what had been housed within churches and chateaux from what the Revolution called covert 'superstition' and 'debauchery'. Viewing of such objects was now proclaimed a right: people were encouraged to see the things that exemplified their national caste. Despite Napoleon's extraction of art from their foreign homes, the domestic rhetoric was adamant about the need to preserve national treasures for posterity, as evidenced in a text from 1803 by the sculptor Louis-Pierre Deseiné:

> Artistic monuments are comparable to certain indigenous plants that will not endure transplanting. All monuments derive their appeal from the place in which they are displayed and from which they cannot be removed without killing them or stripping them of all historical, moral and historical relevance. It is the destination of a monument that gives it beauty and where it must be appreciated: only there can the historian enter into a dialogue with it and discover the causes of its production; only there will that monument make known to posterity the state of the arts and the spirit of the age in which it was made.[7]

Although more than 200 years old, the passage holds arguments regarding public collections, display and museums, that continue to be debated: context as a factor in meaning; the problems entailed when an object is removed from its place of origin; the cultural specificity of beauty; the importance of posterity; art as indicative of its time. These arguments are still on the lips of contemporary curators and spokespeople who defend cultures whose art and artefacts have been stolen from them.

AGAINST THE MUSEUM

The one-man exhibition had its origin in the growth of the commercial gallery at the close of the nineteenth century. By the time of the First World War, commerce

had swiftly become seen as a taint on art's brush. Since for many intellectuals the war was a culmination of imperial self-interest and the final sign of the redundancy of the ruling classes, they were devout about reorienting artistic concerns away from those who once patronized them. (Such diversions rarely last long.) Although he was never as interested in the political agitation of his peers, because of his legacy, it was Marcel Duchamp who has had an unequivocally lasting effect on the way art has been made, displayed and evaluated. His readymade (his word) cast the relationship between art, value, talent and skill into a state of pandemonium. Although not his first, the inverted urinal of 1917 that he signed 'R. Mutt'[8] is by far the most famous and is indispensable to any overview of the twentieth century.

In April 1917, Duchamp submitted it to the Society of Independent Artists of Grand Central Palace, New York. It was 'scandalously' rejected, since all members were entitled to a showing. Ironically, the exhibition's fame owes itself to the one object it refused to display. The rejection was followed up by an anonymous pamphlet by Duchamp and his friends, with the sardonic title *Blind Man*, which took issue with the whole affair, treating it as 'The R. Mutt Case'. For all its faux earnestness, it contains the emblematic statement that was to change art forever: 'Whether or not Mr Mutt with his own hands made the fountain or not has no importance. He CHOSE it. He took an ordinary article of life, placed it so that its useful significance disappeared under the new title and point of view – created a new thought for that object.'[9]

Duchamp's gesture had seismic repercussions for artists and curators. He had distilled the idea that art is not just an object but an effect of an indefinable, yet thickly present, matrix of choices culminating in priorities. When Duchamp performed his stunt he did so as a relatively well-known artist in the still fledgling New York art scene, having excited great interest with his *Nude Descending a Staircase* (1911) when it was exhibited in 1913 in the historical Armory Show, which essentially introduced European (French) Modernism to American shores. So Duchamp did what he did *in the capacity of* a recognized artist. He denatured ('created a new thought') for the object on several counts: by inverting it, by calling it art, and by placing it in a gallery setting.

Most probably Duchamp did not know the full consequences of his act. But the effect of his readymades (and it is now normal to refer to 'the Duchamp effect') was to draw attention to the fact that placement of an object within a gallery endows it with credentials of 'artness'. Certainly Duchamp monopolized on the fallout from his works – and he would continue to toy, in his laconic way, with the museum, refusing to exhibit for a time while still happy to act the artist. After that he re-editioned little maquettes of former readymades, placing them in a custom-designed case, the *Boîte-en-valise* – a suitcase-cum-mini art gallery. Always one for the last laugh, the artist who introduced 'context' into the evaluation of the art object was contextualizing his own work by curating his own work into a 'gallery' that could be taken anywhere.

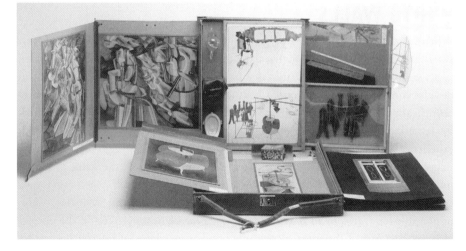

55. Duchamp, *Boîte-en-valise, Paris 1936 – New York 1941*. Cardboard box covered in red leather containing miniature replicas of works: 69 photographs, or facsimiles; interior of black cloth. 40.7 × 38.1 × 10.2 cm; when opened out: 102 × 90 × 39.5 cm. © Centre Georges Pompidou, Paris.

Duchamp played scurrilous havoc with the sanctity of the art object and in his more constructed works (such as his last great work, *Étant donnés: 1. La chute d'eau/2. Le gaz d'éclairage*, which went on show at the Philadelphia Museum of Art in June 1969) tantalized the viewer with enigmas designed never to be solved. He made us aware – and many are still unable to handle the fact, just ask a devotee of figurative oil painting – that artistic value is a linguistic relation with its own set of rules and that the gallery is like a shrine that sanctifies the objects within it.

Let me pose an airy example. Your next-door neighbour paints pictures. You find them execrable. Many years later you see one of his paintings hanging in MoMA with a solemn, erudite dedication on the didactic panel beside it. What of that? Even if your opinion is unchanged, you are forced to think twice, if only for an instant. Duchamp's readymade causes such a re-evaluation but in reverse, because it has (or had) nothing at the time that associated itself with 'Fine Art'. Were one to see said painting at a school fête, one wouldn't think twice; but its presence at MoMA means that it has institutional ratification. Like a party whose fashionability depends on how many celebrities it can attract, an art collection is judged by the proportion of important works. For an artist's work to be rubbing shoulders with Picassos or Matisses is to force the inference that it is of similar importance. What is more, if an artist's work is held in a collection of some consequence, it is a draw card for any dealer whose job it is to convince prospective buyers that they are buying prudently. Coming full circle, Duchamp's readymades (in editions), and subsequent works by numerous other artists that are, say, composed of found and prefabricated objects, now command high prices. What is considered 'fine' is now based on an intricate network of critical consensus and reputation, and, it is hoped, the way it stimulates the viewer.

WHITE WALLS

When referring to a gallery space, 'the white cube' is jargon for the ideal modernist paradigm of spare and symmetrical features that afford a seemingly unbiased appraisal of the art inside. It is still a default position for galleries (although in recent decades curators of large collections have selectively reverted to certain nineteenth-century approaches such as coloured walls, although not sharing the Salon penchant for jamming pictures together like an uneven patchwork). The implication of this experience is that we are viewing the work of art in an environment unmolested by stagecraft. It assumes that no extraneous presumptions about the work of art are imposed upon us, except what is imminent within the work itself.

One of the pioneers of the white wall was James McNeill Whistler – also responsible for *Harmony in Blue and Gold: the Peacock Room* (1876–7), the obverse of simplicity: one of the most successfully opulent marriages of interior decoration and painting in the nineteenth century. Recoiling against Victorian clutter, in gallery settings Whistler spaced his works out against a neutral ground, dispensing with distractions to enable the viewer to see the work of art as and for itself, a separate experience, disconnected from the world. It is curious, however, that the same eschewal of the natural in favour of artifice and imagination, and the same priority given to judicious spacing occurs in the Peacock Room.

The white cube takes the Renaissance metaphor that the picture is a window literally and attempts to free the work from the burden of contextual concerns. But

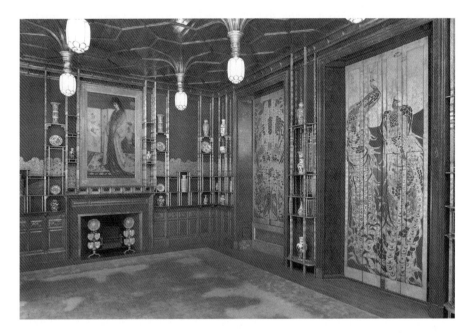

56. James McNeill Whistler, *Harmony in Blue and Gold: the Peacock Room*, 1876–7. Oil paint and gold leaf on canvas, leather and wood, 421.6 × 613.4 × 1,026.2 cm. © Freer Gallery of Art, Smithsonian Institution, Washington, DC. Gift of Charles Lang Freer.

this kind of display has fairly specific expectations of the viewer who is comfortable with seeing works of art as individual specimens of genius, rather than as operating out of a more multifarious historical soup. Curators have more recently returned to the view that, where possible, works of art should not be seen in isolation, but as comprising of family relations. The eighteenth century is a prime example, where paintings were intended for a very particular place, usually an interior. The court painter of Louis XV, François Boucher (1703–70), designed interiors, fabrics, tapestries, upholstery, ceramics and plate, which would have kept company with his painting (a visit to the former house of the collector of all things eighteenth century, Cognac-Jay in Paris, gives a rounded impression of such cross-relationships between fine and decorative art). Or take an entirely different aesthetic, a society and philosophy such as the Bauhaus, which prided itself on all levels of art and design output: from teapots to tables to wall decoration to the buildings that housed them.

So when we see furniture displayed in any decorative arts museum, it is not unusual to feel a pang of disquiet at the sheer incongruity of the experience. We may even be overcome with intellectual disgust, such as that voiced by Adorno, echoing the words of Valéry above:

> The German word, *'museal'* [museum-like], has unpleasant overtones. It describes objects to which the observer no longer has a vital relationship and which are in the process of dying. They owe their preservation more to historical respect than to the needs of the present. Museum and mausoleum are connected by more than one phonetic association. Museums are like the family sepulchres of works of art, they testify to the neutralization of culture. Art treasures are hoarded in them, and their market value leaves no room for looking at them. Nevertheless, that pleasure is dependent on the existence of museums.[10]

But, conversely, were there no museums we may not have great works preserved, and we would not have the opportunity to see them, more often than not at minimal or no cost.

THE CRITIQUE OF THE MUSEUM

The critique of the museum was carried out as a full-scale campaign amongst Conceptualists, Installation, Performance and Land Artists in the 60s. And in fact it is now common for experimental contemporary art to critique that institution, lending credence to Deleuze and Guattari's claim that there is no alternative to capitalism (of which the contemporary art institution is a manifestation) since capitalism will always adapt to absorb any new phenomena that resists it.[11]

LAND ART

The Land Art phenomenon of the late 1960s and 1970s was an effort to join art back to the forces of nature and so-called real life and is therefore connected with

the flower child, back-to-nature cults, and the hippie and yippie movements of the time. Like other experiments from this era, Land Art didn't necessarily make us re-enter into the bosom of mother earth, though it did loosen the boundaries between the inside and outside of the gallery, such that sculpture in the 'expanded field' (borrowed from the famous essay by Rosalind Krauss) or *Kunst im öffenen Raum* (art in open space) as the Germans call it, is an accepted mode of approach. Pioneers in this field include Walter de Maria (b. 1935), Michael Heizer (b. 1944), Christo (b. 1935) and Jeanne-Claude (b. 1935) and Robert Smithson (1938–73). De Maria's *Lightning Field* (1977) in south-western New Mexico uses a vast grid of 400 steel poles to attract electrical activity from the sky. The shining poles are beautiful in themselves but the work exists only at the behest of the random effects of nature. Michael Heizer is best known for *Double Negative* (1969), a 1500-ft (*c.* 450-m) trench carved into the side of the mesa in the Nevada desert. Most famous of all Earth works is Smithson's *Spiral Jetty* (1970), a vast outcrop of rock and earth spiralling from an embankment into the Great Salt Lake, Utah. Christo, together with his collaborator and partner Jeanne-Claude, has made a career of wrapping things on a mammoth scale: a section of Sydney coastline (in 1969, calling for 9300 m^2 of synthetic fabric and 56 km of rope, and 130 helpers), Pont Neuf in Paris (1984), the Berlin Reichstag (1995) and eleven islands off Miami (1983) have been the temporary hosts to their mammoth condom-conceits. Smithson stated that he 'would let the site determine what [he] would build'. How his idea came to him is laced with latter-day mysticism. To him, 'The site was a rotary that enclosed itself in an immense roundness. From the gyrating space emerged the possibility of the Spiral Jetty. [...] It was as if the mainland oscillated with waves and pulsations, and the lake remained stock still.'[12] Smithson's incantatory visions bring to mind another Land artist, Richard Long (b. 1945), who would make his walks the subject of his work, which within the gallery space are displayed as maps and stone sculpture. Not as uncompromising in his rejection of the gallery as Smithson and his peers, Long's works are known for their elegance and poetry and have renewed relevance to the world environmental crisis.

Many Land artists would do works for the gallery, whether maquettes, drawings or sculptural fragments. An example of contemporary installation art informed by Land Art practice is *Cemetery – Vertical Garden* (1992/9) by the Colombian-born artist Maria Fernanda Cardoso, an irregular profusion of flowers placed as if growing horizontally from the wall. Simultaneously affirming and denying the gallery setting, the sanitized white wall of the museum comes to life as riot of spring bloom yet still retains an austere, funerary silence.

INSTALLATION AND SITE-SPECIFICITY

Long's work is typical of such art and hard to classify, as it fits into both camps of performance art and Land Art. This problem of situating the work was common to the Minimalists, whose geometrically inscrutable works depended on location

57. Maria Fernanda Cardoso, *Cemetery – Vertical Garden*, 1992–9. Plastic, flowers, pencil on wall; dimensions variable. Installation at the Museum of Modern Art, New York. Museum purchase with funds from Charles and Sue Edwards. Photograph by Will Brown.
© The artist; courtesy of the artist.

for their meaning. Since the work was neutral, the site couldn't be. Richard Serra (b. 1939), when faced in 1985 with relocating his *Tilted Arc* (1981), which had been commissioned for the plaza of the Javits Federal Building in Lower Manhattan declared, 'To remove the work is to destroy the work', but to deaf corporate ears. Carl André (b. 1935) was a repeated advocate for the site-specificity of the work of sculpture. He saw the lines between inside and outside as dynamic and fluid. When the Tate bought his *Equivalent VIII* (1966), two layers of firebricks laid out as an oblong slab on the floor, in 1972, a royal ruckus ensued. According to André, the work was a metaphor for a shallow stream. Other works, such as his outdoor sculpture in the Tuileries gardens in Paris, *Roaring Forties* (1988), attest to his ongoing project of creating a clinically still space amidst flux. His use of the grid, a format treasured by Minimalism, creates, for André, a deliberate tension between containment (the closed block of the form) and endless serialization (the grid goes on and on).

58. Carl André, *Roaring Forties*, 1988. Steel panels. Jardin des Tuileries, Paris. Photograph courtesy of the author.

André is notoriously non-committal about the role of site in his work.[13] Notwithstanding this, the lasting effect of the great Minimalist works is a self-consciousness about where the work of art is placed. The implications are formal, but also cultural. As later generations of artists have explored installation, the meaning of the work of art has changed according to where it is shown. Many artists base a career on adapting ideas to the places they travel to. In this sense, the artist and curator are forever joined, because each must be sensitive to the cultural bedrock that renders a work of art great or misunderstood. Admittedly this is a cultural relativity that can be taken too far, but especially where visiting and foreign artists are concerned, it exhorts the audience to be sensitive to the artist's cultural (or gender) trajectory, while the artist is expected to choose work to which his new audience might be receptive. Installation, the art of activating and responding to a specific space, is all part of this ethic.

HAPPENINGS AND PERFORMANCE

Among the most radical challenges to the museum are with Performance and Happenings. Alan Kaprow (1927–2006) was one the pioneers, combining the 1960s love of protest and communal living with the vaudeville bluster of Dada and Surrealism. Calling for the immediately present in art, Kaprow categorically declared that 'The concept of the museum is completely irrelevant',[14] pursuing alternatives to the prized gallery object with a campaigner's zeal. Art's greatest strengths lay in experimentation and the moment of exchange between artist and viewer. Kaprow not only called for a collapse of the gallery but for a collapse of genres. He insisted

that his happenings were simply 'doing life'. When simple acts ('telephoning a friend, squeezing oranges') are performed with (artistic) self-consciousness, they are made strange and cause us to learn about so much we take for granted.[15] Lurking in this argument, however, is an admission that art cannot be dispensed with because art is that quality which, if we allow it, makes us take a step sideways and see the word from a parallax angle.

The Art–Life activists did not unfasten art from its institutions any more than free-lovers of the 1970s broke the strain of the Cold War or created paradise on earth. But brief escapes did succeed in exposing the permeability of institutions, and the fact that the gallery is just an idea. The gallery idea is the boundary – a wall or a line, or as immaterial as a set of words or expectations – that exists around a work and distinguishes it from the items of nature, use and workaday habit.

CONCEPTUALISM

Conceptualism puts the idea before the work. But this is not a case of the cart before the horse, because the real value of Conceptualism, a positive arm of Duchamp's legacy, is to give primacy to the ideas and motivations within the work of art, so as to emphasize that the work we see is a remnant of the idea or act, or a trigger to the internal emotive-intellectual work within the viewer. I have covered already somewhat in Chapter 2, but it is still worth mentioning two major conceptual artists, Mary Kelly (b. 1941) and Hans Haacke (b. 1936).

Mary Kelly's *Post-Partum Document* (1973–9) archives the primary stages of the growth and intellectual development of her son through six sub-series of works normally exhibited in an installation format. Each sequence makes the most of the slippage between the bodily and pre-linguistic on the one hand and the intellectualized and linguistic on the other; the formless and the formed. One sequence, *Analysed Faecal Stains and Feeding Charts*, consists of nappies collected between when the boy was five and seven months old. Kelly dispassionately examined the amount of solids her baby consumed then correlated this to what he excreted using a key of 1–5, where 1 stood for 'constipated' and 5 'diarrhoeal'. In her notes to the work, she attempted to find the relationship between: '(1) The kind of food and the completeness of digestion; (2) The amount of putrefaction or fermentation; (3) The amount of bile secreted; (4) The amount of fat and water remaining unabsorbed.'[16] The nappies are presented flat, like abstract paintings, with the relevant data printed on them; gestural painting meets the hospital.

When first exhibited, the adverse reactions to the work were caused by the way it ostensibly reduced the joys of motherhood to a set of bloodlessly clinical criteria. But that was its point. Just as performance art objectifies the body to reveal that very point at which the body can never be objectified, by reducing motherhood to a set of procedures, Kelly exposed all that could not be expressed or categorized. It is also one of the most compelling and ingenious feminist confrontations of 'male' order. By subjecting an essentially female experience to an analysis foreign

to that experience, Kelly exposes the weaknesses both in arbitrary subjectivism and in scientific objectivity. The works are themselves unaesthetic, or not aesthetic in a typical sense, so in other words their exhibition is always a surrogate. Kelly's work, like the best Conceptualist works, makes us powerfully aware of the limits of representation on certain forms of human experience.

Whereas Kelly takes on male systems of knowledge, Haacke attacks the higher echelons of the art Establishment, and with unparalleled success. Haacke is a model for today's politically engaged artists concerned with climate change and militarism. Since the 1970s, Haacke has produced elaborate multimedia installations decrying the self-interest of corporate art sponsors, or drawing attention to the bureaucratic trails and convenient oversights that major institutions make if it means getting what they want. His 1979 exhibition, The Renaissance Society, consisted of altered advertisements for Mobil, Allied Chemical and Tiffany & Co, perverting the messages into declarations of manipulative hypocrisy. In 1990, Haacke produced *Cowboy with Cigarette*, a doctored version of Picasso's *Man with a Hat* (1912–13), as a jibe against the cigarette magnate Philip Morris, who sponsored a Cubist exhibition at MoMA in 1989–90. But Haacke's masterpiece was his exhibit *Germania* in the German Pavilion of the Venice Biennale in 1993, where he jackhammered the site, drawing attention to the Biennale's affiliation with Fascist Italy, and to the scars borne on the German soil. And as an expression of disgust at the hoopla of the Biennale itself, it is unparalleled.

Contemporary efforts to address the corruption of the art market and corporate agendas usually start with the Internet. In the mid-2000s a consortium of artists, designers, theoreticians and scientists in the UK, Platform (www.platformlondon. org), led a campaign against the oil company BP, calling for people to boycott all oil-sponsored cultural events. This had been preceded by a decade-long multi-linked inquiry, '90% Crude', into the 'impact of trans-national corporations'. Platform organizes exhibitions, publications, seminars and educational programmes in addition to its everyday rallying.

THE ETHICS OF DISPLAY

The two post-colonial confrontations of museums in recent years are: firstly, the repatriation of articles that have now taken on the new status of stolen artefact, and secondly, of how items still kept within the museum should be exhibited given that the museum is anathema to their circumstances of origin, the circumstances that give these items genuine meaning. There have been acts of munificent de-acquisitioning, as evidenced by the return of African artefacts by the Yale Museum of Art; more recently still in 2007 the British Museum agreed to return Aboriginal remains to their ancestors, but not before inspecting them scientifically first which, for anyone knowing the solemn rites of Aboriginal burial, is tantamount to rape. Except for individual and symbolic efforts, the prospect of wholesale repatriation of works

from anthropological museums is unrealistic, to hope for or to accommodate, a bit like handing the USA back to the surviving American Indians, or Romania back to Hungary for that matter. The anthropological museum is a fact of change and a legacy of imperialism which, sadly, is as real to the history of a globalized world as any of the indigenous rites they choose to co-opt or ignore. Albeit that the treasures of such museums were acquired in less that auspicious circumstances, their wealth may now be used for rebuilding lost knowledge for indigenous and non-indigenous persons alike.

A reasoned voice in this rising debate is Kwame Anthony Appiah, who makes a common-sense case for an embattled issue of 'finders, keepers' that promises to be with us for some time yet. He takes the example of the destruction of the King of Asante's palace in Ghana by Sir Garnet Wolseley in 1874: the undeniable brutality of the event, argues Appiah, is no basis for an argument that the British Museum should return spoils taken almost 150 years ago. For the relics arguably have more use to Ghanaians as they are. Moreover, they would not be in their present state had they not been stolen. The argument that cultures should be allowed to develop, decline, create and destroy on their own and at their own pace is unrealistic, since few cultures have ever been free from infiltration, and since most cultures have enjoyed confluence with others, often through force. One should also not forget that cultures grew as a result of enclaves to protect themselves against brutality, hence brutality is an unfortunate yet present co-efficient of culture; cultures are defined by what they trade and steal. Venice became a great city after the fall of Constantinople – should that mean that the horses in St Mark's basilica should be returned to Istanbul? Appiah's courageous thesis is maybe the most workable, although it is susceptible to perversion by reactionary conservatism.[17]

These debates have brought the manner in which foreign cultural artefacts are displayed into finer focus, causing many a curator to squirm. White walls and hard vitrines smack too much of the Enlightenment ethic of scientific classification associated with imperialism, yet can there be an alternative that is not tokenistic? The curator is faced with the unrealizable hypothetical that the only way to be true to the object is to see it back with its people in its place of origin. One of the solutions has been, in a way following on from Appiah's cue, to make the experience entertaining and educational. But this can only work with restraint, a quality museums are not always apt to follow.

We only need to set foot again in Paris to see some startling contrasts in museum policy. The Musée Guimet, devoted to Chinese, Korean and Japanese art is all good taste and sympathy of design, while the newly opened (2006) Musée du Quai Branly is a museological theme park. Throwing curatorial strictness to the wind, the various relics seem to be positioned according to an undisclosed principle of decorative compatibility. The president of the museum at the time of its opening, Stéphane Martin, claimed that the museum was a 'neutral environment', but he was either blind or had a jaded view of neutrality. A vulgar cavalcade of the Parisian love of ostentation, the chief critic of *The New York Times*, Michael Kimmelman, put it best:

If the Marx Brothers designed a museum for dark people, they might have come up with the permanent-collection galleries: devised as a spooky jungle, red and black and murky, the objects in it chosen and arranged with hardly any discernible logic. The place is briefly thrilling, as spectacle, but brow-slappingly wrong-headed. Colonialism of a bygone era is replaced by a whole new French brand of condescension.[18]

Where non-Western cultures are concerned, we are treading an ethical minefield, both of how to display their objects and how, in effect, to see them. With the erosion of the criteria that have engendered the circumstances of their display, the revision of criteria is best done without smoke and mirrors.

THE HYPERMUSEUM

This brief discussion of the new anthropological museum in Paris allows for an entrée into the final part of this chapter on the contemporary lust for elaborately designed museums. For the last two decades at least, museums have been blue-chip commissions for any architect, since it is no longer obligatory for them to conform to a classical template, as typified by, say, Schinkel's exquisite Alte Nationalgalerie in Berlin (1869–76; restored 1949–2001). The contemporary hypermuseum is characterized by a certain will-to-sculpture that is often at the expense of the works it is meant to house. The first example is in what is perhaps the first hypermuseum, Frank Lloyd Wright's New York Guggenheim (1937), whose spectacular winding ramp has repeatedly proven inadequate for the successful display of paintings. When, on the opening of the Neue Nationalgalerie in Berlin (1968), a glass shell with the only opaque walls downstairs, the museum's director asked 'Where do I put the art?',

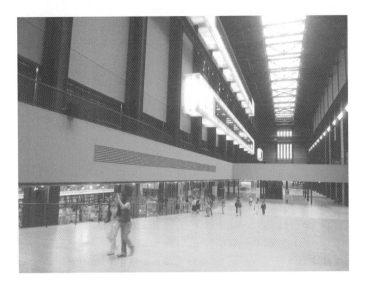

59. Tate Modern, London. Turbine Hall. Photograph by Conrad Suckling.

the architect, Ludwig Mies van der Rohe (1886–1969) reputedly replied, 'That is your problem.' The Tate Modern, beloved to some, is best remembered for the so-called turbine hall, a yawning space that engulfs most of the work exhibited in it; the galleries above are like afterthoughts to the rhetorical majesty of the architectural void below.

The Museum of Jewish History (1999) by Daniel Libeskind (b. 1946) was open to paying guests from 1999–2001 without any displays, before it was filled with objects. So imposing is its design that the objects seem permanently out of place. The same has often been said of Frank Gehry's Bilbao Guggenheim (1997), which bullies the artwork within – yet it is undeniably an architectural masterpiece and has single-handedly caused tourism to the city to flourish. The Tate Modern's (2000) turbine hall, impressive as it is, is so dominant that the art ensconced on the upper levels seems like a begrudged obligation. More successful is I. M. Pei's solution of the glass pyramids (1989) that grace the entry to the Louvre which, like good architecture, is a place where people comfortably assemble. Like the Eiffel Tower, it was derided at first but soon become accepted as integral to the urban architectural family.

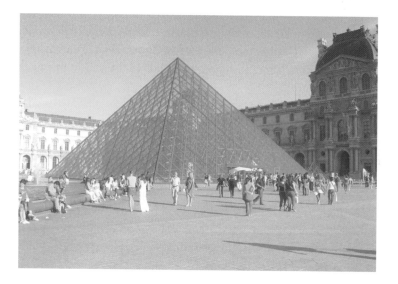

60. Louvre Museum, entrance courtyard. Photograph by the author.

10 AGENCY

Art has always been able to exert some kind of change and alter people's consciousness; objects, transformed by ritual magic and superstition can take on the status of reliquaries that incite awe and inspire silence. Both the Christians and Muslims knew of the power of images to alter minds, which is why they either destroyed images or promulgated laws for the protection of others. In the eighth century, the Eastern Church issued its edict against iconoclasm, 'the breaking of images', a law originating, oddly enough, in Islam, which took all images of the human form as abominations. The Greek Orthodox Church still celebrates the defeat of the iconoclasts who were anathematized in 842 after which icons were restored and the arguments concerning what constituted unalloyed devotional forms were relaxed. Every civilization used images, two-dimensional or three-dimensional, to advance or explain its aims, changing the minds of the masses to suit the views of the few.

I began this book with an examination of how art's origins lay in adapting to more sophisticated responses to the incommensurability of the world, acting as a spiritual release for which no other forms were adequate. When art is enlisted to some religious cause, which it has been for the larger part of history, its purpose is either to express or expel a certain energy that inspires relief or divine grace. When art serves a patron, even when the aims are devotional, it is usually done in his or her name. In both situations, art serves a person or cause. Art does also serve itself, in its claims to beauty and through the personal register of the artist, but this kind of agency is internal to the object; the artist does not expressly set out to alter his (or her) circumstances.

Art has challenged and horrified its audience with the extremity of its vision – Michelangelo's *Last Judgement* again springs to mind, or Grünewald's Isenheim altarpiece (*c.* 1513–15) – but the way in which I mean the agency of art is the point of self-consciousness of art's ability to exert change in the world. This can be to signal defiance, resistance, disgust or partisanship; art can seduce or rally others to its cause; it can be deliberately contrary – whatever it may be, when art assumes the mantle of agency to a secular cause it tackles something quite foreign to its sacred counterparts, and something technically challenging, because art is not outright activism. The most effective of such works, examples of which will be discussed below, speak to their present whilst also retaining relevance once the memory of the circumstances whence they sprang are a distant memory, acting then as symbols of

duress or resistance that bring intellectual succour to those in the present who may be formulating their own solutions to contemporary dilemmas.

Signs of art's retreat from spiritually abstract towards tangibly immediate causes start to appear in the Renaissance when art is permitted, and as much permits itself, to reach beyond religious duty and to instil independent feelings of beauty and wonder. It is at this time when art serves both mythological and civic functions, seen most heroically in Michelangelo's *David* (1501–4), which is as much a visual panegyric to male beauty as a statement of triumphant defiance of the Florentine republic against its enemies. But it is only in the late eighteenth century, having unburdened itself of its obligations to religion, and flaunting its independence from localized patrons, that art begins to serve the direct interests of the artist and his or her social group. The splendid isolation of the individual is still a resounding statement of free-thinking independence at this point and still far from the reactionary stance that it can be used for today.

Once art became (or believed it was) complicit in revolution and in toppling the institutions of kingship and religion – formerly the mainstays of artistic support – art began actively to interrogate itself as to the kind of agency it could perform on the open market. Like the revolutions themselves, allegiances slid between defiance against and complicity with the conservative powers. But it is upon the growth of a belief in art's possibilities for open exchange that we begin to see the emergence of modern art and the avant-garde. Indeed, one of the definitions of the Modernist avant-garde is the campaign for art to change people's minds and the world. Change did occur, though not as unilaterally as some artists and their supporters may have hoped. Nonetheless, the fundamental, tangible effect that some works of art have had is used as a kind of benchmark to this day for what can or should be achieved through art.

From today's perspective, the potential for art to infiltrate into unforeseen areas (as in interventions and some Net Art) and to exert change, is a theme that is very much alive. It is even more alive if we accept that holocausts are a regular hazard of human conflict. While not able to call a stop to injustice, artists can be sensitive gauges of world events, participating in commentary and reflecting on the possib- ilities of liberal communities unhindered by aggression or bigotry. While the best artists are acutely aware that the message of art is different from social activism, they experiment with the role that art has to play in changing people's minds and in giving them spiritual solace, offering reprieve from the social iniquities of forced constraint. Such insights assure others that their strategies are not in vain. Art offers a voice for people, which assures those who wish to listen that there is more to the world than greed, glamour and organized stupidity.

ART AND REVOLUTION

To live in the era in the wake of the avant-garde is to live in an era that brings together the terms 'revolution' and 'art' with relaxed abandon, for the sake of attracting

crowds. What most think as an artistic revolution is most often scandal-mongering. For while we might believe in the power of images, there is not the same faith in revolution. From the point of view of art, the period of the French Revolution (1789–94) can be seen as a crossroads in the agency of both the individual and the image. By the end of the eighteenth century, the image had noticeably begun to slough its reliance on noble and ecclesiastical patronage and the artists themselves took on a much heavier responsibility for their actions and were willing to commit to more overarching concerns with the possibility, indeed the hope, of observing the social consequences of their work; hence the avant-garde, whose job it was to put its hands up the skirts of the bourgeois and to disturb the peace of prevailing conservatism. The Modernist credo is one that expects art to be more than beautiful; it must have a discernible social effect.

The revolutionary appetite had already been whetted by the spectacular success of the North Americans in the wars of independence over the British (1775–83), and was brought to fever pitch with the French Revolution. Mass social upheaval brings with it, by nature or by force, a different style, hence the scorn heaped on the 'aristocratic' (originally coined as pejorative) art of the former regime, whose elite hedonism, to anyone who had not been a part of its glory days, spelled everything that had caused the revolutionary wound to fester. Jacques-Louis David (1748–1825), the leading artist of the Revolution, embroiled himself in political affairs, and assumed the role of artistic dictator, being dubbed 'the Robespierre of the brush'. The philosopher Seneca dabbled zealously in politics and worldly affairs, and emperors, like Marcus Aurelius, were also philosophers, but David had the rare and dangerous combination of extreme talent and equally extreme political savvy and ruthlessness. Several of his works attained the status of religio-political icons.

THE DEATH OF MARAT

David's *The Death of Marat* (1793) is one of the most manipulative and mendacious – gloriously so, and pardonable now that the dust has settled, but mendacious all the same – paintings of its time. It is an unrepentant lie, which survives to this day as an icon of revolutionary sacrifice.

Unlike his earlier major paintings such as *The Oath of the Horatii* (1784) or *The Lictors Bring to Brutus the Bodies of His Sons* (1789), this work is not from Roman history but real events. Mixing fancy and truth, David combines his capacity for mythologizing with his considerable skills as a portraitist. Marat, the coarse, choleric, fanatical, caffeine addict is transformed into a beatific martyr, a *pietà* steeped in the deepest traditions of the Christian imagination. Ironically, with Marat dispatched, the Revolutionary Convention sighed with relief. Marat had become immensely popular and they had lost the ability to control him. Charlotte Corday had sacrificed herself for the cause, rightly believing that Marat had betrayed the aims of the Revolution. It was not long after Marat had breathed his last that David set about having him embalmed and displayed like a fallen god in the Church of the

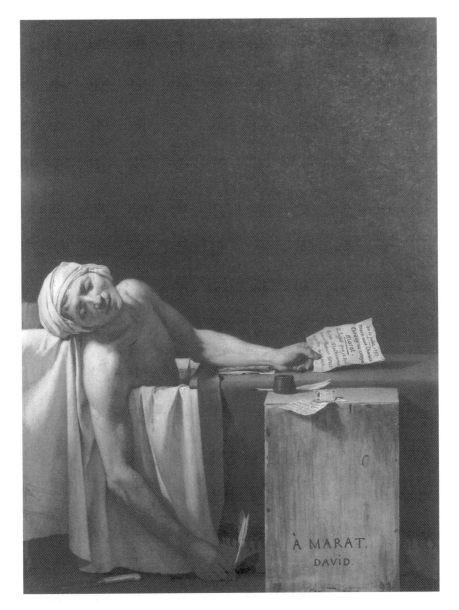

61. Jacques-Louis David, *The Death of Marat*, 1793. Oil on canvas, 162 × 128 cm.
© Royal Museums of Fine Arts of Belgium, Brussels.

Cordeliers in Paris, where people could make their pilgrimage to their revolutionary saint. The painting echoes the altar that David had designed for Marat's in-state apotheosis. It is part iconic, part 'real' snapshot, with Marat still holding the note that Corday used to request entry. As testament to Marat's charitable soul, an *assignat* (the revolutionary currency) lies at the ready in charitable answer to the note from a widow whose husband had died for his country. Ever sedulous, tireless in his labour for the Republic, he is still gripping his feather pen. His musculature is

that of an athlete, and there is no evidence of the skin condition that required Marat to bathe for extended periods. Consistent with the arrangement of hard contrasts, David transformed the wooden handle of the knife into one of ivory. The wound is clear to see, and the face boyishly peaceful in death, worthy of any St Sebastian. The composition is coolly sparse, as if to convey the truth as efficiently as possible. The background seems unfinished, indistinguishable from the scumbled (a brush technique with a dabbed, grinding effect due to only a small amount of paint on the brush) layer that normally lay underneath the polished surface; even the paint on the dangling arm is thin and not overly worked. The apparent lack of finish bespeaks the artist's selfless urgency; it says to the viewer the artist has dashed this off with only the need for its production, not allowed himself to be distracted by any vanities. His purpose is much higher than beauty or pleasure; it is to conserve the truth. And finally, on the block-like table, itself Spartan and timeless in its blocky geometry, David closes the visual transaction with a solemn dedication: 'À Marat. David'. It is all pure rhetoric, which suggests that the artist has sacrificed his own aims, his own artfulness for the sake of a much higher cause. But of course the painting is all artfulness, of such visual precision that even when we know the real story, we enjoy the deceit.[1]

Temporarily disgraced after the fall of Robespierre and the Jacobins in 1794, David soon remade himself into a court painter with the rise of Napoleon. Napoleon was the first modern leader to grasp the power of aesthetics to secure popular opinion. Napoleon was a chameleonic cross between revolutionary leader and kingly usurper. But he soon adopted a style of the weighty classical and guiltlessly overstated grandeur of imperial Rome – in furniture and design called the Empire style, and coveted by collectors to this day – to fashion himself as the new Brutus. The artistic remnants of the Napoleonic age are only a fragment of what was a large aesthetic machine. The cohort of artists and anthropologists who accompanied Napoleon on his Egyptian campaign resulted in a multitude of great discoveries, not least of them deciphering the Rosetta Stone. Napoleon would always ensure that artists and reporters were on hand in any great battle. Once over, they would dispatched back to Paris to bend the truth. Napoleonic France was the beginning of the culture that now puts pictures of its leaders on T-shirts, tea towels and teacups, from the Queen of England to Che Guevara. All subsequent authoritarian regimes would use aesthetics to further their aims, reaching a grisly climax with Nazi Germany. The manipulation of images and power of the leader's image is for us a norm and comes to us via the medium of television.

THE BATTLE OF EYLAU

Although David's great feat of Napoleana was the spectacularly vast coronation scene of the new emperor crowning Josephine, it was one of his most gifted pupils, Antoine-Jean Gros (1771–1835), who specialized in battle scenes that immortalized some of the great leader's encounters. I use the word 'encounters' because, like his

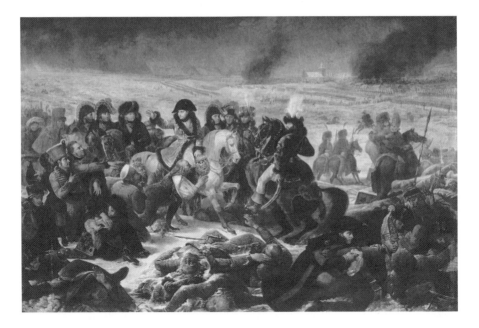

62. Antoine-Jean Gros, *The Battle of Eylau*, 1808. Oil on canvas, 521 × 784 cm. © Musée du Louvre, Paris.

master, Gros was an adept at the glamorous lie. His greatest work in this manner is *The Battle of Eylau* (1808). Gros had already recorded a young Napoleon, Christ-like, ungloved, anointing the sick in his *Napoleon Bonaparte Visiting the Plague-Stricken in Jaffa* (1804), and although Napoleon did nothing of the kind, the work does the effective task of obscuring his shabby record of medical care, and his neglect of troops no longer battle-able. Now, in *Eylau*, Napoleon has abandoned his role as prophet and his presence is elevated to godlike magnificence and humility. The emperor is situated left of centre and gestures outwards to his surrounding generals – spruce and dashing as if untouched by a gruelling two-day battle – with an expression of wan sagacity, his right arm extended in an act of mercy. The difference between the French and Russian troops is as plain as any *Asterix* comic: a man with long plaits kneels as Napoleon grants him mercy. In the foreground to the right, an officer offers to comfort a frightened Russian soldier. Other French troops nearby struggle to set fears at rest. Napoleon is represented not only as victor but liberator, a saviour, the result a foregone conclusion because he is the purveyor of all justice.

Amusingly, the reality is miles apart. To date, the Battle of Eylau was perhaps the least successful battle in eight years. In the words of the military historian David Chandler,

> Overnight Bennigsen [head of the Russian forces] withdrew his troops, conceding Napoleon a technical rather than a true victory. In fact a draw would be the fairest assessment of the day's fortunes. Napoleon had lost at least 10,000 men; the Russians may have lost as many as 25,000. Certainly the French were

in no position to pursue the foe next day, and soon both armies returned to their winter quarters to await the advent of the spring. Eylau was the nearest thing to a defeat Napoleon had experienced since his repulse before Acre in 1799.[2]

This painting now appears in the Great Hall of the Louvre, around the corner from the *Mona Lisa*. Given that the Louvre is visited by over ten million people a year, and assuming that most will pay their respects to the world's most famous painting, we can also safely assume that almost as many will see this one. Napoleon may not have won the battle, but if numbers count, according to popular memory, he most certainly has.

ART, EMPATHY AND RESISTANCE

Maybe if we searched the era for some redress to the gross infidelities of Napoleon's propagandists, it is in Goya's *Third of May, 1808*. Goya never favoured the well-enamelled finish of his neo-classical contemporaries, and the handling of this work is rich in spontaneous urgency, and its goal more agitating than David's visual rhetoric in *Marat* because Goya is guided by the fundamentals of protest against brutality, not ideology. If it can be called superior to David's works, it is because Goya's appears to lack any calculation; rather it is like a necessary reflex. This picture

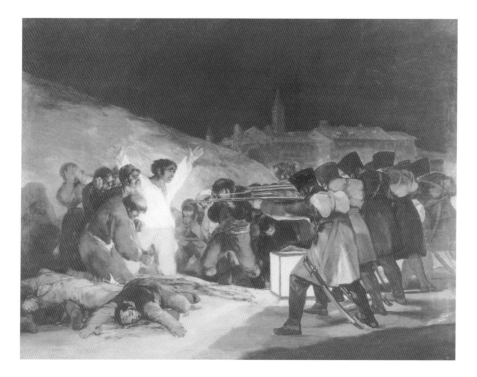

63. Francisco de Goya, *Third of May, 1808*, 1814. Oil on canvas, 266 × 345 cm. © Museo del Prado, Madrid.

of a firing squad executing the Spanish who had rebelled against the French has qualities of what philosophers call the pre-predicative, that raw mix of phenomena before they become slotted into linguistically identifiable quanta.

In 1814, when the French were finally ejected from Spain, Goya requested to the government that he be able to 'perpetuate by the means of his brush the most notable and heroic actions of our glorious insurrection against the Tyrant of Europe'. He had already turned out dozens of the most stirring etchings dealing with the French occupation, *The Disasters of War*. They are ghastly images. Their horror derives from fact rather than invention. Goya's exhaustive suite of images of the Napoleonic years turn the hale revolutionary genius, as he was known to some, into a tyrannical band-leader of rapacious thugs. Napoleon may have had a knack for manipulating images, but, with the benefit of time, disingenuousness is no match for empathy with which, as an artist, Goya is all but synonymous. The figure in *The Third of May*, his arms cast skywards and seemingly emanating light, is among the most powerful expressions of human helplessness in the face of conflict. As an act of unanswered protest – 'What good comes from this?' – his gesture is timeless and emblematic, as relevant today as ever.

BEGINNINGS OF THE AVANT-GARDE

It is appropriate to begin to tell the story of the avant-garde while still on a military note since the term 'avant-garde' and its sister term, 'vanguard', are both of the same origin, used to designate the troops sent to scout before the main battalion. The idea could not be more apposite, since the avant-garde artists are generally viewed as those who are not only ahead of their time, but who meet the fray of criticism by critics and public who are as yet unaccustomed to their stylistic innovations. The avant-garde themselves had to be militant in defence of their cause and resourceful enough to weather the assaults that came their way.

But what also needs stressing about the artistic avant-garde is their freedom as singular agents within an open political and economic market. In the shift that slowly begins to occur in the eighteenth century as a result of the Enlightenment and the Industrial Revolution, artists act and think more as they please than at the behest of a patron. Some of these changes are best seen in music, especially in the examples of Haydn (1732–1809), Mozart (1856–91) and Beethoven (1770–1827). Haydn spent most of his life under the cosy aegis of the Esterhazy princes, while Mozart found himself peregrinating from city to city in search of adequate patronage. Yet Mozart could not always easily compromise between what he wanted to do and what his public wanted to see. Several of the operas for which he is known are laced with overt social commentary such as *The Marriage of Figaro* (1786), which is an adaptation of the famous play by Beaumarchais (1732–99), a comedy directed at aristocratic privilege, or Beethoven's *Fidelio* (1805–14), which is a plea against abuses of power. Beethoven entered into a generation in which many of the sources of patronage, which had kept Mozart barely afloat, had begun to dry up. For most

of his career, Beethoven was reliant on giving music lessons and on subscriptions to concerts. By the early nineteenth century there were fewer concerts given as a pageant at the expense of a single patron. More common were concerts financed according to entrance fees and subscriptions, which meant that the popularity of the performer played a critical role. As such, artists adopted curious traits and delivered enticements to attract the public; then, and only then, was the virtuoso artist born. To be sure, virtuosity had always been alive, but the public flaunting of it, as found in the pyrotechnics of such legends as Niccolò Paganini (1782–1840) and Franz Liszt (1811–86), was a reflection of the need to get people in the door. Even in late eighteenth-century Vienna, when the aristocracy still held sway, there was a noticeable change from the discernment of 'good taste' towards a more lofty appreciation of 'greatness' in which the composer and his output were mutually exclusive.[3]

Raising the stakes of taste, and the new power bestowed upon the individual – both the one who made the work of art and the one who participated in it – accounts for why styles, which included the emphasis on national, even vernacular traits, began to change more rapidly from this time, since the style is the lens by which the world can be seen in a better, or at least more novel way. In answer to a more diverse, educated and literate public, always hungry for alternatives to the status quo, it was up to the artist to assert his (and later also her) approach as the most relevant, most up to date, most fashionable – the best.

It is during this period in the early nineteenth century that artists not just self-consciously adopt and cultivate a signature style that reflects their individual, irreplaceable personality (and therefore 'not to be missed'), but that artists, acting as free agents in the world, begin to notice their capacity to change public opinion. The French Revolution was decisive in this regard. It empowered artists, composers, poets, novelists and philosophers all over Europe. The presence of it can be felt in countless works, from Wordsworth's *Prelude* (publ. 1850) to Beethoven's Third Symphony, the 'Eroica' (1803–4), dedicated to Napoleon, whom Beethoven saw as the bringer of the revolution to the rest of Europe (which he later retracted). If artists could be alone to pursue their own interests, then they could also assert beliefs that, they hoped, reflected the better aims of society.

While David was living out his last days in exile in Belgium, painting rather unvigorous works, Théodore Géricault (1791–1824) was planning a work whose disruptive, frenetic energy sought to place him at the centre of contemporary events. His painting *The Raft of the Medusa*, 1819, is a massive painting (491 x 716 cm), which for any artist at the time and was an inordinate investment in time and money without a commission. Sombre in colour and with a strikingly triangular composition, the painting represents the moment when wreck victims on a raft sight a ship on the horizon. In 1816 a flagship leading a convoy of French soldiers and settlers to the colony of Senegal ran aground in shallows near the West African coast, the fault of their captain, an inexperienced nobleman, Hugues Duroys de Chaumereys, appointed by the restored monarchy of Louis XVIII. While the captain and his officers took to the seaworthy boats, 150 of the 400 crew members were left to fend

for themselves on a raft made from wrecked timber. Reduced to cannibalism, fifteen remained to be rescued. The painting depicts bodies reduced to anthropomorphic larvae, haplessly dissipated by their exposure to salt and sun. One critic at the time admitted that 'The sight of this large composition inspires terror', while a less sympathetic respondent exclaimed that Géricault 'could have made it horrible, and he has made it merely disgusting; this painting is a heap of cadavers from which one turns away'.[4]

By eschewing classical narrative in *The Raft of the Medusa*, Géricault broke with the decorum of over two centuries of painting, dispensing with visual metaphor from the past to instate the presence of something present within the living minds of its audience. Curiously enough, although it was a direct snub to the Establishment, the Establishment, embodied in a tired and gout-ridden king, showed its tolerance to the extent that Louis XVIII himself paid it special attention and exclaimed to the artist, 'Monsieur Géricault, you are about to cause a shipwreck that is not of your own making [*qui n'en est pas un pour vous*]!'[5]

The story of the painting does not end there. Consonant with the way in which the content of the work had direct rapport with contemporary events, the artist entered the painting, both physically and topically, into the public market. Géricault found a temporary solution to the problems of storing his gargantuan canvas in his small lodging by exhibiting it in England, at the invitation of an English showman, William Bullock, who ran the Egyptian Hall in Piccadilly, where it was lodged for

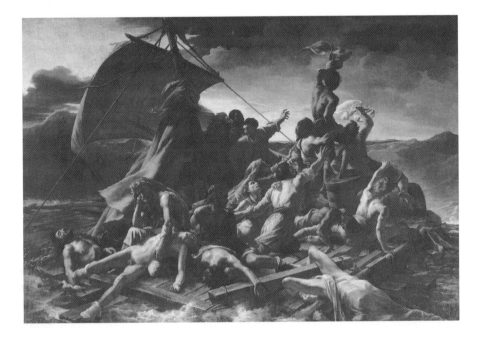

64. Théodore Géricault, *The Raft of the Medusa*, 1819. Oil on canvas, 491 × 716 cm. © Musée du Louvre.

the latter half of 1820, receiving around 50,000 paying visitors. From there the picture went to Dublin, where it was exhibited for two months to a less responsive audience.

While pictures had been put on public show in this way, there had never been such a showing of such a large picture with such confrontational and (what was to some) such vulgar content. If the subject was unappealing it was because Géricault's painting was impelled not only by aesthetic concerns but political ones as well. And it would soon become evident, from this time on, that the aesthetic and the political were intricately intertwined. If the artist spoke for himself, he also spoke for his public, aiming to lend them a voice that salvaged their dignity or gave them cause to feel that there was the space for protest and thereby the possibility for change. Certainly, even today, when the artist asks him or herself, 'What should I do? What should I make?', the response that frequently looms is that to be responsible, the artist must seek some redress from injustice, conservatism, narrow-mindedness, bigotry and everything else that represses or kills.

Géricault's yet more renowned student, Delacroix, would go on to paint works such as *Scenes from the Massacres at Chios* (1824), about the Turkish invasion of Greece, and *Liberty Leading the People* (1830), glorifying the French revolution of 1830 (the July Revolution) that ousted the last Bourbon king, Charles X, but such works are still laced with a flourish, an ennobling fantasy that separates them from the real world. *Liberty Leading the People*, with Liberty in the form of the woman, her breast bared, is a self-consciously manifesto work and one that the French Republic in the recent years was proud to put on postage stamps. Co-option by the Establishment is the common fate of political art, like political radicals themselves, who get absorbed by the institution in later life.

There is a definite continuity between Romanticism and Realism, but whereas Romanticism still liked to escape in invention and fancy, Realism took a different licence by attempting to cover over any suggestion that it was taking licence. If Romanticism could be brash, then Realism could also be prosaic. It took pride in glorifying the down-at-heel and it was the first artistic tendency to concentrate on work as a subject. It took a perceptive critic like Baudelaire to locate this bias of Realism when he called to task its *nostalgie de la boue*, the hankering after muck, in some artists. Until the end of the nineteenth century, Realism would continue to be enormously challenging to lay audiences, since it continued to jar their expectations of what beauty was and where it was found to lie. (A contemporary analogy is the extremes that performance artists put themselves through – bodily mutilation, privation and the like – leaving them open to charges, voiced also even by specialists, of making a gratuitous spectacle of unpleasantness.) This was also the period when Dickens wrote the industrial novel *Hard Times* (1854) and Zola wrote *Germinal* (1885), both dealing with the exploitation of the poorest working classes. It was the responsibility of the artist, the Realists believed, to bring the condition of the needy to the attention of others in better circumstances, communicating on behalf of those who were muted by lack of education and by the crushing onus of survival. It might

be true that novelists and painters could wallow in their own aestheticization of tragedy, it is also fair to claim that such work had effects similar to investigative and tabloid journalism today in changing the face of public opinion. Realist art is part of a much larger drive behind democracy that believes, at least in theory, that the most unattractive truth should be brought to the public milieu for public judgement – whose reactions are unfortunately not always that liberal and in their own best interests.

Realism became a useful visual tool for countries at the end of the nineteenth century who, as a result of the gradual shift from monarchic autocracy to a democracy were undertaking a reassessment of national identity as seen through their own eyes, as opposed solely to that of their sovereign. Realism's 'hankering for muck' was only too appropriate when we consider that a sizeable component of identity, be it personal or national, is the hardships that go to shaping it: war, famine and labour. This was as much the case for artists in Australia at the end of the nineteenth century as much as for artists in Finland, countries which, although on opposite sides of globe, were beginning to receive national independence, a turn that brings in tow ownership over certain images. It was a subconscious instinct of artists of this period to sense this need and to locate and dream up – since national identity is both factual and imaginary – a visual lexicon, a series of visual scenarios, and a style that is particular to the stories underpinning the histories of place. As such, the other component to the Realist point of view comes into direct view: the land.

In the last decades of the nineteenth century, while still a subject state under the power of Russia, fired by the need for national independence, Finnish artists and intellectuals began agitating for a style and subject matter that they could claim belonged to them. Albert Edelfelt (1854–1905), Eero Järnefelt (1863–1937), Axel Gallen (1865–1931) and Pekka Halonen (1865–1933), together with the composer Jan Sibelius (1865–1957) are associated with what in Finland is called the 'National Romantic' school. In rallying for a national school, they inevitably chose from national folklore and areas where they perceived the spirit of Finland to linger more than others – much the same way as Émile Bernard and Paul Gauguin in this period saw in Pont-Aven in Brittany the reigning vestiges of the untouched and 'primitive' France. One of their favourite areas was Karelia in the north-east, and the township of Koli, one of the few raised regions of a flat landscape where one could stand and view the countless of islands flecking Lake Piellinen, one of the larger of Finland's thousands of lakes. Many of their works are haunting evocations of *genius loci*, the spirit of the place, with shades of styles such as art nouveau, or *Jugendstil*, and Symbolism, and if they do not seem overtly political they are aimed at locating the inner source of a Finnish essence (how such beliefs come to be corrupted in the twentieth century will be dealt with shortly).

Järnefelt's *Wage Slaves* (*Raatajat rahanalaiset*, or *Kaski*), 1893, is an image that is instantly recognizable to any Finn, as it relates the plight of peasants engaged in slash-and-burn agriculture, clearing the dense forest to make remote areas habitable. Pausing from her work, the girl stares out with an expression of despair and

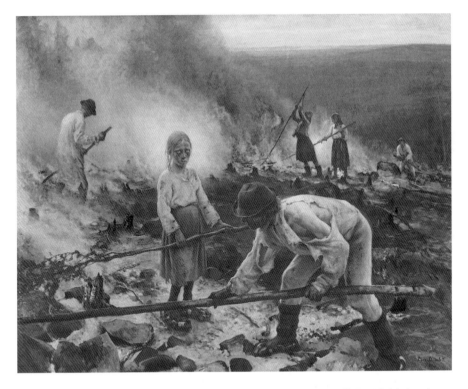

65. Eero Järnefelt, *Wage Slaves*, 1893. Oil on canvas, 131 × 167.5 cm. © Finnish National Gallery, Helsinki.

imprecation. All the other figures are thin and strained in positions of work. Järnefelt has purposely chosen the snapshot idiom of documentary photography – the girl posing to register her complaint to the camera – to amplify the image's claim to truth. But the overall sensory texture of the painting, and its stark colouration along with its size (131 × 167.5 cm) lend it a pathos, resonance and amplitude that are hard to find in photography. Here the girl stands for the people and for the land itself, neither of which has the power to escape an unpleasant fate. This and works like these occupy a special place in the Finnish national character and speak strongly for a nation that wore the subjugation of other countries for over 800 years.

THE TWENTIETH-CENTURY AVANT-GARDE

The twentieth century avant-garde pursued something of a contradictory course between iconoclasm and nation-building. And even those artists who didn't fit into either camp felt compelled to have some political affiliation, however cosmetic, like the anarchist leanings of the Cubist circle and Picasso's membership of the Communist Party. If we put aside the unfortunate puerile extremism of the Futurists who allied themselves to the Italian Fascists, the two examples to be held up of art absorbing itself into politics are Dada and Russian Constructivism.

Dada, which I have mentioned at various points, was already orientated to several centres in Europe, principally Zurich, Paris and Berlin. There is nothing to match it as the artistic paroxysm of the modern secular age. Its anti-art tag is not to be misconstrued with the abandonment of art – only the art that they feared had been sanitized to the point of irrelevance by bourgeois lethargy. By reverting to childish nonsense and by using non-precious materials, Dadaists by and large sought a return to what they believed were the ritual truths of art. Art had become an inert commodity and by definition not art. Springing up in a small café-bar in Zurich in 1917, the 'Academie Voltaire', Dada began as protest against the war and the imperial self-interest that caused it. If art could be returned to spiritual as opposed to monetary value, we would all be better off. As suggested in previous chapters, Dada has provided a conscience for artists ever since.

The Russian avant-garde pursued a less iconoclastic, more conciliatory course. Its members – such as Tatlin (1885–1953), Rodchenko (1891–1956), El Lissitzky (1890–1941) – were devout on employing a visual vocabulary comprehensible to the proletariat, based on geometrical forms simplified to what they believed were their most essential elements. By distancing themselves from Realism, 'bourgeois Realism', they wanted to invent a truly proletarian art to be embraced and understood by all.

But their work had the opposite, alienating effect. To the point of being a prerequisite, it was a trait of the avant-garde to assume things of their public, whom they took it upon themselves to save. The Constructivist project is proof enough that the so-called masses love verisimilitude – the appearance of the real – in all its forms: narrative pictures, narrative movies and now virtual realities. The masses do not want to be saved; they want to be entertained. This does not, however, discredit the Constructivists in any way whatsoever; on the contrary, their art sought to do something more adventurous than entertain and it had a philosophical, artistic and political sophistication resistant to ideology, the official art of Stalinist Russia, which put the country into stagnation and from which it is only now barely recovering.

The two major theses of the avant-garde are by Renato Poggioli (1962) and Peter Bürger (1979), which arrive at different conclusions. Poggioli's idea was that the avant-garde was like an artistic lurch, a necessary and ongoing reform that cleansed art, including music and literature, from the inevitable habituation that arises from unquestioning acceptance and repetition. In his defence of the autonomy of art, Poggioli sides with Adorno, who believed that art that embroiled itself too much in politics risked turning into 'pantomime'. Bürger took the view that Poggioli was incorrect in separating the avant-garde from the so-called real world, which also had to do with Poggioli going as far back as the eighteenth century. For Bürger, the avant-garde was a decidedly twentieth-century phenomenon whose trajectory was the betterment of society. Bürger's notion of the avant-garde was in terms of an impulse that is anti-institutional and which attempts to fuse art and life, eventually destroying the boundaries which have divided classes and alienated people. Marxist in conception, Bürger's view nevertheless does not know where to place the role of the individual except as something to be overcome; he is also uncomfortable with

Postmodernism, which he regards as anti-avant-garde – which it isn't, but it isn't avant-garde either.

POSTMODERNISM AND POST-POSTMODERNISM

There have been phases of Postmodernism, particularly in the 1980s, that have been dismissive of politics, but this is itself not without complication. Just as Dada was anti-everything, repudiating politics can be effective in discrediting an ineffective state of socio-political affairs. Artists perennially retreat from their present environment to explore a language that has less of the taint of their contemporary world, thereby giving refreshing insights into it.

The relationship between Postmodernism and the avant-garde can be put down to the simple point that the avant-garde has no place within it in so far as the avant-garde claims itself as a more vital alternative to a dominant, but corrupted style. Postmodernism – and I have facetiously noted post-Postmodernism because since the turn of the millennium the term is not as widely discussed as it was – is by definition a plurality of styles that encompass a wide range of points of view, such as feminist and post-colonialist, that were commonly repressed or ignored within the modernist project. The precondition of a unified 'Modernist project' is itself unfathomable to the Postmodernist mind; the project is full of holes and assumptions, which is why it never fully succeeded. The avant-garde also assumes that it is an active instrument in change and that the avant-garde style is the more truthful reflection of the condition whence it sprang. But to the Postmodern consciousness, conditions are changing and cannot be pinned down to a single style and while political change is possible, it is not universal. Trotsky's 'world revolution' has gone out the door. Change is an active ingredient in human existence; one of art's purposes is to speculate on what that change is, how it can be located and adequately judged. The presumption that any art is a full-blown truth is not only false, it is dangerous, since it implies a belligerence that leads to exclusion, the means of which are potentially violent.

Since 1990, which is the beginning of the slackening grip of Maoist totalitarianism and the rise of a more free-market economic model, radical, dissenting voices in Chinese art have become more visible. This is not to suggest by any stretch that the arts enjoy freedom in China; the Internet is still closely policed and radical festivals do not have state support (during the annual Performance Festival in Beijing, held in the arts district of Dashanzai in 2006, the equivalent of the cultural ministry ordered the press not to give it any coverage). Some Chinese artists have made the most of exposure to capitalist markets and have made large sums of money; others have pursued a more risky course in performance art, and many have produced some of the most extreme acts in this genre.

The most extreme of all is by Zhu Yu (b. 1971), known throughout the world through photographic stills of a dog eating a two-month-old foetus. The greater part

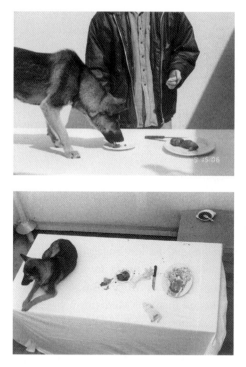

66, 67. Zhu Yu, *Feeding My Own Child to a Dog*, 2002. Two video stills. © The artist; courtesy of the artist.

of the work is of interviews with women whom he convinced to be inseminated for the purposes of this grisly end. Understandably, the work has divided its audience, and it remains an important work since it brings to the surface, like no other, the infanticides that are carried out every day in China owing to the disproportionate precedence males have over females and that there are financial penalties imposed by the state for couples with more than one offspring. Shocking as it is, Zhu's work is not gratuitous and can be called a form of Realism. It has been instrumental in making many people from the West reflect on the extraordinary pressures imposed on an overpopulated country.

Hailing from a country diametrically opposed to China, Thomas Hirschhorn has produced work that has alienated him from his native Switzerland. His loathing of Swiss conservatism led him, in 2003, to make a public declaration in the tradition of the Futurist or Surrealist manifesto, in which he states that he is henceforth a voluntary exile. This how the statement, an eloquent diatribe, begins:

I WILL NO LONGER EXHIBIT IN SWITZERLAND

I am purposely unaccommodating. I cannot accept the newly elected Swiss Upper House of Parliament because nothing is more luxurious, nothing is more comfortable and nothing is more egocentric than to be a democrat today. Democracy is not untouchable, since our current state proves that democracy is vulnerable. The problem of democracy is that it implies its own inviolability. My intent is not to go against democracy; my intent is to go beyond democracy.

I authorize myself in rashness, in blindness and headless [*sic*] to make a decision which requires me to go beyond myself. I want to challenge myself; I want to ask more than I demand. I don't want what's possible, I want the impossible – art does not want what's possible, art wants the impossible – I WILL NO LONGER EXHIBIT IN SWITZERLAND – in art the impossible triumphs over the possible.

The response of the Swiss government was to cut 1 million Swiss francs from their Pro Helvetia (culture ministry) fund, but they reneged soon after realizing the stupidity of the action.

The image on the cover of this book is *Superficial Engagement*, an installation at the Gladstone Gallery in New York in 2006. The title is ironically double-edged, since the work deals with the lack of the West's half-hearted efforts to avert atrocities for which it is, to a greater or lesser extent, responsible. But the artist, who is devout on distancing himself from politics and politicking, is no less 'engaged', despite his paradoxes and ironic twists. Hirschhorn knows that such twists are necessary. His example is proof that we haven't lost the better beliefs of Modernism, but that we know that to simplify things too much into 'us and them', as Modernism was apt to do, has dire consequences. This sort of work seeks to speak to an audience who share similar interests and are equally concerned about their inability to act positively, whether through foreign policy impasse, or through the belligerence of conservative government.

Sometimes, humour is the most effective weapon. A consortium of feminist artists based in New York, the Guerilla Girls – who proclaim the new 'f-word' to be feminism – is now something of a household name amongst artists and art students. The artists are known for their witty bluster at male-oriented control of all kinds. Operating since 1985, some of their most recent fillips have been directed at the Bush government, which they see, probably rightly, as the most odious embodiment of conservative, phallocentric power-mongering. With an active website (www.guerillagirls.com), their strategies are various: symposia, posters, performances and films. Beginning as a feminist protest group, they have burgeoned into their own small cottage industry, which distributes all forms of satirical-subversive paraphernalia: posters, pictures, T-shirts and the like, available through their website or museum shops. A recent (2003) poster, entitled *Estrogen Bomb*, used to combat 'Bush's war against women's issues' reads, 'Drop it on Washington and the guys in government will throw down their guns, hug each other, say it was all their fault, and finally start to work on human rights, education, health care and an end to poverty...' If only it were so simple, but it is because the Guerrilla Girls are so persistent and so winningly funny that their art, cheap and ready, has infiltrated into thousands of homes, where, through the stealth of the non-aggressive reaction of laughter, it has either given solace to the converted, or caused the undecided to think twice, or burlesqued the priggishly inflexible into a state of temporary silence.

Since the 1970s many artists have consistently worked together, temporarily or constantly, in pairs, in groups, or to coordinate a wider field of non-artists to

participate within performances (Hirschhorn does this with many of his event-happenings to do with the urban dispossessed) that combat the myriad injustices of gender, race and class. The collaborative ethos displaces the self-interest of the individual to present itself as a dynamic symbol of micro-community. Whether alone or en bloc, the spirit of protest and the desire to change with art is indisputably alive. It says two things: that art does change people's minds and dispositions in a certain way, and that the faith of artists in art to do so is a vital impetus in the creative endeavour.

CONCLUSION — EXCEPTIONS

'I am attracted to the idea' declared Alan Kaprow,

> of clearing out the museums and letting better designed ones like the Guggenheim exist as sculptures, as works, as such, almost closed to people. It would be a positive commitment to their function as mausolea. Yet, such an act would put so many artists out of business … I wonder if there isn't an alternative on the fringes of life and art, in that marginal or penumbral zone […] at the edges of cities, along vast highways with their outcroppings of supermarkets and shopping centres, endless lumberyards, discount houses […].[1]

In a sense, all art worth the word (all 'good art') is seeking to be the last word, the best solution to a problem, or the best way of imagining a particular condition. And art has had a long tradition of wanting to step outside itself: to meet God, to meld with life, to communicate with the masses, whatever they are. In short, art is always striving to be the exception.

I began this book with an examination of ritual from pre-civilized *Homo sapiens* to recent examples. As we saw, one of the most compelling arguments about the origins of art conjectures that there was a point at which human beings became aware of an abstract force that was neither accountable to nor provided for in the processes of everyday living. Paradoxically, although supplemental to the courses of human subsistence, this energy, an impulse that coalesced into acts and its visual registrations, was somehow essential to it. Art began as a celebration of the deepest instincts that were linked to the sources of all life. The act of production was an expressive outpouring of these instincts and the more permanent remainders – what we today call art – served as reminders of an act that was both blessed and bodily.

The role of the body and sensation in art has led to many biases and misprisions that reached a head in the first half of the twentieth century, especially when it came to voluntarily depreciating the complex and tight relationship that the visual arts have to the written word. A reason for this exclusion can be deduced from the presence of the written word within all forms of modern life. It was a reflex of the Modernist artists to make of art a protectorate against the world's clumsy wordiness: its simplistic, illustrative explanation, its sloganeering, its commercial ploys. For Modernism, the safe haven of the purely visual held the possibility of a better consciousness and promised to be a filter against industrial dross. To some extent it was, but not through its pieties, and not through its exclusions, for as the twentieth

century hideously confirmed, acts of strenuous elimination within culture, taken too far, lead to violence. But what Modernism did help to define was the agonistic relation that art has to words, and the way that, taken together, visual and written forms of information can be both complementary and contradictory.

The earliest forms of art were themselves a form of writing; letters and images were one. After art separated itself from written script, both nevertheless maintained an active relationship, especially in art's venerable role of narrating stories to those who cannot read or write. The relative instantaneity of the image, as opposed to the time it takes to read a story, is one of its primary strengths. This did not stop people writing about art, however. From the Renaissance onwards, as society became increasingly more diverse, the demands made of art by both artists and its public grew in kind – which necessitated a new breed of specialist who served to demystify and enrich the viewing experience. It is one of those resounding ironies that the movements who profess to be the most independent of the written word, from the pre-eminently visual (Impressionism) or expressive (the New York School), relied heavily on critics to make this relationship plain, to bolster reputations and to ensure that the artists' audiences would see their works in the way that the artists and critics intended.

To a greater extent, the acts of imagining and of gazing are freer from the ropes of words. The ability to create images in one's head, the raw material for much image-making, is a basic function of consciousness and is still unaccounted for, scientifically or otherwise. It is also our ability to imagine that underscores our capacity to inter-pret, by making sense of symbols with what are essentially other symbols or images. How we see into something is as much a measure of our expectations as it can be of our willingness to make more of what is there. Many works of art not only heighten our capacity to invent meanings, but they just as often make us aware that we are doing so; in other cases we are able to use art for a better understanding of how people viewed themselves and things during different epochs. And it would be naive to expect that art should always reflect the best intentions. It is unnerving to see how images were used to contain and subjugate people, whether in a certain violence of repressive representation, or through manipulating them through forms of propaganda.

The way of seeing and imaging the world is given shape in art through style. When we look at art as a progression of styles, we forget that the initial inventors, or proponents, of a particular style were exceptional for the way that they superseded a status quo, or for the way that the norm suppressed them, which has been the historical case for women. Is there a style proper to a type of person, a culture, a gender, an age? To some extent, but never – thankfully – completely, since once a style becomes overly clear and diagnosed, it loses its vitality, which is its capacity to intrigue us with what is, or seems to be: a complete and clear expression of a person-ality or idea.

Needless to say, the most formidable expressions of an age or condition are the most valuable, since they can be held up as emblems. The relationship between art

and money begins once artists act as purveyors of something valuable in life that cannot be supplied anywhere else. It is ironic that the cliché that art eludes words has been exploited to an extreme degree by the commodity market, whose values are highest when they are least quantifiable yet particular to a source. Thus the artist, as genius-celebrity and wellspring of uniqueness, becomes his or her own brand name. And if a work of art is not accountable to words, it is not only *ipso facto* transcendent, but it also, conveniently, eludes criticism. Millions of dollars change hands in the art market based on this jaundiced principle, and this shows no sign of abating.

But take away, if we can, the negative stress of class and money, and the art object can still afford us inordinate pleasure: sex, opulence, plenty, happiness are to be found in all their unapologetic grandeur. On the other hand, art is also pleasurable through the relief it brings by permitting a truthful image of something, or at least giving us some whiff of truth. As we have seen in some of the art after the world wars of the twentieth century, the best art gives us morality without necessary shame, or shame without the onus of didacticism. It does not hector us; it declares itself simply and softly and is all the more striking because of it. And this is one of the pleasures I have in looking, writing about and making art: to try for an honesty and clarity that nevertheless has no truck with the disingenuous testimonials of the media or of vapid jingoism. There is pleasure to be had in the exceptions, which are those artists who risk obloquy, or 'lay their hearts bare', to paraphrase Baudelaire.

Art's capacity for change is not numerically causal or easily measurable. But it is all the better for that. Art can give someone relief that there is someone else out there who offers an exception to the enormous amount of crap in the contemporary world, and it can articulate a concern, an interest, a condition that may not be acceptable to mainstream eyes, yet which are, as Nietzsche said, 'human, all too human'. It was also Nietzsche who argued that the exceptions found in art are more normative than most believe, yet their 'truth' is reserved for a few because the truth can be difficult to bear, terrifying, perhaps harmful. But this need not necessarily be taken as elitism as such, since artists and writers are always trying to communicate to as many people who will look or listen. To take a cue from Nietzsche, we might say that art's obscurity is not the fault of artists; rather it has to do with the fact that the profoundest truths are hard to understand and take time to reach us. On the contrary, it is thanks to art that we are given at least glimpses of that 'truth' whose proper name daren't be spoken and will never be known to us.

The purpose of this book has not been to locate the proverbial 'bit that matters' that Georges Braque once said that explanations about art will always fail at, because were it to be located it would cease to matter. Instead it has attempted to describe certain standards and their histories against which works of art, far exceeding, I hope, those mentioned here, can be measured. I have tried to give a range of works of art and vignettes of how works of art have been received. Where it succeeds, it may also fail, as there will always be exceptions to the rule. But hopefully I have allowed you to at least to anticipate them.

NOTES

INTRODUCTION

1. Mark Rothko and Adolf Gottlieb in Mark Rothko (2006), *Writings on Art*, ed. Miguel López-Remiro, New Haven, CT and London: Yale University Press, pp. 35, 32.
2. Rothko, *Writings on Art*, p. 36.
3. William Hazlitt (2000), 'The Same Subject Continued', *The Fight and Other Writings*, eds. Tom Paulin and David Chandler, Harmondsworth: Penguin, p. 31.
4. Peter Shjeldahl (1994), 'Notes on Beauty', *Columns and Catalogues*, New Jersey: The Figures Press, p. 254.
5. Hazlitt, 'Why the Arts are not Progressive', *The Fight*, p. 206.

CHAPTER I RITUAL

1. Georges Bataille (1979) [1955], *Lascaux où la naissance de l'art* in *Œuvres complètes*, v. 9, Paris: Gallimard.
2. Jean-Jacques Rousseau (1993) [1781], *Essai sur l'origine des langues*; various editions; cited from Paris: Flammarion, p. 97. Some of Rousseau's fancies are echoed by recent anthropological research, particularly regarding the role of music in the assumption of language. Language, in its earliest formations, was accompanied with bodily gestures, which at their extreme were like dance, and by extreme voice modulation, similar to song. In short, language began as a richly aesthetic and multi-sensory. Communication, ritual and play were thus branches of the same tree. See Stephen Mithen (2006), *The Singing Neanderthals: The Origins of Music, Language, Mind and Body*, Cambridge, MA: Harvard University Press, *passim*.
3. Bataille, p. 33.
4. Denis Hollier (1989) [1974], *Against Architecture*, trans. Betsy Wing, Cambridge, MA: MIT Press, p. 61.
5. Bataille, p. 79, his emphasis; p. 39.
6. G. Bataille (1967), 'La Notion de dépense', *La Part maudit (précédé de La Notion de dépense)*, Paris: Minuit, *passim*.
7. *Aristotle's Theory of Poetry and Fine Art* (1951), trans. and ed. S. H. Butcher, New York: Dover, p. 240.
8. See Ivan Morris (trans. and ed.) (1991), *The Pillow Book of Sei Shonagon*, New York: Columbia University Press.
9. Mircea Eliade (1964) [1951], *Shamanism: Archaic Techniques of Ecstasy*, trans. Willard Trask, Princeton, NJ: Princeton University Press, p. xix.
10. Eliade, p. 13.
11. Claude Lévi-Strauss (1963)[1958], *Structural Anthropology*, trans. Claire Jacobson and Brooke Grundfest Schoepf, Harmondsworth: Penguin, pp. 182–3.
12. Eliade, p. 27.
13. See also Simon Schama (1995), *Landscape and Memory*, London: Fontana, pp. 123–4.

CHAPTER 2 WRITING

1. Brassaï (1964), *Conversations avec Picasso*, Paris: Gallimard, p. 60.
2. Pierre Bourdieu (1998) [1992], *Les règles de l'art: Genèse et structure du champ littéraire*, Paris: Seuil, p. 231.
3. In the preface by Jean Palahilde, in Pierre-Louis Mathieu (ed.) (1984), *L'Assembleur de rêves. Écrits complets de Gustave Moreau*, Paris: Fata Morgana, p. 11.
4. While we take some of Rousseau's value judgements, with their own brand of evolutionism, with a grain of salt, this observation can also be found in his *Essai sur l'origine des langues*, op. cit., p. 68.
5. That is, pre-1788 when Australia was settled by British First Fleet. It is also popular (and appropriate) in Australia to use the stronger term, 'pre-invasion'.
6. For the authoritative account on this work see the essay by its key instigator and spokesman, Djon Mundine, 'Forest of Dreams, Forest of Hope: The Aboriginal Memorial, *200 Poles*', in Adam Geczy and Benjamin Genocchio (eds.) (2001), *What is Installation?*, Sydney: Power Publications, pp. 205–15.
7. See Edward Gibbon (1994) [1781], *The History of the Decline and Fall of the Roman Empire* (v. 2, 1781), ed. David Womersley, Harmondsworth: Penguin, pp. 752ff.
8. Charles Le Brun in Henri Janin (1883), *Conférences de l'Academie Royale*, Paris, pp. 51–61.
9. See Roy Strong (2004) [1978], *Painting the Past*, London: Pimlico, pp. 8–11.
10. Novalis (Georg Philipp Friedrich Freiherr von Hardenberg) (1996), *Fragmente* in *Die Christenheit oder Europa und andere philosophische Schriften*, Cologne: Könemann, p. 263.
11. Virginia Spate (1992), *The Colour of Time*, London: Thames and Hudson, p. 11.
12. Antonin Artaud (2001) [1947], *Van Gogh, Le Suicidé de la societé*, Paris: Gallimard, *passim*.
13. Tom Wolfe (1971), *The Painted Word*, New York: Farrar, Straus and Giroux, *passim*.
14. Giorgio de Chirico (1965), *Mémoires*, tr. French Marin Tissilit, Paris: La Table Ronde, p. 9.
15. See David Bromfield (1991), *Identities: A Critical Study of the Work of Mike Parr, 1970–90*, Perth: University of Western Australia Press, pp. 304–5.
16. Julian Stallybrass (2003), *Internet Art: The Online Clash of Culture and Commerce*, London: Tate Publishing, pp. 126 and *passim*.

CHAPTER 3 IMAGING

1. Jean-Pierre Vernant (1979) [1966], 'Raison hier et d'aujourd'hui', *Raisons, histoires, raisons*, Paris: Éditions La Découverte, p. 97.
2. Jean Baudrillard and Paul Virilio are good thinkers to turn to for this point of view. See Baudrillard's *The Evil Demon of Images* (Sydney: Power Publications, 1987), *Seduction* (New York: St Martin's Press, 1990), or *The Gulf War Did Not Take Place* (Sydney: Power Publications, 1995); and Virilio, *Art and Fear* (London: Continuum, 2003), or *Art As Far As the Eye Can See* (New York and Oxford: Berg, 2007) (the original title, *L'Art à perte de vue* gives a much more vivid sense of visual insight into a state of decline).
3. Quintilian, *Institutio*, cit. by Vernant, 'La naissance des images', *Raisons, histoires, raisons*, p. 105.
4. Vernant, pp.110–111.
5. Leon Battista Alberti (1966), *On Painting*, trans. and ed. John Spencer, New Haven, CT: Yale University Press, pp. 63, 77.
6. Hubert Damisch (1987), 'Ce point que la perspective assigne', *L'Origine de la perspective*, Paris: Flammarion.
7. Leonardo Da Vinci (2005), *The Da Vinci Notebooks*, ed. Emma Dickens, London: Profile Books, pp. 47–8.
8. John Richardson (1988), *A Life of Picasso, Volume 1: 1881–1906*, London: Pimlico, p. 475.

9. Guillaume Apollinaire (1911; 1912), 'The Cubists', *L'Intransigeant*, 10 October, 1911; 'On the Subject in Modern Painting', *Les Soirées de Paris*, February 1912; both in Charles Harrison and Paul Wood (1992), *Art in Theory, 1900–1990*, Oxford: Blackwell, pp. 178–180.

10.

11. Rainer Maria Rilke (2000) [1917], letter to Elisabeth Taubmann, 8 August, 1917, in *Über moderne Malerei*, ed. Martina Kreissbach-Thomasberger, Frankfurt am Main: Insel, p. 86.

12. The great Huang Kung-wang described, in the fourteenth century, the three kinds of perspectives for looking at mountains: from below looking straight ahead is the 'level perspective'; from a nearby point looking across to another hill opposite is called the 'broad perspective' (elsewhere called 'deep perspective'); to see a distant view from outside the mountains is called 'high perspective'. Lin Yutang (trans. and ed.) (1967), *The Chinese Theory of Art*, London: Heinemann, p. 114.

13. James Cahill (1982), *The Compelling Image*, Cambridge, MA: Harvard University Press, p. 2.

14. Shih-t'ao, 'An Expressionist Credo', in Lin Yutang, *The Chinese Theory of Art*, p. 150.

15. Cit. Joseph Leo Koerner (1990), *Caspar David Friedrich and the Subject of Landscape*, London: Reaktion, p. 121.

16. Friedrich Nietzsche (1985), 'Über Wahrheit und Lüge im Aussermoralischem Sinn', *Werke*, ed. G. Stenzel, Salzburg: Bergland, s4: 546.

17. Oscar Wilde (1948), 'The Critic as Artist', *The Works of Oscar Wilde 1856–1900*, ed. G. F. Maine, London: Collins, p. 969.

18. Heinrich von Kleist (1810), 'Empfindungen vor Friedrich's Seelandschaft', *Erklärung*, 22 October, 1810; see also Kleist (1964), *Anekdoten und Kleinere Schriften, Gesamtausgabe*, Munich: Deutsche Taschenbuch Verlag, 5: 61.

19. Samuel Beckett (1999) [1931], *Proust*, London: John Calder Publishing, p. 92.

20. Wassily Kandinsky (1977) [1914], *Concerning the Spiritual in Art*, trans. Michael Sadler, New York: Dover, p. 19.

21. Beckett, *Proust*, p. 92.

22. Piet Mondrian, 'Le cubisme et la Néo-plastique' in Martin James and Harry Holtzman (1986), *The New Art – The New Life: The Collected Writings of Piet Mondrian*, Boston: G. K. Hall, p. 240.

23. See also Mark Cheetham (1991), *The Rhetoric of Purity: Essentialist Theory and the Advent of Abstract Painting*, Cambridge: Cambridge University Press, pp. 67–8 and *passim*.

24. Charles Baudelaire (1954), 'Le Gouvernement de l'imagination', *Salon de 1859*, *Œuvres complètes*, ed. Y.-G. le Dantec, Paris: Gallimard Pléiade, p. 778.

25. Arthur Rimbaud (1966), *Complete Works, Selected Letters*, trans. Wallace Fowlie, Chicago and London: Chicago University Press, p. 307.

26. G. E. Bentley (2004), *Blake Records*, New Haven and London: Yale University Press. See also James Fenton (2006), 'In Samuel Palmer's Garden', *The New York Review*, May 11, 2006, p. 34.

27. Joris-Karl Huysmans (1998) [1884], *Against Nature*, trans. Margaret Mauldon, Oxford: Oxford University Press, pp. 52–3.

28. Sigmund Freud (1991) [1905], 'Three Essays on Sexuality', ed. Anna Freud, *The Essentials of Psychoanalysis*, Harmondsworth: Penguin, p. 371.

29. Arnold Hauser was the first to think seriously of the methodological application of psychoanalysis to the history of art. Speaking of sublimation, Hauser rightly points out that 'the whole definition of it is almost entirely negative. It consists mainly in the diversion of an impulse from its direct but objectionable aim to an indirect and socially more acceptable gratification. We learn that, in the process of artistic creation, a biological urge is being deflected from its normal course, but in the

sublimated form of behaviour we can recognize only the aim to which the force has been directed; we see nothing of the process of diversion itself, and we learn hardly anything about the way in which the change occurs, that is, about the power that diverts the biological impulse in question from one course to another or the means and methods by which the diversion is formed'. Arnold Hauser (1985) [1958], *The Philosophy of Art History*, Evanston, IL: Northwestern University Press, p. 45.

30. Octavio Paz (1992), 'Luis Buñuel: Three Perspectives', in *On Poets and Others*, ed. and trans. Michael Schmidt, London: Paladin, p. 152.

31. André Breton in Charles Harrison and Paul Wood (eds.) (1992), *Art in Theory 1900–1990*, Oxford: Blackwell, p. 434.

32. Gilles Deleuze (2002) [1981], *Francis Bacon: Logique de la sensation*, Paris: Seuil, p. 47.

33. Deleuze, pp. 102–3.

34. Julia Kristeva (1989), 'Holbein's Dead Christ', *Black Sun. Depression and Melancholia*, trans. Leon Roudiez, New York: Columbia University Press, pp. 136–7 and *passim*.

35. Jean-François Lyotard (1989), 'Newman: The Instant', trans. David Macey, in Andrew Benjamin (ed.), *The Lyotard Reader*, Oxford: Blackwell, pp. 240–9.

36. Lyotard, pp. 246, 249.

37. Susan Sontag (1973), *On Photography*, Harmondsworth: Penguin, p. 3.

38. Guy Debord (1992) [1967], *La Société du spectacle*, Paris: Gallimard, p. 27.

39. Ron Burnett (2004), *How Images Think*, Cambridge, MA: MIT Press, pp. 40ff.

40. Lev Manovich (2001), *The Language of New Media*, Cambridge, MA: MIT Press, p. 183.

41. Jacques Derrida (1988), 'The Deaths of Roland Barthes', in Hugh Silverman (ed.), *Philosophy and Non-Philosophy Since Merleau-Ponty*, New York: Routledge, pp. 90, 34.

CHAPTER 4 GAZING

1. Plato, *Republic*, Book VII, numerous editions; this version is (1969) [1942] *Plato: Five Great Dialogues*, ed. Louise Ropes Loomis, New York: Gramercy, p. 398.

2. Slovaj Zizek (1992), 'Why Does the Phallus Appear?', *Enjoy Your Symptom!*, London: Routledge, p. 137.

3. Jean-Paul Sartre (1943), *L'Être et le néant*, Paris: Gallimard, p. 300.

4. Jacques Lacan (1979) [1973], 'The Eye and the Gaze' and 'Anamorphosis', *The Four Fundamental Concepts of Psycho-Analysis*, ed. Jacques-Alain Miller, trans. Alan Sheridan, Harmondsworth: Penguin, pp. 67–90.

5. Laura Mulvey (1989), 'Visual Pleasure and Narrative Cinema', *Visual and Other Pleasures*, Bloomington: Indiana University Press, pp. 14–26.

6. Charles Baudelaire (1954), 'Le peintre de la vie moderne', *Œuvres complètes*, ed. Y.-G. le Dantec, Paris: Gallimard Pléiade, pp. 881–920.

7. For the best book on this subject see T. J. Clark (1999) [1984], *The Painting of Modern Life*, London: Thames and Hudson.

8. Rozsika Parker and Griselda Pollock (1981), *Old Mistresses: Women, Art and Ideology*, London: Pandora, p. 41.

9. Griselda Pollock (1988), *Vision and Difference: Femininity, Feminism, and Histories of Art*, London: Routledge.

10. Edward Said (1978), *Orientalism*, London: Routledge, p. 7.

11. Michel Foucault (1977), 'Intellectuals and Power', a discussion with Gilles Deleuze, *L'Arc*, 1972, pp. 3–10, trans. Donald Bouchard and Sherry Simon, *Language, Counter-Memory, Practice*, Ithaca, NY: Cornell University Press, p. 213.

12. Foucault (1966), *Les Mots et les choses*, Paris: Gallimard. See also David Carroll (1987), *Paraesthetics*, New York and London: Methuen, p. 59: 'The painting is presented by Foucault as a kind of labyrinth

of representation – is this the essence of representation, one could already ask? – from which there seems to be no escape, where the outside (all subjects and spaces in front or behind the space of representation) is brought inside and the inside is projected outside. Representation thus dominates not only its own space but also the space it projects outside itself. There seems to be no alternative to representation possible, for it, too, would have to be *represented* either as absent or as present.'

13. Jürgen Habermas (1990) [1985], *The Philosophical Discourse of Modernity*, trans. Frederick Lawrence, Cambridge, MA: MIT Press, pp. 238–293.

14. Homi Bhaba (1994), 'The Other Question: Stereotype, Discrimination, and the Course of Colonialism', in Bhaba (ed.), *The Location of Culture*, London and New York: Routledge.

15. Karina Eileraas (2003), 'Reframing the Colonial Gaze: Photography, Ownership, and the Feminist Resistance', *MLN* 118, 2003.

16. Jacques Derrida and Marie-Françoise Plissart (1985), *Droit de regards*, Paris: Minuit. See also the translation, 'Right of Inspection', *Art and Text* 32, autumn 1989.

17. Lisa Parks (2002), 'Satellite and Cyber Visualities', in Nicholas Mirzoeff (ed.), *The Visual Culture Reader*, second edition, London and New York: Routledge, pp. 284 and *passim*.

CHAPTER 5 MEDIA

1. John Berger (1977), *Ways of Seeing*, Harmondsworth: Penguin, *passim*.

2. Johann Gottfried Herder (1999), *Journal meiner Reise im Jahr 1769*, Berlin: Aufbau Taschenbuch Verlag, p. 97.

3. Jonathan Crary (1990), *Techniques of the Observer*, Cambridge, MA: MIT Press, pp. 38–9.

4. Cit. Graham Clarke (1997), *The Photograph*, Oxford: Oxford University Press, p. 13.

5. Meyer Schapiro (1982) [1957], 'Recent Abstract Painting', *Modern Art*, New York: George Braziller, pp. 217–19.

6. Walter Benjamin (1977), 'Das Kunstwerk im Zeitalter seiner technischen Reproduzierbarkeit', *Illuminationen*, Frankfurt am Main: Suhrkamp, pp. 136–169.

7. Martin Heidegger (1971), 'The Origin of the Work of Art', *Poetry, Language, Thought*, trans. Albert Hofstadter, New York: Harper and Row, pp. 17–81.

8. M. Heidegger (1977), 'The Question Concerning Technology', *The Question Concerning Technology and Other Essays*, trans. William Lovitt, New York: Harper and Row, pp. 3–35.

9. Julian Young (2002), *Heidegger's Later Philosophy*, Cambridge: Cambridge University Press, pp. 37–62.

10. Marshall McLuhan (1964), *Understanding Media*, London: Routledge, pp. 24–33.

11. Rosalind Krauss (1999), *A Voyage on the North Sea: Art in the Age of the Post-Medium Condition*, London: Thames and Hudson.

12. Erkki Huhtamo (1996), 'Time Travelling in the Gallery', in Mary Anne Moser with Douglas McLeod (eds.), *Immersed in Technology: Art and Virtual Environments*, Cambridge, MA: MIT Press, p. 244.

13. Mark Hansen (2004), *New Philosophy for New Media*, Cambridge, MA: MIT Press, p. 10.

14. Hansen, pp. 116–17.

CHAPTER 6 STYLE

1. Kenenth Clark (1972), *The Nude: The Study in Ideal Form*, Princeton: Princeton University Press.

2. Lynn Nicholas (1994), *The Rape of Europa. The Fate of Europe's Treasures in the Third Reich and the Second World War*, New York: Vintage, p. 20, quotation emended.

3. J. J. Winckelmann (1972), *Writings on Art*, selected and ed. David Irwin, London: Phaidon, p. 104.

4. Gottfried Semper (1989), 'Science, Industry, Art', *The Four Elements of Architecture and Other Writings*, trans. Harry Malgrave and Wolfgang Hermann, Cambridge: Cambridge University Press, p. 142.

5. Semper, p. 143.

6. Semper, p. 136.

7. Harry Malgrave (1996), *Gottfried Semper, Architect of the Nineteenth Century*, New Haven and London: Yale University Press, pp. 206–7.

8. Erwin Panofsky (1993) [1955], 'Iconography and Iconology: An Introduction to the Study of Renaissance Art', *Meaning in the Visual Arts*, Harmondsworth: Penguin, p. 51.

9. Meyer Schapiro (1943), 'Style', *Anthropology Today*, ed. Sol Tax, Chicago and London: Chicago University Press, p. 293.

10. Schapiro, p. 302.

11. Craig Owens (1980), 'The Allegorical Impulse: Toward a Theory of Postmodernism', *October*, 12, spring 1980, pp. 67–86, reprinted in Craig Owens (1992), *Beyond Recognition: Representation, Power, Culture*, ed. Scott Bryson et al., Berkeley and Los Angeles: California University Press, pp. 52–69.

12. Émile Zola (1970) [1867], 'Édouard Manet', *Mon Salon, Écrits sur l'art*, ed. Antoine Ehrard, Paris: Flammarion, pp. 101–2.

CHAPTER 7 PLEASURE

1. Plotinus (1991), *The Enneads*, trans. Stephen Mackenna, ed. John Dillon, Harmondsworth: Penguin, pp. 30–44.

2. A. Riegl (2000), introduction to *A Historical Grammar of the Visual Arts*, in Isabelle Frank, *The Theory of Decorative Art*, New Haven, CT and London: Yale University Press, p. 114.

3. Aristotle (1953), *Nichomachean Ethics*, trans. J. A. K. Thomson, Harmondsworth: Penguin, p. 297.

4. Terry Eagleton (1990), *The Ideology of the Aesthetic*, Oxford: Blackwell, pp. 13–14.

5. Cit. Eagleton, p. 16.

6. George Santayana (1942), *Realms of Being*, New York: Scribner's, p. 8.

7. Santayana (1988) [1896], *The Sense of Beauty*, Cambridge, MA: MIT Press, p. 79.

8. William Hazlitt (2000), 'On the Pleasure of Painting', *The Fight and Other Writings*, eds. Tom Paulin and David Chandler, Harmondsworth: Penguin, pp. 24, 30.

9. T. W. Adorno (1981), 'Cultural Criticism and Society', in *Prisms*, trans. Samuel and Sherry Weber, Cambridge, MA: MIT Press, p. 34.

10. Jean Genet (1979), 'L'Atelier d'Alberto Giacometti', in *Œuvres complètes*, Paris: Gallimard, 5: 42.

11. T. W. Adorno and Max Horkheimer (1972), *The Dialectic of Enlightenment*, trans. John Cumming, London and New York: Verso, p. 122.

12. Adorno and Horkheimer, p. 126.

13. Adorno and Horkheimer, p. 139.

14. Jonathan Vickery (2002), 'Art Without Administration: Radical Art and Critique after the Neo-Avant-Garde', *Third Text*, 61, December 2002.

15. R. G. Collingwood (1938), *The Principles of Art*, London: Clarendon, p. 91.

CHAPTER 8 MONEY

1. Ingrid Rowland (1998), *The Culture of the High Renaissance*, Cambridge and London: Cambridge University Press, p. 31.

2. Pierre Bourdieu (1992), 'Le marché des biens symboliques', *Les règles de l'art*, Paris: Seuil, pp. 234–88.

3. Robert Jensen (1994), *Marketing Modernism in Fin-de-Siècle Europe*, Princeton, NJ: Princeton University Press, p. 51.

4. Jean Baudrillard (1981), *For a Critique of the Political Economy of the Sign*, trans. Charles Levin, New York: Telos Press, p. 185. See also Julian Pefanis (1991), 'Theories of the Third Order', *Heterology and the Postmodern*, Sydney: Allen and Unwin, pp. 59–81.

5. Baudrillard, p. 118.

6. Peter Watson and Cecilia Todeschini (2006), *The Medici Conspiracy: The Illicit Journey of Looted Antiquities from Italy's Tomb Raiders to the World's Greatest Museums*, New York: Public Affairs, *passim*.

7. Marcel Proust (1983) [1907–22], *Remembrance of Things Past*, tr. C. K. Scott Moncrieff and Terence Kilmartin, Harmondsworth: Penguin, 1: 17.

8. John Updike (2006), 'The Artful Clarks', *The New York Review of Books*, October 5, 2006, p. 11.

9. It is useful to note that in his introduction to the book by Lucy Lippard on Pop Art, Alloway cites an enlightening, curious genealogy of art which responds to the commercial world that dates back to Picasso and Schwitters. Lucy Lippard et al. (1966), *Pop Art*, London: Thames and Hudson, revised 1970.

CHAPTER 9 DISPLAY

1. Paul Valéry (1960) [1923], 'Le problème des musées' (*Le Gaulois*, 4 April, 1923), *Œuvres II*, ed. Jean Hytier, Paris: Gallimard Pléiade, pp. 1290–3.

2. Paul Virilio (2005), *L'Art à perte de vue*, Paris: Galilée, *passim*.

3. James Shapiro (2006), *1599: A Year in the Life of William Shakespeare*, London: Faber, pp. 32–3. See also Simon Thurley (1999), *Whitehall Palace: An Architectural History of the Royal Apartments, 1240–1698*, New Haven, CT and London: Yale University Press.

4. Stephen Bann (1995), 'Shrines, Curiosities and the Rhetoric of Display', in Lynne Cooke and Peter Wollen (eds.), *Visual Display: Culture Beyond Appearances*, Seattle, WA: Bay Press.

5. See Sidney Hutchison (1986) [1968], *The History of the Royal Academy, 1768–1986*, London: Robert Royce Ltd., pp. 37 and *passim*.

6. Andrew McClellan (1994), *Inventing the Louvre*, Berkeley and Los Angeles: California University Press, pp. 98–9.

7. Louis-Pierre Deseiné, *Opinion sur les musées*, Paris 1803, cit. A. McClellan, *Inventing the Louvre*, p. 195.

8. 'Mott was too close [to J. L. Mott Iron Works, the manufacturer of bathroom fixtures] so I altered it to Mutt, after the daily strip "Mutt and Jeff" which appeared at the time […] And I added Richard [French argot for someone well-heeled] … Get it? The opposite of poverty. But not even that much, just R. MUTT.' Cit. Otto Hahn (1966), 'Passport No. G255300', *Art and Artitsts*, 1, no. 4 (July 1966), p. 10.

9. *The Blind Man*, no. 2, May 1917; see also Thierry de Duve, 'Given the Richard Mutt Case' in Thierry de Duve (ed.) (1991), *The Definitively Unfinished Marcel Duchamp*, Cambridge, MA: MIT Press, pp. 199 and *passim*.

10. T. W. Adorno, 'The Valéry-Proust Museum', *Prisms*, trans. Samuel and Sherry Weber, Cambridge, MA: MIT Press, p. 175.

11. Gilles Deleuze and Félix Guattari (1980), *Mille Plateaux*, Paris: Minuit, *passim*.

12. Robert Smithson (1996) [1972], 'The Spiral Jetty', in *Robert Smithson: The Collected Writings*, ed. Jack Flam, Berkeley and Los Angeles: California University Press, pp. 145–6.

13. See for example, Douglas Crimp (1993), 'Redefining Site Specificity', *On the Museum's Ruins*, Cambridge, MA: MIT Press, pp. 154–5.

14. Kaprow and Smithson, 'What is a Museum?', originally published in *Arts Yearbook*, 1967, republished in *Robert Smithson: The Collected Writings*, p. 43.

15. Alan Kaprow (1993) [1979], 'Performing Life', *Essays on the Blurring of Art and Life*, ed. Jeff Kelley, Berkeley and Los Angeles: California University Press, p. 195.

16. Mary Kelly (1983), *Post-Partum Document*, London: Routledge, p. 9.

17. Kwame Anthony Appiah (1996), *Cosmopolitanism: Ethics in a World of Strangers*, New York: Norton, passim.

18. Michael Kimmelman (2006), 'A Heart of Darkness in the City of Light', *The New York Times*, 2 July, 2006, p. 22.

CHAPTER 10 AGENCY

1. For perhaps the most entertaining and informative account of the circumstances surrounding *The Tennis Court Oath* and *Marat Assassinated* see Simon Schama (1989), *Citizens*, Harmondsworth: Penguin, pp. 356–61, 741–6.

2. David Chandler (1999) [1993], *Dictionary of the Napoleonic Wars*, Hertfordshire: Wordsworth Editions, p. 147.

3. See also Tia DeNora (1995), *Beethoven and the Construction of Genius. Musical Politics in Vienna, 1972–1803*, Berkeley and Los Angeles: California University Press, passim.

4. Lorenz Eitner (1972), *Géricault's Raft of the Medusa*, London: Phaidon, p. 59.

5. Eitner, pp. 1–11.

CONCLUSION – EXCEPTIONS

1. Kaprow and Smithson, 'What is a Museum?', in *Robert Smithson: The Collected Writings*, ed. Jack Flam, Berkeley and Los Angeles: California University Press, p. 45.

FURTHER READING

INTRODUCTION

Bové, Paul (ed.) (1995), *Early Postmodernism, Foundational Essays*, Durham, NC and London: Duke University Press.

Bryson, Norman, Michael Ann Holly and Keith Moxey (eds.) (1994), *Visual Culture: Images and Interpretations*, Hanover and London: Wesleyan University Press.

Calinescu, Matei (1987), *Five Faces of Modernity*, Durham, NC and London: Duke University Press.

Carter, Michael and Adam Geczy (2006), *Reframing Art*, Oxford: Berg.

Craske, Matthew (1997), *Art in Europe 1700–1830*, Oxford: Oxford University Press.

Deleuze, Gilles and Félix Guattari (1988), *A Thousand Plateaus: Capitalism and Schizophrenia*, trans. Brian Massumi, London: Athlone.

Deleuze, Gilles and Claire Parnet (1977), *Dialogues*, Paris: Flammarion.

Foucault, Michel (1972), *The Archaeology of Knowledge*, trans. A. M. Sheridan Smith, New York: Pantheon.

Fry, Roger (1956) [1920], *Vision and Design*, Cleveland, OH and New York: Meridian.

Gombrich, Ernst (1979), *Ideals and Idols. Essays on Values in the History of Art*, Oxford: Phaidon.

Nelson, Robert and Richard Shiff (eds.) (1996), *Critical Terms for Art History*, Chicago and London: Chicago University Press.

Preziosi, Donald (ed.) (1998), *The Art of Art History: A Critical Anthology*, Oxford: Oxford University Press.

Shiner, Larry (2001), *The Invention of Art*, Chicago and London: Chicago University Press.

Walker, John and Sarah Chaplin (1997), *Visual Culture: An Introduction*, Manchester and New York: Manchester University Press.

Wollheim, Richard (1980) [1968], *Art and its Objects*, second edn., Cambridge: Cambridge University Press.

CHAPTER I RITUAL

Boardman, John (1978), *Greek Sculpture, The Archaic Period*, London: Thames and Hudson.

Cioran (1956), *La tentation d'exister*, Paris: Gallimard.

Clastres, Pierre (1989), *Society Against the State*, trans. Robert Hurley and Abe Stein, New York: Zone.

Curtis, Gregory (2006), *The Cave Painters: Probing the Mysteries of the World's First Artists*, New York: Knopf.

Adams, David (1992), 'Joseph Beuys: Pioneer of a Radical Ecology', *Art Journal*, v. 51, 2, *Art and Ecology* (summer 1992), pp. 26–34.

Guthrie, R. Dale (2006), *The Nature of Paleolithic Art*, Chicago and London: Chicago University Press.

Vernant, Jean-Pierre (1988), *Myth and Society in Ancient Greece*, trans. Janet Lloyd, New York: Zone.

Ward, Frazer (2001), 'Gray Zone: Watching *Shoot*', *October*, 95, winter 2001.

Williams, Emmett (2007), *A Flexible History of Fluxus Facts and Fictions: 70 'Kunstfibel' Collages Digitally Remastered by Ann Noël*, London: Thames and Hudson.

CHAPTER 2 WRITING

Ashbery, John (1989), *Reported Sightings: Art Chronicles 1957–87*, ed. David Bergman, Cambridge, MA: Harvard University Press.

Bann, Stephen (1997), *Paul Delaroche: History Painted*, London: Reaktion.

Bardon, Geoffrey (1991), *Papunya Tula, Art of the Western Desert*, Adelaide: J. B. Books.

Barthes, Roland (1977), *Image-Music-Text*, trans. Stephen Heath, New York: Farrar, Straus and Giroux.

Brookner, Anita (1971), *The Genius of the Future*, London: Phaidon.

Bush, Vanevar (1945), 'As We May Think', *Atlantic Quarterly*, July 1945, 176, no. 1.

Cabanne, Pierre (1971) [1967], *Dialogues with Marcel Duchamp*, trans. Ron Padgett, New York: Da Capo.

Carrier, David (1987), *Artwriting*, Amherst, MA: Massachusetts University Press.

Cézanne, Paul (1978), *Correspondence*, ed. John Rewald, Paris: Grasset.

Danto, Arthur (1995), 'Diderot on Art, 2 vols.'; book review, *Artforum*, Nov. 1995.

Florence, Penny (1986), *Mallarmé, Manet and Redon*, Cambridge: Cambridge University Press.

Gamboni, Dario (1989), *La plume et le pinceau. Odilon Redon et la literature*, Paris: Minuit.

van Gogh, Vincent (1979), *The Complete Letters of Vincent van Gogh*, (3 vols.), London: Thames and Hudson.

Green, Rachel (2004), *Internet Art*, London: Thames and Hudson.

Greenberg, Clement (1986–93), *The Collected Essays and Art Criticism*, ed. John O'Brian, 4 vols., Chicago and London: Chicago University Press.

Hubert, Renée (1988), *Surrealism and the Book*, Berkeley and Los Angeles: California University Press.

Ingres, J. A. D. (1994), *Écrits sur l'art*, Paris: La Bibliothèque des Arts.

Kandinsky, Wassily (1955), *Essays über Kunst und Künstler*, Berne: Benteli Verlag.

Kosuth, Joseph (1991), *Art after Philosophy and After. Collected Writings, 1966–1990*, ed. Gabriele Guercio, Cambridge, MA: MIT Press.

Lovink, Geert (2002), *Dark Fiber*, Cambridge, MA: MIT Press.

Mâle, Emile (1994) [1948], *Notre-Dame de Chartres*, Paris: Flammarion.

Meier-Graefe, Julius (1907), *Impressionisten*, Munich and Leipzig: Piper and Co.

Merod, John (1987), *The Political Responsibility of the Critic*, Ithaca, NY and London: Cornell University Press.

O'Brien, W. A. (1995), *Novalis: Signs of Revolution*, Durham, NC and London: Duke University Press.

Orwicz, Michael (1994), *Art Criticism and its Institutions in Nineteenth-Century France*, Manchester and New York: Manchester University Press.

Redon, Odilon (1961), *À soi-même: Journal 1867–1915*, Paris: José Corti.

Rice, David (1963), *Art of the Byzantine Era*, London: Thames and Hudson.

Richter, Gerhard (1995), *The Daily Practice of Painting. Writings 1962–1993*, Cambridge, MA: MIT Press and London: Anthony D'Offay Gallery.

Runge, Philipp Otto (1982), *Die Begier nach der Möglichkeit neuer Bilder*, Leipzig: Verlag Philipp Reclam.

Schom, Alan (1987), *Emile Zola*, London: Queen Anne Press.

Schwartz, Sanford (1990), *Artists and Writers*, New York: Yarrow.

Vollard, Ambroise (1938), *En écoutant Cézanne, Degas, Renoir*, Paris: Grasset.

White, Edmund (1993), *Genet*, London: Chatto and Windus.

CHAPTER 3 IMAGING

Bersani, Leo (1986), *The Freudian Body: Psychoanalysis and Art*, New York: Columbia University Press.

Bersani, Leo and Ulysse Dutoit (1993), *The Arts of Impoverishment*, Cambridge, MA and London: Harvard University Press.

Brookner, Anita (2001) [2000], *Romanticism and its Discontents*, Harmondsworth: Penguin.

Blayney-Brown, David (2001), *Romanticism*, London and New York: Phaidon.

Buydens, Mireille (2005), *Sahara: l'esthétique de Gilles Deleuze*, Paris: Vrin.

Damisch, Hubert (1994), *The Origin of Perspective*, trans. John Goodman, Cambridge, MA: MIT Press.

Damisch, Hubert (1997), *Un souvenir d'enfance par Piero della Francesca*, Paris: Seuil.

Debray, Régis (1992), *Vie et mort de l'image*, Paris: Gallimard.

Derrida, Jacques (1978), *La vérité en peinture*, Paris: Flammarion.

Elkins, James (1994), *The Poetics of Perspective*, Ithaca, NY and London: Cornell University Press.

Feher, Michael et. al. (eds.) (1989), *Fragments for a History of the Human Body, Part One*, New York: Zone.

Flanagan, Sabina (1989), *Hildegard of Bingen: A Visionary Life*, London: Routledge.

Foucault, Michel (1983), *This Is Not a Pipe*, trans. James Harkness, Berkeley and Los Angeles: California University Press.

Francastel, Pierre (1974), *L'Impressionisme*, Paris: Denoël.

Freud, Sigmund (1986) [1901], 'On Dreams', *The Essentials of Psychoanalysis*, ed. Anna Freud, trans. James Strachey, Harmondsworth: Penguin.

Golding, John (1959), *Cubism: A History and Analysis 1907–1914*, London: Faber.

Golding, John (1994), *Visions of the Modern*, Berkeley and Los Angeles: California University Press.

Harrison, Charles and Paul Wood (eds.) (1992), *Art in Theory 1900–1990*, London: Blackwell.

Hartley, Keith (1994), *The Romantic Spirit in German Art 1790–1990*, London: Thames and Hudson.

Jullien, François (2003), *La grande image n'a pas de forme*, Paris: Seuil.

Julius, Anthony (2001), *Idolizing Pictures: Idolatry, Iconoclasm and Jewish Art*, London: Thames and Hudson.

Kermode, Frank (1957), *Romantic Image*, New York and London: Routledge.

Kemp, Martin (1997), *Behind the Picture*, New Haven, CT and London: Yale University Press.

Kudielka, Robert (2003), *Bridget Riley: Dialogues on Art*, London: Thames and Hudson.

Moi, Toril (1986), *The Kristeva Reader*, Oxford: Blackwell.

Mitchell, W. J. T. (1986), *Iconology: Image, Text, Ideology*, Chicago and London: Chicago University Press.

Mossop, D. J. (1971), *Pure Poetry*, Oxford: Oxford University Press.

Newman, Barnett (1990), *Selected Writings and Interviews*, ed. John O'Neill, Berkeley: California University Press.

Nietzsche, Friedrich (1979), *Philosophy and Truth. Selections from Nietzsche's Notebooks of the Early 1870s*, trans. and ed. Daniel Breazeale, New Jersey and London: Humanities Press.

Overy, Paul (1991), *De Stijl*, London: Thames and Hudson.

Padovan, Richard (2002), *Toward Universality: Le Corbusier, Mies and De Stijl*, London and New York: Routledge.

Redon, Odilon (1961), *À soi-même. Journal 1867–1915*, Paris: José Corti.

Ricoeur, Paul (1970), *Freud and Philosophy*, trans. Denis Savage, New Haven, CT and London: Yale University Press.

Rosset, Clément (2001), *Écrits sur Schopenhauer*, Paris: PUF.

Sartre, Jean-Paul (1936), *L'imagination*, Paris: Presses Universitaires de France.

Schapiro, Meyer (1995), *Mondrian: On the Humanity of Abstract Painting*, New York: George Braziller.

Shapiro, David and Cecile Shapiro (1990), *Abstract Expressionism, A Critical Record*, Cambridge: Cambridge University Press.

Shattuck, Roger (1955), *The Banquet Years*, New York: Vintage.

Talens, Jenaro (1993) [1986], *The Branded Eye: Buñuel's* Un Chien Andalou, trans. Giulia Colaizzi, Minneapolis: Minnesota University Press.

Zweite, Armin (ed.) (2006), *Francis Bacon: The Violence of the Real*, London: Thames and Hudson.

CHAPTER 4 GAZING

Apter, Emily (1988), 'The Garden of Scopic Perversion from Monet to Mirbeau', *October*, 47, winter.

Ashton, Dore (1981), *Rosa Bonheur: A Life and a Legend*, London: Secker and Warburg.

Benjamin, Roger (2003), *Orientalist Aesthetics: Art, Colonialism and French North Africa, 1880–1930*, Berkeley and London: California University Press.

Bhaba, Homi (1994), *The Location of Culture*, London and New York: Routledge.

Bowie, Malcolm (1991), *Lacan*, London: Fontana.

Butler, Judith (1990), *Gender Trouble: Feminism and the Subversion of Identity*, New York and London: Routledge.

Cannadine, David (2001), *Ornamentalism: How the British Saw Their Empire*, Oxford: Oxford University Press.

Caplan, Jay (1986), *Framed Narratives: Diderot's Genealogy of the Beholder*, Manchester: Manchester University Press.

Descombes, Vincent (1980) [1979], *Modern French Philosophy*, trans. L. Scott-Fox and J. M. Harding, Cambridge: Cambridge University Press.

Fauconnier, Bernard (2006), *Cézanne*, Paris: Gallimard.

Ferguson, Frances (1992), *Solitude and the Sublime: Romanticism and the Aesthetics of Individuation*, New York and London: Routledge.

Foucault, Michel (1988), *Politics, Philosophy, Culture: Interviews and Other Writings, 1977–1984*, ed. Lawrence Kritzman, trans. Alan Sheridan et al., London: Routledge.

Geczy, Adam (2005), 'Phillip George: Night Vision and the Post-Oriental', *Art Asia Pacific*, 47.

Irigaray, Luce (1974), *Speculum*, Paris: Minuit.

Garb, Tamar (1998), *Bodies of Modernity: Figures and Flesh in Fin-de-Siècle France*, London: Thames and Hudson.

Grosz, Elizabeth (1989), *Sexual Subversions*, Sydney: Allen and Unwin.

Kemp, Martin (1997), *Behind the Picture. Art and Evidence in the Italian Renaissance*, New Haven, CT and London: Yale University Press.

Lacan, Jacques (1966), *Ecrits I & II*, Paris: Seuil.

Lynn, Victoria (1999), *Voiceovers*, exhibition catalogue, Sydney: Art Gallery of New South Wales.

Mehlman, Jeffrey (1993), *Walter Benjamin for Children. An Essay on His Radio Years*, Chicago and London: Chicago University Press.

Merleau-Ponty, Maurice (1964) [1948], 'Cézanne's doubt', *Sense and Non-Sense* (1948), trans. Hubert Dreyfus and Patricia Allen Dreyfus, Evanson: Northwestern University Press.

Moore-Gilbert, Bart (1997), *Postcolonial Theory*, London and New York: Verso.

Pollock, Griselda (1998), *Cassatt, Painter of Modern Women*, London: Thames and Hudson.

Rajchman, John (1991), 'Foucault's Art of Seeing', *Philosophical Events*, New York: Columbia University Press.

Rewald, John (1986), *Studies in Post-Impressionism*, New York: Abrams.

Rhodes, Colin (1994), *Primitivism and Modern Art*, London: Thames and Hudson.

Ross, Christine (2001), 'Vision and Insufficiency at the Turn of the Millennium: Rosemarie Trockel's Distracted Eye', *October*, 96, spring.

Said, Edward (1993), *Culture and Imperialism*, London: Chatto and Windus.

Whitford, Margaret (1991), *Luce Irigaray: Philosophy in the Feminine*, London: Routledge.

CHAPTER 5 MEDIA

Bailey, Anthony (2001), *Vermeer: A View of Delft*, London: Chatto and Windus.

Belting, Hans and Elrich Schulze (eds.) (2000), *Beiträge zur Kunst und Medientheorie*, Stuttgart: Hatje Cantz.

Bois, Yve-Alain (1990), *Painting as Model*, Cambridge, MA: MIT Press.

Buck-Morss, Susan (1989), *The Dialectics of Seeing*, Cambridge, MA: MIT Press.

Church, A. H. (1890), *The Chemistry of Paints and Painting*, London: Seeley and Co. Ltd.

Cohen, Margaret (1993), *Profane Illumination: Walter Benjamin and the Paris of the Surrealist Revolution*, Berkeley and Los Angeles: California University Press.

Darley, Andrew (2000), *Visual Digital Culture: Surface Play and Spectacle in New Media Genres*, London and New York: Routledge.

Eagleton, Terry (1981), *Walter Benjamin, or Towards a Revolutionary Criticism*, London and New York: Verso.

Gage, John (1993), *Colour and Culture*, London: Thames and Hudson.

Goldberg, RoseLee (2000), *Laurie Anderson*, London: Thames and Hudson.

Griffiths, Antony (1980), *Prints and Printmaking: An Introduction to the History and Techniques*, London: British Museum Press.

Hall, Doug and Sally Jo Fifer (1990), *Illuminating Video: An Essential Guide to Video Art*, New Jersey: Aperture.

Hall, James (2006), *Michelangelo and the Reinvention of the Human Body*, New York: Farrar, Straus and Giroux.

Haraway, Donna (1991), *Simians, Cyborgs, and Women: The Reinvention of Nature*, New York and London: Routledge.

Hegel, G. W. F. (2005), *Philosophie der Kunst*, Frankfurt am Main: Suhrkamp.

Hegel, G. W. F. (1993), *Introductory Lectures on Aesthetics*, trans. Bernard Bosanquet, Harmondsworth: Penguin.

Joselit, David (2003), *American Art Since 1945*, London: Thames and Hudson.

Kraynak, Janet (ed.) (2003), *Please Pay Attention Please: Bruce Nauman's Words*, Cambridge, MA: MIT Press.

Kultermann, Udo (1999) [1966], *Geschichte der Kunstgeschichte*, Vienna and Düsseldorf: Econ-Verlag.

Levinson, Paul (1999), *Digital McLuhan*, London: Routledge.

Markley, Robert (ed.) (1996), *Virtual Realities and Their Discontents*, Baltimore, MD and London: Johns Hopkins University Press.

Paul, Christiane (2003), *Digital Art*, London: Thames and Hudson.

Phillips, Christopher (ed.) (1989), *Photography in the Modern Era. European Documents and Critical Writings 1913–40*, New York: The Metropolitan Museum of Art/Aperture.

Riley, Charles (1995), *Color Codes*, Hanover and London: University Press of New England.

Round Table (2003), 'The Projected Image in Contemporary Art', *October*, 104, spring.

Stafford, Barbara and Frances Terpak (2001), *Devices of Wonder: From the World in a Box to Images on a Screen*, exhibition catalogue, Los Angeles: Getty Research Institute.

Steadman, Philip (2001), *Vermeer's Camera: Uncovering the Truth Behind the Masterpieces*, Oxford: Oxford University Press.

Townsend, Chris (ed.) (2004), *The Art of Bill Viola*, London: Thames and Hudson.

Wands, Bruce (2007), *Art of the Digital Age*, London: Thames and Hudson.

Whitford, Frank (1984), *Bauhaus*, London: Thames and Hudson.

Zimmerman, Michael (1990), *Heidegger's Confrontation with Modernity: Technology, Politics, Art*, Bloomington and Indianapolis: Indiana University Press.

CHAPTER 6 STYLE

Alpers, Svetlana (1983), *The Art of Describing*, Chicago and London: Chicago University Press.

Ashton, Dore and Denise Browne Hare (1981), *Rosa Bonheur, A Life and a Legend*, London: Secker and Warburg.

Bauman, Zygmunt (1978), *Hermeneutics and the Social Sciences: Approaches to Understanding*, London: Hutchison.

Blais, Joline and Jon Ippolito (2006), *At the Edge of Art*, London: Thames and Hudson.

Blanxandall, Michael (1972), *The Eye of the Quattrocento*, Oxford: Oxford University Press.

Bois, Yve-Alain (1990), *Painting as Model*, Cambridge, MA: MIT Press.

Bové, Paul (ed.) (1995), *Early Postmodernism: Foundational Essays*, Durham, NC and London: Duke University Press.

Calinescu, Matei (1987), *The Five Faces of Modernity*, Durham, NC and London: Duke University Press.

Desmond, William (1986), *Art and the Absolute: A Study of Hegel's Aesthetics*, New York: SUNY Press.

Focillon, Henri (1943), *Vie des formes*, Paris: Presses Universitaires de France.

Gablik, Suzi (1984), *Has Modernism Failed?*, New York: Thames and Hudson.

Gombrich, Ernst (1972), 'Psychology and Riddle of Style', introduction to *Art and Illusion*, London: Phaidon.

Hauser, Arnold (1965), *Mannerism*, Cambridge, MA: Harvard University Press.

Hegel, G. W. F. (1971), *Introduction to the Lectures on the History of Philosophy*, trans. T. M. Knox and A. V. Miller, Oxford: Clarendon Press.

Hegel, G. W. F. (1977), *Phenomenology of Spirit*, trans. A. V. Miller, Oxford: Oxford University Press.

Hegel, G. W. F. (1956), *Philosophy of History*, trans. J. Sibree, New York: Dover.

Jones, Amelia (1994), *Postmodernism and the En-Gendering of Marcel Duchamp*, Cambridge: Cambridge University Press.

Le Corbusier (Charles-Édouard Jeanneret) (1925), *L'Art decoratif d'aujourd'hui*, Paris: Grès et Cie.

Nochlin, Linda (2007), *Courbet*, London: Thames and Hudson.

Panofsky, Erwin (1995), *Three Essays on Style*, ed. Irving Lavin, Cambridge, MA: MIT Press.

Panofsky, Erwin (1968), *Idea: A Concept in Art Theory*, Columbia, SC: University of South Carolina.

Pater, Walter (1889), 'Style', *Appreciations*, London: Macmillan and Co.

Perry, Gill and Michael Rossington (eds.) (1994), *Femininity and Masculinity in Eighteenth-Century Art and Culture*, Manchester and New York: Manchester University Press.

Podro, Michael (1982), *The Critical Historians of Art*, New Haven, CT and London: Yale University Press.

Potts, Alex (1994), *Flesh and the Ideal: Winckelmann and the Origins of Art History*, New Haven, CT and London: Yale University Press.

Riegl, Alois (1985), *Late Roman Art History*, Rome: Giorgio Bretschneider.

Shiff, Richard (1984), *Cézanne and the End of Impressionism*, Chicago and London: Chicago University Press.

Sontag, Susan (1994), *Against Interpretation*, London: Vintage.

Stangos, Nikos (ed.) (1994), *Concepts of Modern Art From Fauvism to Postmodernism*, London: Thames and Hudson.

Stokes, Adrian (1968) [1932], *The Quattro Cento*, New York: Schocken.

Taylor, Charles (1975), *Hegel*, Cambridge, Cambridge University Press.

Thomas, Nicholas and Diane Losche (eds.) (1999), *Double Vision: Art Histories and Colonial Histories in the Pacific*, Cambridge: Cambridge University Press.

CHAPTER 7 PLEASURE

Adorno, T. W. (1974), *Minima Moralia*, trans. E. F. N. Jephcott, London: Verso.

Bowie, Andrew (1990), *Aesthetics and Subjectivity, from Kant to Nietzsche*, Manchester and New York: Manchester University Press.

Conisbee, Philip (1981), *Painting in Eighteenth-Century France*, Oxford: Phaidon.

Djikstra, Bram (1986), *Idols of Perversity: Fantasies of Female Evil in Fin-de-Siècle Culture*, Oxford: Oxford University Press.

Donoghue, Denis (2003), *Speaking of Beauty*, New Haven, CT and London: Yale University Press.

Guyer, Paul (1997), *Kant and the Claims of Taste*, Cambridge: Cambridge University Press.

Hale, John (1994), *The Civilization of Europe in the Renaissance*, New York: Atheneum.

Jameson, Frederic (1990), *Late Marxism: Adorno, or, The Persistence of the Dialectic*, London and New York: Verso.

Marcuse, Herbert (1964), *One-Dimensional Man*, London: Routledge.

Marcuse, Herbert (1988), *Negations. Essays in Critical Theory*, trans. Jeremy Shapiro, London: Free Association Books.

Pacteau, Francette (1994), *The Symptom of Beauty*, London: Reaktion.

Paz, Mario (1970), *The Romantic Agony*, Oxford: Oxford University Press.

Sylvester, David (1994), *Looking at Giacometti*, London: Chatto and Windus.

Watteau, 1684–1721 (1984), exhibition catalogue, Paris: Éditions de la Réunion des Musées Nationaux.

White, Edmund (1993), *Genet*, London: Chatto and Windus.

Wilson, Derek (2006) [1996], *Hans Holbein: Portrait of an Unknown Man*, London: Pimlico.

CHAPTER 8 MONEY

Alpers, Svetlana (1983), *The Art of Describing*, Chicago and London: Chicago University Press.

Baudrillard, Jean (1979), *De la séduction*, Paris: Éditions Galilée.

Baümer, Angelica (1986), *Gustav Klimt: Women*, London: Winfield and Nicolson.

Bunskirk, Martha (1992), 'Commodification as Censor: Copyrights and Fair Use', *October*, 60, spring.

Cannadine, David (2006), *Mellon: An American Life*, New York: Knopf.

Jaucovic, Milan, 'Most Expensive Paintings Ever', available from http://www.renoir.org.yu/most-expensive-paintings.asp (accessed December 2007).

Lacey, Robert (1998), *Sotheby's – Bidding for Class*, Boston: Little, Brown and Company.

Marx, Karl (1977), *Selected Writings*, ed. David McLellan, Oxford: Oxford University Press.

Mulvey, Laura (1993), 'Some Thoughts on Theories of Fetishism in the Context of Contemporary Culture', *October*, 65, summer.

Niess, Robert (1968), *L'Œuvre: Zola, Cézanne, Manet*, Anne Arbor, MI: Michigan University Press.

Schama, Simon (1987), *The Embarrassment of Riches*, New York: Knopf.

Schorske, Carl (1981), *Fin-de-Siècle Vienna*, New York: Vintage.

Secrest, Meryle (2004), *Duveen: A Life in Art*, Chicago and London: Chicago University Press.

Tadié, Jean-Yves (1996), *Marcel Proust*, Paris: Gallimard.

White, Cynthia and Harrison (1965), *Canvases and Careers*, New York: John Wiley and Sons.

CHAPTER 9 DISPLAY

Battcock, Gregory (1968), *Minimal Art: A Critical Anthology*, New York: Dutton.

Benjamin, Walter (1979), 'Eduard Fuchs, Collector and Historian', trans. Kingsley Shorter, *One-Way Street*, London: New Left Books, p. 360.

Buchloch, Benjamin (ed.) (1988), *Broodthaers: Writings, Interviews, Photographs*, Cambridge, MA: MIT Press.

Dunlop, Ian (1999), *Louis XIV*, London: Chatto and Windus.

Cooke, Lynne and Peter Wollen (ed.) (1995), *Visual Display: Culture Beyond Appearances*, Seattle, WA: Bay Press.

Geczy, Adam and Benjamin Genocchio (eds.) (2002), *What is Installation? An Anthology of Writings on Australian Installation Art*, Sydney: Power Publications.

Goldin, Amy (1974), 'The Esthetic Ghetto: Some Thoughts About Public Art', *Art in America*, 62, no. 3, May–June.

Haskell, Francis (2000), *The Ephemeral Museum: Old Master Paintings and the Rise of the Art Exhibition*, New Haven, CT and London: Yale University Press.

Judd, Donald (1965), 'Specific Objects', *Arts Yearbook*, 8.

Karp, Ivan and Steven Lavine (eds.) (1991), *Exhibiting Cultures: The Poetics and Politics of Museum Display*, Washington, DC and London: The Smithsonian Institution Press.

Krauss, Rosalind (1985), 'Art and the Expanded Field', *The Originality of the Avant-Garde and Other Modernist Myths*, Cambridge, MA: MIT Press.

Malraux, André (1978), *The Voices of Silence*, trans. Stuart Gilbert, Princeton, NJ: Princeton University Press.

O'Doherty, Brian (1976), *Inside the White Cube: The Ideology of the Gallery Space*, Santa Monica and San Francisco: Lapis Press.

Pevsner, Nikolas (1940), *Academies of Art, Past and Present*, Cambridge: Cambridge University Press.

Putnam, James (2001), *Art and Artifact: Museum as Medium*, London: Thames and Hudson.

Richards, Charles (1927), *Industrial Art and the Museum*, New York: Macmillan.

Schildkrout, Enid and Curtis Keim (eds.) (1998), *The Scramble for Art in Central Africa*, Cambridge: Cambridge University Press.

Serota, Nicholas (2000), *Experience or Interpretation: The Dilemma of Museums of Modern Art*, London: Thames and Hudson.

Tilghman, Benjamin (1984), *But Is It Art?*, Oxford: Basil Blackwell.

Tomkins, Calvin (1996), *Duchamp*, London: Chatto and Windus.

Virilio, Paul (2000), *La Procédure silence*, Paris: Éditions Galilée.

CHAPTER 10 AGENCY

Berghuis, Thomas (2006), *Performance Art in China*, Hong Kong: Timezone 8.

Bloch, Ernst (1988), *The Utopian Function of Art and Literature. Selected Essays*, trans. Jack Zipes and Frank Mecklenburg, Cambridge, MA: MIT Press.

Boime, Albert (1990), *Art in the Age of Bonapartism, 1800–1815*, Chicago and London: Chicago University Press.

Brookner, Anita (1980), *David*, London: Thames and Hudson.

Crow, Thomas (1978), 'The *Oath of the Horatii* in 1795: Painting and Pre-Revolutionary Radicalism in France', *Art History*, 1, pp. 428–71.

Crow, Thomas (1985), *Painters and Public Life in Eighteenth-Century Paris*, New Haven, CT: Yale University Press.

Eitner, Lorenz (1983), *Géricault*, London: Orbis Publishing.

Fried, Michael (1990), *Courbet's Realism*, Chicago and London: Chicago University Press.

Herbert, Robert (1972), *David: Brutus*, London: Allen Lane Penguin Press.

Hutton, John (1994), *Neo-Impressionism and the Search for Solid Ground. Art, Science and Anarchism in Fin-de-Siècle France*, Baton Rouge, LA: Louisiana State University Press.

Melzer, Annabelle (1976), *Dada and Surrealist Performance*, Baltimore, MD and London: Johns Hopkins University Press.

Nochlin, Linda (1971), *Realism*, London: Pelican.

Outram, Dorinda (1989), *The Body and the French Revolution: Sex, Class and Political Culture*, New Haven, CT and London: Yale University Press.

Schapiro, Meyer (1982), 'Courbet and Popular Imagery', *Modern Art*, New York: George Braziller.

Shiner, Larry (2001), *The Invention of Art*, Chicago and London: Chicago University Press.

Wright, Beth (ed.) (2001), *The Cambridge Companion to Delacroix*, Cambridge: Cambridge University Press.

Zuidervaart, Lambert (1991), *Adorno's Aesthetic Theory*, Cambridge, MA: MIT Press.

INDEX

Note: numbers in *italics* denote illustrartions.

A

Abstract Expressionist/Expressionism, American abstraction, 19, 34, 57, 88, 102, 108, 143
Acconci, Vito, 81–2, *81*
Action Painters, 34
Addison, Joseph, 123
Adorno, Theodor Wiesengrund, 123, 126–7, 128–30, 155, 177
Aegean art, 117
aesthetics, 121–4
African sculpture/artefacts, 48, 160
Akira, Kanayma, 16
Alauddin Khilji, Sultan, 114
Alberti, Leon Batistta, 11, 27, 45–7, 104
Algerian revolution, 78
Alhazen (Ibn al-Haytham), 47
allegory, 112
Alloway, Lawrence, 143
Alte Nationalgalerie, Berlin, 162
American Indian burial ceremonies, 11
American invasion of Iraq, 2003, 40
American-type painting, 34
Ancient Greeks/Greece, 8, 12–13, 44–5, 52, 58, 65, 84, 85, 89, 95–6, 103, 105, 107–8
	Grecian urns, 139
Ancient Egypt, 20, 24, 84, 85, 107
André, Carl, 157–8, *158*
Antonioni, Michelangelo, 80
Apollinaire, Guillaume, 33, 48
Appiah, Kwame Anthony, 161
Aragon, Louis, 71
Argyrol, 142

Aristippus, 115
Aristotle, 10, 12–3, 90, 115, 117, 122
Armory Show, 152
Art-Life, *159*
Artaud, Antonin, 33
Arte Povera, 143
Asante, King of Ghana, 161
askesis, 91
Asterix comic, 169
Augustus Octavian, 132
Aurelius, Marcus, 166
Australian Aboriginal art, 9, 20–3, *22*, *23*, 43, 160
	burial ceremonies, 11
Aztecs, 85
	sun worship, 11

B

Bacon, Francis (artist), 62–3, 90
Bann, Stephen, 148
Barbizon school, 87, 149
Barnes, Alfred, 142
	Barnes collection, 142
Baroque, 47, 109, 117, 133, 148
Barthes, Roland, 65
Bataille, Georges, 9–12, 138
Batteux, Charles, Abbé, 121
Baudelaire, 57–8, 71–2, 94–5, 101–3, 174, 184
	flâneur, 71–2
Baudrillard, Jean, 61, 64, 128, 138–9
Bauhaus, 111, 155
Baumgarten, Alexander, 121–3
Baziotes, William, 34

Beatles, The, 143
 Sergeant Pepper, 143
Beckett, Samuel, 55
Beckmann, Max, 126
Beethoven, Ludwig van, 128, 171–2
Bellini, Giovanni, 87
Bellini, Jacopo, 73
Benjamin, Walter, 95
Bennigsen, Levin August, Count von, 169
Bentham, Jeremy, 76
Berenson, Bernard, 141
Berger, John, 86–7
Bergson, Henri, 48, 110
Berkeley, Bishop, 91
Bernard, Émile, 36, 175
Bertrand, Aloysius de, 32
Besonnenheit, 106
Beuys, Joseph, 15–16, *16*
Beyeler museum, 142
Bi Sheng, 92
Bingen, Hildergard von, 58
Blake, Peter, 143
Blake, William, 58
Bloch-Bauer, Adele, 137, 138
blogging, 41
Boer Wars, 125
Bologna, Giovanni, *see* Giambologna
Bonaparte, Napoleon, *see* Napoleon
 Bonaparte
Bondone, Giotto di, *see* Giotto di Bondone
Botticelli, Sandro, 103
Boucher, François, 31, 155
Bouguereau, William-Adolphe, 136
Bourdieu, Pierre, 136–7
Bracciolini, Poggio, 104
Brahmin, 114
Braque, Georges, 48, *49*, 184
Brassaï, 19
Brauntuch, Troy, 112
Bresdin, Rodolphe, 93
Breton, André, 36
British Museum, 141, 160, 161
Brown, Ford Madox, 27, *28*
Bronze Age, 84
Brunelleschi, Filippo, 47
Buckley, Brad, 39–40, *39*

Buddhism, Buddhist, 2, 51, 58, 114
Bullock, William, 173
Buñuel, Luis, 60–1, *61*
Buonarotti, Michelangelo, *see* Michelangelo
 Buonarotti
Bürger, Peter, 177–8
Burke, Edmund, 123
Burnett, Ron, 64–5
Burt, T.S., 114
Bush, Vannevar, 40
Byzantium, Byzantine Empire, Byzantine,
 24–5, 104

C
Cahill, James, 50
Caillebotte, Gustave, 72
calligraphy, 23–4
camera obscura, 90–1
Canady, John, 34
Canaletto (Giovanni Antonio Canale), 91
Canova, Antonio, 103
Catholicism, 25, 117
Caravaggio, Michelangelo Merisi da, 87
Cardoso, Maria Fernanda, 156, *157*
Carlos III (of Spain), 120
Carpaccio, Vittore, 26–7
Cassatt, Mary, 72–3, *73*
Catherine the Great, 140
Cellini, Benvenuto, 35–6, 119, *119*
Cézanne, Paul, 35, 36, 48, 50, 60, 62, 88,
 102, 142
Champfleury (Jules François Felix Fleury-
 Husson), 33
Chandela dynasty, 114
Chandler, David, 169
Chardin, Jean-Baptiste-Siméon, 31, 33
Charles V (Hapsburg Emperor), 117
Charles X, 174
Chartres Cathedral, *26*
Chaumereys, Hughes Duroys de, 172
Chinese art, 23–4, 35, 50–2
 Han period, 23–4
 Southern Song Dynasty, 50–1
 Tang Dynasty, 50
 urnware, 84
 woodblock printing, 92

chinoiserie, 73

Christian, Christianity, 4, 25–6, 109, 131, 164, 166
 the Church, 136

Christie's, 137

Christo, 156

Churchill, John, 1st Duke of Marlborough, 133

Cicero, 45

Clark Institute, 142

Clark, Kenneth, 102

Clark, Stephen, 142

Clark, Sterling, 142

Claude Lorrain, 2

Clement VII, Pope, 117–18

clientelismo, 131

Coates, Robert, 34

Code of Hammurabi, 24–5, *25*

Cognacq-Jay museum, 142, 155

Cold War, 78, 159

Coleridge, Samuel Taylor, 32

commedia del'arte, 82

Communism, 4
 Communist Party, 176

Comte, Auguste, 33

Conceptual artists/art, Conceptualism, 38, 155, 159

Conrad, Joseph, 40

Constable, John, 87

Constantine, Emperor, 24

Constantinople, 25

Constructivism, 176–7

Cope, Walter, 147

Corday, Charlotte, 166

Corinthian, 103

Correggio, Antonio da, 124

corroberee, 21

Courbet, Gustave, 33, 136, 149

Crary, Jonathan, 90–1

Crimean War, 125

Cromwell, Oliver, 29

Cross, Charles Frederick, 33, 88

crucifixion, 12

Cubism, Cubist, 34, 47–50, 75, 160, 176

cyberspace, 82

D

Da Vinci, Leonardo, 35, 47, 87

Dada, Dadaist, 17, 130, 143, 158, 176–7
 Academie Voltaire, 177
 post-Dadaist, 15

Daguerre, Louis, 94

Dalí, Salvador, 60, *61*

Damisch, Hubert, 46

David, Jacques-Louis, 31, 166–8, *167*, 170, 172

Dashanzai art district, Beijing, 178

De Chirico, Giorgio, 36

De Stijl, 111

death, 10–11

Debord, Guy, 64

Debussy, Claude, 56

decadents, decadence, 53, 58

deconstruction, 61

Degas, Edgar, 72, 102

degenerate art, 104

Del Favero, Dennis, 99, *99*

Delacroix, Eugène, 36, 94, 150, 174

Delaroche, Paul (Hippolyte), 29, *29*, 94

Délécluze, Étienne-Jean, 31

Deleuze, Gilles, 61–3

Deleuzian, 4

Denis, Maurice, 36

Denon, Vivant, 151

Depression, the, 142

Derrida, Jacques, 4, 61, 65, 82

Descartes, René, 117

Deseiné, Louis-Pierre, 151

Dickens, Charles, 174

Diderot, Denis, 31, 33, 133, 140

Digital Earth, 82–3

Disneyland, 9

Dix, Otto, 125–6, *126*

Dr Seuss, 135

Dokumenta, 15, 149

Domenichino, 106

Donatello (Donato di Niccolò di Betto Bardi), 47

Doric, 103

Dostoyevski, Fyodor, 2

Duchamp, Marcel, 19, 152–3, *153*, 159

Dürer, Albrecht, 92, *92–3,* 102
Duveen, Joseph, Baron Duveen of
 Millbank, 141

E
Eagleton, Terry, 122
Eastern art, 36
Edelfelt, Albert, 175
eidôlon, 44
Eiffel Tower, 163
Eileras, Karina, 78
El Lissitsky (Lazar Markovich Lissitzky),
 177
Eldorado, 114
Elgin Marbles, 141
Eliade, Mircea
 shamanism, 14–15
Eliot, George (Mary Ann Evans), 146
 Cassaubon, 146
Eliot, Thomas Stearnes, 32
Elizabeth II, Queen of England, 168
Elizabethan Society of Antiquaries, 147
Engels, Friedrich, 33
Enlightenment, 10, 30, 171
Éphrussi, Charles, 140
Epicurus, 115
episteme, 96
L'Esprit Nouveau, 49
Esterhazy princes, 171
Euclid, 90
Expressionism, 110
Eyck, Jan van, 85, *86*

F
familiaris, 132
Fascist Italy, 104, 160 176
Fauvism, Fauvist, *fauve,* 35, 87
femme fatale, 125
Fénéon, Félix, 33
feuilletons, 30
First World War, 53, 100, 125, 151
Flaubert, Gustave, 40
Fleischman, Barbara and Lawrence, 139
Fluxus, 15–16
Foucault, Michel, 67, 76–77
Fra, Angelico, 46, *46*

Fragonard, Jean-Honoré, 31, 102
Franco-Prussian War, 125
François I, 119
French Monuments, Museum of, 151
French Revolution, 4, 111, 149, 151,
 166
French Symbolism, 55
Freud, Lucien, 35
Freud, Sigmund, 52, 59–60
 cathexis, 10
 dreams, 59
 sublimation, 59–60
Frick, Henry Clay, 141
Friedrich, Caspar David, 53–5
Fuseli, Henri, 58
Futurism, 36, 176, 179

G
Gachet, Dr, 137
Galerie Durand-Ruel, 137
Galerie Petit, 137
Gallen, Axel, 175
Garanger, Marc, 78
Gauguin, Paul, 75–6, *76,* 175
Gautier, Théophile, 31
Genet, Jean, 127
Geoffroy, Gustave, 33
George, Phillip, 78, *79*
Géricault, Théodore, 172–4, *173*
German Expressionism, 75, 87
Gérôme, Jean-Léon, 66–83, *74,* 136
Getty Foundation, 139
Giacometti, Alberto, 127
Giambologna, 119
Gibbon, Edward, 28
Gibson, William, 32
Giorgione (Giorgio Barbarelli da
 Castelfranco), 85, 87, 102, 106 141
Giotto di Bondone, 26, 48
Gladstone Gallery, New York, 180
Gleizes, Albert, 49
Goethe, Johann W., 31–2, 141
Goncourt Brothers (Edmund and Jules),
 121
Google Earth, 82
Gore, Al, 82

Gothic art, 46
 Gothic, the, 125
Gothic cathedral, 25–6, 113, 114
Gothic revival, 125
Gottlieb, Adolf, 1,2
Goya, Francisco de, 58, 102, 103,120–2, *122*, 125, *170*, 170–1,
Grand Tour, 141
Greco-Roman, 104–5
Greek Orthodox Church, 164
Greek revival, 105
Greenberg, Clement, 34, 88, 108
Gris, Juan, 49
Gros, Antoine-Jean, 168–70, *169*
Grosz, George, 126
Grünewald, Matthias, 164
Guattari, Felix, 18, 61, 155
Guercino (Giovanni Francesco Barbieri), 106
Guerilla Girls, 180
Guevara, Che, 168
Guggenheim, Berlin (Deutsche Guggenheim), 38
Guggenheim, Bilbao, 146, 163
Guggenheim, New York, 162, 182
Guicciardini, Francesco, 132
Guillaume, Paul, 142
Guimet Museum, 146
Gursky, Andreas
Gutai group, 16–17
Gysels, Peeter, 133, *133*

H
Haacke, Hans, 159–60
Haas, Charles, 140
Habermas, Jürgen, 77
Habsburg, Empire, 133
 Habsburg regime, 136
Hagia Sophia, 25
Halonen, Pekka, 175
Hammurabi
 code 24–5
 King of Babylon, 24
Hansen, Mark, 99
Happenings, 16–17, 158–9
Hausmann, Baron, 72

Haydn, Joseph, 171
Hazlitt, William, 2–4, 31, 124, 133
Hearst, William Randolph, 141
Heckel, Erich, 75
Hegel, G.W.F, 1, 55, 89–90, 97–8, 107–8, 133
 Hegelian, Hegelianism, 77, 110
Heidegger, Martin, 95–6
Heiterkeit, 105
Heizer, Michael, 156
Henry VIII, 147
Hepworth, Barbara, 98
Herculaneum, 9, 85, 105
Herder, Johann Gottfried, 88–9, 106–7
Hermitage Museum, 140
hieroglyphs, 20
Hill, Adam, 22–3, *23*
Hinduism, 2
Hiroshige, 13
Hirschhorn, Thomas, 179–81
Hirst, Damien, 129
Hitchcock, Alfred, 80
Hitler, Adolf, 104
Holbein, Hans (the Younger), 63, *69*, 70
Hölderlin, Friedrich, 107
Hollier, Denis, 11
Holocaust, the, 38
Holzer, Jenny, 40
Homo erectus, 9
Homo faber, 11
Homo ludens, 11
Homo sapiens, 9, 11, 43, 182
Honorar, 132
Horace, 27, 45
Horkheimer, Max, 128
Hôtel Drouot, 137
Hubbuch, Karl, 126
Hugo, Victor, 125
Huhtami, Erkki, 99
Humboldt, Alexander von, 38
Hume, David, 1–2, 28, 62, 123
Huntington, George, 141
Hutcheson, Francis, 123
Huysmans, Joris-Karl, 35, 58
hypertext, 40

I

imaginary, 42
Impressionism, Impressionist, 47–8, 56,
 72–3, 137
Industrial Revolution, 171
Ingres, Jean-Auguste Dominique, 94
installation artists/art, 155–7
Ionic, 103
Irigaray, Luce, 70
Iron Age, 84
istore, 26–7

J

Jacobinism, Jacobin, 4, 168
James, Henry, 140
Japanese art
 Gutai group, 16–17
 Heian period, 13
 ukiyo-e prints, 13
Järnefelt, Eero, 175–6, *176*
Javacheff, Christo, *see* Christo, 156
Javits Federal Building, 157
Jeanne-Claude, 156
Jeanneret, Charles-Édouard (Le Corbusier),
 49, 111
Jensen, Robert, 137
Jewel, Edward, 1
Jewish History Museum, Berlin, 146, 163
Jiro, Yoshihara, 16–17
Johns, Jasper, 37
Johnson, Samuel, 31
Jugendstil, 175
Julius II, Pope, 117
Jungian, 19

K

Kamakura Shogunate, 13
Kandinsky, Wassily, 36, 56–7
Kant, Immanuel, 52, 63, 67–8, 123–4
Kaprow, Alan, 158–9, 183
katharsis, 10, 13
Kazuo, Shiraga, 16
Kelly, Mary, 159–60
Kennedy, Peter, 37, *37*
Kentridge, William, *129*, 130
Kepler, Johannes, 90

Khajuraho, 114–15, *115*, 117
Khommeni regime, 79
Kierkegaard, Søren Aabye, 52
Kimmelman, Michael, 161–2
Kiyonaga, 13
Klein, Calvin, 6
Klein, Yves, 135
 International Yves Klein Blue, 135
Kleist, Heinrich von, 53–5
Klimt, Gustav, 136, 137, 138
Kline, Franz, 34
Koberger, Anton, 92
Kodak camera, 94
Kooning, Willem de, 34
Koons, Jeff, 143–4, *144*
Kosuth, Joseph, 38
Krauss, Rosalind, 98, 156
Kress, S. H., 141
Kristeva, Julia, 61, 63
Kunst im öffenen Raum, 156
Kunstkabinett, 147
Kunstwollen, 8
Kupka, Frantisek 56

L

Lacan, Jacques, 68–70, 82, 91
 castration, 70
 objet petit 'a', 69
 scopic field, 69
Land artists/art, 155–6
Laocoon and His Sons, 89
Lascaux (Dordogne, France), 9–11, 43
Lauder, Robert, 137
Lautréamont (Isidore Ducasse), 60
Lawrence, Thomas, 86
Le Brun, Charles, 27, 148
Le Corbusier, *see* Jeanneret, Charles-
 Édouard
Le Nain brothers (Antoine and Louis),
 102
Léger, Ferdinand, 49–50
Leibniz, Gottfried, 93
Lenoir, Alexandre, 151
Leo X, 117
Lessing, Gotthold, Ephraim, 88–9, 96–8,
 107

Lévi-Strauss, Claude
 abreaction, 10, 14
 shamanism, 14
Levine, Sherry, 112
Lewis, Wyndham, 36
Lhote, André, 49
Libby, W.F., 9
Liberman, Alexander, *127*
Libeskind, Daniel, 163
Lichtenstein, Roy, 143
Liebovitz, Annie, 86
Lipschitz, Jacques, 49
Liszt, Franz, 172
LiveType, 97
Long, Richard, 156
Longinus, 123
Longo, Robert, 112
Loos, Adolf, 109, 111
Lorrain, Claude, *see* Claude Lorrain, 2
Los Angeles Art Museum, 146
Louis XIV, 133, 148
Louis XV, 155
Louis XVIII, 172–3
Louvre Museum, 149–51, 163, *163*, 170
Luther, Martin, 92
Luxembourg Gallery, 149
Lyotard, Jean-François, 61, 63, 112

M
Machiavelli, Niccoló, 132
Maecenas, Gaius, 132
Malevich, Kasimir, 49, 111
Malgrave, Harry, 109
Man Ray, 60
Manet, Édouard, 27, *101*, 72, 101–3, 113
mannerism, 47–8, 109, 117–18
Manovich, Lev, 65
Mao, Maoist, 178
Maoist China, 104
Marat, Jean-Paul, 166–8
Maria, Walter de, 156
Marinetti, 36
Martin, Stéphane, 161
Marx Brothers, 162
Marx, Karl, 12, 33, 138
 Marxism, Marxist, 77, 87, 95, 177

Matisse, Henri, 35, 36, 102, 125, 142, 153
Mazarin, Jules, Cardinal, 148
McLuhan, Marshall, 96–7, 138
mecanitismo, 132
Medici, the, 132
Medici, Giacomo, 139
medieval illuminations, 60
Meier-Graefe, Julius, 33
Méliès, Georges, 130
Mellon, Andrew, 141, 142
Mendieta, Ana, 17–18, *17*
Merleau-Ponty, Maurice, 62, 82
Messina, Antonello da, 85
Metzinger, Jean, 49
Mexican art, 20
Michelangelo Buonarotti, 10, 35, 48, 85,
 106, 118, 164–5
Middle Ages, 25–6, 27, 76, 104, 131, 151
Mies van der Rohe, Ludwig, 111, 163
Millet, Jean-François, 136
Milwaukee Art Museum, 146
Minimalism, 157
Minotaurmachy, 11
Mirbeau, Octave, 33
Miró, Joan, 102
moiete, 21
Modernism, Modernist, 34, 102, 117, 178
Mondrian, Piet, 36, 56–7, 102
Monet, Claude, 33, 72
Montaigne, Michel de, 117
Moreau, Gustave, 20
Morgan, John Pierpont, 141
Morisot, Berthe, 72
Morris, Philip, 160
Motherwell, Robert, 36
Mozart, Wolfgang Amadeus, 130, 171
Mulvey, Laura, 70–1
Museum of Modern Art, New York
 (MoMA), 48, 153, 160
Muslim 164
Muslim illuminations, 60

N
Nabis, 36
Nadar, Caspar, 101
Nadar, Félix, 94

Napoleon Bonaparte, 27, 151, 168–71, 172
 Napoleana, 168
 Napoleonic years, 134
Napoleon III, 72, 149
Narcisus myth, 11
National Gallery, Washington, 142
National Socialism, *see* Nazism
Nauman, Bruce, 3–4, 98
Nazism, 5, 95, 104, 106, 168
Neo-Platonism, 115, 132
Neotraditionalism, 36
Nerval, Gérard de, 32
Neshat, Shirin, 78–80, *80*
Net Art ('net.art'), 40–1, 165
Neue Galerie, New York, 137
Neue Natioanlgalerie, Berlin, 162–3
Neue Sachlichkeit, 126
Neuschwanstein castle, 9
New York School, *see* Abstract
 Expressionism
Newman, Barnett, 34, 63–4, 87
Newton, Isaac, 94
Niépce, Joseph, 93
Nietzsche, Friedrich, 52–3, 62, 107, 184
Nissim de Camondo museum, 142
Nokia, 97
nostalgie de la boue, 174
noumenon, 67
Novalis, 32

O
Octavian, Augustus, *see* Augustus Octavian
onar, 44
Orient, Orientalism, Orientalist, 74–5,
 77–80
Ossian, 55
Other/other, the, 68–71, 74
Owens, Craig, 112
Ozenfant, Amédée, 49

P
Paganini, Niccolò, 172
Paleolithic man, 9
Paleolithic period, 9
Palmer, Samuel, 58
Panofsky, Erwin, 109

Paolozzi, Edouardo, 143
Pardo Palace (El Pardo Palace), 120
Parks, Lisa, 82–3
Parr, Mike, 37, *37*
pastiche, pasticheur, 102
Paz, Octavio, 60
Pei, I. M., 163
peinture, 29
performance artists/art, 155, 158–9
Perugino, Pietro, 118
phantasiai, 44
phasma, 44
phenomenon, 67
Philadelphia Museum of Art, 153
Philip, IV of Spain, 77
Picasso, Pablo, 19, 48, 75, *75,* 87, 98, 103,
 127, 160, 176
Piles, Roger de, 105–6
Pillow Book, The (Sei Shonagon), 13
Pink Floyd, 3
Piombo, Sebastian di, 132
Pissarro, Camille, 72
Platform, 160
Plato, 30, 44, 55, 67, 122
 Platonism, 61–2
 see also Neo-Platonism
Platter, Thomas, 147
Pliny, 30
Plissart, Marie-Françoise, 82
Plotinus, 115–16
Poe, Edgar, Allan
poète maudit, 134
Poggioli, Renato, 177
poiêtes, 44
Pointillism, 56
Pollio, Marcus Vitruvius, *see* Vitruvius
Pollock, Griselda, 72–3
Pollock, Jackson, 34, 87
Pompeii, 45, 85, 105
Pont-Aven school, 175
Pop Art, 130, 143
positivism, 77
Post-Impressionism, 56
Postmodernism, 112, 178
Poussin, Nicolas, 27, 86
Prado, 46

Pre-Raphaelitism, 27–8
'primitive', 'Primitivism', 73–6
Princet, Maurice, 48
Pro Helvetia, 180
Protestantism, 117
Proud'hon, Pierre-Joseph, 33
Proust, Marcel, 31–3, 140
psuchê, 44
Purism, 49, 111

Q
Quai Branly, Musée du, 146, 161–2
Quicktime, 97
Quintilian, 44

R
Raphael Sanzio, 102, 106, 117, 132
rappel à l'ordre, 49
Realism, Realist, 101, 137, 174–6, 177,
 179
Redon, Odilon, 58–9, 93
Reeves, William, 87
Reich, Steve, 38
Reinhardt, Ad, 36, 87
Rembrandt van Rijn, *see* Rijn, Rembrandt
 van
Renaissance, 47, 49, 60, 84, 90, 103, 105,
 108, 109, 115, 117–9, 130, 132, 141,
 148, 150
Renoir, Pierre-Auguste, 138, 142, 149
Reynolds, Joshua, 36, 149
Ribera, Jusepe de,102
Richmond, George, 58
Riegl, Alois, 9, 35, 90–1, 109–10, 111, 116
Rijn, Rembrandt van, 93, 106, 119–20,
 121
Rilke, Rainer Maria, 50
Rimbaud, Arthur, 58
ripolin, 87
Robert, Hubert, 150
Robertson, William, 28
Robespierre, Maximilien, 166, 168
Rockefeller, Nelson, 20, 141
Rodchenko, Alexander, 177
Rodin, Auguste, 102, 149
Roman art, 25, 110

Roman Empire, 24, 104, 115, 131, 147–8,
 168
Romantic, Romanticism, 19, 32, 52–5, 62,
 67, 107, 108, 118, 125, 174
 'National Romantic School', Finland,
 175
Roosevelt, Franklin Delano, 142
Rosenberg, Harold, 34
Rosenquist, James, 143
Rosetta Stone, 168
Rothko, Mark, 1–2, 20, 34, 57, 87
Rousseau, Jean-Jacques, 10
Rowland, Ingrid, 132
Royal Academy, Britain, 149
Rubens, Peter Paul, 27, 85, 103, 106, 119
Ruff, Thomas, 98
Ruskin, John, 31–2, 33, 35
Russian Formalists, 34

S
Saatchi, Charles, 128
Saburo, Murakami, 16–17
St John, Henry, Viscount Bolingbroke, 27
St Marks, Venice, 161
St Sebastian, 168
Saint-Simon, 33
Saito, Ryoei, 137–8
Salon (Paris), 27, 135–6, 148–9, 154
Salon d'Automne, 149
Salon des Refusés, 149
Samurai, 4
Santayana, George, 124
Sanzio, Raphael, *see* Raphael Sanzio
Sargent, John Singer, 142
Sartre, Jean-Paul, 68–9, 82
Schad, Christian, 126
Schapiro, Meyer, 94, 110, 112
Schedel, Hartman, 92
Schelling, Friedrich Wilhelm Joseph, 55
Schinkel, Karl Friedrich, 162
Schlegel, Friedrich, 32, 52
Schleiermacher, Friedrich, 107
Schopenhauer, Arthur, 52, 55, 124
Schrimpf, Georg, 126
scopophilia, 71
Secession, Vienna, *see* Viennese Secession

Second World War, 14, 26, 126, 128

Section d'Or, 49–50

Seek, Otto, 103

Semper, Gottfried, 108–9, 111, 112

Seneca, 166

Serra, Richard, 157

Seurat, Georges, 33, 56, 88

Sforza, the, 132

Shaftesbury, Anthony Ashley-Cooper, 7th Earl of, 88

Shakespeare, William, 147

shamanism, 14

Shaw, Jeffrey, 99, *99*

Sherman, Cindy, 71, *71*

Shih-t'ao, 35, 51

Shjeldahl, Peter, 3, 30

Shostakovich, Dmitri, 3

Shozo, Shimamoto, 16–17

Sibelius, Jan, 175

Signac, Paul, 33

Smithson, Robert, 156

social Darwinism, 104

Socrates, 115

Sontag, Susan, 64

Sony Walkman, 97

Sotheby's, 137

Spartan, 168

Spate, Virginia, 33

Spencer, Diana, Princess, 45

Spengler, Oswald, 104

Spinoza, Baruch, 62

Stalinist Russie, 104

Stallybrass, Julian, 41

Star Wars, 3

Stein, Gertrude, 142

Stein, Leo, 142

Still, Clyfford, 20, 34

Struth, Thomas, 98

studiolo, 147

sublime, 63–4, 123–4

 sublimis, 123

Suprematism, 111

Surrealism, Surrealist, 36, 52, 58, 60–1, 125, 148, 158, 179

Swann, Charles, 140

Symbolism, 125, 175

T

Talbot, William Fox, 94

Tale of Genji (Murasaki Shikibu), 13

 film by Kazaburo Yoshimura, 13

Tantrism, 115

Tate Gallery, 157

Tate Modern, *162*, 163

Tatlin, Vladimir, 177

techne, 95–6

Technicolor, 27

Theosophy, 56

Thomas, Rover, 20

Tieck, Ludwig, 32

Tintoretto, Jacopo, 85

Titian (Tiziano Vecelli or Tiziano Vecellio), 85–6, 102, 103, 106, 141

Tobey, Mark, 34

Tolstoy, Leo, 128

Torvill and Dean, 33

Toulouse-Lautrec, Henri de, 93

Toynbee, Arnold, 103

Troostwijk, Wouter van, *134*

Trotsky, Leon, 178

Tuileries gardens, 157

Turner, Joseph Willam Mallord, 33, 87

U

Updike, John, 30, 142

ut pictura poesis, 27

Utamaro, 13

Uylenborch, Saskia van, 120

V

Valéry, Paul, 145–6, 155

Van Gogh, Vincent, 33–4, 60, 137

vanitas, 132

Vasarely, Victor, 93

Vasari, Giorgio, 30, 35

Vauxcelles, Louis, 35, 48

Vecchio, Palma, 106

Velazquez, Diego Rodriguez de Silva y, 77, 102, 119–20, *120*

Venice Biennale, 149, 160

Venus, 103

Vermeer, Jan, *91*, 91–2

Vernant, Jean-Pierre, 43, 96

Vernet, Horace, 31
Vickery, Jonathan, 128
Viennese Secession, 111, 136
Virgil, 32
Virilio, Paul, 146
Vitruvius, 85, 103–4
Vlaminck, Maurice de, 87
Voigtländer, Johann Christoph, 93
Vorticism, 36

W
Wackenroder, Wilhelm Heinrich, 32
Wallace collection, 142
Warhol, Andy, 93, 135, 143–4
 Interview (magazine), 135
 Factory, the, 135
Weibel, Peter, 99, *99*
Weiner, Lawrence, 38, *38*
Weltanschauung, 107, 116
Whistler, James McNeill, 35, 55–6, 93,
 154, *154*
Whitney Biennial, 149
Wilde, Oscar, 53, 125
Winckelmann, Johann Joachim, 105–6, 107

Wölfflin, Heinrich, 109
Wolgemut, Michael, 92
Wolsley, Sir Garnet, 161
Wordsworth, William, 32, 172
Work Bench, 83
Worringer, Wilhelm, 110
Wright, Frank Lloyd, 162
Wunderkammer, 146–8
Wyeth, Andrew, 84

X
Xia Gui, *51*

Y
Yale Museum of Art, 160
'Young British Artists' ('YBA'), 128
Young, Julian, 96
YouTube, 41

Z
Zampiero, Domenico, *see* Domenichino
Zhu Yu, 178–9, *179*
Zizek, Slovaj, 68
Zola, Émile, 33, 101, 113, 174